FINANCIAL LEADERSHIP

FOR THE ARTS

FINANCIAL LEADERSHIP FOR THE ARTS

Sustainable Strategies for Creative Organizations

CLEOPATRA CHARLES AND MARGARET F. SLOAN

The University of North Carolina Press
Chapel Hill

This book was published with the assistance of the
Luther H. Hodges Jr. and Luther H. Hodges Sr. Fund of the University of
North Carolina Press and the Rutgers University Research Council.

© 2024 The University of North Carolina Press
All rights reserved

Set in Garamond by Copperline Book Services, Inc.

Manufactured in the United States of America

Cover art © Mr Twister/stock.adobe.com.

Complete Library of Congress Cataloging-in-Publication Data
is available at https://lccn.loc.gov/2024000448.

ISBN 978-1-4696-7878-8 (paper: alk. paper)
ISBN 978-1-4696-7879-5 (epub)
ISBN 979-8-8908-8707-8 (pdf)

*This book is dedicated to the arts leaders
who inspire, encourage, and refresh all of us.*

CONTENTS

List of Illustrations ix

Acknowledgments xi

Introduction to Finances for
Arts and Cultural Nonprofit Organizations
1

CHAPTER ONE
Budget Process Basics for the Creative Mind
15

CHAPTER TWO
Preparing Operating Budgets That Perform
31

CHAPTER THREE
Stubs and Subs:
Sources of Revenue for Nonprofit
Arts Organizations
49

CHAPTER FOUR
Liquidity and Managing Cash Flow
in Arts Nonprofits
67

CHAPTER FIVE
Singin' in the Rain:
Why You Need a Rainy Day Fund
77

CHAPTER SIX
Spotting Opportunities or Trouble:
Understanding Financial Statements
95

CHAPTER SEVEN
Managing the Audit and
Selecting an External Auditor
115

CHAPTER EIGHT
Financial Statement Analysis for Arts Leaders
129

CHAPTER NINE
More Than Just Audience Satisfaction:
Measuring Organizational Performance
145

CHAPTER TEN
Accountability and Governance for Arts Stability
163

CHAPTER ELEVEN
Worth a Pound of Cure:
Preventing Fraud and Abuse in Arts Nonprofits
177

CHAPTER TWELVE
Short- and Long-Term Trade-Offs:
Investing Funds and Managing Debt
189

CHAPTER THIRTEEN
Keeping the Arts Alive:
Adapting to Turbulent Times and
Developing Resilience
207

CHAPTER FOURTEEN
Creativity Takes Courage:
Making Great Financial Decisions for Arts Leaders
225

Appendix 233

Notes 243

Index 265

ILLUSTRATIONS

FIGURES

FIGURE 6-1 Form 990 for Charles Center for Contemporary Art 98

FIGURE 9-1 Performance Measurement Cycle 147

FIGURE 9-2 FACE Performance Metrics 154

FIGURE 13-1 Fireproof Strategies for Improving Your Outcomes before, during, and after a Crisis 220

TABLES

TABLE 1-1 Scrambled Budget Cycles 23

TABLE 2-1 Lee Children's Theater 2022 Budget 36

TABLE 2-2 Lee Children's Theater, January 2022 Variance Analysis 41

TABLE 2-3 Indirect Cost Allocation 46

TABLE 3-1 Total Earned Revenue Annual Averages, 2014–2020 53

TABLE 4-1 Quarterly Cash Budget for Project Art 74

TABLE 5-1 How Substitutes for Operating Reserves Measure Up 82

TABLE 5-2 A Comparison of the Operating Reserves among Arts and Cultural Subcategories 84

TABLE 6-1 Statement of Financial Position 108

TABLE 6-2 Statement of Activities 109

TABLE 6-3 Statement of Functional Expenses 110

TABLE 6-4 Statements of Cash Flows 112

TABLE 10-1 Roadblocks to High Performance 172

TABLE 10-2 Practices of a High-Performing Board 175

TABLE 12-1 Average Annual Investment Income for Arts Organizations 193
TABLE 12-2 Sample Asset Allocation Plan 197
TABLE 12-3 Average Debt Ratio across Arts Subsectors 201
TABLE A1 Financial Ratios Cheat Sheet 233
TABLE A2 Nonprofit Financial Management Self-Assessment Tool 234

ACKNOWLEDGMENTS

We would like to express our sincere gratitude to everyone who has contributed to the creation of this financial leadership book. Your invaluable support and assistance have been instrumental in making this project a reality.

First and foremost, we would both like to thank our family for their unwavering support and understanding throughout this journey. Their love and encouragement have been our constant motivation, and we are deeply grateful for their patience and belief in us.

We extend our heartfelt appreciation to our editor Catherine Hodorowicz and the entire UNC publishing team, who believed in the potential of this book and provided valuable guidance and expertise. Their input and suggestions have significantly enhanced the quality of the content.

We wish to acknowledge the valuable contributions of the anonymous reviewers regarding the improvement of quality, coherence, and content presentation of chapters. We owe a debt of gratitude to the arts and finance scholars whose impactful research has informed the insights in this book as well as the numerous experts and professionals in the field of nonprofit financial management and arts administration who graciously shared their knowledge and insights during the research phase. Their expertise has greatly enriched the content and ensured its accuracy and relevance. Special thanks to the Nonprofit Association of Oregon, Katy Brown, Jenny Burden, John Burgess, Stephanne Byrd, Jenn Clemo, Mark Finks, Mark Hager, Sharryl Jennell, Cobi Krieger, Dustin Loehr, Sarah MacDonald, Rick Moyers, Deb Polich, David Sloan, Brian Smallwood, Jonathan Stewart, Ari Teplitz, and Judith Wolf.

We would also like to acknowledge the contributions of our many colleagues and friends who provided valuable feedback and support during the writing process. Their input and discussions have been invaluable in shaping the ideas presented in this book.

Finally, we are indebted to all the readers who will engage with this book. Your interest and willingness to explore the subject of financial leadership inspire us to continue sharing knowledge and insights.

Once again, we extend our deepest gratitude to everyone who has played a role in bringing this financial leadership book to fruition. Your support and collaboration have been vital, and we are truly honored to have worked with such exceptional individuals.

Thank you.
Cleopatra Charles and Margaret F. Sloan

FINANCIAL LEADERSHIP
FOR THE ARTS

Introduction to Finances for Arts and Cultural Nonprofit Organizations

> Annual income twenty pounds, annual expenditure nineteen, nineteen and six, result happiness. Annual income twenty pounds, annual expenditure twenty-pound ought and six, result misery.
> —WILKINS MICAWBER in Charles Dickens, *David Copperfield*

In Charles Dickens's literary masterpiece *David Copperfield*, the idiosyncratic and penurious character Wilkins Micawber gives young Copperfield this amazingly simple yet powerfully astute financial recipe for success. While Micawber had tremendous difficulty following his own teaching and ended up in debtors' prison, his words, which we will call Micawber's Maxim, convey sound financial wisdom for personal finance.

Organizations, too, could do well to heed this simple principle. We agree that organizational finance should be simple and clear to allow organizational leaders to do their important work for communities. Arts organizations, in particular, need clear finance principles to free their leaders' time for creative pursuits.

We've been there: Trying to figure out how to fund just one more community arts program. Staying up late eating donut holes to get the grant application in by the deadline. Figuring out how to bring in disadvantaged young people to experience the magic of theater or get the lighting necessary for the watercolors exhibition without breaking the bank. Watching board members gloss over the financial statements because "that's the treasurer's job" or crossing our fingers and just hoping that we will break even for the year. Our love of, and experiences with, nonprofit arts and cultural organizations infuse our real-world understanding of the specific needs of arts professionals, the perspectives, and examples in this book; and our academic backgrounds in finance, budgeting, and nonprofit management and leadership help us translate the wealth of scholarship in these areas into sound application strategies.

This book is about the way arts and cultural nonprofits are financed, funded, and sustained in contemporary culture. If you are saying to yourself, "But I don't have any formal training or equivalent on-the-job experience," then this is the book for you! If you have years of experience, we hope you will find new ideas to incorporate into your financial toolbox to make your job less stressful and more enjoyable. We'll be covering the fundamentals to give you a strong financial grounding to get started if you are new to arts leadership or to serve as a refresher if you have years of experience. We expect that this book will be used by arts professionals in a range of capacities: leaders of the organization, board members who won't necessarily be preparing the financials but need to understand them, financial and budgeting administrators who are in the financial weeds but also would like a larger perspective on how all the pieces fit together, or those starting out in the arts world who seek to help organizations grow to their potential.

The core of the book examines important contemporary financial management issues relevant to the arts and cultural nonprofits. Ideally, this book will equip you and other nonprofit arts leaders with a financial understanding and skill set that can be immediately applicable to your work so that you can continue to excel in your creative endeavors and not only keep the house lights on but also thrive!

Students engage with art. Patrons support art. Scholars study art. Politicians debate about it. Yet few of these participants understand how accounting and other financial information is used in management and policymaking within arts and cultural nonprofits. Understandably so. Arts professionals often came into their profession by virtue of their artistic training, not financial training, and their arts expertise enables them to bring to life experiences, ideas, and values in ways that exemplify and amplify those of our collective identity. Accountants can't necessarily do that, so it wouldn't make sense for us to expect creatively oriented people to also be masters of financial principles. However, arts professionals can master some core financial principles in order to accomplish their creative work free from financial anxiety and strengthen their organization's long-term sustainability and resilience in times of financial downturn, which often impact arts organizations more adversely than other nonprofit subsectors.

Research on nonprofit finance is vast, yet it tends to focus on specific subsectors, primarily in health care and higher education. However, fundamental concepts and methods of finance and financial analysis of arts and cultural nonprofits receive less attention, and it is more difficult to find specific examples relative to the arts environment, particularly beyond performing arts

and museums. Although academic research on arts and cultural nonprofits' financial issues, including their capital structures, remains tucked away in journals very few people read and is sometimes filled with inaccessible jargon, we strive to accumulate the best of current scholarly wisdom regarding nonprofit organizational financial practices and distill those into immediately applicable practices for your arts organization.

Focusing on the theoretical and practical developments that have molded arts and cultural nonprofit budgeting and the related discipline of financial management in recent years, our principal goal in this book is to illuminate basic accounting and fundamental financial principles through the specific lens of the arts. While the core of the book examines important contemporary financial management issues relative to arts and cultural nonprofits, other topics include internal and external controls, risk management, and reporting requirements to further broaden your comprehension of the intricacies of arts and cultural nonprofit budgeting and financial management.

The increasing practice of financial management coupled with recent financial crises demands intellectual clarity and knowledgeable guidance. We hope to encourage and inspire you with a clear picture of the budgeting and financial management process and, along the way, assist program managers, policymakers, students, and professors in better understanding how to sustain and manage efficient and financially sound arts and cultural nonprofit organizations.

THE ECONOMIC SIDE OF THE ARTS

In describing his experiences with funding the arts, a friend shared his frustration with not only the ongoing struggle for financial resources often faced by those working in the arts but also the "**poverty mentality**" of many artists and arts directors themselves, a state of mind where financial lack and struggle are consistently expected. Describing this mentality, another arts professional shared more about how it inadvertently gets perpetuated: "We teach art students to be frugal but also seek funding. . . . Part of this is that they need to learn to advocate for the resources they need. But more importantly, the poverty mentality trains arts professionals to be expecting little to no profit—we need to struggle against that mental model and introduce new ones that allow for arts organizations to flourish and meet their missions. . . . It's all right to make art *and* make money from your art—we need to get over that hurdle."[1]

Where does this poverty mentality come from? One explanation is simply the lived experiences of many artists over the centuries. That long history of financial struggle leads to an expectation that arts organizations are constantly

in crisis, with little to no profit on the horizon. Nearly sixty years ago, William Baumol and William Bowen formulated a theory of costs in the arts by analyzing financial difficulties experienced across opera, music, theater, and dance over the previous forty years, and they pointed out a consistent "income gap" between revenues generated and costs to run these organizations.[2] Their perspectives have become known as **"Baumol's disease" or "cost disease,"** and they encourage some financial and managerial strategizing to avoid this pervasive disease and provide some cure.[3]

Contrary to the poverty mentality, arts organizations are classified as nonprofits, not-for-profits, or nongovernmental organizations (NGOs), not because they often struggle to make a profit but because they add public benefit to our communities and nations. They make up part of the expressive function of the nonprofit sector but also often demonstrate values and have educational purposes as well. Before we go any further, there are fundamental differences between nonprofit arts organizations and for-profit arts organizations that bear recognition.

DIFFERENCES BETWEEN NONPROFIT AND FOR-PROFIT ARTS ORGANIZATIONS

First, there are no autonomous private owners in a nonprofit arts organization, and no stocks, and there is little access to equity in the private market.[4] A for-profit arts organization can raise money by offering stock in the company, but money gifted to a company by a donor is an unusual occurrence and cannot be classified as tax exempt. Second, arts nonprofits operate under what Henry Hansmann calls the "**nondistribution constraint**," which prohibits net earnings distribution among individuals who manage and govern the organization.[5] Unlike with public corporations, which can provide dividend checks to their stockholders, all earnings are "reinvested" in a nonprofit organization to further its mission. While arts nonprofits can and do model business practices, those practices cannot violate the nondistribution constraint. For example, nonprofits practice debt issuance, which Robert Yetman notes as "one of the few (and in many cases the only) way for an arts nonprofit to generate cash," charging fees for services and competing for private funders like their for-profit counterparts.[6] Yet even when they make a profit, nonprofits put these monies back into programming, not into any individual pockets. The nondistribution constraint is one reason the public has historically higher levels of trust in nonprofit organizations than in business enterprises.

A third significant difference is that for-profit arts organizations seek to maximize their profits, while nonprofit arts organizations exist to maximize a social benefit. Arguably, most organizations exist on a continuum of social benefit, and some for-profit companies espouse the principle of **social responsibility**, an idea that even though these corporations are pursuing a profit, they should also seek to create some positive outcomes for society at large. Several companies also sponsor **corporate social responsibility** initiatives, or projects and partnerships that convey a commitment to social value beyond profit maximization. Although several types of organizational forms can demonstrate some aspect of social responsibility, within the United States an organization must demonstrate public benefit as the primary reason for its existence to receive designation as a tax-exempt nonprofit.

Although we primarily cover financial leadership from the nonprofit perspective, social enterprises with organizational forms can and do support artistic output. Indeed, past National Endowment for the Arts chairman Bill Ivey has been known to claim that the difference between for-profit and nonprofit arts organizations "does not hold up to even superficial scrutiny."[7] Many businesses with familiar household names produce and promote arts of various types, particularly the more popular genres. Some business forms, including limited liability corporations and benefit corporations, are purposefully constructed to prioritize social value, rather than profit maximization, as their primary objective.

In addition, professionals within the creative economy often switch back and forth between working in nonprofit and for-profit settings. Design professions including advertising, media, entertainment, and the like are massive economic drivers on the local, state, national, and international levels; nonprofit arts organizations are often the progenitors and birthing centers for creative professionals who inhabit the for-profit arts arena.[8] Both types of organizations build community economies by creating jobs, and they support community health and development by bringing audiences to town, increasing the visibility and marketability of locales, encouraging investment, and bolstering related industries, such as tourism, insurance, restaurants, building safety inspection, and more.[9]

NONPROFIT PURPOSES IN THE CREATIVE ECONOMY

For nonprofit arts organizations to continue to serve the broader community economies, they first must ensure their own economic vitality. As you know and have likely experienced, arts organizations are not a single organizational type

but a mosaic of advocacy, education, expressive, and cultural organizations. In fact, over thirty different organization types are categorized by the National Taxonomy of Exempt Entities (NTEE) as arts and cultural organizations, spanning from music groups, museums, radio, and print media to arts awareness and arts policy centers.[10] With this tremendous variety of organizations making up the arts and cultural sector, no single financial matrix can fit the diverse needs and contexts of all these organizations. For example, performing arts organizations are much more reliant on tickets and subscription sales than an organization that promotes arts awareness, which might rely more heavily on grants as a revenue source.

Undoubtedly, arts and cultural nonprofits across the United States play a significant role in the country's economy. Not only do arts and cultural organizations serve expressive and value purposes in our society; the nonprofits in this industry also generate billions in economic activity and government revenue each year. The arts and cultural sector makes significant contributions to most Americans' lives and serves a range of public purposes.

The arts help define what it means to be a community, contribute to the quality of life, form an educated and informed citizenry, and inspire individual creativity and potential. Yet compared to other types of nonprofits, arts and cultural nonprofits are faced with different fiscal pressures, since they must compete with society's more pressing needs (e.g., education, health, and social well-being) for limited public support and with for-profit entertainment companies for audiences.[11]

Aside from the fact that arts and cultural organizations add expressive values to our communities and countries, they are a viable economic concern within those spheres as well. According to the National Endowment for the Arts (NEA), the 2021 value of the arts to the US economy was roughly just over $1 trillion (about $3,100 per person in the United States), approximately 4.4 percent of the country's gross domestic product (GDP).[12] Between 2020 and 2021, the total economic value added by arts and cultural industries grew by 13.7 percent, surpassing the growth rate of the US total economy, which grew by 5.9 percent in the same period.[13] Moreover, a nation's jobs are tied to the arts economy. Within the United States, roughly 4.9 million people work in arts- and culture-related organizations, which is less than the 2019 (pre-pandemic) level of 5.2 million workers but more than the 2020 level of 4.6 million.[14] A great example of how the arts can drive economic growth comes from the North Adams community in western Massachusetts, where an economically depressed community was transformed by a creative nonprofit:

North Adams is really the lens to see the effect of the Great Recession and other economic changes on the creative economy in Western Mass. Pre-2008, the Sprague Electric factory closed, and a massive percentage of the population was connected to it at the time. North Adams fell off the tax rolls, and they were considering paths forward like a shopping mall, a prison, or developing lakefront real estate. No one was thinking of a contemporary art museum as an economic development opportunity, but Mass MoCA really emerged as a major employer, economic driver, and amplifier that supported the development of hotels, restaurants, and other businesses locally. Because of what we saw firsthand, there is not a question about whether the arts can be an economic driver in a region. Culture is an economic driver. 2008 stopped the trajectory to some extent, but culture was already part of the recovery path and the continued relevance of Mass MoCA during and after the Recession reconfirmed this.[15]

This Massachusetts community demonstrates the power of the arts not only for expression and quality of life but also for bringing dollars into the region for sustainable development. We believe, along with you, that the arts and the economy are inextricably linked.

AN OVERVIEW OF THE CHAPTERS

Despite wide variation in purposes and programming, Micawber's Maxim is a unifying imperative for arts and cultural organizations, and in this book we endeavor to provide practical applications that can serve within most arts environments and provide resilience and sustainability practices that can serve you well into the future. With this goal in mind, the book is divided into the following chapters:

Chapter 1, "Budget Process Basics for the Creative Mind": The budget planning process is introduced in this chapter, which emphasizes key elements of the budget process, including roles and responsibilities of the board and staff, assumptions, and strategy.

Chapter 2, "Preparing Operating Budgets That Perform": This chapter addresses designing budget policies and procedures for the arts nonprofit. Here we also discuss setting timelines, establishing program goals, and identifying major categories for operating budget planning. We also introduce some important tools to aid budget operations, including break-even analysis, forecasting revenues and expenses, measuring depreciation, assigning indirect expenses, and of course creating a contingency plan.

Chapter 3, "Stubs and Subs: Sources of Revenue for Nonprofit Arts Organizations": Support for the arts is a mosaic of funding sources, and this chapter focuses on where revenue for arts nonprofits comes from. Even a small fluctuation in one source of revenue can mean deficits for many arts organizations. This chapter identifies revenue strategies that managers can use to develop, expand, and diversify their revenue base in the context of mission achievement and concludes with a discussion on collaborations, organizational hybridization, and social enterprise.

Chapter 4, "Liquidity and Managing Cash Flow in Arts Nonprofits": Liquidity means having cash on hand for the day-to-day operation of an arts nonprofit. This chapter discusses liquidity and how arts nonprofits can manage cash flow both during boom times and during recessions. We focus on best practices for arts nonprofits to anticipate and manage cash flow shortfalls.

Chapter 5, "Singin' in the Rain: Why You Need a Rainy Day Fund": For several reasons, rainy day funds (also called contingency funds, precautionary savings, operating reserves, organizational slack, or high cash holdings) are not widely used in the arts sector. However, they not only can help nonprofit organizations navigate periods of fiscal stress but also have the potential to stabilize finances by providing a cushion against unexpected events, loss of funding, and large unbudgeted expenses. Promoting rainy day funds during a fiscal crisis may seem odd, but for arts nonprofits that survive these difficult times, reestablishing a rainy day fund or starting one now will help them emerge from this current crisis in a stronger financial position, poised to withstand any future crises. This chapter helps you learn how to create, maintain, and effectively use a rainy day fund.

Chapter 6, "Spotting Opportunities or Trouble: Understanding Financial Statements": After explaining how financial statements differ from annual reports and the Internal Revenue Service 990 form, this chapter provides guidance on how to read the 990 form and find out what it means for your organization. We briefly introduce generally accepted accounting principles (GAAP) and the fundamental accounting equation before diving into the three primary financial statements that arts nonprofits must prepare: the balance sheet, activity statement, and cash flow statement.

Chapter 7, "Managing the Audit and Selecting an External Auditor": Does your organization need to have an independent audit? This chapter will help you understand what an independent audit is and what it is not. We detail the role of the board in the audit process and share tips and tools to help you manage the audit process.

Chapter 8, "Financial Statement Analysis for Arts Leaders": Many people will have jobs or sit on boards for which they will need to understand nonprofit financial statements. This chapter explains how to define and measure profitability, liquidity, solvency, efficiency, and other important concepts. We also teach you how to communicate basic results and information from financial statements to individuals without an accounting or finance background (organizational leadership, board members, community stakeholders) so that they can truly understand the impact of your work.

Chapter 9, "More Than Just Audience Satisfaction: Measuring Organizational Performance": Historically, nonprofits have not viewed measuring success as a powerful marketing or fundraising tool. In the last several years, however, increased competition for limited funds and the trend toward greater accountability have caused nonprofit organizations to more frequently try to measure their own performance. The overall mission of arts and cultural nonprofits is to promote arts appreciation and strengthen communities by providing a wide range of arts programming. We suggest several common and program-specific outcomes that can be used to measure performance for arts and cultural organizations.

Chapter 10, "Accountability and Governance for Arts Stability": How your organization practices accountability directly impacts your levels of public trust and legitimacy. Your board leads this accountability charge. This chapter considers models for effective fiscal compliance and the role of your staff, board, and other volunteers in this process as well as the leadership role of boards and the characteristics of financially competent boards.

Chapter 11, "Worth a Pound of Cure: Preventing Fraud and Abuse in Arts Nonprofits": In this chapter, leaders will learn how to identify potential opportunities for fraud and abuse to creep into their organization as well as simple internal controls that can prevent them. We also consider how leaders can better establish a culture of organizational compliance and trustworthiness.

Chapter 12, "Short- and Long-Term Trade-Offs: Investing Funds and Managing Debt": Inevitably, fundraising efforts will have down years, and an important strategy is to set aside funds for lean times by creating an investment account. This chapter explores creating an investment policy, asset allocation targets, and the process for investment selection and monitoring. We also address the price of debt for arts nonprofits, short-term debt versus long-term debt, and debt management strategies.

Chapter 13, "Keeping the Arts Alive: Adapting to Turbulent Times and Developing Resilience": In light of the Great Recession, impacts of the

pandemic, and other external shocks on arts nonprofits, this chapter offers easy-to-implement strategies for before, during, and after crises. Here you will learn how to implement cutback budgeting, increase revenue during turbulent times, engage and talk to donors in a crisis, and recognize and embrace both the threats and opportunities brought by fiscal crises.

Chapter 14, "Creativity Takes Courage: Making Great Financial Decisions for Arts Leaders": Helping to shed the poverty mindset once and for all, this last chapter summarizes the financial and engagement trade-offs identified throughout the text from a strengths-based perspective and highlights the significance of understanding financial leadership for the future of your organization. We discuss your organizational balancing act between (1) stability and risk, (2) access and influence, (3) artistry and audience, (4) passion and pragmatism, (5) community and capacity, and (6) tradition and transition.

All chapters contain features to help the arts professionals reading this text to quickly identify the key concepts and issues aligned with the finance activity discussed in that chapter, including

> **Definition of key terms and concepts:** Each chapter contains key terms in bold. We define the financial concept(s) and/or method featured in the chapter, especially their application in arts nonprofit organizations.

> **Issues:** Each chapter identifies key issues and discusses contemporary thinking, debates, and/or critical perspectives on the financial concept(s) and/or method highlighted by the chapter, including our own views, especially as they relate to the management, leadership, and governance of different types of arts nonprofits.

> **Challenges:** Since no organizational context is ideal, each chapter also describes the arts leadership challenges and trade-offs relative to the topic in a variety of arts management sectors.

> **Short cases exemplifying the key challenges:** Examples are provided within the text of each chapter to contextualize the application of each financial principle. Cases are based on our professional experiences in the arts and those of our colleagues, although the names of some organizations have been changed. These stories and examples are designed to highlight the key leadership decisions, issues, and trade-offs associated with each topic.

> **Practical approaches to the issues:** The bulk of each chapter is dedicated to various strategies and approaches that can be easily implemented

by arts professionals for efficiently and effectively making decisions relative to the chapter's main topic. Within the chapter, we provide practical examples and templates to quickly adapt for your own organizations.

The future: While financial strategies offer arts professionals mechanisms for organizational resilience and sustainability, the world external to our organizations is constantly in flux. While no crystal balls can tell us the future, each chapter anticipates some trends for arts organizations and what they mean for optimal financial decisions.

Questions to consider: To help you diagnose your organization's current finance strategies and the organization's capacity for change relative to financial operations, where relevant, chapters include key questions that arts leaders can ask to analyze their organization relative to the central topic, based on the practical approaches described. These questions are not prescriptive, because financial decision-making depends on numerous organizational factors, but going through the questions as an arts professional, arts organizational leadership team, or arts nonprofit governance board can help identify areas of financial weakness or lack of accountability. It can help leadership consider whether the strategies we discuss could be implemented to improve your current practice and financial outlook.

Additional readings: Each chapter concludes with a short list of key books or articles for further reading on the topic.

THREADS RUNNING THROUGH THE TEXT

Some key ideas run through the text and should be bedrock values for your organization's financing and financial management strategies.

Ethics and accountability: These two principles are consistent regardless of which subsector or specific arts mission your organization pursues. Not only is ethical behavior imperative to keep your organization out of financial trouble with regulators and legal authorities; such behavior also builds stakeholder trust. Accountability is part of the process of exercising ethical behavior within your organization. And there are multiple layers of accountability for arts and cultural organizations, including internal accountabilities to employees and volunteers, and external accountabilities to funders, audience members, patrons, clients, community partners, and society at large.

Hybridity: Like the permeability between for-profit, nonprofit, and governmental creative industries discussed earlier, blurred boundaries are a lived reality for most cultural organizations. Most organizations accomplish their missions while constantly navigating and transgressing such boundaries. The word **hybrid** connotes a combination of two of more things. Research indicates that cultural and arts organizations demonstrate a hybrid nature in a variety of ways, including their organizational form, their identity, their purposes, and their service delivery.[16] From partnerships and collaborations to articulations of social enterprise, to their dual expressive and commercial imperatives, to reaching out to clients, students, and audiences in new ways, we highlight examples of organizational hybridity throughout the chapters.

Large and small organizations: Arts and cultural organizations are diverse both in mission and in size. The Metropolitan Museum of Art and the community artisan's co-op staffed by volunteers with no annual budget to speak of share many of the same financial concerns but have different contexts and capacities for responding to those concerns. Some constants in terms of sound management principles apply to both ends of the size spectrum, but strategies may differ because of varying internal and external capacities. We have experience on both ends of the size spectrum and seek to include examples across that spectrum and point out strategies best suited to either. So whether you are swimming in staff and revenue (okay, probably none of you are there) or are a one-person start-up squeaking by on the grace of just a few donors, we will cover strategies you can use.

Overall, we seek to give you an easy and concise understanding of financial management information so your organization can maximize its expressive value as well as its value to your community. Whether you are a newbie or seasoned professional, we hope the following chapters help you reverse the poverty mentality, stay on the right side of Micawber's Maxim, and fulfill your mission.

KEY TERMS

Baumol's disease
corporate social responsibility
cost disease
hybrid

hybridity
nondistribution constraint
poverty mentality

ADDITIONAL READINGS

Bowman, Woods. *Finance Fundamentals for Nonprofits: Building Capacity and Sustainability.* Hoboken: John Wiley & Sons, 2011.

Korza, Pam, Maren Brown, and Craig Dreeszen. *Fundamentals of Arts Management.* 5th ed. Amherst: Arts Extension Service, University of Massachusetts Amherst, 2007.

National Endowment for the Arts. "The U.S. Arts Economy in 2019: A National Summary Report." March 2021. www.arts.gov/sites/default/files/SummaryReportAccess.pdf.

Sargeant, Adrian, and Jen Shang. *Fundraising Principles and Practice.* 2nd ed. Hoboken: Wiley & Sons, 2017.

Worth, Michael, J. *Nonprofit Management: Principles and Practice.* 4th ed. Los Angeles: Sage, 2017.

CHAPTER ONE

Budget Process Basics for the Creative Mind

Creativity starts when you remove a zero from your budget.
—JAIME LERNER, Brazilian architect, urban planner, and politician

LEADER TAKEAWAYS

After reading this chapter, you should be able to

- Introduce budget terminology and vocabulary
- Explain what it means to link your mission with budgeting
- Discuss the roles and responsibilities of the key players in the budget process
- Explain what the typical budget process looks like in an arts nonprofit
- Explore budget cutbacks and budgeting in a fiscal crisis

Establishing the annual budget and monitoring the budget regularly against the actual expenditure of funds are key financial management functions in arts nonprofit organizations. Budgets are tied to effective planning, and a well-planned budget can prevent art productions from running out of money at the last minute or needing to access emergency contingency funding (if they have it). In this chapter we will introduce the budget planning process for arts nonprofits and discuss key elements of the budget process, including the roles and responsibilities of board members and staff, budget assumptions, and budget strategy. Let us begin by first defining what is meant by the term *budget*.

WHAT IS A BUDGET?

A nonprofit organization's **budget** is its financial plan for receiving and spending money in a given time frame, also known as a **fiscal period**; it is your organization's strategy expressed in dollars. Most nonprofit organizations prepare a budget each fiscal year. A **fiscal year** is a one-year period that organizations use

for financial reporting and budgeting. A budget is a political instrument because it allocates scarce resources among social and economic needs of the organization and as such is a representation of organizational values. Budgets are the core of proficient financial management—they function as statements of how scarce resources will be allocated to achieve an organization's objectives for a specific period. An organization's budget must be linked to its mission to accomplish stated goals. A budget is a guide and should not be written in stone. A budget is a plan for the future, and because none of us can totally predict the future, budgeting is an ongoing process: an organization's budget should be reviewed periodically and adjusted as needed. An effective budget is thoughtful, deliberate, and inclusive. The top economic priority of any nonprofit should be staying solvent, and budgeting is the optimum tool for promoting this goal.

One nonprofit executive told us, "Budgets are representations of organizational values—the budget for LA or DC is not the same budget for rural America, so people have to learn to get comfortable networking without alcohol, for example."[1] What you spend as an organization is what you value as an organization. "Trying to get people to work for as little as possible is a representation of your nonprofit's values. How much can you ask of people for their stipend? Pay people a living wage and ask them to do a reasonable amount of work." Another executive noted, "It's not just about budgeting for a particular show but also for yourself as an independent contractor on the entrepreneurial side, think through the things you are doing now in your current position and get comfortable with them so you can practice them later in your own independent work."[2]

WHY SHOULD YOUR ORGANIZATION PREPARE A BUDGET?

The budget is both a managerial and an administrative tool. It gives the board and staff an opportunity to link the organization's mission, goals, and objectives directly with the expenditure or resources (i.e., the budget). A thoughtful budget can help your organization identify priorities, assess its current state of financial health, and better prepare for the future. More important, the budget can help provide accountability to donors and other stakeholders.

LINKING YOUR MISSION TO THE BUDGET

Earning a surplus each fiscal year is a fundamental goal of for-profit organizations, and while it is certainly important for nonprofit organizations to spend less each year than they bring in, generating a surplus is not central to the performance of a nonprofit organization. Every nonprofit organization has a mission, and each exists to fulfill their specified mission, yet there is always a

tension between fulfilling the mission, on the one hand, and maintaining financial viability, on the other. A compelling mission statement provides a nonprofit organization with ethical and strategic guidance; it also rallies staff, donors, and other stakeholders around a common goal while clarifying routine operations.[3]

The Lincoln Center for the Performing Arts provides a typical example of a mission for an arts and cultural nonprofit organization: "To sustain, encourage, and promote the performing arts and to educate the public with relation thereto."[4] This mission is certainly direct, specific, and brief; it is also very broad. The Lincoln Center's management and staff cannot fulfill the entire mission all at once—and that is why a nonprofit organization needs a good plan. Staff and executives must be able to show how the annual plan relates to the organization's mission statement. Their objectives must be directly related to the available resources for that given year. If the organization is facing a fragile financial environment, then the objectives for the year will be threatened; if specific yearly objectives are beyond reach due to resource scarcity, then the nonprofit organization's overall mission will also be threatened.

In *Linking Mission to Money*, Allen Proctor explains that a good budget connects an organization's mission to how money is spent in that organization based on its evolving needs.[5] He describes a budget as a story that happens to use numbers rather than words to let stakeholders know what the nonprofit plans to achieve that year toward fulfilling its overall mission.[6] Proctor urges nonprofit organizations to tell that story as frequently as possible to staff, donors, clients, and other stakeholders.

An effective budget has five characteristics: First, effective budgets should take a long-term perspective of the organization, recognizing that decisions made today will have consequences tomorrow. Second, activities and resources in the budget must be directly linked to the overall mission and goals of the organization. Third, an effective budget should identify the results and outcomes to be accomplished with the resources allocated for that fiscal period. Fourth, an effective budget communicates organizational priorities to donors and other stakeholders, helping to ensure their donations are well spent. Finally, an effective budget should excite and motivate staff; it should encourage dialogue about how to effectively and efficiently use available resources to fulfill the organization's mission.[7]

TYPES OF BUDGETS

Most nonprofit organizations have three basic types of budgets to prepare during a fiscal period. An **operating budget** is a key tool in effectively and efficiently achieving an organization's mission because it reveals the nonprofit's

revenue, expenses, and surplus/deficit for the coming fiscal period while also focusing on the day-to-day operations of the organization. When done correctly, a sound operating budget allows for the most efficient use of scarce resources and establishes procedures for effectively fulfilling the organization's mission. A **cash budget** shows the organization's expected cash receipts, cash payments, and ending cash balance for the coming fiscal period; it can help an organization identify periods where there may be a cash flow shortage so that it can arrange for extra funding, like a line of credit from a bank. A **capital budget** is a tool for planning long-term investment projects, such as new construction, renovations, and/or expansions of publicly accessible arts spaces. Capital budgets are multiyear budgets, since new construction or renovations generally require many years for completion. Most nonprofits finance capital projects through borrowing or running a capital campaign for that specific project.

The mission of Healing Arts Initiative, a New York City arts nonprofit based in Queens and founded in 1969 that provided arts performances and workshops for the city's disabled, poor, and elderly, was simple: to remove barriers to arts and culture, inspire healing, and provide growth and learning through engagement with the arts. Despite its long history and exceptional mission, the organization was forced to declare bankruptcy, and on May 11, 2016, the Healing Arts Initiative closed its doors for the final time. The organization's debt increased from less than $100,000 in 2012 to $2.2 million in fewer than four years; in an effort to remain afloat, the organization moved from SoHo to Queens to save on rent and cut its staff in half (from twenty-eight to fourteen).[8] Fortunately, the organization's story was not finished when it declared bankruptcy, and a few months later, another nonprofit, Young Adults Institute Inc. (YAI), purchased Healing Arts' programmatic assets and committed to resuming its programs.[9]

Healing Arts Initiative did not have a chief financial officer on staff in 2011. It was during this period that a new employee came on board, hired as a payroll clerk.[10] By 2015, this new employee was thriving; in fact, they were effectively running all fiscal operations of Healing Arts Initiative. A new chief financial officer had not been appointed.[11] But some of the staff began noticing an increase in financial irregularities, even though the organization had been drastically cutting its expenses:[12] bounced checks, declined credit cards, ballooning debt. After learning about the organization's messy financial problems, a former board member urged the current board to investigate.[13] In July 2015, the nonprofit hired a forensic accountant, who ultimately failed to detect any irregularities.[14] But everything changed later that month, when Healing Arts hired a highly qualified executive director, who then hired a new chief financial

officer with an expertise in fraud detection to help investigate the concerning financial situation.

Two weeks later, while walking through the Healing Arts Initiative parking lot, the executive director was brutally attacked with drain cleaner, causing severe burns to her face. During the course of their investigation, prosecutors realized that the payroll clerk was responsible for the heinous crime. She had also been stealing approximately $1,000 a day from the nonprofit, beginning in November 2012 and continuing through August 2015, for a total of $750,000. The executive director subsequently sued the board on behalf of Healing Arts Initiative, alleging that the fraud and embezzlement occurred due to fiduciary negligence and a lack of stewardship on the board's part and insisting that an audit committee made up of two new board members and one holdover be created.[15] The executive director was fired by the board, as was the chief financial officer who uncovered the fraud.[16]

The demise of the Healing Arts Initiative helps shed light on the proper roles of the board, chief financial officer, executive director, and other staff as they relate to budgeting, financial management, and financial oversight in a nonprofit organization. A recent article in *Nonprofit Quarterly* notes that the job of an executive director is to provide financial leadership to a nonprofit organization: in simple and direct terms, this means guiding the organization to financial sustainability.[17] How can the executive director meet this goal?

THE KEY PLAYERS AND THEIR ROLES IN THE BUDGET PROCESS

The primary responsibilities of the executive director are to understand the organization's finances, interpret them for other stakeholders, and ensure the organization's financial accountability to its community, in conjunction with the board.[18] Strong annual budgeting is an integral aspect of financial leadership. A competent executive director must have a basic understanding of bookkeeping and nonprofit financial management. They should be able to read a budget, interpret monthly financial statements, and audit reports; they should be able to understand (and sometimes develop) internal financial management systems and controls.[19] In small arts nonprofits, it is quite common to have an executive director assume the roles and functions of a finance manager, in addition to their own responsibilities, or perhaps the executive director (or a board member) may fulfill the role of a bookkeeper. We highly discourage this practice for ethical reasons and strongly recommend seeking external help in the community from a local accountant willing to provide pro bono services to analyze your financial management practices and recommend adequate checks and

balances.[20] Gracia Chua explains that having the executive director attempt to navigate the wide range of accounting tasks faced by any arts organization, regardless of size, can result in squandered resources, more risk, and oversights in both accountability and financial decisions.[21]

Mary Diegert notes that if the executive director is the engine of the bus, the chief financial officer is the insurance, the maintenance, and, yes, sometimes the brakes.[22] However, not every art nonprofit needs to have a chief financial officer or director of finance on staff. As your organization grows and your budget and financial matters become more complicated, you may outsource the position of chief financial officer to an external accounting firm. If your organization has a chief financial officer on staff, recognize that their role and responsibilities depend on the size of your organization and the complexity of your revenue sources. At a minimum, the chief financial officer will work closely with the executive director, program managers, development director, finance committee, and treasurer to develop the budget. The chief financial officer should also meet regularly with the board and executive director to report on the organization's finances. Some other important responsibilities for a chief financial officer in a midsize to large arts nonprofit organization include analyzing investments and capital, managing risk, and devising financial strategies. The ideal chief financial officer should have a certified public accountant (CPA) designation, and optimally an MBA. A chief financial officer should have prior experience working in the nonprofit sector; they should also have an in-depth knowledge of accounting, finance, and tax rules as they relate to nonprofit organizations. In addition, because the chief financial officer will be presenting financial reports regularly to the board and the executive director, the position requires strong communication skills, strategic thinking, financial reporting expertise, and the creativity to deal with resource constraints.[23]

Members of the board of trustees should not be involved in the day-to-day management of a nonprofit—those roles are reserved for the executive director and staff. The board's responsibilities involve policymaking, fulfilling legal duties, and serving as a fiduciary of the organization's assets. A **fiduciary** is a person or organization that acts on behalf of another and is legally bound to place their client's interest above all self-interest and the duty to exercise reasonable care, skill, and diligence proportionate to the circumstances in every activity.[24] Board members should also provide significant guidance, according to the National Council of Nonprofits, especially through contributions to the organization's culture, strategic focus, effectiveness, and financial sustainability. Board members should serve as ambassadors and advocates for the nonprofit organization.[25] In a large, well-established arts nonprofit, the chief executive

officer and the chief financial officer will begin the annual process by presenting a draft of the budget to the board of trustees for discussion and approval. In smaller arts organizations, the finance committee of the board of trustees will take a more prominent role in preparing the draft budget.[26]

In general, the board of trustees holds legal responsibility for ensuring that the organization's budget meets all relevant state and federal laws and regulations, while also assessing whether that budget is fiscally sound and helps the organization fulfill its mission. The board of trustees is responsible for establishing the budget policies that govern the organization. For example, will the organization need to approve a balanced budget each year? Does the nonprofit have policies on rainy day funds or cash reserves? Does the organization have policies in place about salary increases for staff and for the creation of new program initiatives? The board of trustees is responsible for significant policy decisions such as these; it is also responsible for regularly reviewing financial documents, such as variance reports, and correcting errors where necessary. Hope Goldstein, CPA, advises that the board is not responsible for reviewing every single line item in the budget; rather, the board's governance responsibilities, as they relate to the budget review and approval process, should focus on answering one simple question: *Does the spending match the organization's priorities?*[27]

Goldstein recommends six primary questions that the board of trustees should answer during the budget and approval process: (1) Does the budget honor donor restrictions on contributions with regard to purpose or time? (2) Where is the bulk of spending being budgeted, and is the allocation of budgeted expenses, relative to programs and supporting services, in line with nonprofit peers and subsector standards? (3) Is the budgeted spending greater than anticipated revenues? (4) Does the budget include savings for a rainy day? (Best practices suggest that it is prudent to have at least three to six months' worth of operating expenses in reserve.) (5) Are the budgeted salaries and compensation in line with our staffing strategy, and are we making an earnest effort to recruit the best talent? (6) Is the budget realistic? If we are unable to receive all anticipated funds, do we have a plan B?[28]

Board approval of the annual budget is a key financial management function in arts nonprofits. The approved budget will help guide the organization's future spending, serve as a tool to assess its financial health during the year, and help set the organization up for a productive and well-managed financial year.

Program directors, creative directors, development directors, and other staff who have responsibility for fulfilling the annual budget should also play a key role in budget preparation. Not only does staff inclusiveness build buy-in to the budget; it also ensures that the budget process is informed by those who are in

the front line every day and have direct experience in the day-to-day operations of the organization. Staff members generally have more knowledge about operating details than board members, and their input can be very useful in creating an early draft of the budget.

Frequently, many arts organizations leave creative directors out of the budget preparation phase. This occurs primarily because creative directors are viewed as creative visionaries who lead and direct all phases of creative development work, from concept to completion, yet those very creative directors are then responsible for keeping projects like theater productions within the budget (i.e., no cost overruns). Briefly consulting the creative director positions available in arts nonprofits reveals that most job descriptions make no mention of the word *budget*, and only a handful of advertised positions included the words "may provide input into developing the budget." Excluding individuals like creative directors and other staff who have responsibility for fulfilling the annual budget will lead to a budget that is unrealistic and restrictive. Not having input from the individuals who know exactly what resources are needed to create a brilliant production will most certainly lead to a less-than-stellar stage production. By involving the creative director in the budget preparation phase, the organization will have a more realistic budget and will be more likely to get the artistic results it desires.

In describing his experience with the role of staff in the budgeting process, an arts professional we've worked with has this to say: "Arts organizations need more transparency about what people have in their budgets. Share that out so people know—demand transparency if you aren't the finance person and demonstrate transparency if you are."[29]

THE BUDGET CYCLE

The budget cycle consists of four distinct phases: (1) preparation and submission, (2) approval, (3) execution, and (4) audit and evaluation. Although we often speak about a budget cycle, it is important to clarify that a single budget cycle really does not exist.[30] Instead, a cycle exists for each budget period, and several cycles are in operation at any given time.[31] Budget cycles overlap: for example, while one budget is being prepared, another budget is being executed, and yet another is being audited. A pattern of overlapping budget cycles can be seen in table 1-1, which shows the sequencing of five budget cycles typical of a large arts nonprofit that begins its fiscal year on January 1.

TABLE 1-1. Scrambled Budget Cycles

Budget Year	Preparation	Approval	Execution	Audit
2021	Complete	Complete	Complete	Complete
2022	Complete	Complete	Complete	In progress
2023	Complete	Complete	In progress	Upcoming
2024	Complete	In progress	Upcoming	Upcoming
2025	In progress	Upcoming	Upcoming	Upcoming

STEPS IN THE BUDGET PROCESS

Each organization's budget process is developed with a strategic plan in mind, including a governing structure and role responsibilities assigned to board members and staff; hence, each nonprofit follows a unique budget process. Preparing the budget is a dynamic process and involves the following six key steps. To discuss the budget process, we will analyze a hypothetical arts nonprofit organization: Young Arts of Rhein Town (YART).

1. **Prepare budget request instructions and guidelines.** Clearly communicate responsibilities, expectations, timelines, key deadlines, and assumptions to everyone involved in the budget process. YART's budget covers one fiscal year, from January 1 to December 31. Last fiscal year, YART's board voted unanimously that the organization should build and maintain an adequate level of net assets without restrictions to support the organization's day-to-day operations in the event of unforeseen shortfalls; therefore, following guidelines established for the upcoming fiscal year, the total budget must generate a surplus of at least $10,000. The surplus will be deposited into YART's operating reserve fund.
2. **Finalize revenue projections.** The budget committee, which comprises two senior staff members, the executive director, and the chief financial officer, should examine the reasonable expectations of each source of revenue. It is important that the committee forecast revenue conservatively and examine each potential source of revenue carefully to determine possible increases or decreases in the future. YART has a highly diversified portfolio of revenue sources, including contributions from the public, government grants and contracts, ticket sales, and fees from students who participate in the after-school dance program. When

evaluating each source of revenue, YART's budget committee should ask questions like these:

- How much do we expect in contributions from individuals next year?
- What impact will the current downturn in the economy have on donations?
- Does the new grant from the state provide an allowance for the organization's overhead expenses?
- Will the grant from the National Endowment for the Arts lead donors to believe their contributions are no longer needed?
- What are the revenue expectations from the after-school dance program?
- Since we serve a predominantly low-income district, would it be better to have a "suggested donation" or sliding-fee scale for the after-school dance program instead of a set fee?
- Does the state require that YART go through an independent audit to qualify for the grant?
- How much should we set aside for fundraising expenses?

3. **Preparation of budget requests.** YART currently offers two programs: (1) Education and Public Outreach and (2) Advocacy. Working with the budget committee as necessary, program heads begin the process of preparing budget requests as soon as revenue projections are finalized. They research all program costs carefully. Program budgets will be examined, altered, and eventually combined into one organizational budget draft before submission to the executive director and finance committee.

4. **Analysis of budget requests and submission.** After analyzing the budget draft, the executive director and finance committee report to the program heads and other members of the budget committee with any questions or concerns. They will make revisions, keeping YART's strategic plan foremost in their minds. Once everyone is satisfied with the budget draft, the executive director will schedule a meeting to gain board approval of the budget. It is important to ensure that members of the board receive copies of the budget draft, program goals, and other supporting documentation in advance so they can review everything adequately before the meeting.

5. **Presentation and adoption of the budget by the board.** Annual budget approval is a fundamental building block for the sound financial

management of any nonprofit organization. An approved budget will guide an organization's future spending and serve as a tool to assess its financial health throughout the year. Asking the right questions and focusing on key areas of concern, such as future spending, will help the board review the budget more efficiently and approve a version that sets the organization up for a productive and well-managed financial year. Overall, the board is legally responsible for ensuring that the budget meets applicable laws and regulations, is fiscally sound, and will further the organization's mission. Christine Burdett recommends that the board review the total picture to see whether it meets budget guidelines and is realistic and achievable.[32] The board should negotiate potentially conflicting uses of resources, eliminate costs, and combine resources to prevent deficits.[33] Finally, YART's board votes to approve the budget before the start of the new fiscal year (January 1).

6. **Execution of the budget.** Once the board of directors approves the proposed budget, it is now time for the executive director to implement or execute the budget. The executive director begins by communicating the budget, program goals, and timelines to key staff, asking the chief financial officer to allocate funds to the two program directors in YART. During the fiscal year, the budget should be monitored periodically by the executive officers for expenditure and revenue variances (i.e., "budget versus actual"). Executive officers should prepare periodic budget and financial reports to present to the board, while the board should approve any significant changes to the budget.

Budgeting does not have to be intimidating or complex. As one arts manager explained, "It doesn't have to be a high-tech solution or software—it can be as simple as having an up-to-date spreadsheet or simply tracking expenses with free Google sheets—sometimes you just need to know how to auto-sum a row and do low-level data manipulation. Today there are many courses for basic budgeting available for free online. A simple budget is better than having no budget at all."[34] Some tools that can help make the budget process run smoother before and during a production include "(1) having a formal estimating process to assess a show's priorities and the scope of work, (2) maintaining clear documentation for the change order process, (3) setting clear deliverable completion milestones at the onset, (4) having transparency about expenditures by allowing both finance and production people to view the spreadsheets or financial dashboard, and (5) ensuring clarity around who is making financial decisions."[35]

COPING WITH BUDGET SHORTFALLS: KEEP CALM AND CARRY ON

In recent years, the arts nonprofit sector in the United States has been plagued by shrinking government support and falling revenues. The Great Recession and, more recently, the COVID-19 pandemic caused incalculable and potentially irreversible damage to the nonprofit arts world.[36] The pandemic adversely impacted nonprofit arts organizations due to the nature of their work. Lockdowns were particularly devastating, forcing arts nonprofits to go dark, suspend programs indefinitely, cancel fundraising activities, and, if possible, adapt their program delivery models.[37] According to the National Endowment for the Arts, COVID-19 changed nearly every element of the arts and cultural landscape, including how art is created, consumed, and monetized.[38] Although more than 60 percent of nonprofit arts and cultural organizations obtained loans from the federal government's Paycheck Protection Program (PPP), many still had to scale back their work or cut staff.[39]

The pandemic had a catastrophic economic effect on arts nonprofits, with an estimated $14.6 billion lost, according to a recent survey by Americans for the Arts; more than 62,000 arts workers were laid off, more than 50,000 employees were furloughed, and a third of arts organizations were forced to reduce the salaries of remaining staff.[40] In addition, about 15 percent of nonprofits eligible for PPP loans either didn't apply or were denied loans they sought.[41]

How can arts nonprofits respond to serious fiscal constraints both now and in future recessions? We will discuss navigating turbulent times in greater detail in chapter 14. Here we will focus on strategies that can be used when dealing with budget changes. How do we best communicate those changes to the board, staff, and other stakeholders?

A budget is a plan for the future—and sometimes expectations are not realized and budgets must change. A budget is not a static document but a living, breathing artifact that should be adjusted when an emergency or opportunity arises during the fiscal year. Through regular reviews of budget variances, in conjunction with accurate forecasting, a nonprofit can determine whether the originally adopted budget is sound or a new budget must be approved. The Nonprofit Finance Fund recommends that for a budget to be effective, it cannot be a static document. Rather, your board-approved budget should be used as a tool that compares expected results with actual results in order to ensure that they are in line.[42] Only in very rare instances would the board need to reapprove an amended budget (e.g., if the fiscal year is likely to end very differently than the predicted original budget).[43] To ensure that the organization is managed consistently and to allow management to respond quickly and efficiently in the

event of a budget shortfall, we recommend that organizations have a policy in place providing guidance on the process of rebudgeting or budget revision and procedures for addressing revenue and expenditure variances when they occur. Most nonprofits allow executive officers to make small changes up to a certain threshold, while larger changes beyond the established threshold would have to be approved by the board of directors. That is a good financial management practice because it allows the organization to react quickly in the event of a budget shortfall. Lena Eisenstein recommends that management always be prepared for a financial crisis by developing an alternate budget to fall back on in case a major funder falls through unexpectedly or the board faces a major expense unexpectedly.[44] Let us go back to YART and see how management was able to overcome a major donor falling through unexpectedly after the budget had been approved by the board.

An anonymous donor pledged $50,000 to YART to use exclusively for its after-school dance program. This pledge could not have come at a better time. The after-school program director proposed expanding the program by offering tap dancing, in addition to ballet and hip-hop classes. YART hired two new dance instructors, and the tap-dancing classes filled up almost immediately. Two months into the fiscal year, Dolly, the chief financial officer, received the donor's check in the mail, but instead of the anticipated $50,000, the check was written for $25,000. Bill, the executive director, quickly reached out to the donor hoping that it was an oversight on their part. The donor apologized for the misunderstanding and explained that the donation was $50,000 over the next two years. The after-school program had already begun for the spring term and the two new dance instructors were already hired; now the budget for the fiscal year would be short $25,000. Dolly started to panic. What could she do?

The most obvious answer is to seek other sources of funds for the after-school dance program. The fundraising or development office can help identify new or existing donors inclined to support the shortfall in the after-school dance program. It may also be prudent to ask "restricted donation" donors to release restrictions on their gifts so they can be used for unrestricted operating costs in the present fiscal year. A group of young women from a downtown law firm have been making a $10,000 donation every Thanksgiving for the past five years. Dolly thinks that it may be a good idea to reach out, explain the situation, and ask whether they would consider making their donation earlier this year. Another option is raising the fees paid by dance students each month, but YART serves a predominantly low-income school district, and increasing the fees would make the classes unaffordable for most students.

Bill suggests looking at the expenditure side of the budget. Perhaps YART

could cut or even rearrange some expenses in the existing budget. A new writing program scheduled to begin in the summer could be moved to the fall, allowing that program's expenses to be shifted as well. Bill also remembered that his old college roommate—he ran into him on the train a few days ago—mentioned that he was now a certified public accountant at one of the country's top accounting firms. YART was scheduled to undergo an external audit in the second quarter of the fiscal year. It certainly would not hurt to reach out and ask if his roommate's firm would be willing to do a pro bono audit for YART. That could potentially save the organization another $5,000.

Bill also remembers that YART has a line of credit at the local bank of up to $25,000. A line of credit can be used as a cash backup plan for emergencies—and this certainly counts as an emergency. Many nonprofits often use their line of credit when reimbursements, donations, or grants are delayed, or when important bills, like payroll, must be paid on time. Bill also notes that the current budget has a $10,000 cushion built in for a reserve fund, if needed. It may be a good idea to delay starting the reserve fund until next year and use the money to help close the gap in the budget. Dolly feels much better after brainstorming with Bill. She suggests that they schedule a meeting with the budget committee and board as soon as possible to discuss strategy and make some tough decisions.

CONCLUDING THOUGHTS

A budget is a plan that helps an organization focus on its mission and goals; it should demonstrate accountability, transparency, and good faith, while also letting donors and grantors know exactly where their money is going.[45] Budgeting is not an exact science, but a well-planned budget can bring greater financial control, helping organizations achieve financial sustainability. George Thorn, a well-respected arts consultant, encourages arts nonprofits to be income driven as opposed to expense driven. Thorn argues that being expense driven is not a good strategy, because expense-driven organizations build a budget based on what they want or need to do, then create income budgets to balance those efforts, while income-driven organizations develop their expenses responsibly and in line with the money they have.[46] In addition, cutting costs should not be the first option during a fiscal crisis. Periods of fiscal stress are the best time to plan and strategize, so that during boom times, the organization is prepared and ready to respond.

Michael Kaiser, a renowned arts management expert and former president of the John F. Kennedy Center for the Performing Arts in the nation's capital,

offered budgeting advice in a recent arts nonprofits interview: "1. Leadership is crucial; 2. So is planning; 3. Saving money isn't the sole answer; 4. Focus on the present and future, not the past; 5. Extend programming calendars; 6. Marketing is more than glossy brochures; 7. Don't send mixed messages; 8. Achieve diverse funding sources and don't rely solely on one big donation; 9. Assemble a committed board; and 10. Show discipline in following all of the rules."[47] In the next chapter we will introduce some important tools to use in your organization's budget operations, including break-even analysis, forecasting revenues and expenses, measuring depreciation, assigning indirect expenses, and creating a contingency plan.

KEY TERMS

budget
capital budget
cash budget
fiduciary
fiscal year
operating budget

ADDITIONAL READINGS

Finkler, Steven A., Thad D. Calabrese, and Daniel. L. Smith. *Financial Management for Public, Health, and Not-for-Profit Organizations.* Thousand Oaks, CA: CQ Press, 2022.

Weikart, L. A., and G. G. Chen. *Budgeting and Financial Management for Nonprofit Organizations.* Long Grove, IL: Waveland, 2020.

CHAPTER TWO

Preparing Operating Budgets That Perform

A budget is more than just a series of numbers on a page;
it is an embodiment of our values. —BARACK OBAMA

LEADER TAKEAWAYS

After reading this chapter, you should be able to

- Identify major categories for operating budget planning for the arts nonprofit
- Utilize some important budget tools like break-even analysis, forecasting revenues and expenses, measuring depreciation, and assigning indirect expenses in your organization
- Discuss budget variances, how to calculate them, and what to do about them
- Explain how to create a contingency plan

Riverfront Theater first opened its doors as a state-of-the-art facility to the public in 1930 with great fanfare. The theater prospered for decades despite the Great Depression and World War II. However, as shopping malls took over as cultural and social centers where people could gather and as the number of television sets in use in US households increased, the Riverfront Theater no longer held the appeal it once did. In 1977, the building that housed the theater was acquired by River City due to a tax default by the theater owners. The River City Arts Council, a nonprofit organization, was brought in to operate the theater, leasing the building from River City for one dollar a year. The River City Arts Council thrived and was able to keep the doors open for many years.

During the Great Recession of 2007–9, contributions to River City Arts Council decreased substantially, while expenses continued to grow exponentially. The building was old, and it felt like there was a new emergency every month. First it was the plumbing; the following month it was the lighting; a few weeks later part of the roof started leaking during a thunderstorm. Coupled with a decrease in

government funding for the arts nationally, each year the River City Arts Council budget gap grew wider.

Finally, in 2012, facing a $300,000 budget gap, the River City Arts Council board announced it was going to cease operations and close the theater doors. Sadly, this type of situation is not uncommon, especially in small cities and among small arts nonprofits. Running a theater is tough business even under the very best conditions. Riverfront Theater had limited seating capacity and a very small backstage area, which made it difficult to bring in large shows. In addition, the population base within the twenty-to-thirty-mile radius of River City was not large. Coupled with that, not only was River City located one hour away from the entertainment capital of the world, Apple City, but within the twenty-to-thirty-mile radius of River City there were two other similar nonprofit art venues: the Field Playhouse and the Valley Music Hall.

How can we ensure that arts nonprofits thrive and survive not just for several months but for many years? Are there tools that arts nonprofits can use to aid budget operations and identify budget issues before they become insurmountable?

In the previous chapter we introduced the budget planning process for arts nonprofits and discussed key elements of the budget process, including the roles and responsibilities of board members and staff, budget assumptions, and strategy. In this chapter we will identify major categories for operating budget planning. Here we will also introduce some important tools to aid budget operations, including break-even analysis, variance analysis, forecasting revenues and expenses, measuring depreciation, assigning indirect expenses, and creating a **contingency plan**.

According to Bohor Enamhe, an organization without a budget has no direction; a budget is a weapon that will help keep your organization alive, particularly during times of crisis and uncertainty.[1] Enamhe also says that generally when an arts nonprofit fails to attain its objectives, it is because of a lack of budgeting or inappropriate budgeting.[2] Running arts nonprofit organizations is expensive and can be unpredictable, and one never knows when a problem may arise: for example, lighting failure, repairs, inadequate security, or low attendance.[3] As such, managers need the ability and discipline to operate within a budget to help keep the organization afloat.

BUDGETING 101

Many arts nonprofits create an operating budget every year not just for the entire organization but also separately for the various programs they run. To put it simply, a budget has two main parts: revenue or income (funds that are raised

through various means) and expenses (costs that nonprofits incur to fulfill their mission). The two parts are equally important, and whether your organization forecasts its revenue or expenses first is a matter of preference (we prefer forecasting revenue first). Ellen Rosewall notes, "Financial management is one of the things we do to enable the art to happen. Good financial management is one of the best ways to ensure that arts organizations survive, thrive, and bring art to the communities they serve."[4] An important part of financial management is proper budgeting. We begin by talking about forecasting revenues in the next section.

Revenue Forecasts

A **revenue forecast** is an estimate or prediction of how much revenue or income your organization is likely to bring in during the upcoming year. When forecasting revenues, we recommend practicing **conservatism**: always forecast your revenue or income low and expenses high. Your organization will be in a much better position if your revenue or income comes in higher than expected than if the opposite happens. By virtue of their mission, arts nonprofits often have programs for which they charge admission fees, and they should spend as much time forecasting their earned income as they do forecasting their contributed or donated income.

According to Rosewall, very often arts nonprofits neglect to consider costs associated with expanding or creating new programs and increasing income.[5] An organization trying to increase private donations, for example, should remember that for private donations to increase, marketing and fundraising costs must also increase.[6] Staff, or in some cases volunteers, will have to prepare new marketing material, process incoming donations, send reminder emails to prospective donors and write thank-you letters to donors once the donations are received.

When preparing your budget, it is important to remember to account for **overhead expenses**. **Program expenses** are the expenses incurred in directly furthering a nonprofit's mission, while administrative and fundraising costs are collectively referred to as **overhead expenses** (or operating expenses) and include expenses for the organization's overall operations and management.[7] Charles and others note that some overhead spending is necessary for organizations to survive and thrive relative to accomplishing their missions, and increasing overhead spending can foster organizational growth and can better position organizations to achieve success relative to their missions.[8] For example, if an organization needs to hire additional staff to manage grant activities, the administrative overhead could increase as a result. In addition, higher compensation for an organization's leadership in a competitive marketplace could translate

into better management, in which case such compensation, if appropriate for the organization's overall financial picture, may be a worthy trade-off for the organization and may enable the organization to better absorb the overhead expenses associated with other operational and program expenses.

A budget is a financial plan, and as such it is important to forecast or estimate future revenues and spending accurately, since you want to avoid a deficit during the fiscal year. The forecast predicts the revenue or spending baseline, meaning how much revenue will be collected or how much spending will occur in the next fiscal period. The goal when forecasting is to arrive at the most accurate yet conservative estimate rather than being too confident and overestimating your revenue. Forecasting is not an exact science, and no two forecasts are the same. However, forecasting is the best tool nonprofits have at their disposal to ensure that they do not get caught off guard during the fiscal year. Alice Antonelli notes that while expenses are relatively easy to forecast, forecasting revenue can be one of the more difficult parts of developing a budget for a nonprofit organization; forecasting unknown or uncertain contributions can be tricky and can increase the level of risk in the budget.[9]

The first step in accurately forecasting your organization's revenue is understanding how your organization makes money and knowing what your main source of revenue is. Each revenue source has its own strengths, risks, and associated costs. How has your revenue mix worked in the past, and how does that mix match your organization's mission, vision, and strategic plan? At a basic level, forecasting involves looking at your revenue mix from previous years, then accounting for expected trends and changes in certain areas in the upcoming year.

Ryan Jones notes that if you examine data from past years, you should be able to identify both the high and low seasons for revenue.[10] For example, on average across the nonprofit sector, about a third of all donations are made during the traditional holiday season, the period between Thanksgiving and Christmas. Perhaps your organization holds an annual fundraising event every summer and your main revenue sources spike during that period. Can you identify your organization's slow season each year, the period when revenue is low? These types of data points help make revenue forecasting more accurate. Jones recommends knowing what the general philanthropic trends in the nonprofit market are and knowing about any changes in general giving behavior overall to specific shifts in different categories of supporters, since trends can affect your organization either negatively or positively and it's a good idea to account for them.[11] How are your competitors doing? Looking at how your competitors are doing can be a helpful way to inform your forecasting. It may be important to investigate whether other arts organizations are raising prices, whether there will be new

arts organizations in your community or organizations going out of business, or whether redevelopment or other factors will affect the community where you operate.[12] Jones points out that a lot of relevant financial information on nonprofit organizations is available from GuideStar, and a young nonprofit organization that does not have a long history of internal data to use in its forecasting might find it a useful tactic to use this external data in preparing its forecast.[13]

Preparing a Simple Operating Budget

Table 2-1 shows a simple line-item operating budget for an arts nonprofit organization. Lee Children's Theater has three main types of revenue or income: contributed, earned income, and in-kind donations. The difference between revenues and expenses is called a **surplus** if anticipated revenues are greater than projected expenses and a **deficit** if anticipated revenues are lower than projected expenses. Note that in-kind services must be included on both the revenue and expenditure sides of the budget. Chen and Weikart recommend that any in-kind services or contributions that create or enhance nonfinancial assets or require specialized skills and are provided by someone with those skills and otherwise would have had to be paid for must be counted as a contribution.[14]

In the next section we will introduce break-even analysis, an important tool that managers can use to determine the effects of changes in fixed and variable costs, develop a pricing strategy, and monitor and control costs within the organization.

BREAK-EVEN ANALYSIS

As a nonprofit manager, one of the most challenging situations you will face is the need to expand an existing program or venture out to start a new program. This can also be a very exciting challenge for you and your organization. One of the most common tools used to evaluate the potential financial results of adding a new service or program or starting a new program is the break-even analysis.[15]

A **break-even analysis** is a financial calculation used to determine the break-even point for a program expansion or a new program. The **break-even point** is the service level at which **program revenue** exactly equals program expenses. Break-even analysis is an internal management tool, and it is not normally shared with outsiders such as donors and other external stakeholders. To make sound financial decisions about proposed new programs and existing program expansions, managers must understand which programs are self-supporting and which programs are being subsidized.

TABLE 2-1. Lee Children's Theater 2022 Budget

Revenue	Annual Budget
Contributed	
Government grants	282,350
Foundation support	398,375
Individual contributions	272,250
Corporate contributions	120,181
CARES Act	141,000
Earned Income	
Education programs	11,500
Ticket sales	35,380
Miscellaneous	5,086
In-kind (donations)	
Equipment (instruments)	90,000
Services (space rental)	7,500
Total Revenue	**1,363,622**
Expenses	
Administrative salaries	504,095
Education program salaries	183,000
Production salaries	38,417
Payroll taxes	63,777
Equipment (in-kind)	90,000
Services (in-kind)	7,500
Professional fees	89,925
Production expenses	152,861
General operating expenses	169,875
Contracted production creative services	64,172
Total	**1,363,622**
Surplus/Deficit	0

In the following paragraphs we will explore how to apply a break-even analysis to a nonprofit arts organization, Black Box Inc. Black Box Inc. is a 501(c)(3) arts nonprofit organization in Rhode Island that supports collaborations between local artists and communities that are chronically underrepresented in the public space to create public art and educational programs that inspire

social justice. We are going to get a little technical and do some simple mathematical calculations. However, we promise that this will be a fun and helpful exercise that will help you make sound financial decisions in your organization.

Let us begin by defining some concepts and terms that will be useful when we apply a break-even analysis later. **Fixed revenues** are revenue sources that remain unchanged regardless of the number of performances scheduled or the number of people who visit a museum. Fixed revenues include for example grants and individual donations that do not change when the service level changes. **Fixed costs** are expenses that do not change but remain the same no matter how many performances are scheduled or how many tickets are sold. An example of a fixed cost would be the monthly rent payment for the space that an arts organization runs its after-school program from. The monthly rent is the same whether ten students or fifty students participate in the program. **Variable revenue** is revenue that changes based on the number of clients served. If the Rhein Ballet charges $100 per person for admission to its *Swan Lake* performance, the performance ticket sale revenue would vary depending on the number of patrons who attended the performance. If ten people attended, performance ticket sale revenue would be $1,000; however, if the show was sold out and all 150 tickets were sold, the performance ticket sale revenue would be $15,000. Similarly, **variable costs** are expenses that vary or change as the number of clients served changes. An after-school arts program provides a snack and a beverage for each child who participates in the program. The amount spent on snacks and beverages varies based on the number of children who participate in the program, so it would be a variable cost in running the program. Another example of a variable cost might be musicians' fees (if they are paid per performance) or theater rental (if the organization is paying per use). Rosewall notes that striking a balance between fixed and variable costs is a determining factor in how long a show or exhibition will be open to the public.[16] Now that we have all our terms defined, let us move on to an example.

The program manager David Lee at Black Box Inc. is thinking of starting a new program called "Art Creates Community." This new program will grant elementary school students in some of the poorest school districts in Rhode Island the opportunity to interact with professional artists and create art projects while exploring various media (clay, watercolor, pottery, charcoal, etc.). Each student will pay a fee of $150 for the entire semester. In addition, an anonymous donor donated $3,000 to help defray costs for the program. David anticipates the following expenses to run the program: snacks $55 per student, art supplies $40 per student, and teacher's assistant $10,000 stipend for the entire semester. David's best friend from high school is now a famous artist in France known

for his geometric abstraction work who has agreed to donate his time for the semester and will be the program's first artist-in-residence. A local high school has agreed to host the program and will charge a fee of $5,000 for the semester to defray utility and cleaning costs. Based on conversations David has had with teachers in the target schools, he expects 200 students to attend in the first semester, but he would like to know how many students he would need to attend for the program to break even.

The first thing David needs to do is identify his fixed revenues and costs as well as his variable revenues and costs.

- Revenues
 » Anonymous donation: fixed
 » Student fee: variable

- Costs
 » Snacks: variable
 » Art supplies: variable
 » Teacher's assistant: fixed
 » Utility and cleaning fee: fixed

The break-even point will occur when total revenue equals total costs, and we can calculate this using the following equation:

$$\text{Break-even point} = \frac{\text{Fixed cost} - \text{Fixed revenue}}{\text{Variable revenue} - \text{Variable cost}}$$

$$\text{Break-even point} = \frac{\$15,000 - \$3,000}{\$150 - \$95} = 218.18$$

There must be at least 219 students for the "Art Creates Community" program to break even. If David recruits fewer students than the break-even quantity, the program will incur a loss. Similarly, if David recruits more students than the break-even quantity, the program will incur a surplus. David is absolutely certain that he will only be able to recruit 200 students the first semester, but he also knows that if he wants to continue this program, it has to break even in the first year. Since 200 students is less than the break-even quantity, he needs to raise some additional revenue. He is considering raising the student fee from $150 per student to some higher amount. If we assume that everything else remains the same, how much must he charge per student for the program to break even?

David knows what the quantity will be (200) but does not know what price to charge to break even, so he needs to calculate the variable revenue. Luckily for

David, there is a very simple equation that he can use to determine the student fee amount that will allow the program to break even.

$$\text{Variable revenue} = \frac{\text{Fixed cost} - \text{Fixed revenue}}{\text{Quantity}} + \text{Variable Cost}$$

$$\text{Variable revenue} = \frac{\$15{,}000 - \$3{,}000}{200} + \$95$$

$$\text{Variable revenue} = \$155$$

If only 200 students sign up for the "Art Creates Community" program, David will have to raise the student fee to $155 per child for the program to break even. If David is unwilling to increase the student fee and wants the program to break even that year, he will have to search for additional revenue from donors.

BUDGET VARIANCES

A budget is a plan for the future, and because none of us can totally predict the future, budgeting is an ongoing process: an organization's budget should be reviewed periodically and adjusted as needed. What we budget and what we actually spend are rarely the same. The difference between what is budgeted and what we actually spend or receive in revenue or support is called a **variance**. **Variance analysis** involves not only calculating what the variance is; it also involves investigating the reasons for differences between what we planned for and what actually happened. Variance analysis can help nonprofit managers identify and correct problems and capitalize on unexpected opportunities when they arise. Variance analysis can be applied to revenues, spending, and surpluses or deficits.

Community Brands explains that variances—even large ones—are not necessarily a bad thing.[17] Small variances are typical, while large variances may point to a problem or opportunity that needs attention from management; they can also help you understand how well your organization is operating in the face of current real-world conditions versus prior expectations. They recommend that whatever the cause of a variance, regular assessments will help you uncover why variances occur and will allow you to deal with their implications.

We recommend that arts nonprofit organizations conduct a budget variance analysis at least every quarter. This should involve not only calculating the budget variances but also determining why there are differences between the budgeted amounts and the actual amounts.

Greg Chen and others note that variances can be caused by many factors, and

the most common factor is personnel changes.[18] For arts nonprofits it can be lackluster sales for a new production, donors falling through on their commitment, failing to receive a grant or contract that management was almost certain the organization would receive, or higher-than-expected lighting costs due to rising energy prices. These types of changes require that the chief financial officer or other finance employee responsible for the budget carefully examine the budget each month for variances, determine why they have occurred, and make changes to the budget so the organization can continue to operate seamlessly. In the next example we will examine how an arts nonprofit organization goes through a typical variance analysis.

Lee Children's Theater is a south Florida arts nonprofit that promotes children's literacy and social development by providing accessible professional theater productions and arts-in-education programs. Table 2-2 shows a typical variance analysis for Lee Children's Theater. The variance formula is used to calculate the difference between the budget and the actual results.

Unfavorable variances occur when spending is higher than expected or revenues are lower than expected and are treated as negative numbers.

Revenue variance $ = Actual revenue − Budgeted revenue

Revenue variance % = $\frac{\text{Revenue variance \$}}{\text{Budgeted revenue}}$

Expenditure variance $ = Budgeted expenditure − Actual expenditure

Expenditure variance % = $\frac{\text{Expenditure variance \$}}{\text{Budgeted expenditure}}$

The variance analysis in table 2-2 shows that the revenues collected are lower than expected. At the end of January, Lee Children's Theater should have brought in $113,181 in revenue. However, only $105,014 had come in, resulting in a negative revenue variance of $8,167. The variance analysis also reveals that total actual spending for the month of January was higher than expected. At the end of January, Lee's Children Theater should have spent $113,181. However, the organization had spent $119,082, resulting in a negative expenditure variance of $5,902.

On further examination of the revenue side of the budget, we notice a couple of things: earned income from education programs and ticket sales are down substantially from the budget plan for January, and the money transferred to the organization from the CARES Act is much lower than what was expected. When we examine the expenditure side of the budget, we see underspending in some line items (production salaries, payroll taxes, professional fees, and

TABLE 2-2. Lee Children's Theater, January 2022 Variance Analysis

Revenue	Annual Budget	January Budget	January Actual	Variance	% Variance
Contributed					
Government grants	282,350	23,435	23,435	—	—
Foundation support	398,375	33,065	33,065	—	—
Individual contributions	272,250	22,597	22,597	—	—
Corporate contributions	120,181	9,975	9,975	—	—
CARES Act	141,000	11,703	5,000	(6,703)	(57.28)
Earned Income					
Education programs	11,500	955	552	(403)	(42.17)
Ticket sales	35,380	2,937	1,875	(1,061)	(36.14)
Miscellaneous	5,086	422	422	—	—
In-kind (donations)					
Equipment (instruments)	90,000	7,470	7,470	—	—
Services (space rental)	7,500	623	623	—	—
Total Revenue	1,363,622	113,181	105,014	(8,167)	(7.22)
Expenses					
Administrative salaries	504,095	41,840	41,840	—	—
Education program salaries	183,000	15,189	15,189	—	—
Production salaries	38,417	3,189	2,420	768	24.10
Payroll taxes	63,777	5,293	4,719	574	10.84
Equipment (in-kind)	90,000	7,470	7,470	—	—
Services (in-kind)	7,500	623	623	—	—
Professional fees	89,925	7,464	5,755	1,709	22.89
Production expenses	152,861	12,687	11,923	764	6.02
General operating expenses	169,875	14,100	22,084	(7,984)	(56.63)
Contracted production creative services	64,172	5,326	7,059	(1,733)	(32.53)
Total	1,363,622	113,181	119,082	(5,902)	(0.05)
Surplus/Deficit	0	0	(14,068)		

Negative numbers are in parentheses.

production expenses) and overspending in others (general operating expenses, contracted production creative services).

The next step is trying to determine and record why there are differences between what was budgeted and the actual results in the organization. Variance explanations should be as detailed as possible. For example, we observe a negative 46 and 36 percent variance in education programs and ticket sales, respectively. After a meeting with the respective program heads, we have a better understanding of why the variance occurred and record our explanation as follows:

> **Explanation:** Lee Children's Theater experienced a 45 percent decrease in the number of tickets sold for the January theater production and a 38 percent decrease in enrollment for after-school programs due to the lingering effect of the COVID-19 pandemic.
>
> **Documentation provided:** Student roster for after-school program last year and current year, along with ticket sales receipts for last January's theater production and this year's production.

The director of operations also attended the meeting and noted that general operating spending was up 57 percent compared to the budget primarily due to inflation, unexpected expenses, and increased prices. In addition, to reopen the organization had to comply with several new health policies to ensure that additional hygiene practices became commonplace in the office, including the installation of Perspex screens, hand sanitizing units, and antibacterial wipe dispensers; deep cleaning of shared areas; and masks and other PPE for all employees and students who participate in the organization's programs.

> **Explanation:** Lee Children's Theater experienced an increase of 57 percent in general operating expenses in January due to the COVID-19 pandemic.
>
> **Documentation provided:** Invoices for the current and previous year highlighting the dramatic changes in general operating expenses from year to year.

Now that management knows what the variances are and what caused them, it is time to formulate a plan to take corrective action to reduce future variances and get the budget back under control. Michelle, the chief financial officer, suggests that the organization market the education programs and theater productions more aggressively to increase ticket sales and attendance. She also recommends speaking to other arts nonprofit organizations in the community

and inquiring about sharing information and experiences, pooling resources, and making purchases collectively to reduce general operating expenses.

DEPRECIATION

According to the Internal Revenue Service (IRS), generally a nonprofit cannot deduct in one year the entire cost of any property or fixed asset acquired, produced, or improved, and used in the organization if it is a capital expenditure. Instead, such property or assets must be depreciated. **Depreciation** is the recovery of the cost of a capital asset over a number of years by deducting a part of the cost every year until the organization fully recovers its cost.[19] Property that nonprofits can depreciate include machinery, equipment, buildings, vehicles, and furniture. Land is never depreciable, although buildings and certain land improvements can be depreciated. **Fixed assets** are noncurrent assets that have a useful lifetime greater than one year and are classified on the balance sheet as property, plant, and equipment (PP&E). For fixed assets to be depreciated, they must meet all the following requirements: (1) the nonprofit organization must own the fixed asset; (2) the fixed asset must be used in fulfilling the organization's mission; (3) the fixed asset must have a determinable useful life; (4) the fixed asset must be expected to last more than one year; and (5) it must not be excepted property (i.e., certain intangible property, certain term interests, equipment used to build capital improvements, and property placed in service and disposed of in the same year).[20]

Many arts nonprofit organizations have works of art, historical treasures, and similar assets that have aesthetic, cultural, or historical significance and are employed in their day-to-day operations. Such assets include landmarks, monuments, cathedrals, historical treasures, and art collections. Rare works of art or historical treasures with cultural, aesthetic, or historical value worth preserving in perpetuity do not have to be depreciated.[21] Depreciation rules can become very complicated, so we urge you to speak to your organization's accountant about which fixed assets require depreciation and which do not.

Depreciation of a fixed asset is a noncash expense, but the initial purchase of a fixed asset is shown as cash spent but *not* an expense. Depreciation never appears on the cash budget. Instead, the cash budget shows the full cash impact on the budget in the year in which the fixed asset is purchased. Depreciation appears as an expense in the organization's operating budget. Most arts nonprofit organizations use **straight-line depreciation**, which assumes the same fraction of the fixed asset is used each year. This is the simplest and most

common depreciation method used by nonprofit organizations. The straight-line depreciation formula is

$$\text{Depreciation} = \frac{\text{Purchase price} - \text{Salvage value}}{\text{Estimated useful lifetime}}$$

The **salvage value** is the estimated sale value of the fixed asset at the end of its useful life. Let us look at one example of how a typical arts nonprofit would calculate and record depreciation of a fixed asset.

New City Ballet does not own any land or buildings; instead, it occupies space owned by the city of Arlington, Virginia. Any purchases of furniture and equipment that are not material are charged to current operations by New City Ballet. Significant additions, those that cost thirty-five dollars or more and have a useful life greater than three years, are capitalized and depreciated using the straight-line method over the estimated useful lives of the assets. Management evaluates the recoverability of the investment in long-lived assets on an ongoing basis. Two years ago, New City Ballet upgraded the stage lighting, video, and sound equipment used in their productions. The state-of-the-art sound and lighting systems cost $65,000 and $125,000, respectively. Both sound and lighting systems will last an estimated ten years. The sound system can be sold for 30 percent of its cost at the end of its useful life, and the lighting system will have no salvage value. Here we calculate the total depreciation expense that New City Ballet will record this year on its operating budget:

Sound System

$$\text{Depreciation} = \frac{\$65{,}000 - 30\%\,(\$65{,}000)}{10 \text{ years}}$$

$$\text{Depreciation} = \$4{,}550 \text{ per year}$$

Lighting System

$$\text{Depreciation} = \frac{\$125{,}000 - 0}{10 \text{ years}}$$

$$\text{Depreciation} = \$12{,}500 \text{ per year}$$

Total

$$\text{Depreciation} = \$4{,}550 + \$12{,}500$$

$$\text{Depreciation} = \$17{,}050$$

Throughout the useful lifetime of the lighting and sound equipment, each annual operating budget and activity statement should record an annual depreciation expense of $17,050 for these two capital assets.

INDIRECT AND DIRECT COSTS

Most arts nonprofit organizations classify their costs into two main categories: direct costs and indirect costs. **Direct costs** are incurred by a single program within a nonprofit organization, while **indirect costs** are incurred by multiple programs within that same organization. The sum of direct and indirect costs of a program is the **total or full cost** of that program. For example, New Town Theater's after-school dance program direct costs include the salaries and benefits of the two dance teachers who teach ballet and tap dance to program participants every afternoon during the school year. The after-school dance program's indirect costs include the theater's utility costs (heat, electricity, and water) and the salary of its executive director.

The management and board of New Town Theater is thinking of expanding the after-school program and decide to prepare a program budget to help make an informed decision. One of the first things they need to agree on is how to allocate the cost of utilities to the after-school program. The traditional approach of indirect cost allocation assigns costs to programs in proportion to a simple easy-to-measure cost base; for example, the number of employees in the after-school program versus the advocacy program or the square feet occupied by the after-school program versus the advocacy program. Let us look at how this would work.

New Town Theater has four departments: general administration and fundraising, community theater program, after-school dance program, and advocacy program for diversity in the arts. All four departments share the same 200,000-square-foot warehouse facility. New Town Theater uses the number of square feet occupied by each department as the cost base to assign its annual $250,000 utility costs. As we can see in table 2-3, when New Town Theater prepares the program budget for the after-school dance program, it should include a $75,000 annual expense for utilities.

CREATING A CONTINGENCY PLAN

Rosewall explains that one way to prepare for different eventualities that may affect the organization during the fiscal year is through a contingency budget.[22] In contingency budgeting, the organization prepares a budget and then examines what would happen if different realities came to pass: What if our organization does not receive the grant from the National Endowment for the Arts? What if the roof on our dated building collapses? What if our primary foundation funder chooses a different priority next year? Contingency budgeting allows an organization to responsibly plan for any scenario that could happen so

TABLE 2-3. Indirect Cost Allocation (Utilities)

	General Administration & Fundraising	Community Theater	After-School Dance	Advocacy	Total
Allocation base	20%	40%	30%	10%	100%
Utility costs	$50,000	$100,000	$75,000	$25,000	$250,000

that it can move quickly if necessary. Remember, when one door closes, another one opens. Find the open door and rush right through it.

CONCLUDING THOUGHTS

Building the annual budget is always a fascinating task for nonprofit arts organizations. Budgeting involves estimating revenue that may or may not materialize, stretching scarce resources to seemingly impossible lengths, and juggling the demands of the mission against the realities of the marketplace.[23] Community Brands notes that an effective, efficient, and successful nonprofit organization needs to have a sound annual budget in order to enable well-informed and responsive management.[24] Budgets must be cautiously monitored and updated continuously throughout the fiscal year, reflecting any inevitable changes like new funding, higher spending, unexpected opportunities, or anything material and relevant that will affect the nonprofit's ability to fulfill its mission.[25]

KEY TERMS

break-even analysis
break-even point
conservatism
contingency plan
deficit
depreciation
direct cost
fixed assets
fixed cost
fixed revenue
forecast
full cost
indirect cost

overhead expenses
program expenses
program revenue
revenue forecast
salvage value
straight-line depreciation
surplus
total cost
unfavorable variance
variable cost
variable revenue
variance
variance analysis

ADDITIONAL READINGS

Finkler, Steven A., Thad D. Calabrese, and Daniel L. Smith. *Financial Management for Public, Health, and Not-for-Profit Organizations.* Thousand Oaks, CA: CQ Press, 2022.

Sermier, E., L. A. Weikart, and G. G. Chen. *Budgeting and Financial Management for Nonprofit Organizations.* Long Grove, IL: Waveland, 2020.

CHAPTER THREE

Stubs and Subs

*Sources of Revenue for
Nonprofit Arts Organizations*

LEADER TAKEAWAYS

After reading this chapter, you should be able to

- Identify types of revenue that support arts and cultural organizations
- Consider strategies for obtaining various sources of revenue
- Consider the role of arts leaders in identifying, determining, evaluating, and assessing types of revenue
- Implement success strategies for gaining and maintaining various sources of revenue
- Determine challenges and limitations of resource streams to consider

In 1933, at the height of the Great Depression, an arts troupe in the hills at the juncture of Virginia, Tennessee, and Kentucky began scheduling performances. Because many patrons didn't have cash to pay for tickets, the founder, Robert Porterfield, also accepted vegetables, dairy products, and even small livestock in exchange for a seat in the house, valued at forty cents. Early marketing proclaimed, "With vegetables you cannot sell, you can buy a good laugh." Hence, the name Barter Theatre has stuck for nearly a hundred years. According to the theater's website, "At the end of the first season, the Barter Company cleared $4.35 in cash, two barrels of jelly, and a collective weight gain of over 300 pounds."[1]

Although most arts organizations these days are not going to accept livestock, the Barter example illustrates that support for the arts is a mosaic of funding sources. This chapter details the variety of revenue streams for arts organizations. Because even a small fluctuation in one source of revenue can mean deficits for many arts organizations, we will also identify revenue strategies that managers can use to develop, expand, and diversify their revenue base in the

context of mission achievement so that they can expand beyond ticket stubs and subscription models, as appropriate for their organizational mission.

Here we'll focus on big-picture resource development, including an overview of the types of resources available, basic techniques to implement, the challenges and limitations of each, and questions to ask yourself and your organization. Although the point seems gratuitous, it bears thinking about why arts and cultural organizations need resources. The adage "No money, no mission" is no less applicable in arts organizations than in other types of nonprofits.

As arts leaders, how do you develop resources? There are **trade-offs**, or exchanges, inherent in every finance decision, because resources—not only financial resources but also human, social, and technical resources—are scarce. These trade-offs can create organizational tension, since how we allocate resources is a demonstration of what we value as an organization. Whether to fund sixteen additional student arts awards or set up an exhibition in the community center can sometimes become an argument that derails the board from achieving other critical needs. Understanding the various sources of revenue and their availability and stability can help mitigate false steps, identify opportunities for growth, provide the ability to support programs and services, increase opportunities to build supportive relationships, attract people and institutions to your mission, and better steward the time and sanity of your staff.

Your responsibilities as an arts leader relative to resource development are to identify, determine, establish, and act on the revenue options available to your organization. In other words, a good arts leader will be an IDEA person:

> **Identify:** Arts leaders identify the revenue opportunities available to their organizations. What types of revenue streams are already coming into your organization? Are there any opportunities to develop new revenue streams?
>
> **Determine:** Each type of revenue stream comes with potential benefits and drawbacks, so after identifying current and potential revenue streams, you'll need to evaluate them in terms of these trade-offs. Assess each one to determine its level of stability, the feasibility of pursuing that type of revenue, what amount of staff time is needed to acquire and manage that revenue stream, how well each revenue stream aligns with your organization's mission, and each stream's current or potential return on the human resources investment. As you assess your current revenue streams, rate their stability, make note of whether the source is restricted for a single purpose or whether it can be used by your organization for any needs you have, and how related each revenue stream is to your

overall mission. The chart at the end of this chapter can help you briefly identify these characteristics of your revenue streams.

Establish: If the evaluation demonstrates a high alignment with mission and the ability to provide stability, then you and your team will work together to determine whether to continue or pursue this revenue source. A more difficult decision will be to cut or say no to a revenue stream that is not well aligned with your mission or is costing more in time and human resources than is warranted by the return. The example of a gala may fit into this category for your organization. The opportunity cost of pursuing an ineffective revenue stream could be losing the opportunity to pursue a more fruitful and beneficial one, so consider this step in the process carefully. The key questions and revenue mix worksheet at the end of this chapter can serve as a guide for this process. While you will want to assess your revenue streams during this decision-making process, you will also want to assess them as you go along, perhaps quarterly as you review financials, but at least once a year to note how well any particular revenue stream is producing.

Act: Finally, an arts leader needs to take the plunge and act on the decisions made. If the gala is not producing enough return on investment and doesn't even really make enough sense for nonfinancial reasons, then act boldly and cut it. Then staff can focus their energies more productively on securing higher-dollar commitments from donors or turn attention to other revenue options. Because you can see the whole picture, you are in the best position to weigh the short- and long-term obligations of your organization as well as what revenue, or income, are needed across the programs you run. Choose wisely, with a better understanding of the types of revenues available to you.

Arts and cultural organizations have a wide variety of options for generating revenue. Maybe your organization currently uses only one or two. In that case, you may want to use the framework above (IDEA) to consider other potential revenue sources. If your organization uses multiple sources of revenue, perhaps it is time to assess how well those streams are serving it.

There is no special formula for determining the appropriate revenue mix for your organization, so using the IDEA framework can help you critically consider what the optimal mix is to meet your unique arts mission. After we explore a variety of revenue sources, along with their pros and cons, we'll come back to some key questions to help you think through these important decisions.

REVENUE SOURCES FOR ARTS AND CULTURAL NONPROFITS

Earned Revenue / Fees for Service (a.k.a. Commercial Revenue)

Basically, **earned revenue** (also known as fee-for-service revenue or commercial revenue), includes any commercial ventures that your organization engages in where you receive money for various services your organization provides. Common types of fees for services include tickets for performances or events, subscriptions for a series of events, gift shop sales, educational training fees, licensing, facility rentals for external events, food and beverage sales, program ads, artifact or exhibition rental fees, and so on. While the amount of revenues from fees for service varies across nonprofit subsector, ranging from approximately 27 percent for civic organizations to 65 percent for education nonprofits, about 45 percent of arts revenues writ large come from fee-for-service activities.[2] The amount of fee-for-service revenue is highly influenced by mission and has the pluses of being potentially more stable than grants and not dependent on donors.

Organizations that have ticket revenue or charge for admission have an easily identifiable earned revenue stream and need to establish strategic pricing structures that both advances their creative missions and supports access, inclusion, and appropriate representation for arts patrons; this revenue stream can also smooth risk over a season's bundle of programming. But even organizations with a stable history of ticket sales need to also consider new strategies for revenue. After all, some studies indicate that earned revenues in the performing arts are on the decline because audiences are attending less.[3] And not just post-COVID audiences: the trend started well before.

In considering the benefits of fee-for-service revenue in your organization, you may spot some low-hanging fruit that has been overlooked that you can easily pick for immediate revenue. Think about what your organization is already doing. Can anything be monetized that is not already? Do you have skills or areas of expertise on your staff that could be used to create revenue? Who are your stakeholders, and what might appeal to them? For example, do you make things that could be reproduced and sold? Do you have in-house expertise (voice coaches, tech staff, pottery, etc.) that could translate into workshops? Do you have entries in a nature photography contest that could be turned into a calendar? Could your organization educate young people in your community about some aspect of what you do? Or provide creative aging programs?

In a novel example of hybrid collaboration, a partnership between the Toledo Museum of Art and manufacturer Owens Corning developed the Center for Visual Expertise (COVE) to help manufacturers spot workplace hazards. In

TABLE 3-1. Total Earned Revenue Annual Averages across Arts and Cultural Subsectors, 2014–2020

Arts Category	Average Total Earned Revenue
Support organizations	$200,477
Performing arts	$425,780
Arts education	$535,657
Community	$767,490
Museums	$944,915
Broadcasting	$1,245,291

Source: Calculations made using data from SMU DataArts, https://culturaldata.org/what-we-do/for-researchers-advocates/access-the-dataset/.

this unique partnership, the museum provides classes in visual literacy to Corning employees and discusses how using such skills can help those employees spot and avoid workplace accidents. And the project seems to be working:

> Since we founded the Center of Visual Expertise (COVE) three years ago, COVE has established a thought leadership position in the Environmental Health and Safety (EHS) field and counts numerous Fortune 500 companies among its clients. COVE generates hundreds of thousands of dollars in revenue, allowing us to metabolize the considerable start-up costs of a services business. This past year, in the face of a global pandemic, COVE turned its first profit. But more important than COVE's thought leadership or economic contribution is its demonstration of the social value that museums can have, as it uses art history to save lives and livelihoods.[4]

In a double win, the program is also having a real impact in reducing workplace safety hazards and accidents.

In this case, museum trainers were already experts in visual literacy but had not yet trained others in how to develop and use them so they could easily capitalize those skills. Finding a revenue stream based on already-occurring practice is optimal. Otherwise your organization may lose more in terms of time and human resources than it gains with the additional revenue stream.

Fee-for-service or commercial income is the fastest-growing source of revenue for nonprofits in general, and arts and cultural organizations are leading the charge, with years of experience and numerous opportunities for expansion into commercial endeavors.[5] And the best way to see those opportunities is to simply ask yourself, "Are there things my organization is already doing that could be monetized?"

Membership Income

Some arts and cultural organizations exist for members to come together around a common purpose. For example, Americans for the Arts, an advocacy, research, and network organization, offers membership to related organizations with a mission "to build recognition and support for the extraordinary and dynamic value of the arts and to lead, serve, and advance the diverse networks of organizations and individuals who cultivate the arts in America," and it serves "more than 6,000 individuals representing over 1,500 organizations across the United States."[6] This organization offers a member network, professional development opportunities, email discussion forums, a quarterly magazine, and discounts on conference registrations, job postings, and the like. Often such organizations are classified in the US tax code as 501(c)(6) organizations, or organizations not primarily for public benefit: business leagues, chambers of commerce, boards of trade, and the like.

Arts and cultural organizations charging membership dues must create defensible and fair dues consistent with the organization's mission, consider member motivations, think about recruitment and retention strategies, and keep member tax obligations in mind, since donations to organizations outside the 501(c)(3) designation are not tax exempt. While the benefits of membership revenue include additional engagement with stakeholders, there is some question about whether this stream may have a negative relationship with or "crowd out" private donations. If members see dues as a substitute for donations to the organization, donations may suffer. Alternatively, paying membership dues may increase a donor's interest in an organization's mission, essentially "crowding in" donations. Whether the ultimate impact is one of crowding in or crowding out may depend on how much personal as opposed to public benefit an individual sees in the organization.

If your organization already collects dues, as a leader you will need to assess the types of membership dues structures. The arts organizational leader also must pay attention to what membership dues strategies are going to provide the optimal benefit to the organization. Sliding scale dues provide access across socioeconomic levels for greater engagement with your community. Dues with member benefits entice greater participation as well. The Seattle Art Museum offers some unique member benefits, like art rental or no-interest installment for certain membership levels, and arts companion passes with the Seattle Opera, Seattle Symphony, and Seattle International Film Festival, and the Field Museum in Chicago allowed members use of their comprehensive research library.[7]

Some questions to consider: Do you have different membership categories for areas such as age groups, students, income levels? Do you offer varying levels of

benefits across membership levels? Do you offer membership structures that are equitable and encourage participation from diverse members? Do your current dues structures maximize your membership's satisfaction and opportunities to engage with your organization? If your organization does not collect dues already, you may consider whether your organization provides any benefits that would be worthwhile to your stakeholders at large or a select group of your stakeholders. If so, you might have some room for membership revenue.

Private Giving

Private giving is revenue from private donors. Arts organizations are particularly reliant on private gifts, particularly from high-income donors.[8] As counterintuitive as it may seem, research indicates that across the arts, organizations that spend more on fundraising serve more people and have a more solid pipeline of private donors in the future, so investing time and energy in cultivating private gifts can help you both now and in the future.[9] Along with higher education, the arts are considered elite donor subsectors, because even though low- and middle-income donors support nonprofits of all stripes, higher-income donors give to arts and higher education institutions at higher rates. This is one reason that during times of fiscal crisis, giving to arts nonprofits fluctuates more than giving to human service organizations does. During the last US recession, giving to arts organizations dropped, while human service organizations, whose donors are less wealthy in comparison to arts and cultural organizations, remained more stable and even increased in some cases. "Individuals that earn $25,000 or less donate the largest share (16.6%) of their income to charity," but they are giving more to human service organizations than to arts organizations.[10] Making the arts more relevant to lower-income individuals would be helpful.

As an arts organizational leader, whether you love or hate fundraising, you'll have to be part of that process. People give because of an affinity to your mission, but first and foremost they give *because they are asked*. So your board members, individuals who care about your mission, local businesses, other volunteers, and even those who have benefited from your work need to be aware of your funding needs and how their financial gifts can make a difference and need to be asked to donate. The positive contact you have with donors and potential donors can mean the donation lands in your organization's bank account rather than that of the gallery across town.

Some common issues in fundraising management across nonprofits include volunteer leadership in giving, organizational readiness, stewardship and organizational investment in fundraising, the role of technology in your fundraising plans, and ethics. The Association of Fundraising Professionals has established a

code of ethics for fundraising that you should check out, if you haven't already; you can also share it with your board and any volunteers who may be helping garner private gifts.[11]

While private giving is an important source of income for many arts and cultural nonprofits, giving from individuals is also responsive to changes in the economy, as we noted earlier. In 2021, giving to arts, culture, and humanities is estimated by Giving USA to have declined 7.5 percent, to $19.47 billion (about $60 per person in the United States), and a similar downturn occurred with the 2007 recession.[12] In 2020, during the height of the COVID-19 pandemic, giving to all nonprofit categories except health and arts and cultural organizations increased. As we noted earlier, because some donors view the arts as more expendable in times of fiscal downturn, arts and cultural organizations are considered elite donor outlets, along with higher-education institutions. Partly for this reason, smaller arts organizations are more likely than larger ones to realize more return on investment by focusing on expanding their philanthropic base.[13] So, along with raising private dollars, consider the potential for other sources of revenue that can produce stability during times of fiscal crisis.

Corporate Giving

If you have never thought about approaching a corporation for funding, then put that ask on your to-do list. Many corporations consider funding the arts a good business practice and can be key funders for arts organizations.[14] Corporations provide a little less than 10 percent of nonprofit revenues, according to the American Association of Fundraising Counsel (AAFRC) Trust for Philanthropy. Corporations offer revenue in the forms of direct donations, sponsorships, corporate foundation gifts, or corporate social responsibility (CSR) partnerships with arts organizations. Since creative and technical professions support income generation for corporations through commercials, branding, marketing, and other arts-related activities, it is appropriate as well as good business for big-name companies to support arts education. A good example of this type of collaboration is the Americans for the Arts pARTnership Movement, which not only demonstrates how arts partnerships help businesses but also prepares arts organizations to partner with businesses in new and creative ways.[15]

But with this income stream as with any other, consider the potential tradeoffs of associating your organization with a particular corporation. While there are positive reasons for seeking sponsorships, be careful in choosing a business to yoke your organization with, because sometimes such partnerships can take a turn for the worse. BP Oil sponsorships became odious to demonstrators at the British Museum, while the Tate hushed up their BP donations yet still took the money.[16] The British Museum also got flack for tobacco sponsorships.[17] More

recently, the Metropolitan Museum of Art, the Louvre, and several other museums removed the name Sackler from exhibitions and building wings because of that family's association with Purdue Pharma, the company that developed and aggressively marketed OxyContin. While this change was made in concert with the Sackler family, extricating your organization from a sticky corporate relationship may be more difficult than staying out of it in the first place. Finally, remember that corporations generally fund "corporate social responsibility" out of their marketing budgets, which says quite a bit about philanthropic intent.

Foundation Giving

The greatest number of arts groups funded by foundations are in the rather general categories of Performing Arts (approximately 800) and Museums (approximately 900), but that doesn't mean that more specialized arts organizations should give up hope. After all, foundations also provide funding to less ubiquitous and even offbeat groups such as Printmaking, War Memorials, and even Circus Arts! So don't assume that your organization is out of the running for foundation funding. And do your homework to make the right connections with foundations with proven interest in your area.

There are several different types of foundations (independent, family, operating, community, and corporate), along with multiple perspectives, but all seek to allocate funds according to their missions. According to the Foundation Center's online Foundation Directory, 90 percent of foundations do not have an online presence, which means gaining access to these groups can be difficult without the right envoy.[18] The best strategy for obtaining foundation funding is to develop relationships. While this strategy is important for all revenue streams, it is especially so for foundation funders.

Along with the money itself, foundation funding can have additional benefits for your organization. For example, some foundations engage in a multiyear or ongoing relationship with organizations they appreciate, providing a relatively stable source of income during those years. Furthermore, foundations are becoming more likely to provide technical support for funded organizations. Finally, foundation funding can offer increased legitimacy to your organization in the eyes of other funders.

Drawbacks of foundation funding include (1) the time invested to develop the relationship; (2) the potential for mission drift; (3) potential instability in the long term; and (4) difficult to infiltrate their boundaries—particularly for rural organizations, which are often poor in community resources and outside most of the foundations' geographic interest areas.

However, we are happy to report that positive trends for arts and cultural

organizations are taking place on the foundation front. Since the US Great Recession, some foundations are willing to gift more unrestricted and more operating funds as well as more multiyear grants. Foundations are also embracing greater roles in public policy and advocacy for arts organizations. They are seeking collaboration among organizations, which can benefit your organization by connecting you with additional resources but also requires the time and energy of your team members who engage in and support collaborative endeavors. Some foundations are also streamlining their application processes to relieve the undue burden of applying, in an effort to better engage small and medium organizations with limited staff resources. Plus, "foundation funding did play a pivotal role in turning small- and medium-sized nonprofits into large ones in the first decade of the 2000s," according to Peter Kim and Jeffrey Bradach.[19]

State and Federal Grants and Contracts

Grants and contracts from governments have been on the rise in the United States since Lyndon Johnson's presidency. Both types of funds are associated with work requirements, but grants have greater flexibility. A grant typically involves one partner, the grantee, agreeing to do its best to achieve either specific or general outcomes. There is an intention to fulfill the agreement, but if the outcomes are not achieved, then typically the harshest consequence might be that you will not get another grant to try again. Contracts, however, are usually more in terms of a buyer and a seller. A contract, just as its name implies, is a more detailed, specific, and legally binding agreement: if the recipient fails to achieve certain outcomes or goals, they can face legal repercussions, often in the form of paying back the money. Both can be good sources of revenue, but be especially careful in pursuing contracts and make sure that they (1) make sense for your organization beyond simply a revenue source and (2) will not cause a greater outflow in costs, staff time, or mission goals than they bring in.

Government funding can be a distinct driver of organizational growth across nonprofits.[20] The National Endowment for the Arts (NEA), one of the most important federal arts funders, has awarded more than $5.5 billion to US organizations and communities since 1965.[21] Yet NEA funding can be difficult to access, especially for smaller organizations, who often lack the capacity to seek federal grants. "When you want NEA funds, you have to have a new project, and we're busy doing what we're doing," says Judith Wolf of Young Arts Arizona, an arts education organization that teaches ill, disabled, and at-risk children and has displayed over 4,000 pieces of their work across 130 exhibitions yet has only one full-time staff member.[22]

Local arts agencies can access some federal sources and local government

funding. State art agencies, which received over $111 million in dedicated funding in 2020 for twenty-seven states, and even more—and with wider distribution—across general fund designation from their respective state governments, according to the National Assembly of State Arts Agencies, may also provide funding for organizations like yours through competitive calls for proposals.[23] By a mandate of Congress, at least "40 percent of NEA funding goes directly to state arts agencies and regional arts organizations," with the goal of putting arts dollars into the coffers of organizations that are most closely tied to their communities.[24]

One positive benefit from grants and contracts is readily apparent: the money. In addition, the potential exists for external stakeholders to see grants and contracts as contributing to your organization's legitimacy, which may encourage more funders to jump on the bandwagon. On the flip side, potential donors may also view government grants and contracts as a substitute for their own donations, or what the finance literature calls the crowd-out effect: "If they've got all that federal money, they don't need mine." Some research indicates that federal grants crowd out private donations as well.[25] Also, if grants or contracts are a dominant source of funding to the exclusion or diminution of other potential revenue streams, it could be that your organization is overly reliant on grants and contracts. While some scholars argue that governmental funding sources can be a stable source of revenue, there is always the potential for a federal program to shift priorities or get cut altogether, so depending on one large grant or contract could be a short-term vision for your organization. Finally, organizations need to ask whether the grant or contract scope is in line with their mission. If not, attaining a contract might help the bottom line but could also lead to mission drift, potentially taking the organization into waters it doesn't wish to tread. For example, if your primary mission is opera, does it make sense to go after a federal grant to support the development of young hip-hop artists? On the other hand, sometimes these waters are opportunities for growth and reassessment of the organization's direction.

Here are some success strategies for gaining, maintaining, and managing grants and contracts:

- Develop relationships with funding officers
 » Be responsible with the funding you get (monitor, report, and evaluate appropriately and on time—keeping the relationship strong)
 » Plan for assessment in advance (to the extent possible, measure what you are already tracking or think about how you can track other information with current processes)
- Prepare for cashflow gaps (example government payments)

Events

Special events can be fabulous affairs with all the flair and elegance one could imagine (think Met Gala) or something as simple as a bake sale. They bring together old friends and rivals; they give stakeholders time to dress up, get happy with food and drink and often music, and associate fond thoughts of our events with our organization, prompting goodwill and providing good public relations value. On the other hand, executing special events well requires copious amounts of time, energy, and planning. These administrative hurdles are even more taxing for small organizations with limited staff capacity. As one arts professional related, "Half the year is spent getting our major fundraiser together."[26]

According to qgiv.com, 56 percent of nonprofit organization donors attend fundraisers. Virtual event elements, incorporated during the pandemic, are seemingly here to stay as well: nearly 70 percent of nonprofits plan to include some virtual elements in their fundraising events in the future.[27] Often such events serve multiple purposes along with raising funds. Young Arts Arizona holds an ArtyParty each year that "raises maybe $6,000 a year, but it's primarily friend raising," says organizational founder and director Dr. Judith Wolf. "It's hard to market here, so having a party is a good way to get the word out."[28] In such cases, the benefits can outweigh the costs invested in special events.

Before deciding on holding your next fundraising event, ask yourself, How much return will my organization get from this event? Think about the intangibles like public relations benefits, but also ask hard questions about how much money is raised relative to the event's costs, including **opportunity costs**, or things the organization had to forgo because it was focusing energy on the special event planning and execution. Perhaps such events will pay off down the road even if they don't reap copious cash rewards, or perhaps you could produce higher returns by using your time and talent to cultivate major donors or explore a fee-for-service revenue opportunity.

Gifts in Kind

Gifts in kind can be a great source of support for arts organizations. Whether props for a stage show, building supplies for new office space, paints and papers for a painting course, or time from professionals in your community (serving as board members, offering class instruction, or providing the sort of professional advice an accountant might offer), these resources can have a positive benefit on your organization's bottom line. The amount of gift-in-kind income appropriate for your organization depends on the kind of work you are doing and the resources available in your community.

The benefits of gifts in kind are immediately apparent. Who doesn't love

free stuff? But gifts in kind can come with strings or constraints, so arts leaders need to ask questions before saying yes, no matter what the gift on the table is. For example, if you receive a gift of instruments for your string quartet, how will you store them? Are they the kind of instruments you would have selected yourself? How old are they?

High capital gifts require extra scrutiny before saying yes. If a donor offers you land, for example, ask tough questions about whether there is a lien on the property, or back taxes, or an environmental hazard. What are the restrictions on the use of the land? Can the organization sell it?

These are just a couple of examples, but the same principles apply for all gifts in kind. While we all want to believe donor intentions are always good, unfortunately you'll run into the occasional problem donor who just wants to unload their bad investment on an unsuspecting organization. Exercise gracious caution.

Matching Gifts

Matching gifts are donations made by another individual or organization that match, either 1:1 or at some other ratio, a gift made by a private individual. According to Double the Donation, over 18 million individuals work for matching gift companies, and 65 percent of Fortune 500 companies participate in matching gift programs. For example, Microsoft, Pfizer, American Express (up to $8,000), ExxonMobil (3:1), CarMax, Avon, Johnson and Johnson ($2 for every $1 donated by an employee, up to $20,000), and Coca-Cola all sponsor vibrant matching gift programs for their employees that include monetary and volunteer matches. Annual estimates of matching funds going into nonprofits generally reach $2–3 billion, but unfortunately, around $4–7 billion in matching gifts remains unclaimed in any given year.

Donors are attracted to the idea of a match, and research supports that donors are more inclined to give, and to give larger amounts, when a match is available. Your organization may be missing out on some relatively easy additional revenue if you are not promoting matching gifts. Although researching each individual donor's employer may be time consuming, free searches online can help locate potential matching gifts from over 1,300 corporations. Even a timely reminder on solicitation materials—"Check to see if your employer will match your gift"—is a low-cost solution that could bear strong returns.

Investment Income and Debt Financing

Investment income and debt financing are covered more fully in chapter 13, but we'll provide a quick overview here. While they are opposite sides of the same coin, both investment income and debt financing can guard against fiscal

uncertainty and diversify your organization's revenue streams.[29] Both can also offer a fixed revenue line that fluctuates much less than event revenue, ticket sales, or gift shop income, which lowers volatility and increases stability over time.

With debt financing, payback time is certain. Your organization will get an immediate return, but the day will come, sooner or later, when those funds must be paid back. Prudent organizations will plan for paying back debt financing by setting aside or paying a bit over time.

With investment income, your organization provides money to purchase stocks, bonds, or other types of financial investment that offer a return on that investment. Most often, investments have an associated management fee. If your organization pursues investment income, be sure your organization understands the terms that govern the investment and how much management fee is required and how it is assessed.

With debt financing, your organization is trading current pressing needs with future needs. With investing income for future return, it's the other way around. Your organization's donors or board members may have strong preferences when considering these trade-offs.

OTHER RESOURCES

We're focusing on financial resources here, but many other types of resources are needed for arts and cultural organizations to get their work done (employees, volunteers, capital structures and spaces, partners, etc.). All those resources involve trade-offs of time, energy, attention, and accountability.

Volunteers

Volunteers are certainly resources that save your organization money and are necessary for many arts and cultural organizations to thrive. Far beyond just stuffing envelopes, arts volunteers serve as docents, house managers, trainers, artists, builders, board members, and so on. According to data from the Cultural Data Profile (CDP), supportive arts groups have the highest number of volunteers, with over 500 on average per organization from 2014 to the present; performing arts groups have the least, with an average of 101 per organization. But if you or any of your board or staff harbor the notion that volunteers are free, then the blinders need to come off. We love them and often rely on them, but they require time, energy, and attention, which means that time and attention spent on volunteers is not allocated elsewhere within the organization. So be aware of the opportunity costs involved in working with volunteers.

Collaboration and Resource Sharing

Organizational leaders can sometimes save money through collaborative arrangements or resource sharing with others. Suffice it to say here that collaborations can be very beneficial to art nonprofits. Think about the freedom afforded to your leadership team if your financial, human resources, or technology needs were handled by a partnership agreement with another organization.

Consider partners beyond the usual artsy types too. For example, recent educational emphasis on STEAM (Science, Technology, Engineering, Arts, and Math) programs opens a window of opportunity to draft productive partnerships across disciplinary perspectives. Initiatives that fit into this category are not just arts-based but cross boundaries and can broaden your revenue base. Consider the Save the Music Foundation's collaborative perspective on incorporating STEM with arts programming: "In the music and arts sector, there's much discussion about STEM to STEAM—taking STEM education and adding the arts. We search for opportunities to link STEM to the arts, as musicians can hone their listening skills or enhance their creative problem-solving ability. When students learn music, they're learning a set of skills and abilities that translate well to any environment in the working world."[30]

Put your creativity to good use in identifying potential collaborations that may open up programmatic and revenue-enhancing opportunities. Such opportunities can sometimes manifest as "organizational hybridization" or "cause-related marketing" or "social enterprise" for your potential partners or external stakeholders.

One of our favorite cartoons shows Dostoevsky talking to Tolstoy and proposing a collaboration: "War and punishment. We'll make a killing," he says. But collaborations also require a great deal of work to be successful. To make sure they don't kill you as an organizational leader, you'll want to weigh the pros and cons.

Other Hybrid Structures

Along with collaborations and partnerships, organizations can express and experience other types of hybrid structure. In fact, some claim that artistic ventures are by nature hybridized because of "the combining of core organizational elements that sometimes conflict with each other," like serving a wide public audience and taking artistic risks.[31] Hybrid organizational forms such as **social enterprises**, often defined as businesses that serve a social purpose along with their profit motive, are becoming more popular for arts entrepreneurs. Social enterprises are sometimes also defined within the scholarship as nonprofit

organizations with an entrepreneurial component, which further underscores the fluidity of the concept. **Benefit corporations (B-corps), limited liability corporations (LLCs),** and **low-profit limited liability corporations (L3Cs)** are all business forms that allow for social benefit purpose as coequal with revenue generation as part of the business model. Although such organizations, unlike charities, cannot accept donations that are tax exempt, they can have access to other types of capital, like investors.

After an explanation of different types of for-profit social enterprises, Michael Rushton concludes that "hybrids, at least in their current state, do not present a model likely to be widely adopted in the arts," largely because of the differential trust factor between nonprofit and for-profit forms.[32] Yet other scholars take a more measured, if not entirely optimistic, alternative view. Aside from the hybrid continuum of business and nonprofit, a variety of hybrid relationships exist within the nonprofit-governmental space as well, particularly outside the United States, where the relationship between governmental and nonprofit sectors is not always defined by the tax code. For example, Ruusuvirta's research on hybrid theaters highlights organizations that are legally private entities but have varying degrees of municipal control.[33] If you are considering a start-up, a bit of extra research regarding these various organizational forms will help you decide how those forms would impact your potential sources of revenue.

CHALLENGES AND LIMITATIONS OF RESOURCE STREAMS TO CONSIDER

While the benefit of pursuing an additional revenue stream is of course the potential money flowing into your organization's account, the drawbacks require due consideration. Each type of revenue must be managed effectively, which can mean increased bureaucracy within your organization. If your efforts to gain additional revenue are not tempered by strict adherence to your mission, they could result in mission drift: your organization might follow a money trail that leads somewhere you did not intend to go. In addition, your organization has to have money to seek more money; in other words, seeking additional revenue often adds costs. Also, scholars conjecture that some revenue streams can either encourage other streams (for example, government funding could demonstrate legitimacy and give private donors more confidence in making their gifts to the organization) or discourage them (i.e., a private donor may see government funding and believe an organization doesn't need their private funds).

As an organizational leader, your job will not necessarily be to manage finances directly, unless you are in a small organization with limited staff.

However, you need to understand these various revenue streams and the trade-offs that come along with pursuing them. In addition, leaders need to have a good knowledge of their finances in order to make the final determinations on what revenue streams to pursue and how those resources should be allocated once they are obtained. It might not be ledger accounting, but it is financial leadership. Understanding the stability of your revenue streams and how they relate to your organization's core mission as well as how much it costs your organization in terms of time and talent to pursue those streams will be time well spent.

As we've identified here and you've no doubt experienced, revenues come in many forms and from many sources. Your knowledge of your organization is your greatest strength in determining the best revenue path for your organization to pursue. Remember to do the following:

Understand your mission needs and what resources are appropriate. If it's outside your mission, don't go down the path. If it's an opportunity for growth in keeping with your organizational goals and directions, find out more.

Plan for growth; build a pipeline of revenue. Financial leadership means thinking about the future, so take some time with your staff and board to think about what revenue streams may continue to bear fruit beyond the current fiscal year or what new revenue streams need to be added to your fiscal tool kit for long-term mission attainment.

Diversify resources, but only as appropriate. Consider the potential return of various revenue streams and the risks associated with each. Your best revenue mix should not simply mirror another organization's but should reflect the unique mix optimal for accomplishing your own mission.

Do what you do best: be creative. Thinking creatively about programming, fee-for-service opportunities, and/or collaborations will help your organization adapt to changing circumstances and potentially tap new revenue streams for your organization.

Managing wisely not only supports your programs and services but also strengthens your organizational growth potential, increases opportunities to build supportive relationships, and, more important, attracts people and institutions to your mission!

KEY TERMS

benefit corporation
earned revenue
limited liability corporation
low-profit limited liability
 corporation
opportunity costs
social enterprise
trade-offs

QUESTIONS TO CONSIDER

What type of revenue structure is best for my organization?

Are the current revenue streams or revenue streams under consideration consistent with our mission?

What percentage of organization income is mission oriented?

How much of our income portfolio is from relatively stable sources?

How much of the organization's income is restricted?

Is my organization reliant on one or only a few sources of income?

If a primary source of income were to be dissolved, how would your organization survive? Does the organization have an operating reserve? Are there issues like crowd-out, resource dependency, or mission drift?

What revenue mix is best for your organization? Can you diversify? Should you diversify?

Have you invested in the technology needed for resource development?

Does the organization have adequate staffing and development resources to achieve funding goals?

Are funds raised in an ethical manner?

ADDITIONAL READINGS

Bergin, Ron. *Sponsorship and the Arts: A Practical Guide to Corporate Sponsorship of the Performing and Visual Arts.* Evanston, IL: Entertainment Resource Group, 1989.

Young, Dennis, ed. *Financing Nonprofits: Putting Theory into Practice.* Lanham, MD: AltaMira, 2006.

CHAPTER FOUR

Liquidity and Managing Cash Flow in Arts Nonprofits

Cash is king.—UNKNOWN

LEADER TAKEAWAYS

After reading this chapter, you should be able to

- Understand why arts nonprofits should keep cash on hand
- Understand the benefits of liquidity and the importance of managing cash flow during boom times and during a recession
- Identify some best practices for arts nonprofits to anticipate and manage cash flow shortfalls
- Prepare a cash flow budget for your arts organization

The North River Museum (NRM), a preeminent cultural institution in North Town, was founded in 1982. The NRM's mission is to engage, inspire, and connect diverse communities through the power of art and history. Since 1982 NRM has received millions of dollars in donations and grants, including a $2 million grant from the National Endowment for the Arts (NEA) in 2019. In a statement on January 11, 2021, a spokesperson for NRM said the organization will close in one week due to "financial issues focused on cash flow." Ten full-time and two part-time employees were notified that same day and will be paid through the end of the week. The executive director resigned the previous Monday and did not respond to requests for comments. How did NRM, a seemingly fiscally healthy nonprofit, end up in this predicament, and what can your organization do to manage cash flow and liquidity so that it can remain viable for many years to come?

In the first line of his chapter on managing cash flow, Charles Coe notes, "Cash is the mother's milk of nonprofits, but many nonprofits operate with

razor-thin cash margins."[1] Indeed, effective cash flow management is essential to the sustainability of arts nonprofit organizations. While the operating budget and financial statements provide valuable information for managers, they cannot make guarantees or inform managers whether there is enough cash on hand to pay for an unexpected set design or lighting repair, or even to cover payroll costs for artists and performers next month. For this, effective cash flow forecasting and control is essential. Let us begin this chapter by defining some concepts that are essential to effective cash management.

Solvency or financial viability, the ability of an arts organization to meet its financial obligations, is an important measure of financial health: it is one way an arts nonprofit will demonstrate to its stakeholders that it is a going concern. To maintain solvency and the ability to pay its bills, the organization must have sufficient liquid assets, the cash must flow smoothly, and the cash must be readily available when it is time to pay creditors and personnel.

Liquidity means having enough cash on hand for the day-to-day operation of an arts nonprofit. Cash is the most liquid asset an organization can hold. Greg Chen, Lynne Weikart, and Daniel Williams explain that although having a strong cash position is important, having too much cash on hand is a waste of resources, since idle cash does not go toward fulfilling the mission or producing financial returns.[2] This chapter will discuss liquidity and how arts nonprofits can manage cash flow during boom times and during a recession. We will also focus on best practices for arts nonprofits to anticipate and manage cash flow shortfalls and determine how much cash is the ideal amount to have on hand at any given point.

WHY ARTS NONPROFITS SHOULD KEEP CASH ON HAND

We recommend that arts nonprofits keep cash on hand for three main purposes: (1) to pay for normal daily transactions like paying employees, utilities, and buying supplies; (2) to provide a safety cushion in case of an emergency; and (3) to avail itself of an attractive investment opportunity that may arise. Hilda Polanco and John Summers define **cash flow** as the mix and timing of cash receipts into and cash payments out of an organization's accounts.[3] It is where the numbers on budget spreadsheets and financial reports translate into the reality of money moving into and out of the organization.[4] Managing your organization's cash flow, therefore, is primarily a question of *when*: when you pay the staff, when the light bill is due, when the donor's check will come in.[5]

Rosewall explains even though an organization may anticipate having enough cash to cover expenses by the end of the year, there may be times during

the year when expenses are anticipated but cash is not available.[6] She uses the example of government agencies that typically do not reimburse organizations until a given program is complete; in some cases, organizations must wait for months after a program ends before the check arrives. Under these conditions, would your organization be able to find enough resources to cover its operating expenses while you wait for the check to arrive? Rosewall recommends that arts nonprofits learn how to schedule anticipated revenue and expenses such that the organization is never unable to pay its bills. She goes on to recommend that organizations work with a surplus, credit line, or endowment fund during slow periods so that rent and salaries can be covered during a projected temporary cash shortage.

THE IMPORTANCE OF MANAGING CASH FLOW

According to Propel Nonprofits, every nonprofit organization will experience ups and downs in cash flow at some point in time.[7] This is because the timing seldom matches: cash is not necessarily received at the same time payments are due. They list several common causes of cash flow shortages in nonprofit organizations, including but not limited to the timing of donations, grants, and disbursements such as advance payments; reimbursement-based contracts; operating with a deficit; changes in revenue sources or payment schedules; and unexpected or unplanned events. Cash flow shortages can have many negative implications for nonprofit organizations, including late fees, penalties and finance charges, damaged relationships with vendors and contractors, and lost opportunities for new mission-building activities.[8]

Steven Lawrence notes that, sadly, many arts and cultural nonprofits are surviving paycheck to paycheck, scraping by until the next infusion of cash, with the average arts and cultural organization having just five months of cash on hand.[9] Of course, this varies by type of organization. Operas and orchestras, for example, average two to three weeks of liquidity. This means that if no more money came into the organization, operas and orchestras would be able to pay their bills and continue running for two to three weeks on average. Lawrence remarks that in some cases cash flow shortages are a direct result of the mindset of donors or the board, who encourage arts leaders to "budget to the zero mark" so that the organization does not appear to be flush with cash.[10] This mindset can unintentionally perpetuate a starvation cycle. Lawrence recommends explaining to donors and board members that having a certain amount of savings or cash on hand is essential to an organization's good fiscal health.[11]

DEALING WITH CASH FLOW PROBLEMS

There are several steps that arts nonprofit organizations can take when faced with a projected cash flow problem. We highly recommend having an open line of credit with your bank as a best practice even before you face a cash flow problem. If you wait to apply for credit during a cash flow crisis, it will be very difficult to convince any financial institution that your organization is a going concern. The term **going concern assumption** describes an organization that is expected to operate for the foreseeable future or at least the next twelve months. The point is to establish a line of credit when you do not need it so that it is available when you do need it. Claire Knowlton recommends that nonprofit arts organizations use their line of credit responsibly: a line of credit is not meant to cover lost revenue, pay for annual deficits, or continue unsustainable activity.[12]

Another step your organization can take when facing a projected cash flow problem is speeding up the collection of receivables. While getting paid in full or in advance of providing goods or services would be ideal, it is not always possible. Many small nonprofits are just happy to get paid, so they never focus on when they get paid. However, an outstanding invoice that will be paid in three months or more will not help the cash flow problems that you are facing today. How can you speed up the time that it takes for you to collect your accounts receivables?

First, generate and send out your invoices as soon as the goods or services have been delivered. Second, ensure that your invoices are clear and transparent. At a minimum, invoices should include an invoice number, the date when service was provided or goods were delivered, the amount due, the nature of the goods or services, due date, payment terms, late payment fees or penalties if applicable, and, more important, how and where payment can be made. Third, offer vendors and clients as many payment options as possible. Some people prefer checks, others prefer debit or credit cards, and others prefer a direct deduction from their account, so try to accommodate everyone as best you can. Credit and debit cards may have transaction fees associated with them, but getting paid faster and improving your cash flow may be well worth the cost.

Finally, offer your vendors and clients incentives and disincentives. Everyone likes saving a few dollars. For example, you could offer a 5 percent discount for tickets purchased one month before a performance, or a 5 percent discount for all invoices paid within thirty days. It may also help to impose late payment fees or penalties for invoices that are not paid within thirty days. While we are on the topic of late payment fees or penalties, we would also recommend being

selective about who you extend credit to. If a vendor or client is chronically late with payments, it may be the time to reconsider limiting the amount of credit that is extended to them or preventing them from receiving any goods or services until their balance is settled.

One of the best cash flow management practices that many nonprofits overlook is financing the purchase of new equipment through leasing. State-of-the-art theatrical equipment can be very expensive and can involve high upfront costs. Although in some cases owning can be cheaper over the lifespan of the equipment, leasing can prevent a major hit to your organizational finances and prevent immediate cash burn.

Another asset that many organizations overlook as a source of revenue is unused space. Perhaps your organization has a large conference room that is used only once a month for board meetings. Or a large theater that only gets used during rehearsals and performances might be the perfect spot to rent out to the local high school or college for graduation events or proms. The point is, every asset you own is a resource for your organization.

Another step you can take is slowing down your payments to vendors and for contractual agreements within reason. If a bill is due on the last day of the month, unless the vendor is providing an incentive for paying early, hold on to the cash in your bank account and pay the bill on its due date. (Note that we are in no way advocating making late payments.)

Finally, as a last resort you could liquidate nonproductive investments and other nonessential assets. We know of one community theater that sold the building it owned and then leased the building from the new owners. The building was old and required expensive maintenance, a new roof, and updated lighting and plumbing. The sale provided the organization with a large, much-needed cash infusion that was used to pay vendors and creditors and expand several existing programs. The theater was also able to start its first reserve fund with some of the proceeds of the sale.

PROACTIVE, NOT REACTIVE

Zannie Voss, Manuel Lasaga, and Teresa Eyring explain, "Proper planning and preparedness can help arts leaders avoid crisis mode in the event a recession does occur and, equally important, to navigate through longer-term changes that are affecting their financial performance."[13] Too many arts organizations plan only one year ahead and do not have a backup plan beyond the short term. Boom times may be good opportunities "to cultivate an exciting, mission-aligned project for a future year while the economy is still strong—one that will reinvigorate

your artists, staff, audience, and donors."[14] Focus on donor engagement and audience retention. Deepen relationships with existing donors and invest in developing and cultivating relationships with new and prospective donors. Loyalty is very important during and after a recession if you want to encourage midlevel donors to continue their annual philanthropy.

Evaluate all your expenses and find a way to reduce them without compromising the art itself. In a period of fiscal crisis, many organizations are quick to freeze wages, furlough employees, or let them go indefinitely. Avoid reducing administrative costs if possible. Michael Kaiser, an international expert in arts management, explains that wage freezes are not the answer to cash problems and never work; he calls it "saving one's way to health."[15] You are not going to reestablish fiscal health simply by holding wages constant. Instead, Kaiser recommends mobilizing new resources, creating exciting new artistic ventures that are central to your mission and purpose, marketing those new ventures aggressively, and using the new funds to reinvest in additional important projects.[16]

Keep everyone in the loop. Engage with your staff and board as you plan, forecast, and think through options of when and how you will respond in a fiscal crisis. Be proactive. Do not wait for the cash flow crunch to happen; have a plan in place before it happens. It is worth taking time to safeguard your stability and vitality during periods of fiscal stability for the future and to find the growth initiative for your organization that will drive your sustainable long-term success.[17]

Engage with peer organizations to share ideas, solutions, and lessons learned.[18] Collaborate with other arts organizations: instead of competing for a grant, submit a joint proposal and create a joint program. While planning for a future crisis may not be as exciting as staging *The River* or exhibiting the works of Paul Cézanne, liquidity and adequate cash flow will ensure that you can continue staging those wonderful performances and exhibitions this season, next season, and well into the future.

CASH FLOW BUDGETS

In addition to the operating budget, which we discussed thoroughly in earlier chapters, all arts nonprofits should also prepare a **cash flow budget**. A cash flow budget projects monthly cash receipts and cash disbursements each month over the fiscal year and provides insight into periods when your organization will have adequate cash on hand to cover expenses and periods when it will not.

Cash flow budgets are prepared using cash accounting, which recognizes revenue when payments are received in cash and expenses when a resource is

paid for in cash.[19] The format of cash budgets differs from the format of operating budgets and includes the following main sections: beginning cash balance, cash receipts, cash payments, borrowing, repayments, investments, and ending cash balance.

You have just been hired as the executive director of a new Shenandoah Valley nonprofit organization called Project Art that provides opportunities for creative youth development through accessible, multidisciplinary arts education to empower young people and amplify their voices. You are planning for your first year of operations, FY 2023. Project Art collaborates with children, youth, and families in an inclusive and supportive community where art is healing and transformative. Project Art runs a program aptly named Community Art, which includes weekly multidisciplinary arts education classes in partnership with community-based organizations that provide services to children, youth, and families experiencing homelessness and poverty. All art supplies are free, and refreshments are provided for all participants in the program.

Project Art will have three full-time salaried employees. As executive director, you will earn $75,000 per year; the two program managers will each earn $50,000 per year. Health insurance and other benefits will equal 33 percent of each employee's annual salary. Rent and utilities will be $1,000 and $200 per month, respectively. You expect art supplies to cost $100 per participant per month and refreshments to cost $40 per participant per month. As of last week, sixty participants have registered for Community Art. You plan to pay all expenses promptly as they are incurred.

The Department of Social Services (DSS) has agreed to reimburse you for $120 per participant per month; you will receive monthly checks from DSS with a three-month lag (i.e., three months after an individual participates in the program). You also expect to receive $250,000 in contributions from an anonymous donor at the beginning of the fiscal year. You are not planning to borrow or invest any funds during Project Art's first year of operations.

Table 4-1 shows an anticipated cash flow problem for Project Art during its first year of operations, specifically during the fourth quarter of the year. If we take a closer look at Project Art's cash budget, we see that the expenses are spread evenly throughout the year. The cash receipts, however, are a bit lumpy. The big issue seems to be the three-month lag with DSS payments, which essentially means that Project Art provides services the entire first quarter and does not receive reimbursement until the second quarter. Because the executive director is proactive, she can revise Project Art's plans for the upcoming fiscal year. She can embark on additional fundraising and seek out additional donors to close the gap or apply for a credit line or bridge loan at the local bank that she

TABLE 4-1. Quarterly Cash Budget for Project Art, FY 2023

	Quarter 1	Quarter 2	Quarter 3	Quarter 4	Annual
Beginning balance	0	163,013	97,625	32,238	0
Cash receipts					
DSS contract	0	21,600	21,600	21,600	64,800
Contributions	250,000	0	0	0	250,000
Total cash receipts	250,000	21,600	21,600	21,600	314,800
Available cash	250,000	184,613	119,225	53,838	314,800
Cash payments					
Executive Director salary	18,750	18,750	18,750	18,750	75,000
Program Manager salary (2)	25,000	25,000	25,000	25,000	100,000
Benefits	14,438	14,438	14,438	14,438	57,750
Art supplies	18,000	18,000	18,000	18,000	72,000
Food	7,200	7,200	7,200	7,200	28,800
Rent	3,000	3,000	3,000	3,000	12,000
Utilities	600	600	600	600	2,400
Total cash payments	86,988	86,988	86,988	86,988	347,950
Subtotal	163,013	97,625	32,238	(33,150)	(33,150)
Borrowing	0	0	0	0	0
Repayments	0	0	0	0	0
Investments	0	0	0	0	0
Ending cash balance	163,013	97,625	32,238	(33,150)	(33,150)

Negative numbers are in parentheses.

can draw from during the fourth quarter. She can solicit in-kind food donations for the refreshments that will be provided to participants, thus eliminating one expense.

In addition, she can also attempt to renegotiate with DSS and ask for more favorable reimbursement terms, like a one-month lag instead of a three-month lag. By understanding Project Art's cash flow and planning, the executive director can avoid fiscal problems in the future and provide stability to the organization. Cash flow management should be done regularly, and the cash budget should be reviewed and updated monthly.

CONCLUDING THOUGHTS

Michael Kaiser notes, "I have never seen a performing arts organization facing fiscal turbulence in immediate danger of closing its doors that can consistently fulfill its mission."[20] If an arts organization is facing a liquidity crisis, it cannot promote and develop artistic expression; it becomes more focused on keeping the lights on and paying vendors or artists or performers. Kaiser continues, "If you don't have any cash and owe a good deal of cash any amount seems onerous even a weekly $350 payroll check for a dancer."[21]

The first step in cash flow management is understanding what bills are due, when they are due, and how much they are. A performing arts center with productions at various points throughout the year must plan for the surge in cash needs when programming picks up.[22] It is not enough to just break even at the end of the fiscal year. Arts organizations should aim to put aside a small nest egg from surpluses each year for unforeseen emergencies like a leaking roof, broken ventilation or heating system, or theater lights that just will not turn on the night before the biggest performance of the year.

Earlier in the chapter, we saw Project Art face a cash flow crisis because of a three-month lag between service provision and disbursement of cash from DSS. One of the biggest challenges nonprofit organizations face for cash flow management is funding from state and local government. State and local governments generally pay for services only after services are delivered, forcing nonprofits to cover the initial outlay of cash to deliver those services. These delays are often compounded by bureaucratic delays in registering contracts or processing invoices and payments.[23] In some extreme cases, nonprofits face payment lags of six months or more between disbursement of cash to deliver contract services and collection of cash under the terms of the contract.[24] Without advance planning and the ability to seek other revenue streams, these nonprofits can find themselves on the brink of shutting down due to inadequate liquidity.

Unlike with for-profit arts organizations, when it comes to arts nonprofits, cash is often not fungible. Unrestricted cash that can be used for anything your organization needs is very valuable and unfortunately the hardest type of funding to secure. Most funding comes with restrictions, and it is important to know what those restrictions are to be sure that you can use these funds for the things you need to pay for. There are many cases of nonprofits "robbing Peter to pay Paul"—that is, using restricted funds to pay for operating expenses—with the hope of paying it back later.[25] Although this practice is technically not illegal, it is not a recommended practice because inevitably these same nonprofits find themselves in trouble when they fail to or are unable to pay back the funds as intended.[26]

Be informed, strategic, and collaborative when it comes to cash flow management. Develop realistic budgets, review them regularly, and adjust them as needed. Failing to prepare and manage cash flow in your organization is preparing to fail in its mission.

KEY TERMS

cash flow
cash flow budget
going concern assumption

liquidity
solvency

ADDITIONAL READINGS

Coe, Charles K. *Nonprofit Financial Management: A Practical Guide*. Hoboken: John Wiley & Sons, 2011.

Kaiser, Michael M. *The Art of the Turnaround: Creating and Maintaining Healthy Arts Organizations*. Hanover, NH: University Press of New England, 2009.

Kaiser, Michael M. *Curtains? The Future of the Arts in America*. Waltham, MA: Brandeis University Press, 2015.

Kaiser, Michael M., and Brett E. Egan. *The Cycle: A Practical Approach to Managing Arts Organizations*. Waltham, MA: Brandeis University Press, 2013.

Zietlow, John, Jo Ann Hankin, Alan Seidner, and Tim O'Brien. *Financial Management for Nonprofit Organizations: Policies and Practices*. Hoboken: John Wiley & Sons, 2018.

CHAPTER FIVE

Singin' in the Rain
Why You Need a Rainy Day Fund

What a lot of people are saving for a rainy day is somebody else's umbrella.—CAROLINE CLARK

LEADER TAKEAWAYS

After reading this chapter, you should be able to

- Understand the benefits of operating reserves for arts and cultural organizations
- Identify strategies for obtaining, maintaining, and utilizing operating reserves
- Understand the pros and cons of "substitutes" for operating reserves[1]

The small community's theater had seen better days. Ticket revenues, never very large, were dwindling, and attendance lagged. The historic theater's infrastructure was crumbling; there were consistent plumbing issues, and the roof needed extensive repair. Grants were in short supply and were not enough to cover one show's copyright access, let alone market a season. The volunteer board loved the theater and occasionally put personal funds into the coffers to keep the organization afloat but eventually ran out of time, energy, and money. In 2021, the aging owners of the theater, whose zeal and drive sustained it and kept the boards lit up for many years with new shows, had to put up a different sign on the marquee—a For Sale sign.

Did it have to be so? What would it have taken to keep this icon of the community alive through a period of adversity? If the organization had managed their finances differently, not just for a year but for several years, would the doors have been able to remain open?

Arts organizations, often ascribing to the poverty mentality, often prioritize immediate needs rather than long-term ones—understandably so, since many

organizations operate on a break-even basis or even at a deficit. Theater Communications Group found that roughly 20 percent of theaters break even, with 33 percent running a deficit at year's end, like our community theater above.[2] Within this study, only 39 percent had a 1–10 percent surplus.[3] These percentages do not bode well for those organizations during normal times of operation, let alone when trouble comes. Anticipate the trouble on the horizon and meet it head-on by making sure your organization has a rainy day fund.

Rainy day funds, also known as **operating reserves**, are monies set aside by an organization to help sustain operations in times of fiscal stress or to take advantage of a strategic opportunity. Think of it as a personal savings account for business. These funds are meant to be untouched until some external shock, like an economic recession, puts your organization's finances in jeopardy or, although it is much less discussed, until an extraordinary opportunity presents itself. As noted in chapter 1, arts nonprofits are more vulnerable to fiscal shock than many other types of nonprofits are. On a positive note, several studies conducted between 2010 and 2020 found that arts and cultural nonprofits have a higher margin of reserves than most other nonprofits on average, perhaps because of their higher level of revenue diversity across arts organizations.[4] Arts nonprofits took a harder hit from the COVID-19 pandemic than human service organizations; however, those arts nonprofits with operating reserves were less likely to reduce staffing or operating hours or have a breach in supplies from vendors, and actually reported more demand for performances.[5]

Operating reserves can help your organization weather a fiscal storm. There is not necessarily one size that fits all organizations; there is, however, some agreement that finding the optimal size of such a fund should include a variety of factors, such as the type of organization, its size, its current and future plans, and its level of financial maturity. While several studies over the last decade have explored how operating reserves affect the fiscal health of state and local government, in recent years both mainstream and academic publications have devoted increasing attention to the role of operating reserves in the nonprofit sector. Other names sometimes used for operating reserves are rainy day funds, budget stabilization funds, organizational slack, or contingency funds. You may have another name for an operating reserve, but whatever you choose to call it, having one might someday be the fiscal cushion that lets your organization survive.

BENEFITS OF HAVING A RESERVE

Along with the benefit of added resilience when bad things happen, operating reserves can also provide multiple strategic advantages, along with maintaining

operations through a time of crisis. Having the assurance of some reserve funds frees up your organization's leadership to focus on things other than whether you are about to go under whenever a setback arises. If you are only surviving from event to event, then it is much harder to focus on even basics like programming, mission achievement, or even "golden opportunities" that might arise. Reserve funds, or at least a portion of an organization's reserve funds, should not only be thought of as rain insurance; they can also be very useful in taking advantage of strategic opportunities, such as the lot next to yours becoming available or a work that is central to your mission coming to the auction block.

In some cases, reserves can signal financial stability to external stakeholders. Research indicates that simply having reserves can be financially beneficial if your organization seeks to borrow money because the presence of a reserve can garner your organization a higher credit rating than otherwise, which could in turn allow you to get a lower interest rate on the loan.[6] The lower the interest rate, the less you pay back, which in turn means less money going out and more money going into your organization. In all respects, operating reserves can provide a strategic edge to seize opportunities as well as offer a buffer for more volatility within other revenue streams. These are all good reasons to make sure your organization has some financial reserves in place.

WHAT ARE THE CRITERIA FOR AN OPERATING RESERVE?

Ideally, operating reserves meet three criteria: (1) they are unrestricted; (2) they are easily liquidated (or turned into cash); and (3) they have been set aside by your board as untouchable unless a fiscal crisis or other unexpected financial difficulty or opportunity arises. The Nonprofits Assistance Fund (NAF) classifies an operating reserve as "an unrestricted fund balance set aside to stabilize a nonprofit's finances by providing a cushion" against future unexpected cash flow shortages, expenses, or losses; NAF also advocates that boards create a policy surrounding the use of the reserve.[7] The "Operating Reserve Policy Toolkit for Nonprofit Organizations," developed by the Nonprofit Operating Reserves Initiatives Workgroup—a group of scholars and practitioners organized for the purpose of drawing attention to the importance of the operating reserve as a measure of fiscal health, which is sponsored by the National Center for Charitable Statistics, the Center on Nonprofits and Philanthropy at the Urban Institute, and the United Way Worldwide—identified three types of operating reserves: board designated, undesignated, and available. The only one they recommend is the board-designated reserve.[8]

In addition to meeting the criteria of unrestrictedness (not having to be used for a specific purpose other than being reserve funds) and liquidity (being reasonably easy to turn into cash), a reserve needs board designation to provide prudent oversight, easy access, timeliness, and the necessary flexibility to stabilize difficult financial times. Other financial mechanisms, such as undesignated surplus, endowments, capital reserve funds or capital investments, cash flow accounts for grant operations, or even lines of credit, fail to meet one or more of these criteria.

WHAT OPERATING RESERVES ARE NOT

We certainly encourage you to develop and maintain a rainy day fund; however, there are times when organizational leaders set aside monies in other forms and call those operating reserves. While these mechanisms don't meet a strict definition of reserves, some organizations view them as analogous to reserve funds, especially if they have proven to be stable sources over time. Let's compare a few.

Endowments are often invested funds typically set aside for a specific purpose. They are not operating reserves or substitutes for reserves, but you could call them financial cousins. Both can show up as net assets on a finance report, but the unrestrictedness and liquidity criteria often differentiate operating reserves from endowments that have a designated purpose and take longer to access than a reserve. Some scholars distinguish between "true" endowments, those that are designated for a specific purpose, and "quasi-endowments," those that are partially unrestricted. To further distinguish operating reserves from endowments, operating reserves are set aside for fiscal crises or extraordinary growth opportunities, and endowments are meant to provide a stable and enduring source or revenue each year in perpetuity, because organizations generally only spend a small percentage (1–5 percent) of an endowment's annual return. While it is possible for endowments and operating reserves to be housed in similar kinds of accounts, as unrestricted net assets, operating reserves have a higher liquidity, for quicker access to cash.

Although an endowment does not meet the scholarly definition of an operating reserve because it lacks the liquidity and often lacks the unrestricted criteria, nonprofit executives often express confidence in this mechanism as a managerial substitute for an operating reserve.[9] One nonprofit executive told us in a survey response, "Practically, our endowments are just operating reserves . . . so our auditor will say, 'You know, what you really have is a very large operating reserve' but we call them endowments."[10] Another survey respondent said, "Our endowments are our reserve fund, and we call it a cash flow reserve."

Such findings support recent calls for using endowments as spending tools in times of fiscal stress.[11] However, large data studies from financial data conclude that nonprofits with endowment do not generally use endowments like rainy day funds.[12]

Most organizations pine for an endowment but not for a solid reserve. We'd like you to consider reversing that desire. If your organization is fortunate enough to have both, rejoice. But if you can only have one, we recommend reserves first. In both cases, you are trading off current and future needs—such as funding new gallery lighting and frames today or keeping an artist on the books a while longer in the future—and those choices are never easy, but we'll talk about some ways to build reserves that might not feel so dire.

Emergency cash refers to some cash set aside by your organization to assist with cash flow issues. Emergency cash can be beneficial, but is not an operating reserve in the strict sense. Emergency cash can be helpful, particularly for organizations with grant funding that may experience a gap in time between when a grant is allocated and disbursed. However, emergency cash is typically not retained in amounts large enough to maintain operations for a significant period or specifically designated by your board.

Lines of credit essentially act as small loans from your financial institution that can hopefully be paid back quickly and can be useful in establishing a strong credit history for your organization. They can mean easy access to unrestricted quick cash because they can typically be turned around in just a few days. Like investment accounts and certificates of deposit, lines of credit are sometimes viewed by organizational leaders as a rainy day strategy. With appropriate board approval, a line of credit can help you in a pinch. However, the funds come with a string attached, the interest that must be paid, so this short-term strategy can turn into a longer-term debt if your organization does not plan to pay it back in a timely manner.[13]

Capital reserves are funds set aside by your organization for building or high-expense projects. Although it is tempting to view such funds as part of your operating reserve, they are restricted and not fungible (available for transfer across budget categories). Besides capital reserves, your organization may have other types of restricted funds. If donors supplied those restricted funds, you are honor bound to use those funds in accordance with the donor's wishes, which, again, means they cannot be used for unrestricted purposes like a rainy day fund. Although capital, donor-restricted funds, investment, and general savings accounts may make your balance sheet look like you are better able to take a hit, these types of funds are not interchangeable with an operating reserve and serve different purposes for your organization.

TABLE 5-1. How Substitutes for Operating Reserves Measure Up to Strict Reserve Criteria

Type of Fund	Unrestricted	High Liquidity	Board Designated	Permanent
True operating reserve	Yes	Yes	Yes	No
Endowment	Yes/No	No	Maybe	Yes
Emergency cash	Yes/No	Yes	Maybe	No
Line of credit	Yes	Yes	No/Maybe	No
Capital reserves	No	Maybe	Yes	No
Other investment accounts	No	No	Maybe	Maybe
General savings account	Yes	Yes	Maybe	No
Sister foundations	Maybe	No	No	No/Maybe

A few lucky arts and cultural nonprofits are fortunate to have affiliated foundations (sister foundations) or other nonprofits that offer ongoing direct support or can serve as financial backup plans if the organization hits a financial bump in the road. For example, Creative Washtenaw is affiliated with Artrain, an organization with higher levels of financial capacity—a "friendly lender," so to speak. While an affiliated foundation or nonprofit does not meet any of the recommended criteria of liquidity, unrestrictedness, and board designation, depending on the relationship between the organization and foundation, such a foundation could potentially supply a stable revenue source. Table 5-1 provides an explanation of how the various substitutes for operating reserves measure up to true operating reserves.

While these alternative financial supports do share some of the benefits of a reserve fund, they usually come at a greater cost both financially and in expediency and thus are not direct substitutes for an unrestricted, board-designated operating reserve fund. Although these alternative examples don't meet all the requirements for an operating reserve in the strict sense, your organization may derive benefit from these arrangements as part of your overall revenue plans. But we do recommend that you have some funds set aside so the tunes you are singing in the rain won't be the blues.

HOW MUCH RESERVE IS ENOUGH?

Planning for a reserve takes some vision because designating reserves may not be considered important in times of fiscal prosperity. After all, most people cruising down the interstate at seventy miles per hour aren't concerned about

whether they have a spare tire in their trunk. But after a blowout, *everyone* is interested in what's in their trunk. However, if you didn't pack a spare tire before the blowout, it's too late to drive to the tire shop and get one. The need for a cushion quickly becomes apparent in times of fiscal shock, but how much operating reserve is enough to inoculate an organization from a fiscal crisis? Here is the frustrating but also hopeful answer: it depends.

Noted nonprofit finance scholar Woods Bowman recognizes not only that an operating reserve is one of the "basic tools of financial security" but also that "the appropriate size for an operating reserve depends on the nature of a nonprofit's business."[14] In recognizing the importance of operating reserves for long-term fiscal health, scholarship identifies four stages of nonprofit financial development and organizations that "meet 3–6 months of operating expenses in cash" are classified as either in progress or thriving.[15] Using the "Operating Reserve Policy Toolkit" mentioned earlier, you can calculate your own organization's operating reserves ratio as a percentage that demonstrates what portion of the calendar year your organization could meet its expenses lacking any other income:

Unrestricted net assets ÷ Your annual expense budget

or by calculating the number of months your organization could operate if no other income comes in:

Unrestricted net assets ÷ Average monthly expenses

The Nonprofit Operating Reserves Initiative Workgroup recommends a minimum operating reserve ratio of 25 percent, or three months of annual operating budget.[16] Similarly, the Better Business Bureau's Wise Giving Alliance also recommends that nonprofits save enough to continue operating for three months in case of an emergency. Standard 10 of the Wise Giving Alliance's Implementation Guide advises nonprofits to avoid accumulating funds that could be used for current program activities and advocates that they limit savings to less than three times the size of the past year's budget or past year's expenses, whichever is higher. CharityWatch, a nationally prominent charity rating and evaluation service, reduces the grade of any nonprofit that has available assets equal to three to five months of operating expenses. In CharityWatch's view, a reserve of less than three months is reasonable and does not affect a nonprofit's grade. Thus, although there is no optimal dollar amount for all organizations, consensus converges around three months of operating expenses as an amount both prudent for the organization and acceptable to outside funders.

Typically, the amount of reserves held by arts organizations varies according to the type of organization. According to Cultural Data Profile data spanning

TABLE 5-2. A Comparison of the Months of Operating Reserves, Least to Greatest, among Arts and Cultural Subcategories

Arts Category	Operating Reserves Ratio
Arts support	1.45
Performing arts	1.49
Broadcasting	1.61
Unclassified	1.65
Arts education	1.90
Total arts	2.69
Museums	2.77
Community	2.96

Source: Calculations made using data from SMU DataArts, https://culturaldata.org/what-we-do/for-researchers-advocates/access-the-dataset/.

2014 to present, community arts organizations have the highest levels of reserves, with almost three months (2.96), followed by museums (2.77), while arts support (1.45) and performing arts (1.49) have the least, with less than one and a half month's reserves.[17] However, on average, arts organizations across categories have less than the minimum recommended reserve of three months.

So while the typical prescription in finance literature has been three to six months, scholars and seasoned practitioners also know that this prescription, like an actual medical prescription, is not appropriate in all cases.[18] Regarding types of revenue, there are a variety of revenue streams appropriate for arts and cultural organizations. Moreover, organizations have disparate financial needs, so the answer depends on numerous organizational factors.[19]

What kinds of work are you doing? How many people are employed by your organization? Is there any type of seasonality to your work? Also, your organization's stakeholders may have preferences about reserve amounts. Too little may be considered irresponsible, but too large may lead donors to feel you are hoarding money that should be spent on current needs. What's a leader to do?

According to recent scholarship, organizational size impacts the optimal amount of reserves to hold.[20] Larger organizations, those with over $1 million in revenues, may be successful just holding three months of their annual operating expenses as reserves, while smaller organizations need more because, on average, smaller organizations are more susceptible to a hit from fiscal shock. Smaller organizations may want to hold, if possible, up to one year in reserve.[21]

So if you are overwhelmed, shoot for three months. But if you have the time

to assess more carefully, consider how long your organization could potentially operate if a significant portion of revenue (a grant, private donations, ticket sales, etc.) were removed.

If you have more leadership experience, you may view academic and consultant guidelines as best practice in an aspirational sense but not feel compelled to follow them to the letter for ideological or experiential reasons. On the ideological side, you may not believe your organization should amass cash if it could be providing another opportunity for community engagement. But we encourage you to take the long view. Leadership experience seems a pivotal variable in the ability to evaluate the overall financial revenue mix and to respond to contingencies appropriately.

Within our research, more experienced leaders in larger organizations express greater confidence in their abilities to cover unexpected shortfalls through means other than a straightforward operating reserve, citing relationships and access to other funding as potential safeguards instead of reserves. Based on experience, one leader expressed her ability to handle situations such as low cash reserves or serious deficits because she has always successfully managed to overcome similar situations in the past. Others cited the belief that personal or organizational networks (for example, community banks or philanthropists) will bolster the organization during financial difficulties. In the words of one respondent, "We have a fairly good network of folks that are willing to put word out when there is an unexpected and immediate need." If you are starting from zero reserves, let's discuss some ways to begin moving in the right direction.

RATIONALE FOR ESTABLISHING A RESERVE

Nonprofit organizations employ a variety of strategies to maintain solvency and continue to provide services to clients, even during external financial constraints. Recognizing the importance of reserves, many nonprofit leaders seek to create a cushion against fiscal shock, although these cushions often do not match the textbook definitions of operating reserves or organizational slack. Even though holding some cash in reserve is considered a best practice by nonprofit practitioners, results indicate that reserves are created in a predominantly ad hoc manner; few organizations purposefully budget for the reserve. Formal policy regarding how funds are used is minimal, with significant director discretion, and reserves are used more for cash flow assistance than for catastrophic responses to organizational need.

Organizations are also different in the level of authorization needed to access and/or use funds, and the three models presented outline variance in flexibility

and director discretion. According to nonprofit executives, operating reserves are not only for the torrential downpours but also provide needed fiscal support and flexibility when the rain clouds appear on a more routine basis. Sources of funding also play a role in whether an operating reserve exists and, if so, how large it is. Organizations with a larger dependence on government grants tend to maintain larger operating reserves. Again, the perceived stability of government grants and contracts can alleviate the sense of immediacy to make cuts associated with organizations with no or low reserves. This reliance on government grants for stability through rough financial times must be tempered with discretion: as has been noted in other recent research, problems with government grants increase the likelihood of drawing down reserves.[22]

Not surprisingly, organizations that indicated less drastic responses to fiscal shock such as seeking more direct donations or drawing from a short-term line of credit noted that either a contingency plan was in place or they would convene an emergency committee meeting to discuss options. Along with spending down reserve funds, other responses to fiscal shock included a hiring freeze or seeking additional grants, sponsorships, or contracts for programs. Cuts were considered a potential imperative among organizations that perceived their reserves as smaller than necessary, whereas organizations with more substantial reserves bundled cuts as one of several potential options, demonstrating that the reserve provided greater flexibility.

Organizations with no reserves identified personnel or program cuts as likely when asked how their organization would respond to a fiscal shock. Responses included "cutting programs by cutting people," "immediately cut back on program personnel," and "reduction in workforce tied to funding cut." One executive director in this category explained that the organization "would not fulfill a service need with no income tied to it." Along with personnel and program cuts, these organizations said they might employ a special fundraising appeal, increase membership dues, or seek foundation and other grant funding. Such executives, although they did not express the need for a reserve, reported more drastic responses to fiscal shock than those holding reserves they considered adequate.

FUNDING OPERATING RESERVES

Once an organization has decided to commit to having a reserve fund, it is still left with the sometimes Herculean effort of funding it. So how do arts professionals make the leap from wanting a reserve to funding one? Three common ways are (1) excess funds; (2) receipt of special gift(s) or bequests; and (3) budgeted reserves.

Excess funds: Although any reserve fund is technically made up of "excess funds," or funds that were deemed not necessary for the basic operation of an organization, in this case (1) a reserve may be created from excess holdings that have been accumulating for some time and were then moved to a special reserve account that had not existed before or (2) at the end of a budget year, your organization could move what you deem excess funds to a new account that then becomes your operating reserves. About 37.5 percent of organizational leaders in a recent study started their reserves this way, creating their reserves from several years of surplus or with excess revenue from a shorter period, twelve months or less. For example, the Barter Theatre was able to cut back effectively and take advantage of extra donor support during COVID-19 to create a reserve, noting that "prior to 2020, Barter really did not have such a reserve. With COVID assistance and outstanding patron support, Barter has been able to create a reserve that we hope we can keep.... Of course, this amount will always depend on what type of shows we set for the year and the associated costs."[23] The excess funds you identify may be a small amount at first, but after all, from small acorns mighty oaks grow. Just make sure you keep watering and nurturing it.

Receipt of special gifts/bequests: Although not necessarily common, some reserve funds are created because of a special donation or a bequest. Perhaps you can have a talk with a forward-thinking donor who might be interested in providing this long-term gift to your organization.

Budgeted reserve: Even if you lack a special windfall gift to establish your reserve, sometimes slow and steady can win the race. Some organizations successfully choose to create their operating reserve by strategically including the fund as an expense in their budgets, like the YART example from chapter 2. Then you don't have to hope for "extra" funds at the end of the year to put into the fund; those funds are in the regular budget.

Whatever route you choose to develop your reserve, you'll want to include your board in those decisions. Whether you start by having an ad hoc board committee study the issue, conduct meetings with staff, formulate a recommendation, and present it to the board, or you follow a less linear process, you should get the board's approval. This will help them not only see the need and rally behind you but also, hopefully, even become funders, supporters, and encouragers of such a fund.

MAINTAINING RESERVES

For organizations that have created a reserve, perhaps the most important question they can ask themselves is, How are those reserves being maintained? Not surprisingly, many organizations maintain their reserves the same way they were first created. Based on how organizations maintain their reserves, we identify four categories: *leftovers, replacers, holders,* and *budgeters*.

Leftovers: These organizations maintain reserves with leftover revenue, often moved at the end of the fiscal year. At times, this process can lead to a depletion or even elimination of the reserve if it had been tapped, often leaving only a hope that "good times" or another unexpected gift or bequest would allow for replacement or growth. Organizations that feel like they cannot possibly budget for a reserve might finish a year with some leftover funds they can take out of the operating account and move to a reserve account.

Replacers: Although similar to the leftovers, these organizations occasionally pay out from their reserves and then later try to replace at least a portion of it. Such executives try to put back at least as much as was pulled out and to replace it as soon as the money becomes available (when a grant or contract is paid, usually), not simply at the end of the budget cycle.

Holders: These organizations build up a sufficient reserve and then simply forget about it. They deliberately do not dip into the reserve on a regular basis, and they vow never to tap it unless they're facing an emergency. While they have confidence in their ability to face a crisis, holders need defined parameters for what constitutes an emergency to eliminate ambiguity about decisions.

Budgeters: Budgeters are those few who methodically maintain their reserves through a regular budgeting process. This process is our number one recommendation for establishing and maintaining a reserve. Some budgeters use their reserves periodically and use the reserve amount built into their budget as one way to ensure the presence of a reserve for future need. As one organizational leader said, "Contributing monthly . . . was the key to our success. . . . We actually started talking about it seven years ago. . . . And every year you just never quite had the returns you thought you were going to have. And so, it just didn't happen. And then once

we change into a defined percentage contribution and pay ourselves on a monthly basis, it's become like clockwork." Budgeters reported high levels of satisfaction with their process and confidence in the stability of the reserve over time.

UTILIZATION OF RESERVE FUNDS

How Are Operating Reserve Funds Accessed?

Although a small percentage of organizations with reserves have written policies in place to govern how reserve funds can be used and for what purposes, most organizational leaders would express accountability to expectations or accepted practices for their actions relative to accessing reserve funds. These expectations or practices fall into three models: board approval, contingent board approval, and executive director discretion.

Board approval: Within this scenario, the board must approve any usage of reserve funds. This model offers minimal executive director flexibility but maximum board oversight.

Contingent board approval: A more common model is contingent board approval, where executive directors have discretion to use funds up to a certain dollar amount or percentage of the reserve without board approval. If they wish to move beyond that threshold, board approval is required. Within contingent board approval, the board is consulted prior to spending reserve funds depending on the situation and how large the drawdown from the reserve would be.

Executive director discretion: Within the executive director discretion model, management has control over how and when to use reserve funds for organizational purposes, or the board is made aware of reserve usage but does not give formal approval for the transaction. This model offers maximum flexibility for the executive director but minimal board oversight, leaving the potential for great trouble and later contention.

The contingent board approval model offers more balance between executive flexibility and board oversight, but no clear boundaries exist regarding when it is appropriate to use the reserve, which could prove problematic for executive directors and boards. In such cases, and in other instances where policy has not been created even though the process is well understood by executives, a policy defining the usage and authorization of reserve withdrawals might prevent

future problems with the board and would eliminate uncertainty for nonprofit leadership when the need to use reserve funds arises.

How Are Operating Reserve Funds Used?

Why are operating reserves used? The question of which model to follow for authorizing withdrawal of funds from a reserve is not simply theoretical. Reasons for using the reserves fall into three broad categories: cash flow, government funding issues, and capital expenditures.

Cash flow: Just as all operating reserves could be labeled as excess funds, all expenditures related to the operating reserve could be listed as cash flow needs. If the extra cash flow were not needed, it is unlikely the reserve would have been tapped into in the first place. It is not necessarily unexpected that a nonprofit might find itself with a cash flow problem. One must question whether these boards are handling their fiscal oversight responsibilities well if the reserves are being tapped regularly. Such behavior also indicates a problem with the budgeting model these organizations are using.

Government funding issues: Some tap their reserves in response to issues related to government grants and contracts. The loss of a government grant or grants can cause organizations to have to shore up cash flow, and some tap their reserves on a constant basis for cash flow purposes due to the payment structure or delays often associated with governmental funding.

Capital expenditures: Some dip into reserves for capital expenditures. Most use it for things such as revamping existing structures or required heating, ventilation, and cooling equipment maintenance, or even to help with making a down payment for a new building. A better option, if possible, is to have a separate capital reserve for capital expenditures and keep the operating reserve for operating expenses.

Strategic initiatives: While it isn't reported as often, we'd like to encourage arts and cultural organizations to consider how a reserve might offer the ability to seize a strategic opportunity like a one-time capital expense, programmatic investment, or consultant for a specific organizational growth need. Of course, such a decision should be made (1) in deliberation and concert with your board, (2) with a predetermined plan to repay your reserve, and (3) in alignment with an identified strategic objective. While using funds from your reserves is certainly not

recommended as an ongoing or persistent practice, a strategic initiative that meets the criteria above could be achievable if your reserve is ready and available.

RECOMMENDATIONS FOR NONPROFIT LEADERS

Most arts leaders believe that having an operating reserve of some kind makes sense and is a best practice they wish to follow. Organizational leaders who perceive themselves as successful in creating, using, and maintaining reserves use several practices that may apply across a variety of arts and cultural organization types. As you consider your current reserves circumstances or the possibility of creating a reserve, we recommend the following:

- Consider which revenue streams or potential revenue streams are being used as a substitution or complement to operating reserves in their organization. Is this providing the greatest stability and flexibility for the organization? If not, action should be taken immediately to rectify the situation. The time to fix your roof is before the rain comes.
- Consider reserves as one of your overall financial resiliency strategies, which should also include revenue optimization, prudent fiscal oversight, and growth-minded management.
- Encourage your board to plan for and work toward building the appropriate amount of reserves for your organization. Restructuring organizational leadership, whether at the executive director or board chair level, often offers exciting opportunities for addressing reserves. Not only are changes more likely to be accepted and even expected because of the restructuring, but there is also usually a honeymoon period when ideas and policies are likely to find a more favorable reception than they would later. Newly placed leaders should maximize these opportunities to create reserves or define and refine policy regarding maintenance and utilization of reserves.
- Work with the board and staff to create a written policy defining how and when reserve funds can be used. Following more of a contingent board approval model, these policies should be broad enough to allow for some discretion by the executive but narrow enough to offer appropriate oversight and management of the reserve. The Nonprofit Operating Reserves Initiatives Workgroup offers an "Operating Reserve Policy Toolkit," and other organizations provide helpful sample operating reserves policies.

- Work with the board to make a deliberate plan to budget for a reserve, even if only a small but regular amount, to build and maintain the reserve fund. Although some executives may have the good fortune of a windfall gift or unanticipated financial gain, budgeting provides the most reliable form of creation and maintenance. For nonprofit leaders and their boards, an ongoing tension exists between addressing current needs to fulfill their missions and ensuring their long-term sustainability. Operating reserves offer a vital bridge between current and future needs, positioning organizations to weather financial storms and even take advantage of strategic opportunities. Arts leaders should critically assess their reserve levels and set a course for the strategic creation, maintenance, and use of these funds.

KEY TERMS

capital reserves
emergency cash
endowments
lines of credit
operating reserves
rainy day funds

QUESTIONS TO CONSIDER

What size operating reserve is appropriate for my organization? How many months in reserve are needed for an organization of this size?

If we have an operating reserve, is it unrestricted? Set aside for this specific purpose? Board designated?

If we do not have an operating reserve, how might we establish one? Budget for one? Maintain one?

Do we have policies in place to govern how we can utilize reserve funds?

ADDITIONAL READINGS

Grizzle, Cleopatra, Margaret F. Sloan, and Mirae Kim. "Financial Factors That Influence the Size of Nonprofit Operating Reserves." *Journal of Public Budgeting, Accounting and Financial Management* 27, no. 1 (2015): 67–97.

Irvin, Renée A., and Craig W. Furneaux. "Surviving the Black Swan Event: How Much Reserves Should Nonprofit Organizations Hold?" *Nonprofit and Voluntary Sector Quarterly* (November 2021). https://doi.org/10.1177/08997640211057405.

Nonprofit Operating Reserves Initiative Workgroup. "Maintaining Nonprofit Operating Reserves: An Organizational Imperative for Nonprofit Financial Stability." Nonprofit Accounting Basics (website). December 2008. https://www.nonprofitaccountingbasics.org/sites/default/files/01-OperatingReservesWhitePaper2009.pdf.

Sloan, Margaret F., Cleopatra Charles, and Mirae Kim. "Nonprofit Leader Perceptions of Operating Reserves and Their Substitutes." *Nonprofit Management and Leadership* 26, no. 4 (2016): 417–33.

Sloan, Margaret F., Cleopatra Grizzle, and Mirae Kim. "What Happens on a Rainy Day? How Nonprofit Human Service Leaders Create, Maintain, and Utilize Operating Reserves." *Journal of Nonprofit Education and Leadership* 5, no. 3 (2015): 190–202.

CHAPTER SIX

Spotting Opportunities or Trouble
Understanding Financial Statements

I call it the Rule of Three. If you read an organization's financial statements three times, and you still can't figure out how they make their money, that's usually for a reason.—JAMES CHANOS, president and founder of Kynikos Associates and noted art collector

LEADER TAKEAWAYS

After reading this chapter, you should be able to

- Introduce and define financial reports and discuss how they differ from annual reports and the IRS 990 form
- Discuss how to read the IRS 990 form and learn how to tell your organization's story through the narrative section of the IRS 990 form
- Understand the concept of generally accepted accounting principles (GAAP)
- Discuss the monetary unit assumption, objectivity principle, cost principle, going concern, conservatism, materiality, and accrual GAAP
- Understand how balance sheets, activity statements, and cash flow statements are developed and interact with each other
- Discuss various asset and liability categories typically found in arts nonprofit organizations

Many employees, managers, board members, and volunteers of arts and cultural nonprofits are intimidated by the prospect of managing the finances of their organization or program. In legal terms, of course, fiduciary responsibility lies with the board, yet it is imperative that everyone within the organization understands the basics of financial statements and knows what to look for to spot opportunities or trouble to maintain

organizational sustainability. The good news is that this information is easy to understand and well within the grasp of every key member of the organization. Unless you are an accountant, it is not necessary to know how to prepare financial statements. However, every key member of the organization should know how to read the financial reports prepared by the organization, including the IRS 990 form and the core financial statements.

This chapter discusses how financial statements differ from annual reports and the IRS 990 form, how to read the IRS 990 form, and what it means for an organization. After briefly introducing GAAP and the fundamental accounting equation, the chapter dives into the primary financial statements (balance sheet, cash flow statement, and activity statement) that arts nonprofits must prepare.

Annual reports are prepared to highlight a nonprofit organization's mission and impact, vision for the future, thank current volunteers and donors, and appeal to new donors and supporters. Annual reports are an essential tool for building donor trust. They typically include a letter from management/board, lots of photographs highlighting significant activities and accomplishments for the year, a list of major donors, and financial information, primarily on revenues and expenses, often in tables, figures, and other visually pleasing and easy-to-understand formats.

The **IRS 990 form** is an annual federal tax form required for all tax-exempt organizations (except religious organizations, churches, and political organizations) unless they make less than $200,000 in revenue and have less than $500,000 in **assets**, or items held by the organization that have value and can help pay bills or financial commitments. These smaller organizations have to file either 990-EZ or, if they make less than $50,000, a 990-N "ePostcard." As a manager of an art nonprofit, you must ensure that your organization's 990 form is posted online and made available immediately to anyone who requests it.

The focus of the IRS 990 form is legal compliance with the federal tax code; it isn't about whether an organization is fulfilling its mission, whether patrons are satisfied with its programming, or whether it is making good financial decisions. It records information on an organization's mission, programs, and finances and is a handy document for understanding and evaluating a nonprofit organization. Organizations that do not file the IRS 990 form for three consecutive years automatically lose their tax-exempt status. An automatic revocation is effective on the original filing due date of the third annual return or notice.[1]

Form 990 is necessary for the public disclosure of information about nonprofit organizations because the law does not require the type of annual report from nonprofit organizations that it does for a corporation. In addition, except

in special circumstances, a financial audit by an independent certified public accountant is not required by law. The IRS 990 form suffers from problems of timeliness, lack of verification, and bias, and the validity of IRS 990 data has been called into question by many nonprofit scholars.[2] Specifically, several measures commonly used for research and evaluation purposes, including total revenue and total salaries and wages, are often understated on the IRS return.[3] This problem occurs because 990 preparers either do not read the instructions or take liberties when deducting direct costs (intended to be narrowly defined) before calculating revenues from rents, sales of assets or of goods and services, and fundraising.[4]

To address these concerns with the 990 form, many states—including New York, through the state attorney general's office—require that nonprofits provide supplemental disclosures each year, including but not limited to audited financial statements. In addition, although nonprofit organizations are not legally required to prepare audited financial statements, many still do prepare them because of pressure from donors, clients, and watchdog groups like the Better Business Bureau and Charity Navigator, or just because it is good financial management practice.

HOW TO READ THE IRS 990 FORM

Figure 6-1 shows the first three pages of Form 990 for the Charles Center for Contemporary Art (henceforth CCCA) in Peekskill, New York. If we look at the first (initial) page of the 990, we see that this is the return for the calendar year 2022. Calendar year means January 1 through December 31 of that year. If the tax preparer leaves "calendar year or tax year" blank on the form, you can assume the organization works from a calendar year. If the organization has a fiscal year other than the calendar year, the preparer will fill in the months that the tax year begins and ends.

The initial page of Form 990 also includes the organization's current name and address. To the right of the name/address field is a box for the organization's EIN (employer identification number). This is a unique number assigned by the IRS to each organization, much like a person's Social Security number. Even if the organization changes its name, its EIN remains the same.

Just under the EIN box is a space for the organization's telephone number. We can also see that the CCCA is a 501(c)(3) formed in 2001 and registered in New York. This is important because only donations made to a 501(c)(3) organization are eligible for the charitable contribution deduction.

FIGURE 6-1. Form 990 for Charles Center for Contemporary Art

Form 990 (2022) Page **3**

Part IV Checklist of Required Schedules

			Yes	No
1	Is the organization described in section 501(c)(3) or 4947(a)(1) (other than a private foundation)? *If "Yes," complete Schedule A*	1	✓	
2	Is the organization required to complete *Schedule B, Schedule of Contributors?* See instructions	2		✓
3	Did the organization engage in direct or indirect political campaign activities on behalf of or in opposition to candidates for public office? *If "Yes," complete Schedule C, Part I*	3		✓
4	**Section 501(c)(3) organizations.** Did the organization engage in lobbying activities, or have a section 501(h) election in effect during the tax year? *If "Yes," complete Schedule C, Part II*	4		✓
5	Is the organization a section 501(c)(4), 501(c)(5), or 501(c)(6) organization that receives membership dues, assessments, or similar amounts as defined in Rev. Proc. 98-19? *If "Yes," complete Schedule C, Part III*	5		✓
6	Did the organization maintain any donor advised funds or any similar funds or accounts for which donors have the right to provide advice on the distribution or investment of amounts in such funds or accounts? *If "Yes," complete Schedule D, Part I*	6		✓
7	Did the organization receive or hold a conservation easement, including easements to preserve open space, the environment, historic land areas, or historic structures? *If "Yes," complete Schedule D, Part II*	7		✓
8	Did the organization maintain collections of works of art, historical treasures, or other similar assets? *If "Yes," complete Schedule D, Part III*	8		✓
9	Did the organization report an amount in Part X, line 21, for escrow or custodial account liability, serve as a custodian for amounts not listed in Part X; or provide credit counseling, debt management, credit repair, or debt negotiation services? *If "Yes," complete Schedule D, Part IV*	9		✓
10	Did the organization, directly or through a related organization, hold assets in donor-restricted endowments or in quasi endowments? *If "Yes," complete Schedule D, Part V*	10		✓
11	If the organization's answer to any of the following questions is "Yes," then complete Schedule D, Parts VI, VII, VIII, IX, or X, as applicable.			
a	Did the organization report an amount for land, buildings, and equipment in Part X, line 10? *If "Yes," complete Schedule D, Part VI*	11a		✓
b	Did the organization report an amount for investments—other securities in Part X, line 12, that is 5% or more of its total assets reported in Part X, line 16? *If "Yes," complete Schedule D, Part VII*	11b		✓
c	Did the organization report an amount for investments—program related in Part X, line 13, that is 5% or more of its total assets reported in Part X, line 16? *If "Yes," complete Schedule D, Part VIII*	11c		✓
d	Did the organization report an amount for other assets in Part X, line 15, that is 5% or more of its total assets reported in Part X, line 16? *If "Yes," complete Schedule D, Part IX*	11d		✓
e	Did the organization report an amount for other liabilities in Part X, line 25? *If "Yes," complete Schedule D, Part X*	11e		✓
f	Did the organization's separate or consolidated financial statements for the tax year include a footnote that addresses the organization's liability for uncertain tax positions under FIN 48 (ASC 740)? *If "Yes," complete Schedule D, Part X*	11f		✓
12a	Did the organization obtain separate, independent audited financial statements for the tax year? *If "Yes," complete Schedule D, Parts XI and XII*	12a		✓
b	Was the organization included in consolidated, independent audited financial statements for the tax year? *If "Yes," and if the organization answered "No" to line 12a, then completing Schedule D, Parts XI and XII is optional*	12b		✓
13	Is the organization a school described in section 170(b)(1)(A)(ii)? *If "Yes," complete Schedule E*	13		✓
14a	Did the organization maintain an office, employees, or agents outside of the United States?	14a		✓
b	Did the organization have aggregate revenues or expenses of more than $10,000 from grantmaking, fundraising, business, investment, and program service activities outside the United States, or aggregate foreign investments valued at $100,000 or more? *If "Yes," complete Schedule F, Parts I and IV*	14b		✓
15	Did the organization report on Part IX, column (A), line 3, more than $5,000 of grants or other assistance to or for any foreign organization? *If "Yes," complete Schedule F, Parts II and IV*	15		✓
16	Did the organization report on Part IX, column (A), line 3, more than $5,000 of aggregate grants or other assistance to or for foreign individuals? *If "Yes," complete Schedule F, Parts III and IV*	16		✓
17	Did the organization report a total of more than $15,000 of expenses for professional fundraising services on Part IX, column (A), lines 6 and 11e? *If "Yes," complete Schedule G, Part I.* See instructions	17		✓
18	Did the organization report more than $15,000 total of fundraising event gross income and contributions on Part VIII, lines 1c and 8a? *If "Yes," complete Schedule G, Part II*	18		✓
19	Did the organization report more than $15,000 of gross income from gaming activities on Part VIII, line 9a? *If "Yes," complete Schedule G, Part III*	19		✓
20a	Did the organization operate one or more hospital facilities? *If "Yes," complete Schedule H*	20a		✓
b	If "Yes" to line 20a, did the organization attach a copy of its audited financial statements to this return?	20b		✓
21	Did the organization report more than $5,000 of grants or other assistance to any domestic organization or domestic government on Part IX, column (A), line 1? *If "Yes," complete Schedule I, Parts I and II*	21		✓

Form **990** (2022)

| Form 990 (2022) | | | | | | | | | | Page 7 |

Part VII Compensation of Officers, Directors, Trustees, Key Employees, Highest Compensated Employees, and Independent Contractors
Check if Schedule O contains a response or note to any line in this Part VII ☐

Section A. Officers, Directors, Trustees, Key Employees, and Highest Compensated Employees

1a Complete this table for all persons required to be listed. Report compensation for the calendar year ending with or within the organization's tax year.

- List all of the organization's **current** officers, directors, trustees (whether individuals or organizations), regardless of amount of compensation. Enter -0- in columns (D), (E), and (F) if no compensation was paid.
- List all of the organization's **current** key employees, if any. See the instructions for definition of "key employee."
- List the organization's five **current** highest compensated employees (other than an officer, director, trustee, or key employee) who received reportable compensation (box 5 of Form W-2, box 6 of Form 1099-MISC, and/or box 1 of Form 1099-NEC) of more than $100,000 from the organization and any related organizations.
- List all of the organization's **former** officers, key employees, and highest compensated employees who received more than $100,000 of reportable compensation from the organization and any related organizations.
- List all of the organization's **former directors or trustees** that received, in the capacity as a former director or trustee of the organization, more than $10,000 of reportable compensation from the organization and any related organizations.

See the instructions for the order in which to list the persons above.

☐ Check this box if neither the organization nor any related organization compensated any current officer, director, or trustee.

(A) Name and title	(B) Average hours per week (list any hours for related organizations below dotted line)	(C) Position (do not check more than one box, unless person is both an officer and a director/trustee)						(D) Reportable compensation from the organization (W-2/1099-MISC/1099-NEC)	(E) Reportable compensation from related organizations (W-2/1099-MISC/1099-NEC)	(F) Estimated amount of other compensation from the organization and related organizations
		Individual trustee or director	Institutional trustee	Officer	Key employee	Highest compensated employee	Former			
(1) MARY RHEIN PRESIDENT	20			✓				0	0	0
(2) CONRAD RHEIN CHAIRMAN OF THE BOARD	1			✓				0	0	0
(3) ADAM RHEIN SECRETARY	1			✓				0	0	0
(4) ALLAN CHARLES	1	✓						0	0	0
(5) BERYL CHARLES	1	✓						0	0	0
(6) DAVID SLOAN	1	✓						0	0	0
(7) LOCH SLOAN	1	✓						0	0	0
(8) LI YAN	1	✓						0	0	0
(9) SUSIE PERRIER	1	✓						0	0	0
(10) LIDIA FRANCOIS	1	✓						0	0	0
(11) MARIANNA HUSZAR	1	✓						0	0	0
(12) VANI HUSZAR	1	✓						0	0	0
(13) ESZTER JOHN	1	✓						0	0	0
(14) BRAD JONES	1							0	0	0

Form **990** (2022)

Part I, on page 1, is divided into four subparts: Activities and Governance; Revenue; Expenses; and Net Assets/Fund Balance. The Activities and Governance section reports that CCCA's mission is "the development and presentation of new art exhibits that enrich the understanding of contemporary art." We also learn that CCCA has five employees, fifty volunteers, and a board with fourteen voting members, of which eleven are independent voting members.[5]

Part I, line 8 provides the total amount of contributions and grants the

organization received during the year. According to this return, the total amount of contributions or grants received by the CCCA during 2022 totaled $202,241.

Part I, line 15 provides the amount CCCA paid out ($155,554) in salaries, other compensation, and employee benefits. Lines 16a and 16b reveal that CCCA had no fundraising expenses for the year. From line 19 we learn that CCCA incurred a loss of $206,761 in fiscal year 2022.

Part I, line 22 informs us that CCCA had fewer liabilities than assets and ended the year with net assets of $1,876,324.

Many nonprofit organizations advocate for changes in public policy and as part of their advocacy efforts engage in lobbying. Organizations like CCCA that are exempt under Section 501(c)(3) are permitted to engage in some lobbying but may jeopardize their exempt status if they engage in too much lobbying. Part IV, line 4 informs us that CCCA did not engage in any lobbying during the fiscal year. Also, in part IV we learn that CCCA holds no assets in temporarily restricted endowments, permanent endowments, or quasi endowments.

Part VII of CCCA's Form 990 informs us that none of the organization's board members receive any compensation for their board work. In addition, CCCA reported that none of its key employees earned more than $100,000 in 2022.

TELLING YOUR STORY WITH IRS 990

As an arts organization, you can capitalize on the IRS compliance requirement of filing the IRS 990 form annually by using it to educate current and prospective donors and market your organization and its programs. Consider the following scenario:

Hudson Valley Dance Company has applied for a grant from the Sloan Family Foundation. The grant award selection process involves reviewing Hudson Valley Dance Company's most recent Form 990 to determine whether the mission and accomplishments of Hudson Valley's programs are aligned with the purposes of the foundation grants.

Many individuals, including prospective donors, board members, grantors, and volunteers, use Form 990 to perform due diligence in considering whether to devote precious time and resources to an organization. In fact, the 2022 instructions for Form 990 state, "Some members of the public rely on Form 990 or Form 990-EZ as their primary or sole source of information about a particular organization.[6] How the public perceives an organization in such cases can be determined by information presented on its return."

Today's donors demand much more than donors in the past did. Stories create emotion and have the power to create a connection. Today there is increased competition among nonprofits for a limited pool of donors and resources. Compared to other types of nonprofits, arts and cultural nonprofits are faced with different fiscal pressures: they must compete with society's more pressing needs, like education, health, and social well-being, for limited public support and with for-profit entertainment companies for audiences.[7] It is therefore particularly important for each art organization to be strategic in communicating its mission, marketing, and fundraising. Empowering young people to recognize their innate potential by offering creative and innovative programs that are financially accessible to all is important. That is your mission, the reason you exist, but without funding your organization will fold. Find a middle ground, and do not be afraid to shine a spotlight on your organization and the good work you do. Be the first to tell your story and do not wait until it is too late. Form 990 can be a powerful tool to attract and motivate donors and should be a key component of your overall communications plan.

Form 990 can give an external stakeholder a snapshot of the financial health, governance, and operations of your organization in one document, and it is important to tell the right story in the mission and program descriptions required on the Form 990. Use the narrative sections of Form 990 to market your organization to potential donors by telling a current, accurate, and compelling story about your organization. In the narrative sections, avoid using jargon or terminology that is unique to the nonprofit sector. Help donors connect the dots between the funding they provide for your theater and the results their donation is generating in real time. Merge performance measurement and storytelling to engage your audience, compel people to action, and offer concrete proof of your organization's programs and successes. Be proactive, not reactive. Write your own story. If you don't, others may do it for you.

GENERALLY ACCEPTED ACCOUNTING PRINCIPLES

In the United States, the Financial Accounting Standards Board (FASB), a privately funded organization, oversees the creation and governance of accounting standards for the nonprofit sector. **Generally accepted accounting principles (GAAP)**, created and managed by the FASB, are the rules and conventions used to prepare financial statements. Financial reporting has one primary objective: to provide useful information. Useful information must be relevant, complete, neutral, and free from error. GAAP is important and provides the rules that govern accounting, including these:

Monetary unit assumption: All items on a financial statement must be measured in a monetary unit. In-kind donations are one of the most confusing and challenging areas for nonprofit organizations, and frequently these groups fail to report in-kind contributions because they do not understand the rules. For example, the CCCA leases its exhibition and operations space and administrative offices from the Mary & Conrad Rhein Foundation. The CCCA cannot just put "donated office" on its financial statements. CCCA needs to estimate how much the space is worth in dollars and report that value in its financial statements. If we refer to the sidebar "In-Kind Contributions," we see that CCCA reports in-kind rent of $100,000 for 2022.

Objectivity principle: Monetary values must be independent, verifiable, and supported by an independent party with unbiased evidence. For example, if someone donates a truck to your organization, you can refer to the Kelley Blue Book (KBB) to help determine its value and report it as an asset. Similarly, if your organization invests in Tesla stocks, you will refer to the published market prices of those stocks. The KBB and the published market price of your organization's Tesla stocks are a source of objective evidence that will enable the organization to report market value.

Cost principle: This rule states that if there is no objective evidence about market value, you should report acquired assets and services at their original or historical cost.

Going concern: This rule assumes that the organization will continue to exist in the foreseeable future (usually one year from the balance sheet date).

Conservatism: This rule says that while every organization faces risks, it is better to be too pessimistic than too optimistic. For example, it is expected that not all accounts receivable will be collected—some will turn into bad debts. Conservatism says to reduce the reported amount of accounts receivable by the estimated amount that you could not collect. On the other hand, although the organization might not pay all its accounts payable, it should still report them all.

Materiality: This rule states that financial statements do not have to be precisely accurate and that one can fail to report a financial transaction or item if the net impact of doing so has such a small impact on the

financial statements that it would not mislead a reader of those financial statements. For example, CCCA does not have to count every paper clip in the office and assess its current market value.

Accrual: GAAP says that we should use **accrual accounting**, or accounting methods "where revenue or expenses are recorded when a transaction occurs versus when payment is received or made," for budgeting and financial reporting to measure an organization's profitability.[8]

Financial statements are the best source of information on the financial performance of your organization. They show you where your organization's money came from, where it went, and where it is now. As such, they ought to be comprehensible and must reflect the true financial picture of the organization. They should be all-inclusive in scope and embrace all activities of the organization and clearly show the relationship between funds without a lot of confusing detail. Financial statements should be prepared and presented in a timely fashion and may be audited by an external accounting firm or, in some cases, by the board to ensure accuracy.

Arts nonprofit organizations must prepare four primary financial statements at the end of the fiscal year: (1) a balance sheet, (2) a statement of financial activities or activity statement, (3) a statement of functional expenses, and (4) a cash flow statement. Let us look at each of the financial statements in more detail.

The **balance sheet** or **statement of financial position** provides a snapshot at a single point in time (such as a month or year) of what an organization owns, what an organization owes, and an organization's net worth. Think of a balance sheet as a bathtub. You turn on the faucet and add some water to take a bath. This process can be compared to financial resources being poured into your organization to provide goods and services. When the water becomes too cold, you may decide to let out the plug to drain some water. In the same way, financial resources would flow out of your organization as you incur costs to provide goods and services. The balance sheet measures how much water is in the tub at a specific point in time, usually at the end of the fiscal year.[9] Another way to think of a balance sheet is as a photograph or snapshot of your organization at one specific point in time, such as a month or a fiscal year.

A balance sheet has three main sections. **Assets** are anything of value your organization owns or controls, such as cash, endowment investments, property, and equipment. **Liabilities** are amounts or debts that your organization owes to others. Many liabilities have the word *payable* in their title: for example, accounts payable, notes payable, and salaries payable. **Net assets** are the difference between assets and liabilities. A financially sound organization has more assets than liabilities and will have positive net assets.

In-Kind Contributions

Commitments and Contingencies

CCCA leases its exhibition and operations space and administrative office from the Mary & Conrad Rhein Foundation Inc. ("the Foundation"). Mary and Conrad Rhein are founders and Board Directors of CCCA. Rent for 2022 and 2021 was $100,000 and $62,496, respectively, and the Foundation has agreed to forgive such rent subject to the maintenance by CCCA of its tax exemptions under Section 501(c)(3) of the Internal Revenue Code and CCCA's compliance with the remaining terms of the lease, among other things. Consequently, an in-kind contribution and related rent expense is recorded at $100,000 and $62,496 in 2022 and 2021, respectively.

The cost of the leasehold improvements included in property and equipment have been funded by unrestricted contributions by Mary and Conrad Rhein. Under the terms of the lease, such improvements will revert to the landlord upon termination of the lease.

CCCA receives a substantial amount of its support from Mary and Conrad Rhein and the Mary & Conrad Rhein Foundation, Inc., as follows:

	2022	2021
In-kind rent	$100,000	$62,496
Program expenses	$15,816	$16,612
	$115,816	**$79,108**

A significant reduction in this level of support, if this were to occur, may have an adverse effect on CCCA's programs and activities.

The **accounting equation** is a basic principle of accounting and a fundamental element of the balance sheet. The equation is as follows:

Assets = Liabilities + Net assets

(The left side of the equation must always equal the right side.)

Let us talk about each part of the Charles Center for Contemporary Art's balance sheet. There is no requirement for arts nonprofits to separate current assets from long-term assets on the balance sheet. However, some organizations do so to inform readers which of the organization's assets are readily available for current operations within one year of the balance sheet date. Current assets give us a good sense of CCCA's liquidity. Assets are always listed in liquidity order on the balance sheet. For example, cash and certificates of deposit (CDs) are the most liquid assets, while the prepaid expenses are the least liquid assets that the CCCA owns. It is essential to have some cash on hand to pay for day-to-day operations in case of an emergency and if a favorable investment opportunity arises. However, because cash does not further the mission of the CCCA, managers should ensure that the organization does not have too much cash on hand.

Current liabilities are what the CCCA owes in the short term, that is, within the next twelve months. Liabilities are listed on the balance sheet in order of how soon the organization must repay them: the sooner the organization expects to pay a liability, the higher it appears on the balance sheet.

Net assets are the difference between CCCA's assets and liabilities. We can rearrange the accounting equation to reflect this as follows:

Assets − Liabilities = Net assets

Net assets would remain if the CCCA sold all its assets and paid off all of its liabilities. Nonprofits are required to classify their net assets based on the existence or absence of **donor restrictions** (i.e., limitations made by a donor regarding how a donation can be used within your organization). In 2016 the FASB issued a new update on how nonprofit organizations were to classify their net assets in the statement of financial position. FASB Update No. 2016-14, which took effect in 2018, requires that nonprofits present on the face of the statement of financial position amounts for two classes of net assets at the end of the fiscal period.[10] Previously nonprofits had been required to report three classes of net assets, but now they report only two: net assets with donor restrictions and net assets without donor restrictions, as well as the currently required amount for total net assets.[11]

Net assets without donor restrictions are part a nonprofit organization's net assets that are not subject to donor-imposed restrictions. There are no limits on

how your organization can use those funds. Simply put, funds classified as net assets without donor restrictions can be used for any purpose within the organization: to pay salaries or utility bills, for example, or to buy costumes for the next dance production. Other net assets are subject to donor restrictions. The restriction requires that the donation be used for a specific purpose or within a particular period. For example, a donor may impose a restriction that their contribution is used in a specific fiscal year, or that the donation be used for purchasing art supplies and photography equipment for the organization's after-school program. Another donor may specify that their contribution is used only for scholarships for students who identify as Black, Indigenous, or people of color (BIPOC). Some arts organizations may raise funds in a capital campaign for necessary building renovations. In this case, the donations received would also be classified as net assets with donor restrictions, since a donor's intent would be to use the funds specifically for the building renovations.

It is crucial for an organization to identify donor intent at the time of donation to determine whether a restriction exists and ensure that the funds are classified correctly. When the restriction period runs out on net assets with donor restrictions, the organization must transfer those assets into the net assets without donor restriction section of the balance sheet. This type of transaction, known as reclassification, should be reported separately from other transactions during the fiscal year.

Nonprofits can continue to track internally restricted assets like endowments that are restricted in perpetuity in separate funds. Most true endowments are designed to keep the principal, or original donation, intact, while allowing the organization to use the annual investment income generated for purposes and programs specified by the donor. If the donor does not articulate a specific purpose, the board of directors may decide how to use the investment income. In the end-of-fiscal-year financial statements, all revenue, including the endowment, has to be divided between net assets with donor restrictions and net assets without donor restrictions. If your organization has an endowment, we strongly recommend that you also develop an investment policy to govern how the endowed assets should be invested.

Sometimes the board of directors may designate funds for a specific program or purpose. One common misconception is that board-designated funds are restricted assets. They are not, since the board can only designate unrestricted funds; a donor is the only one who can restrict a contribution.

The **activity statement**, also called the **statement of activities, statement of support**, or **income statement**, provides information on an organization's revenues and expenses and tells us what happened between two balance sheets.

TABLE 6-1. Charles Center for Contemporary Art Statement of Financial Position, December 31, 2021 and 2020

	2021	2020
ASSETS		
Cash	$ 613,193	$ 41,075
Certificates of deposit	595,216	141,730
Marketable securities	7,531	7,532
Pledges and other receivables	2,390	15,000
Prepaid expenses and other	12,500	9,370
Property and equipment, net of accumulated depreciation	101,984	629,880
Art collection	1,154,890	1,154,890
Total Assets	**2,487,704**	**1,999,477**
LIABILITIES AND NET ASSETS		
Liabilities		
Accounts payable and accrued expenses	54,511	50,898
Total Liabilities	**54,511**	**50,898**
Net Assets		
Unrestricted	2,433,193	1,948,579
Total Net Assets	**2,433,193**	**1,948,579**
Total Liabilities and Net Assets	**2,487,704**	**1,999,477**

The activity statement shows how an organization's net assets change over time, increasing as revenue comes in and decreasing as expenses are paid. If you recall the bathtub we discussed earlier, in the balance sheet section, we can think of the activity statement in the following way: you measure how much water is in the bathtub on the first day of this year (last year's balance sheet), then you measure all the water that flows into and out of the tub during the year (this year's activity statement), and then you calculate how much water is in the bathtub on the last day of the year (this year's balance sheet).

The activity statement equation can be defined as

Revenues and support − Expenses = Change in net assets

Like the assets section of the balance sheet, the activity statement distinguishes between restricted net assets and unrestricted net assets. Let us examine the statement of activities for the CCCA (table 6-2).

TABLE 6-2. Charles Center for Contemporary Art Statement of Activities Year Ended December 31, 2021, with Comparative Totals for 2020

	2021	2020
SUPPORT AND REVENUE		
Contributions and grants	$ 296,473	$ 186,585
Special event net of direct expense	527,150	—
Tours, admissions, and education	8,054	13,154
Memberships	5,568	2,942
Unrealized appreciation of marketable securities	—	3,007
Interest income	684	566
Insurance recovery	—	—
Total Support and Revenue	837,929	206,254
EXPENSES		
Program services	328,162	358,571
Supporting services	25,153	42,562
Total Expenses	353,315	401,133
Change in Net Assets	484,614	(194,879)
Net Assets, beginning of year	1,948,579	2,143,458
Net Assets, end of year	2,433,193	1,948,579

Look at the format: Support and Revenue, Expenses, and Change in Net Assets. The organization incurred a deficit in 2020 but recorded a surplus in 2021. The CCCA does not report any restricted net assets. Support and revenues are broken down into the following categories: contributions and grants; special events; tours, admissions, and education; memberships; unrealized appreciation of marketable securities; interest income; and insurance recovery. Note that direct expenses are netted out of the special event's revenue to show that CCCA did not receive the full amount of special events revenue earned. Expenses include two familiar categories: program services and supporting services. We will look at CCCA's statement of functional expenses (table 6-3) to gain further insight into the various categories of expenses.

The **statement of functional expenses** shows the readers of your financial statements (donors, board members, auditors, and other interested parties) the balance your organization maintains between funding programs—that is, fulfilling your mission and running the day-to-day operations. I am sure that many

TABLE 6-3. Charles Center for Contemporary Art Statement of Functional Expenses Year Ended December 31, 2021, with Comparative Totals for 2020

	Program Services	Support Services	Total Expenses 2021	Total Expenses 2020
Salaries	$56,543	$9,977	$66,520	$78,284
Payroll taxes and benefits	8,086	1,427	9,513	12,260
Art exhibitions and installations	7,900	—	7,900	33,974
Events, meetings, and program costs	3,722	—	3,772	18,576
Publicity and marketing	23,292	—	23,292	33,238
Consultants and professional fees	28,406	6,009	34,415	45,341
Rent	97,000	3,000	100,000	62,496
Utilities and fuel	23,619	731	24,350	25,485
Repairs and maintenance—facilities	20,974	649	21,623	25,337
Depreciation	25,444	787	26,231	26,909
Insurance	13,213	695	13,908	16,670
Supplies and office expenses	10,732	933	11,665	7,679
Telephone and internet	5,951	313	6,264	2,863
Equipment repairs and maintenance	3,230	170	3,400	12,021
Other	—	462	462	—
Total Expenses	328,162	25,153	353,315	401,133

of you have been told that an appropriate program services to administrative services ratio is 3:1. We believe that no one ratio works for every organization, and you need to decide for your organization what works best. On the one hand, your administrative expenses should not be highly out of proportion to your program expenses. On the other hand, you should not push your administrative services so low that you have trouble attracting competent, qualified staff to your organization.

Some of the categories of expenses in CCCA's statement of functional expenses include salaries, rent, insurance, publicity and marketing, and telephone and internet. In 2021, CCCA spent 7 percent of its total expenses on overhead expenses (support services). This number is an anomaly among arts organizations but is perfectly acceptable for CCCA.[12] CCCA has many volunteers, including members of the board of trustees who make significant contributions of time to CCCA policies and programs. These contributed services do not meet the criteria for recognition contained in GAAP and, accordingly, are not

reflected in the statement of activities. In addition, CCCA receives a substantial amount of its support from Mary and Conrad Rhein (founders of CCCA and members of the board of trustees) and the Mary & Conrad Rhein Foundation.

The **cash flow statement** shows cash inflows and cash outflows for an organization during the year. The cash flow statement tracks an organization's cash and shows where the organization received cash and how the organization spent cash during the year. The activity statement focuses on earning revenues and using resources and tells us about the organization's profits or losses during the fiscal year. Still, because it is prepared using the accrual basis of accounting, we cannot tell whether the revenues have been collected or the bills have been paid. Similarly, if an organization invests in a new capital asset like a building, the total investment does not show up on the activity statement but will show up on the cash flow statement because the investment is a cash flow. Similarly, the borrowing and repaying of funds do not show up on the activity statement, because they do not directly affect profits, but they will show up on the cash flow statement, because they affect liquidity.

CCCA's cash flow statement (table 6-4) has three main categories: operating cash flows, investing cash flows, and borrowing or financing cash flows. In 2021, CCCA began the year with $41,075 in cash. CCCA received cash from pledges and other receivables. Cash from operating activities in 2021 was positive, which is always a good sign for an organization. CCCA reported no cash flow activity under the category of borrowing or financing in 2021. Investing cash flows for 2021 were positive; CCCA purchased some property and equipment and received some proceeds from certificates of deposit. The net increase in cash at the end of the year was $554,141, and CCCA ended 2021 with $595,216 in cash.

CONCLUDING THOUGHTS

In this chapter we have introduced several important financial documents that managers in arts nonprofits should be familiar with, like the annual report, IRS Form 990, and financial statements. We have also introduced the concept of generally accepted accounting principles and introduced financial statements. Financial statements are one of the primary ways (though not the only way) that you can determine how successful your organization has been in fulfilling its mission.

As an arts leader, you will probably not be the one preparing the financial statements. However, you need to understand how they work and how the statements are linked together. This will help you spot any red flags and allow you to

TABLE 6-4. Charles Center for Contemporary Art Statements of Cash Flows Years Ended December 31, 2021 and 2020

Cash Flows from Operating Activities	2021	2020
Change in net assets	$484,614	$(194,879)
Adjustments to reconcile change in net assets to net cash provided by operating activities:		
Depreciation	26,231	26,909
Unrealized appreciation of marketable securities	—	(3,007)
Decrease (increase) in:		
Pledges and other receivables	2,500	97,063
Prepaid expenses and other	6,980	(100)
Increase (decrease) in:		
Accounts payable and accrued expenses	3,613	(15,428)
Net cash provided by (used in) operating activities	523,938	(89,442)
Cash flows from investing activities:		
Proceeds from certificates of deposit	39,747	49,726
Purchases of property and equipment	(9,544)	—
Net cash used in investing activities	30,203	49,726
Increase (decrease) in cash	554,141	(39,716)
Cash, beginning of year	41,075	80,791
Cash, end of year	595,216	41,075

be proactive in preventing fraud and fiscal mismanagement. In chapter 9 we will learn how to understand what the data in the financial statements are telling us and discuss some of the financial tools that you will need to interpret the data in your organization's financial statements for your external and sometimes internal stakeholders.

KEY TERMS

accounting equation
accrual accounting
assets
balance sheet
cash flow statement

donor restrictions
generally accepted accounting
 principles
going concern
income statement

IRS 990 form
liabilities
net assets
statement of activities

statement of financial position
statement of functional expenses
statement of support

ADDITIONAL READINGS

Lang, Andrew S., William D. Eisig, Lee Klumpp, and Tammy Ricciardella. *How to Read Nonprofit Financial Statements: A Practical Guide*. Hoboken: John Wiley & Sons, 2017.

Reck, Jacqueline L. *Accounting for Governmental and Nonprofit Entities*. New York: McGraw-Hill, 2022.

CHAPTER SEVEN

Managing the Audit and Selecting an External Auditor

The auditor is a watchdog, not a bloodhound. —UNKNOWN

LEADER TAKEAWAYS

After reading this chapter, you should be able to

- Define what an independent audit is and what it is not
- Determine whether your organization needs an independent audit
- Discuss the role of the board and staff in the audit process
- Better manage the audit process and follow best practices for a successful audit, including choosing an auditor, understanding the Auditor's Report, and working with your board audit committee

Mary Finkle had no prior nonprofit experience before joining the Kingstown Arts Council, a nonprofit organization responsible for the day-to-day financing of the Kingstown Community Theater, as artistic director. The audit ended up taking up a lot of her time (including having to add up nickels and dimes from candy bar concession sales). She "never really felt like she had a good process"—every year she went through a different set of steps and yearned for a plan telling her what she needed to track for the audit and how to make the process more seamless. She tracked ticket sales, memberships, rentals of their space, concessions, inventory, and how many people came to the theater in a year, and she needed to know the estimated tax the organization would have had to pay the city if it was a for-profit organization. She encountered many problems: marrying different spreadsheets and software, revenue systems, point of sale (tickets). It was a very time-consuming process, especially because the systems used in the organization were constantly changing, and often the new systems did not sync with old ones. The organization used the cash method of accounting rather than

the recommended accrual method. They did, however, use an external auditor. The organization primarily used QuickBooks, but only the executive director and auditor had access to QuickBooks. Mary and the executive director would meet to marry the information she had been diligently collecting, and then the executive director would send it to the auditor. The entire audit process was stressful, and Mary felt overwhelmed most of the time.

Audit requirements for arts nonprofits will vary by state and by the nature and size of revenue. Some states will require arts nonprofits to submit copies of their audited financial statements during registration as a charity in that state, or to be able to solicit charitable donations in the state. Audit requirements can also vary based on either total revenue or total charitable contributions collected during a fiscal year. For example, Missouri, Montana, and Nebraska have no state law audit requirement for charities registered in those states.[1] In New Jersey, however, the annual financial report of every charitable organization that received gross revenue in excess of $1 million in monetary donations during its most recently completed fiscal year must be accompanied by (1) a financial statement prepared in accordance with generally accepted accounting principles that has been audited in accordance with generally accepted auditing standards by an independent certified public accountant; and (2) any management letters prepared by the auditor in connection with the audit commenting on the internal accounting controls or management practices of the organization.[2]

Regardless of your state's rules, we highly recommend that any arts nonprofit organization that handles sizable financial resources each year have an independent financial audit performed regularly by an external auditor or auditing firm. An independent financial statement audit is the authentication of an organization's financial records, internal controls, financial transactions, and accounting practices by an independent certified public accountant (CPA). The word *independent* here means that the CPA is not an employee of the organization undergoing the audit but is retained externally through a contract describing the audit's purpose and scope.

An auditor's task is to express an opinion as to whether the financial statements present fairly, in all material respects, the financial position of the organization in conformity with generally accepted accounting principles in the United States. A common misconception is that the purpose of an audit is to "clean up" an organization's books; however, that task needs to be completed *before* the audit commences so that the auditors can adequately test ending balances and form an opinion.[3] The purpose of an audit is not to uncover fraudulent activity and embezzlement, and in fact audits rarely detect fraud. **Independent audits** or **external audits** are audits conducted by qualified public

accountants outside your organization. They can help inspire and maintain donor trust because they provide external validation that the organization is committed to financial transparency and accountability.[4] In addition, audited financial statements enhance the confidence of the board of directors in the organization's finances because they are based on an analysis by an objective and independent third party.[5]

Before hiring an auditing firm or even before starting the auditing process, the board of directors should evaluate the benefits to be derived from an audit and the costs associated with performing an independent or external audit. Audits are not free, can be a significant expense, and can run into the tens of thousands of dollars depending on the scope of the audit and the size of the organization. There are several benefits that can be derived from performing an external audit. For example, the external auditor can help the organization meet tax reporting and compliance requirements. The external auditor can also provide professional advice on internal controls and administrative efficiency as well as professional assistance in developing meaningful financial statements. In addition, an external audit can increase the credibility of the organization's financial statements if the organization receives an **unqualified opinion**, an independent auditor's opinion noting that an organization's financial statements are fairly and appropriately represented in compliance with generally accepted accounting principles in all material aspects.

Recently, there has been an increasing trend for smaller nonprofits to undergo a remote audit, which is generally more time and cost efficient, and we expect this trend to continue and become more widespread. Especially for small arts nonprofits, where space is a valuable commodity, having an auditing team on-site for days can be less than ideal for both parties. Imagine a senior accountant performing an audit on-site at a dance studio, for several days, in a tiny cubicle with poor internet connectivity and the constant sounds of dance music and tap shoes.[6]

For very small arts nonprofits there are alternatives to an independent audit that can be explored and will suffice in allowing the organization to responsibly manage its finances at a substantially lower cost. These include a financial statement review or compilation. A **compilation** is a summary of an organization's financial statements written by a CPA. It provides no assurances that the financial statements accurately represent the financial position of the organization. A **financial statement review** is an examination of an organization's financial statements and records also prepared by a CPA but focusing primarily on analytical processes and assessment of management. It is narrower in scope than an independent audit and provides limited assurances that the financial statements

accurately represent the organization's financial position. The National Council of Nonprofits explains the major differences between a financial statement review, compilation, and audit as follows:[7]

1. During an independent audit the auditor collects and examines canceled checks and bank statements and also examines the nonprofit's internal controls that are used to manage the risks of embezzlement and fraud, whereas in a compilation the auditor does not do that.
2. When conducting a compilation, the auditor will only reformat the financial statements to meet GAAP requirements, while in a financial statement review, the auditor will also decide whether the account balances are reasonable by comparing them to his or her expectations.
3. At the end of an independent audit, the auditor will provide an opinion or assurance on whether the financial statements accurately reflect the financial position of the nonprofit organization. In the report after conducting a compilation, the auditor will not provide any opinion or assurance.

It is important that arts nonprofits recognize that although reviews and compilations are acceptable under certain circumstances and are preferable to doing nothing, they are not substitutes for an independent audit and will not meet any of the legal requirements of an independent audit.[8]

WHY AUDITS ARE IMPORTANT

Even if state or federal legal requirements do not apply to a particular arts organization, there are many reasons that such an organization would still decide to get an external financial audit. Most arts nonprofits are small and have a small staff performing all duties, resulting in a lack of checks and balances. Frequently many staff members in arts organizations lack financial expertise. When resources are scarce, as is often the case in arts nonprofits, the creative process tends to dominate, and computer and accounting software and services do not get the attention and financial support they deserve. In addition, members of the board of directors who are volunteers are more likely to focus on other aspects of the organization and are likely to not be fully engaged in the financial management of the organization.

An independent audit can signal a nonprofit's commitment to financial transparency, invoke trust from donors, and assure them that the nonprofit's financial statements are accurate and meet acceptable standards. Charity Navigator and other charity watchdog organizations consider whether a nonprofit organization has an annual independent audit during the charity rating process. An

external financial audit can therefore help boost the rating of an arts nonprofit, which can hopefully translate into more donations. Finally, many foundations and government agencies require that nonprofits undergo an independent audit and submit audited financial statements to be eligible for funding. Conducting independent financial audits regularly is good financial management practice for all arts nonprofits. We encourage arts nonprofits to follow state legal requirements and consult and seek guidance from professionals like accountants and lawyers who are familiar with your organization when deciding whether to undergo an independent audit.

THE AUDIT COMMITTEE

We recommend that every art nonprofit organization that raises funds from the public and or receives grants or membership dues have an active and functioning **audit committee** that provides oversight in the audit process. Sometimes the audit is a subcommittee of the board's finance committee. The audit committee should comprise three to five members. The Nonprofit Law Blog, in its recommendation for the composition of an audit committee, states that the audit committee cannot include the board's president or treasurer and should remain independent of the board as a whole; that the audit committee should not include anyone employed by the nonprofit organization or the firm performing the audit; and that the audit committee members should avoid all conflicts of interest.[9]

The audit committee should be responsible for recommending the appointment of the external auditor/auditing firm and be able to discuss the firm's work with the assigned auditors. In addition, the audit committee should be responsible for reviewing and evaluating any reports prepared by the external/independent auditor that contain recommendations for improvements in financial controls. Further, the audit committee should review the annual financial statements with the external auditors and be able to answer any clarifying questions they may have about the statements. Finally, the audit committee should be responsible for addressing all complaints about financial mismanagement as well as identifying, communicating, and addressing risk management issues that may arise during the fiscal year.

HOW TO SELECT AN INDEPENDENT AUDITOR

The independent auditor/auditing firm should have experience in the area of nonprofit accounting and auditing. In addition, the firm should have prior experience with similar arts nonprofit organizations (size, scope, etc.). It is extremely

important that the independent auditor/s be able to relate well to and work effectively with the staff of the nonprofit organization. The firm should have adequate resources to enhance its ability to respond quickly, effectively, and competently to the organization's needs. The size of the auditing firm is also important and is a good indicator of whether the firm has enough personnel to dedicate to the audit. This ensures continuity of the staff assigned to the audit. Use a request for proposals process (RFP) seeking multiple bids. The fees charged should be competitive and affordable. Request a proposal letter from qualified CPA firms. In your RFP, be very clear about the audit's objectives, time frame, and scope. Pay attention to the approach that the auditing firm or auditor uses in auditing and what value they can add to the organization beyond technical compliance. Create a shortlist and meet with the firms or auditors on that list before committing to one firm. Do not forget to ask for references from nonprofit organization clients, preferably organizations that are like your organization in terms of scope and size. Finally, make sure you have a signed contract that details, at a minimum, the full scope, objectives, and purpose of the audit; the audit schedule and deadlines; the audit cost; and management responsibilities. We recommend seeking the advice of legal counsel if possible before signing the contract.

GETTING READY FOR THE AUDIT

Once you have selected the independent auditor and both parties have signed the contract, it is time for your organization to prepare for the actual audit process. The first step is ensuring that all the organization's accounting and financial records are accessible, updated, accurate, and organized. You should be able to produce and provide the auditors with financial documentation for all material financial events that occurred in the organization during the past fiscal year. Ask the auditors beforehand what format they want to receive requested documentation (i.e., electronic copies or hard copies) and have them ready, as this can help make the process more efficient and reduce costs to your organization. We recommend meeting with the auditing team before the audit commences. Have the audit committee, the chairman of the board or a board representative, and all staff responsible for assisting the auditors present at that pre-audit meeting.

The Role of the Chief Financial Officer or Financial Manager

The role of the financial manager is to provide leadership, education, and assistance for the objective financial management of the arts nonprofit organization. The financial manager in smaller organizations or the chief financial officer

(CFO) in larger organizations will provide and maintain the official accounting systems and records and related systems of internal control. The financial manager should establish and maintain accountability for the organization's assets and for all financial resources received and used during the fiscal year. In addition, the individual in this role will manage and disburse the financial resources of the organization while following all applicable restrictions, policies, laws, and regulations.

The financial manager should follow fund accounting rules and classify revenues and expenses accurately in line with Financial Accounting Standards Board rules. Financial managers are also responsible for maintaining the general ledger and retaining all source documents pertaining to cash receipts and cash disbursement during the fiscal year. It is also the responsibility of the financial manager or CFO to produce all relevant financial reports and statements in a timely manner, ensure that these statements are useful, and present and review these statements with the board. We strongly recommend that all arts organizations conduct an annual **internal audit,** an audit led by the financial manager or CFO to determine whether or not the organization conducts a formal independent audit. The financial manager or CFO will play a leading role in directing the staff as the organization prepares for the audit to ensure that the process goes as smoothly as possible.

The Role of the Staff

The staff is not only responsible for preparing the organization before the audit process begins but is also expected to fully cooperate with the auditors during the audit process, fully support the audit committee's work, and respond promptly to any requests for supporting or clarifying information during the audit process. The auditors are external and need staff support to locate and verify information and documents. Managers and program heads need to set the right tone within the organization, let staff know how important the audit process is, and remind them that it is a top priority to assist the auditors by promptly producing any requested information and documentation. We recommend that the organization refrain from scheduling any other major events (e.g., fundraisers) while the auditors are conducting the audit. If possible, appoint one staff member to be the point person during the audit process to coordinate logistics for the auditor's site visit.

The Role of the Board

In the absence of an audit committee, the board as a whole is responsible for oversight of the organization's accounting functions and the performance of the

independent auditor during the audit process. This is an important part of the board's fiduciary responsibilities to the organization.

Role of the Audit Committee

Audit committees are an essential component of good governance. However, for small arts organizations it is not always feasible to have separate board committees like an audit committee or finance committee. In situations like this, it is acceptable to have the board as a whole provide oversight for the independent audit process. Whether oversight is provided by a separate audit committee or the board as a whole, the ultimate goal is to ensure auditor independence and avoid any conflict of interest. The audit committee in larger arts organizations serves in an oversight role. Members of the audit committee should be financially literate, and at least one member should be designated as a financial expert.[10]

In large arts organizations the audit committee may also coordinate, monitor, and work closely with the staff as they prepare for the independent audit. In some organizations, the audit committee may also play an influential role in deciding which auditor or auditing firm will be hired, evaluating the audit process, presenting the auditors' findings to the board, and making sure that the full board understands any recommendations made by the auditors before formally accepting the audit report.[11] The audit committee also recommends best practices that the organization can adopt to strengthen its internal controls and proactively take steps to prevent fiscal mismanagement.[12]

In some arts organizations the audit committee is responsible for ensuring that all complaints about unethical and illegal conduct are investigated and resolved promptly and with no retaliation against the individual making the complaint. In arts organizations where the audit committee takes on the role of ombudsperson, it is imperative that the audit committee advise the executive director and board of directors of all complaints and their resolutions and report to the treasurer or finance committee at least annually on compliance activity relating to impropriety and fiscal mismanagement.

AFTER THE AUDIT

So you have survived the auditor's site visit. What comes next for you and your organization and is the auditing process over? After the site visit, the auditor will provide the organization with a draft audit report. It is the responsibility of the executive director, chief financial officer, and other finance staff, as well as the audit committee if there is one, to review the draft report, ask any clarifying

questions about the findings, and evaluate any recommendations before presenting the final audit report to the board.

The final audit report contains a formal opinion stating the auditor's conclusions regarding fair representation of the nonprofit's financial statements. The basic elements of an auditor's report can be seen below, in sidebar 7-1, and must include the following:

- A title that includes the word *independent*
- The name of the nonprofit being audited
- The name, address, and contact information of the auditor or auditing firm
- The signature of the auditor
- The date of the auditor's report
- A section with the heading "Management's Responsibility for the Financial Statements"
- A section with the heading "Auditor's Responsibility"
- A section with the heading "Opinion"

The most common type of report issued by an auditor is an **unqualified opinion**, which signals that the organization's financial statements provide an accurate representation of its financial position and comply with generally accepted accounting principles (GAAP) in all material aspects. This is the type of audit you should aspire to receive from your independent auditor.

A **qualified opinion** signals that the financial statements have compliance or financial issues that materially affect the organization's financial position. One reason a nonprofit organization may receive a qualified opinion is its failure to comply with GAAP.

An **adverse opinion** is unusual and very serious: it means that the independent auditor cannot be confident in the accuracy of the financial statements. In this case the auditor would express a professional opinion that the organization's financial statements are "not a fair representation of the organization's financial position."

THE AUDITOR'S REPORT: AN EXAMPLE

Let us now examine the independent auditor's report for Sloan Center for Contemporary Art for fiscal year 2021. The first section, also called the introductory section, usually explains what the auditor was hired to do and points out that management holds ultimate responsibility for the contents of the organization's financial statements.

Unqualified Opinion on Small Arts Nonprofit Organization

Cleopatra Rhein
Certified Public Accountant
P.O. Box 000
Peekskill, NY 10566
Phone: (914) 000 0000 — Email: CRhein@internet.com

INDEPENDENT AUDITORS' REPORT

To the Board of Trustees
Sloan Center for Contemporary Art

Report on the Financial Statements

I have audited the accompanying financial statements of Sloan Center for Contemporary Art which comprise the statements of financial position as of June 30, 2021 and 2020, and the related statements of activities and change in net assets, functional expenses, and cash flows for the years then ended, and the related notes to the financial statements.

Management's Responsibility for the Financial Statements

Management is responsible for the preparation and fair presentation of these financial statements in accordance with accounting principles generally accepted in the United States of America; this includes the design, implementation, and maintenance of internal control relevant to the preparation and fair presentation of financial statements that are free from material misstatement, whether due to fraud or error.

Auditors' Responsibility

My responsibility is to express an opinion on these financial statements based on my audit. I conducted my audit in accordance with auditing standards generally accepted in the United States of America. Those standards require that I plan and perform the audit to obtain reasonable assurance about whether the financial statements are free from material misstatement.

An audit involves performing procedures to obtain audit evidence about the amounts and disclosures in the financial statements. The procedures selected depend on the auditor's judgment, including the assessment of the risks of material misstatement of the financial statements, whether due to fraud or error. In making those risk assessments, the auditor considers internal control relevant to the entity's preparation and fair presentation of the financial statements in order to design audit procedures that are appropriate in the circumstances, but not for the purpose of expressing an opinion on the effectiveness of the entity's internal control. Accordingly, I express no such opinion. An audit includes evaluating the appropriateness of accounting policies used and the reasonableness of significant accounting estimates made by management, as well as evaluating the overall presentation of the financial statements.

I believe that the audit evidence I have obtained is sufficient and appropriate to provide a basis for my opinion.

Opinion

In my opinion, the financial statements referred to above present fairly, in all material respects, the financial position of Sloan Center for Contemporary Art as of June 30, 2021 and 2020, and the changes in its net assets and its cash flows for the years then ended in accordance with accounting principles generally accepted in the United States of America.

Cleopatra Rhein, CPA
June 29, 2022

The second section details the scope of the work the auditor was hired to do and usually explains what the auditor did to ensure that the financial statements are in compliance with GAAP.

The third section is the most important section for our purposes when doing a financial statement analysis and provides the auditor's opinion. Sloan Center receives an unqualified opinion from the auditor: "In my opinion, the financial statements referred to above present fairly, in all material respects, the financial position of Sloan Center for Contemporary Art as of June 30, 2021 and 2020, and the changes in its net assets and its cash flows for the years then ended in accordance with accounting principles generally accepted in the United States of America."

MANAGEMENT LETTER

This final audit report should also include the **management letter**, or "letter to those charged with governance," which identifies any areas of operations or procedures: for example, "material weaknesses" in internal controls that the auditors were concerned about and would like your organization to improve or redesign. Hopefully when your organization selected an auditor or auditing firm you selected an auditor with prior experience auditing arts nonprofit organizations specifically. This will ensure that your auditors are aware of best practices in arts nonprofit organizations and can point those out in the letter to management. Before the letter to management is finalized, it is prudent to have the audit committee or other relevant staff review a draft of the letter to ensure its accuracy before the board receives the final version. Once the letter is finalized, the auditors should make a formal in-person presentation to the board before concluding the audit process. During the meeting the board will vote to formally accept the auditor's report and the letter to management.

The National Council of Nonprofits notes that the issues that auditors point out in the management letter tend to fall into two broad categories: (1) material internal control issues, of which the most common deals with how a nonprofit recognizes and classifies its revenue; and (2) operating inefficiencies, which are issues that are or could become red flags in the future.[13] Recognition and classification of revenue is one of the most challenging aspects of arts nonprofit accounting. To avoid any issues down the road, we recommend first documenting everything in a written format. Confer with donors or grantors to ensure that there is no miscommunication about the use of revenue, detail the use restrictions if any exist, and establish a timeline stating clearly when your organization will have access to the revenue. Based on your conversations with donors or grantors, clearly communicate to all employees in writing the requirements for properly classifying and recognizing the donation or grant.

Many arts nonprofit organizations operate in a small environment, making it extremely challenging to establish proper segregation of duties, which is one of the most important factors when developing strong internal controls. We provide a more detailed discussion of accountability and governance in chapter 10 and preventing fraud and abuse in chapter 11.

CONCLUDING THOUGHTS

One fascinating finding from academic literature is that donors are willing to give more to charities aligned with a quality auditor and are more sensitive to changes in reported accounting information verified by a high-quality auditor.[14]

Similarly, Erica Harris, Christine Petrovits, and Michelle Yetman find that better governance, measured by an organization with a single audit or financial review conducted by an independent auditor and with an audit committee that oversees the financial reporting process, is associated with more donations.[15] Having an audit committee in place is considered a best practice in the nonprofit sector. An audit committee can identify and manage risks as well as ensure that proper financial management policies are in place in the organization.[16] The audit committee's duties include hiring, evaluating, and working with both external and internal auditors.[17] The rigors of an independent audit may instill greater discipline in the financial operations of the organization, since the external auditor not only provides firsthand knowledge about antifraud measures but can also play a key role in providing assurance that the internal control system is operating efficiently.[18] We acknowledge that there are many benefits to be derived from an independent audit like enhancing donor and community confidence and demonstrating a commitment to fiscal accountability. However, we urge each organization to make an individual assessment of the benefits and costs of an independent audit before deciding whether it is time for one. In some cases, the decision about whether to have an audit will come from a funder like the state(s) where your organization is registered, the federal government, a foundation, or even a charity watchdog like the Wise Giving Alliance. Whatever you decide, please keep in mind that an independent audit is a key element of financial accountability and a signal that your organization is being a good steward of its financial resources. Emmanuel Francois notes that sound financial management practices will make your organization more likely to retain existing donors and attract new ones, an opportunity that is essential in ensuring that your organization remains a going concern.[19]

KEY TERMS

adverse opinion
audit committee
compilation
external audit
financial statement review

independent audit
internal audit
management letter
qualified opinion
unqualified opinion

ADDITIONAL READINGS

Larkin, Richard F., Marie DiTommaso, and Warren Ruppel. *Wiley Not-for-Profit GAAP 2020: Interpretation and Application of Generally Accepted Accounting Principles.* 3rd ed. Hoboken: John Wiley & Sons, 2020.

McCarthy, John H., Nancy E. Shelmon, and John A. Mattie. *Financial and Accounting Guide for Not-for-Profit Organizations*. 8th ed. Hoboken: John Wiley & Sons, 2012.

National Council on Nonprofits. "Understanding the New FASB Accounting Standards—an Overview." Accessed June 27, 2022. www.councilofnonprofits.org/tools-resources/understanding-the-new-fasb-accounting-standards-overview.

Ruppel, Warren. *Not-for-Profit Accounting Made Easy*. 2nd ed. Hoboken: John Wiley & Sons, 2011.

CHAPTER EIGHT

Financial Statement Analysis for Arts Leaders

If you take control of your finances today, you won't be a victim of them tomorrow.—EMILY G. STROUD, president and owner of Stroud Financial Management Inc.

LEADER TAKEAWAYS

After reading this chapter, you should be able to

- Explain financial statement analysis
- Explain how to define and measure profitability, liquidity, solvency, efficiency, and other important concepts
- Explain how to identify red flags in financial statements
- Communicate basic results and information from your organization's financial statements to individuals without an accounting or finance background in a way that they can truly understand

Many of you currently or in the future will have jobs or nonprofit board seats that require you to understand how to read and analyze nonprofit financial statements. This chapter will explain how to define and measure a set of critical financial ratios, such as profitability, liquidity, solvency, and efficiency. We will also teach you how to communicate basic results and information from financial statements to stakeholders without an accounting or finance background, like your organizational leadership, board members, donors, and other community stakeholders, in a way that they can truly understand.

As a nonprofit arts organization, the primary goal of your organization is to fulfill its mission, not to make a profit. However, your organization will be unable to fulfill that mission if the board and management are not focused on

the organization's finances. Every organization, including arts nonprofits, needs enough cash on hand to pay salaries, repay debt, run programs, and purchase goods and services. I am certain that you have heard about or had firsthand experience with an arts nonprofit organization that had too much cash on hand or was not spending the right amount on programs. Such organizations frequently draw the ire of nonprofit watchdog agencies like the Better Business Bureau or Charity Navigator, which can eventually result in a loss of donations.

Ensuring that your organization is financially healthy is not only the responsibility of the chief financial officer (CFO) but a shared responsibility of the executive director and upper management, board members, directors, and staff. Good financial management is the responsibility of the entire organization, and everyone must engage in the process to make sure the organization remains financially healthy. Understanding what the numbers in your financial statements say about the health of your organization is critical to successfully managing it. As Ellen Rosewall notes, "Financial management is one of the things we do to enable the art to happen. Good financial management is one of the best ways to ensure that arts organizations survive, thrive, and bring art to the communities they serve."[1]

As a leader in your organization, you must understand how to read your organization's financial statements. In addition, you should be able to use financial statements to determine to what extent your organization is using its available financial resources to achieve its mission; you should also be able to adequately interpret that information for others.

Financial statement analysis is the study of the information in an organization's financial statements to characterize the organization as fiscally healthy or unhealthy. Financial statement analysis involves asking questions about your organization's profitability, liquidity, solvency, and efficiency, and identifying any red flags that may impact its fiscal health. There are endless examples of ratios that can be calculated, but we will focus on the most useful ones for arts nonprofits. In using these ratios, we will examine a hypothetical arts nonprofit in New York: the Children's Theater of the Bronx.

According to information from their 2021 IRS Form 990, the mission of the Children's Theater of the Bronx (CTOB) is to inspire children and families to learn about themselves and our culturally diverse world through a unique environment of interactive workshops and programs. The theater provides cultural and educational services and workshop programs to the Bronx school system and is open to the public in furtherance of its tax-exempt purpose. We begin our financial statement analysis by examining the auditor's opinion.

AUDITOR'S OPINION

Auditing involves making sure the financial statements provide an accurate representation of an organization's financial position and comply with generally accepted accounting principles. This chapter will not teach you how to audit financial statements. Your organization will hire an independent auditor to do that. This chapter will teach you how to analyze financial statements and determine whether your organization is financially healthy.

Not every nonprofit organization is required to get an independent audit of its financial statements. In fact, the IRS does not require most nonprofits to obtain an independent audit. However, nonprofit organizations that expend more than $750,000 in federal award funds during a fiscal year are required to have an independent financial audit. At the state level, the laws that require a charitable nonprofit organization to submit audited financial statements are not uniform. Some states—for example, Alabama, Arizona, Colorado, Delaware, and Iowa—have no state requirement for an independent audit of financial statements. By contrast, charitable nonprofit organizations housed or soliciting contributions in New Jersey are required to have audited financial statements attached to their annual registration filing if their gross receipts for the fiscal year exceed $500,000. We encourage you to consult with legal and tax professional advisers for guidance on the individual circumstances of your charitable nonprofit organization.

Once the auditing process is complete, the auditors issue a report to the nonprofit's board of directors, expressing a professional opinion about the organization's financial practices: specifically, whether the financial statements "fairly present the financial position of the organization" without any inaccuracies or material misrepresentations. Audits and the auditing process are discussed in detail in chapter 7 and will not be repeated here. The point here is that the process of analyzing your financial statements begins with examining the independent auditor's report and making sure that your organization received an "unqualified opinion" at the end of the auditing process.

THE FINANCIAL STATEMENTS

Let's look at CTOB's financial statements before we begin calculating any ratios.

From the balance sheet, we see that the short-term or current assets include cash and cash equivalents, grants receivable, and prepaid expenses. From 2020 to 2021 we see that the organization's cash and cash equivalents increased by

Children's Theater of The Bronx

Financial Statements and Other Financial Information
(Together with Independent Auditors' Report)
For the Year Ended June 30, 2021

INDEPENDENT AUDITORS' REPORT

To the Board of Trustees
Children's Theater of the Bronx

Report on the Financial Statements

I have audited the accompanying financial statements of Children's Theater of the Bronx, which comprise the statements of financial position as of June 30, 2021, and the related statements of activities and change in net assets, functional expenses, and cash flows for the year then ended, and the related notes to the financial statements.

Management's Responsibility for the Financial Statements

Management is responsible for the preparation and fair presentation of these financial statements in accordance with accounting principles generally accepted in the United States of America; this includes the design, implementation, and maintenance of internal control relevant to the preparation and fair presentation of financial statements that are free from material misstatement, whether due to fraud or error.

Auditors' Responsibility

My responsibility is to express an opinion on these financial statements based on my audit. I conducted my audit in accordance with auditing standards generally accepted in the United States of America. Those standards require that I plan and perform the audit to obtain reasonable assurance about whether the financial statements are free from material misstatement.

An audit involves performing procedures to obtain audit evidence about the amounts and disclosures in the financial statements. The procedures selected depend on the auditor's judgment, including the assessment of the risks of material misstatement of the financial statements, whether due to fraud or error. In making those risk assessments, the auditor considers internal control relevant to the entity's preparation and fair presentation of the financial statements in order to design audit

procedures that are appropriate in the circumstances, but not for the purpose of expressing an opinion on the effectiveness of the entity's internal control. Accordingly, I express no such opinion. An audit includes evaluating the appropriateness of accounting policies used and the reasonableness of significant accounting estimates made by management, as well as evaluating the overall presentation of the financial statements.

I believe that the audit evidence I have obtained is sufficient and appropriate to provide a basis for my opinion.

Opinion

In my opinion, the financial statements referred to above present fairly, in all material respects, the financial position of Children's Theater of the Bronx as of June 30, 2021, and the changes in its net assets and its cash flows for the year then ended in accordance with accounting principles generally accepted in the United States of America.

Loch Sloan, CPA
Bronx, NY, December 16, 2021

Children's Theater of the Bronx
Balance Sheet as of June 30, 2021 and 2020

	2021	2020
ASSETS		
Current Assets		
Cash and cash equivalents	$5,734,000	$4,961,000
Grants receivable, net	1,000,000	1,575,000
Prepaid expenses	2,000,000	4,000,000
Total current assets	8,734,000	10,266,000
Property, plant, and equipment, net	62,424,000	53,276,000
Total Assets	**$71,158,000**	**$63,542,000**
LIABILITIES		
Current Liabilities		
Accounts payable and accrued liabilities	$1,925,000	$1,287,000
Total current liabilities	1,925,000	1,287,000
Deferred revenue	8,849,000	7,301,000
Total Liabilities	10,774,000	8,588,000
Total Net Assets	60,384,000	54,594,000
Total Liabilities and Net Assets	**$71,158,000**	**$63,542,000**

See accompanying notes to financial statements.

Children's Theater of the Bronx
Statement of Activities for the Year Ending June 30, 2021

REVENUE AND SUPPORT	
Individual contributions	52,261,000
Ticket sales	61,053,000
Total Revenue and Support	**114,314,000**
EXPENSES	
Salaries and benefits	91,050,000
Scholarships	3,261,000
Interest on loan	7,037,000
Depreciation	594,000
Total Expenses	**101,942,000**
CHANGE IN NET ASSETS	**12,372,000**

See accompanying notes to financial statements.

Children's Theater of the Bronx
Cash Flow Statement for the Year Ending June 30, 2021

CASH FLOWS FROM OPERATING ACTIVITIES

Change in net assets	$12,372,000
Depreciation	594,000
Decreases (increases) in current assets	
Grants receivable, net	575,000
Prepaid expenses	2,000,000
Accounts payable and accrued liabilities	638,000
Net Cash from Operating Activities	16,179,000

CASH FROM INVESTING ACTIVITIES

Purchases of theater lighting and sound system	(9,742,000)
Net Cash from Investing Activities	(9,742,000)

CASH FROM FINANCING ACTIVITIES

Borrowing (repayment) of long-term loan	9,742,000
Net Cash from Financing Activities	9,742,000
NET CHANGE IN CASH	**16,179,000**
Cash, beginning	4,691,000
Cash, ending	$20,870,000

See accompanying notes to financial statements.

NOTE 1—Operations

The Theater's programs are supported primarily by individual contributions and ticket sales.

NOTE 2—Summary of Significant Accounting Policies

Accounting Basis

Children's Theater of the Bronx financial statements are presented on the accrual basis of accounting and in accordance with Financial Accounting Standards Board ("FASB") guidance on reporting information regarding its financial position and activities for not-for-profit organizations.

Revenue Recognition

Contributions: Contributions, including unconditional promises to give (pledges), are recognized as revenues in the period received or pledged.

NOTE 3—Property and Equipment

Depreciation is calculated using the straight-line method and depreciation expense amounted to $594,000 for the year ended June 30, 2021.

22.2 percent, grants receivable decreased by 36.5 percent, and total current assets decreased by 14.9 percent. From 2020 to 2021 the organization's current liabilities increased by 49.6 percent, and its total net assets increased by 9.9 percent. These numbers could be red flags, but we will not know for sure until we complete our analysis.

The organization's assets are not very liquid. As we saw in chapter 7, current assets are the assets that can easily be turned into cash within a fiscal year and are readily available to pay off any existing obligations if the need arises. Current assets make up 12.3 percent of the organization's total assets in 2021, which means that most of the assets are long-term assets that cannot be easily turned into cash if the need arises.

Let us now turn to the activity statement for CTOB. The organization appears to not have a very diversified revenue base, with two revenue sources, individual contributions, and ticket sales.

The cash flow statement demonstrates where your organization's cash came from and how it was used during the fiscal year. If we look at the 2021 cash flow statement for CTOB, we see that at the beginning of the fiscal year CTOB had $4,691,000 in cash and ended the fiscal year with $20,870,000. Andrew Lang and colleagues note that when reading the cash flow statement, it is important

to pay close attention to the bottom line of this statement: the net increase or decrease in cash was $16,179,000 in 2021 for CTOB.[2] Look at the three individual sections of the cash flow statement (operating, investing, and financing) and identify what items contributed to the net increase in cash for CTOB. Did this change come from operations (that is, the day-to-day activities of the organization) or from an investing or financing activity?

Lang and colleagues provide an example of an organization with negative net cash flows from operations but still has working capital because it has just received cash on its line of credit—a cash inflow from a financing activity. They caution, however, that if an organization is constantly using its line of credit, a reader of the financial statements should question why. While it is certainly possible that some organizations frequently use the line of credit to offset the timing or seasonality of cash flows (which is not necessarily a bad thing), this can also be an indicator of potential cash flow problems.

The notes to the financial statements are an integral part of the financial statements and provide readers with additional details and explanations about the numbers in the financial statements, including how soon receivables are expected, what types of investments the organization holds, interest rates on outstanding loans, and how soon loans are due. For example, the notes tell us that the organization prepares its financial statements using the accrual basis of accounting in accordance with the Financial Accounting Standards Board (FASB). We also learn that contributions and pledges are recognized as revenue by CTOB in the period in which they are received or pledged. CTOB uses the straight-line method of depreciation and recorded $594,000 in depreciation expenses for fiscal year 2021. All this information can be very useful for ratio analysis.

Financial ratios, percent change, and common size ratios are best understood as trends across time because an external shock could create short-term volatility that may be smoothed over time. We recommend examining financial metrics across three to five years for a more accurate picture of financial health than a single-year snapshot can provide. Unfortunately, in this case we have only one complete year of financial information for CTOB and therefore will conduct the financial analysis for one year.

RATIO ANALYSIS

Liquidity Ratios

Let us begin our analysis with liquidity ratios. A **liquidity ratio** indicates whether an organization has a sufficient "cushion" of cash and cash equivalent resources (assets that can be quickly converted into cash) to meet organizational

expenses as they come due. The **current ratio** compares an organization's current assets with current liabilities. A higher current ratio indicates a stronger liquidity position, suggesting that the organization will be better prepared to address periodic declines in revenues or unexpected expenses. Although most financial analysts recommend having a current ratio of 2.0 or greater, several factors influence the desired level of financial liquidity. Larger organizations and those with more predictable expenses and more diverse revenue sources tend to maintain lower levels of liquidity. In addition, organizations relying on donated goods and services can operate with lower levels of liquidity, since those goods (rather than cash) are the source of the bulk of their average monthly expenses. As with many other financial ratios, maximizing either of these ratios comes at a cost. Many organizations have a policy of maintaining cash reserves equal to two or three months of expenses. While reserves in the form of cash or short-term investments may make the organization financially secure, these resources could also be used in programs that further the organization's mission.

$$\text{Current ratio} = \frac{\text{Current assets}}{\text{Current liabilities}}$$

Liquidity ratios can be a bit tricky to calculate and take some practice to get quite right because most nonprofit organizations do not have to separate their current assets and liabilities from their long-term assets and liabilities on their balance sheet. Fortunately for us, CTOB does separate its current assets from its long-term assets on the balance sheet.

$$2021 \text{ Current ratio} = \frac{\$8,734,000}{\$1,925,000} = 4.54$$

The liquidity of CTOB is way above the benchmark of >2 in 2021; CTOB has \$4.54 in assets per dollar of liabilities in 2021.

A more conservative liquidity ratio is **days of cash on hand**, which focuses on how long CTOB can meet its daily expenses using just the cash and cash equivalents it has readily available. To determine the cash and cash equivalents, we typically refer to both the balance sheet and the notes to the financial statements, to determine which part of cash and cash equivalents is available for general expenditure within one year of the statement of financial position date, without donor or other restrictions limiting their use.

$$\text{Days of cash on hand} = \frac{\text{Cash + Short-term investments}}{(\text{Expenses} - \text{Bad debts} - \text{Depreciations})/365}$$

There is no rule of thumb for this ratio, but ideally arts nonprofits should have three to six months of cash on hand, meaning the organization could

operate for three to six months in a funding crisis. This ratio tells us how many days an arts nonprofit would be able to get by with the cash the organization has on hand, even if the organization does not collect any receivables.

Leverage Ratios

A **leverage ratio** focuses on the extent to which an organization supports its activities with borrowed funds. The most common ratio utilized is the **debt-to-assets ratio**, which compares what an organization owes to what it owns. Sanchez recommends that nonprofits pay close attention to increasing trends with this ratio, as an increasing leverage ratio over time could be a sign of financial trouble for an organization.[3]

$$\text{Debt-to-assets ratio} = \frac{\text{Total liabilities}}{\text{Total assets}}$$

A lower score is better here, and the recommended benchmark for nonprofit organizations is a ratio of 0.5 or less; the top-rated charities generally have ratios from below 5 percent up to 10 percent. We will go to the balance sheet to obtain the values needed for this calculation.

$$\text{2021 debt-to-assets ratio} = \frac{\$10,774,000}{\$71,158,000} = 0.15$$

CTOB has $0.15 in liabilities for every $1 in assets in 2021. This number is very positive: it shows us that CTOB exceeds the benchmark of 0.5 or less, so we can conclude that CTOB is not a highly leveraged arts nonprofit organization, has quite a bit of cushion to protect against financial risk, and should be able to meet its outstanding obligations adequately.

Another leverage ratio is the **debt-to-equity ratio** or **viability ratio**, a direct measure of net assets available to cover the organization's liabilities. The smaller the ratio, the better, and the recommended benchmark is a ratio of 1.0 or less. We will find the values we need to calculate this ratio in the balance sheet.

$$\text{Debt-to-equity ratio} = \frac{\text{Total liabilities}}{\text{Total net assets}}$$

$$\text{2021 debt-to-equity ratio} \frac{\$10,774,000}{\$60,384,000} = 0.18$$

CTOB has $0.18 in liabilities for every $1 in net assets in 2021. CTOB exceeds the benchmark of 1.0 or less, which means that CTOB has most of its net assets at its disposal and is not relying too heavily on debt to fund the day-to-day operations of the organization.

Coverage Ratios

Together, a **coverage ratio** and a leverage ratio measure the organization's solvency. While leverage ratios measure indebtedness, coverage ratios measure the nonprofit's ability to make its debt service payments. A common coverage ratio is the **times interest earned ratio**, which tells us how many times over the organization would be able to make its interest payment from its surplus. A recommended benchmark is at least 1.0 with a positive upward trend over time.

$$\text{Times interest earned ratio} = \frac{\text{Change in net assets} + \text{Interest expense}}{\text{Interest expense}}$$

$$\text{2021 times interest earned} = \frac{\$12,372,000 + \$7,037,000}{\$7,037,000} = 2.76$$

In 2021, CTOB could make its interest payment 2.76 times out of its surplus.

Surplus Ratios

A **surplus ratio** measures a nonprofit's ability to operate at a surplus. Although nonprofits are not expected to make a profit, they should be good stewards of any profit that is generated and reinvest it into the organization's mission. There is no benchmark for surplus ratios, but we want these ratios to be positive, and bigger and continued negative trends in the surplus ratios can be an indicator of poor financial management.[4] The **return on net assets (RONA) ratio** is a common ratio used to measure the nonprofit's surplus/loss relative to its net assets and is usually expressed as a percentage. We can find the values for this calculation in the activity statement.

$$\text{Return on net assets ratio} = \frac{\text{Change in net assets}}{\text{Net assets}}$$

$$\text{2021 RONA} = \frac{\$12,372,000}{\$60,384,000} = 20\%$$

We see that in 2021 CTOB experienced a 20 percent gain as a share of its net assets.

Asset Turnover Ratios

An **asset turnover ratio** focuses on the efficiency with which nonprofit organizations convert resources to revenue. The **receivables turnover ratio** compares the nonprofit's revenues and support to its receivables. This ratio tells you approximately how many times during the fiscal year your organization's receivables were fully collected.

$$\text{Receivables turnover ratio} = \frac{\text{Unrestricted revenue and support}}{\text{Total receivables}}$$

The numerator in this ratio tells you how much was earned during the year, while the denominator tells you how much was still not collected as of the end of the year.

$$\text{2021 receivables turnover ratio} = \frac{\$114{,}314{,}000}{\$1{,}000{,}000} = 114.3$$

In 2021 CTOB's grants receivables were fully collected 114 times. There is no benchmark for the receivables turnover ratio, but larger is better. According to Sibi Thomas, you can obtain a more effective ratio for measuring asset turnover by calculating the average number of days it takes for a nonprofit to collect cash from governmental agencies or other third-party payers after services are provided and billed.[5] The average collection period for CTOB's grants receivables is calculated by dividing 365 days by the receivables turnover ratio calculated above.

$$\text{Average collection period} = \frac{365}{\text{Receivables turnover ratio}}$$

The average collection period for CTOB is 2 and suggests that on average it takes CTOB two days to collect its receivables. Thomas notes that this ratio can be used to understand the timing of cash flow coming into the organization and to identify any large old receivables that need to be written off or investigated further. But the average number of days it takes to collect the cash can vary from organization to organization and by program or subsector, so it is important to understand the average ratio of your subsector (arts nonprofits in general) or industry (e.g., museums compared to theaters) to benchmark your organization's "days outstanding" number.

Program Services Expense Ratios

The **program services expense ratio** is a popular ratio employed by the nonprofit rating agencies, nonprofit watchdog agencies, major donors, and other stakeholders. This ratio tells us the proportion of a nonprofit's total expenses spent during the fiscal year on fulfilling the mission (i.e., on programs), as opposed to administrative overhead or fundraising.

$$\text{Program service expense ratio} = \frac{\text{Program service expenses}}{\text{Total expenses}} \times 100$$

Jennifer Lammers notes that while different watchdog agencies require different minimum program allocations for compliance or a favorable rating, the range generally falls between 60 and 70 percent of total expenses.[6] The Wise

Giving Alliance of the Better Business Bureau has set a standard of at least 65 percent for this ratio.[7] This is an arbitrary standard and does not take into consideration a variety of factors that could impact the ratio. For example, new organizations (younger than three years) may spend less on their programs than older, more established charities because of the administrative and fundraising efforts involved in launching an organization.[8] An arts organization that focuses on advocacy for increased diversity in the arts may spend more on fundraising than a theater company or museum and therefore have a program services ratio that is below the recommended benchmark of 65 percent. Weikart and Chen argue that advocacy organizations spend more on fundraising because far fewer people and foundations are interested in funding advocacy.[9] The point is, this ratio varies widely depending on the size of the organization and its mission, so try not to focus too much on it, especially if your organization has an acceptable reason for deviating from these recommended benchmarks.

Fundraising Efficiency Ratios

The **fundraising efficiency ratio** measures how much revenue is being generated for every dollar spent on fundraising and reflects the successes of fundraising events and gives organizations an idea of whether or not their current efforts and practices are working. A fundraising efficiency ratio of 6.31, for example, would mean that for every dollar spent on fundraising, your organization raised $6.31. According to Giving Loop, if your organization's fundraising efficiency ratio is less than one dollar, it may mean that you are spending more money than you are getting in return and you need to reprioritize your efforts.[10] Giving Loop notes that a common mistake many organizations make is overspending on things such as marketing—for example, reaching out to donors through expensive snail mail instead of utilizing cheaper alternatives—and on entertainment and decor for fundraising events.[11]

$$\text{Fundraising efficiency ratio} = \frac{\text{Unrestricted contributions}}{\text{Fundraising expenses}}$$

There is no benchmark for this ratio for arts nonprofits, but we recommend aiming for a ratio greater than 1.0.

CASH FLOW STATEMENT

Although the cash flow statement is not typically used in ratio analysis, it is still a very important statement to examine while conducting an analysis of financial statements. Lang and colleagues recommend taking a good look at the organization's cash position at both the beginning and the end of the fiscal

period.[12] They note that as the most liquid asset of all, cash plays a vital role in maintaining an organization's financial health and stability. Having sufficient cash on hand and having the ability to quickly convert other assets into cash is key to maintaining an organization's financial liquidity and flexibility.

Overall, we would characterize CTOB's financial position as healthy. CTOB is not a highly leveraged arts nonprofit organization, has quite a bit of cushion to protect against financial risk, and should be able to meet its outstanding obligations adequately. CTOB had a surplus in 2021, on average takes two days to collect receivables, and can easily cover the interest payment on its outstanding debt.

CTOB has very high liquidity: $4.54 in current assets per dollar of current liabilities in 2021. While having adequate liquidity may make a nonprofit organization financially secure, high liquidity ratios greater than 3.0 could indicate that the organization is not using its assets efficiently, as these resources could also be used in programs that further the organization's mission. We strongly recommend that the board and executive director of CTOB compare its liquidity ratios to those of similar organizations to identify a target range for this ratio.

A good goal for the board and executive director of CTOB would be to identify a target range for each ratio discussed above and to periodically reassess the target range to maximize how resources are used in fulfilling the mission. This can be achieved by performing a risk assessment, trend analysis, or benchmarking with peer organizations. We encourage you to refer to a resource we provide in this book's appendix, "Table A1. Financial Ratios Cheat Sheet: Ten Financial Ratios Every Arts Leader Should Know How to Measure," as a quick reference when you are ready to embark on a financial statement analysis for your organization.

CONCLUDING THOUGHTS

Financial statement analysis is a valuable tool in the financial management workbox for arts nonprofit organizations. Financial ratios can be useful in allowing managers to see how their organization compares to its peers. These comparisons can help inform management decisions and help managers identify financial issues before they become unmanageable. Financial ratios can be useful in helping donors understand how an organization uses their contribution and assist in helping both current and prospective donors make decisions about which nonprofit will efficiently use their charitable contributions. We urge you to use financial ratios as a guide and examine ratios over a period of at least three to five years and not read too much into the ratios from one year of data. The Urban Institute Center on Philanthropy observes that the overreliance on

certain ratios like the program services expense ratio can lead to unintended consequences.[13] For example, the program services expense ratio can lead to a race to the bottom and encourage competition in a market that rewards low administration and fundraising costs. They argue that this type of behavior can result in underinvestment in good governance, planning, compliance and risk management, collection of data for service performance evaluations, and staff training. Ultimately, too much focus on ratios leads to an underdeveloped nonprofit sector and a loss of community trust and confidence in philanthropy. Our advice to you is to use your organization's ratios wisely and never forget the reason your organization exists.

KEY TERMS

asset turnover ratio
auditing
coverage ratio
current ratio
days of cash on hand
debt-to-assets ratio
debt-to-equity ratio
financial statement analysis
fundraising efficiency ratio

leverage ratio
liquidity ratio
program services expense ratio
receivables turnover ratio
return on net assets (RONA) ratio
surplus ratio
times interest earned ratio
viability ratio

ADDITIONAL READINGS

Finkler, Steven A., Thad D. Calabrese, and Daniel L. Smith. *Financial Management for Public, Health, and Not-for-Profit Organizations*. Thousand Oaks, CA: CQ Press, 2022.

Lang, Andrew S., William D. Eisig, Lee Klumpp, and Tammy Ricciardella. *How to Read Nonprofit Financial Statements: A Practical Guide*. Hoboken: John Wiley & Sons, 2017.

Rosewall, Ellen. *Arts Management: Uniting Arts and Audiences in the 21st Century*. New York: Oxford University Press, 2022.

Weikart, Lynne, and Greg G. Chen. *Budgeting and Financial Management for Nonprofit Organizations*. Long Grove, IL: Waveland, 2022.

Zietlow, John, Jo Ann Hankin, Alan Seidner, and Tim O'Brien. *Financial Management for Nonprofit Organizations: Policies and Practices*. Hoboken: John Wiley & Sons, 2018.

CHAPTER NINE

More Than Just Audience Satisfaction
Measuring Organizational Performance

We can become very short-sighted in terms of objectives. The first thing to go during times of economic crisis and budget cuts is funding for things that are essential and not quantifiable, like the arts. Save Big Bird.
—JULIA STILES, actress

LEADER TAKEAWAYS

After reading this chapter, you should be able to

- Use performance measurement to reach strategic objectives
- Consider why you should measure your organization's performance
- Understand the performance measurement cycle
- Create SMART goals
- Understand challenges to measuring performance in your organization
- Use **FACE performance measures** to help your organization tell its story
- Implement strategies for gathering and analyzing data

The local arts council and its subsidiary theater were finding it hard to find the time to do an evaluation, particularly regarding their financial landscape. The executive director "felt like we spent half the year getting ready for the annual gala," so any evaluation not related to that big fundraiser or in response to requests from external funders got tabled. While grant requirements pushed the organization to capture some data, these data were primarily output-based (increased attendance at events, number of shows, concession sales, financial reports, etc.); they reported quantity of activity but not necessarily quality or impact. Plus, the arts council was a pretty lean organization, so capacity for evaluation was limited, even though the team fully supported the idea of demonstrating their work's impact in robust and meaningful ways.

Sustained financial performance is necessary for organizations to accomplish their missions, and ensuring financial performance also unlocks the door for performance across all other organizational fronts. But it's not always a straightforward process, and at its highest levels performance measurement creates cycles of continuous organizational learning that inform decision-making, both financial and otherwise, on a consistent basis. It becomes part of your accountability leadership and organizational culture and gives creativity room to flourish.

We will discuss financial performance measures, of course, but if organizations measure only financial performance, then their advancement toward many vital values, goals, and objectives might be overlooked. And you need others, both within and outside your organization, to understand the story of what you are doing and how well you are doing it. By demonstrating transparency with both financial and program data, your organization will better engage donors, patrons, and others who can influence your ongoing financial sustainability.

WHY MEASURE OUR ORGANIZATION'S PERFORMANCE?

The Bureau of Educational and Cultural Affairs defines **performance measurement** as "regular measurement of **outcomes** and results, which generates reliable data on the effectiveness and efficiency of programs."[1] Historically, nonprofits have not viewed measuring success as a powerful marketing or fundraising tool. In the last several years, however, increased competition for limited funds and the trend toward greater accountability have caused nonprofit organizations to more frequently try to measure their own performance with an eye to motivating outside funders.

The performance measurement cycle represented in figure 9-1 provides an overview of how performance measurement aids in ongoing mission achievement by informing others. When performance measurement takes place and that information is disseminated among your organization's stakeholders (those who have an interest in and connection to your organization's work), you raise their awareness about what you are accomplishing. Performance measurement can be as comprehensive as an annual report or can be specific to a single event, such as the response to a particular event. This awareness will influence their perceptions of your organization's legitimacy, for good or ill, which can in turn determine the level of support for your work through advocacy, donations, or other forms of engagement. And that external support will then feed into how well equipped you are to continue fulfilling your work and running after your mission.

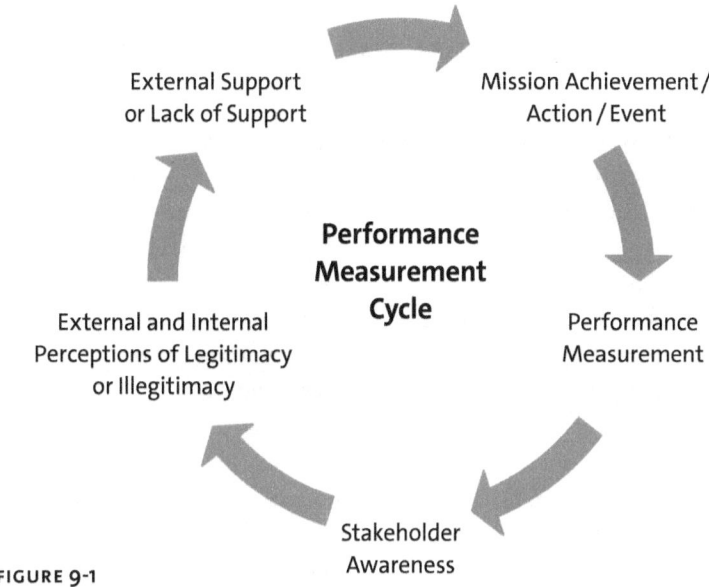

FIGURE 9-1

For those most invested in your organization, even what we might consider unflattering information can be helpful. For example, let's say an event sponsored by your organization has negative reviews. But perhaps the negative reviews were based at least in part on misunderstood or understated goals for the event. Those closest to your organization can balance those reviews by making known the artistic goals of the event: perhaps the event was meant to challenge or be provocative, for example, so negative reviews were expected. In that case, you may have met an artistic goal, and the negative reviews might be more of a messaging issue than an artistic one. Or perhaps your organization is consistently losing money on a particular program. Information about that program's purpose can help your stakeholders rally around it if they find it worthwhile and can help your board and staff identify and focus attention on additional strategies to make the program more effective or, alternatively, to cut it if it is not meeting the goals for your work. Remaining transparent regarding how well you are tracking toward your goals in good times and bad will build your organization's credibility and provide a stronger foundation for building trust with your stakeholders. Eventually, all your leadership decisions become financial decisions because they will impact your bottom line in either the short or the long term.

HOW DO I DETERMINE WHAT TO MEASURE?

Like the budget your organization creates, your performance measurement strategies indicate what your organization values. So performance measurement should flow naturally and organically from your organization's theory of change and strategic planning processes. Fundamentally, the **metrics** or data your organization has decided to track follow after you've identified those key values, goals, and objectives you seek to achieve for your organization; for your stakeholders, clients, and patrons; and for your communities. After your organization has identified your strategic priorities, and not before, you are ready to make the most of your performance measurement landscape.

While we do not cover strategic planning in this text, there are a variety of excellent resources that do, and here are some basic planning questions to get your mind buzzing. If you do not already have a strategic plan in place, then spend some time formalizing (1) your organization's big, overarching goals, (2) the objectives you have within each of those goals, (3) the steps you are taking or will take to obtain them, and (4) how you will assess whether or not you have been successful. Essential to this process is that your planning documents align with your annual budget, the values document that financially backs up your strategic plans.

Here are some planning questions to get you started:

- How well does this goal align with our mission on a scale of 1 to 5 (1 being least aligned and 5 being most aligned)?
- What resources do we need to accomplish this goal (human, technical, social, financial, etc.)?
- What are the individual roles necessary to accomplish this goal, and who will be responsible for each?
- What is the time frame for accomplishing this goal? Is it a short-, medium-, or long-term action item?
- How will we evaluate success for this goal?

The last question is where this chapter comes in. How will you evaluate whether you have been successful in accomplishing your mission? The first step after planning is to establish metrics to measure that success or identify the red flags necessary to keep your organization on the right track to reach its goals.

The best goals for your organization are **SMART goals**: Specific, Measurable, Achievable, Relevant, and Time-bound.

Specific: The goals need to be precise and detailed enough to tell you what you are reaching for and when you have met it. For example,

"increasing your engagement rate by 15 percent in two years" provides much more specificity than simply "increasing engagement."

Measurable: The goal must be capable of measurement. Within arts, culture, and recreation spaces, some goals may be difficult to measure, particularly those related to mental health or prevention effects; however, there are ways to get a strong measure of impact even in those cases. We'll share several here.

Achievable: Even though management gurus often encourage organizations to set "big, hairy, audacious" goals, and goals by their very nature are aspirational, they must also be within the realm of possibility for your team. Don't discourage your employees by setting impossible goals; rather, encourage them by thoughtfully establishing goals that motivate progress and allow people to see the end goal on the horizon.

Relevant: Focus on those goals that are best aligned with your mission. Since evaluation requires time and resources—both of which are likely scarce in your organization—keeping the goals relevant to your primary purpose will help you do a better job of aligning resources and telling your story to others.

Time-bound: Establish a time for when your organization should have each goal completed. That time stamp keeps you and other leaders accountable for maintaining the attention and priority needed for achieving the goal. If I want to write a play, I could languish in rewrites for years unless I establish a goal to send that material out to the publisher by a certain time. A time stamp on goals gives them immediacy and directedness.

Goals that meet these criteria will serve you well and keep you from the frustration of creating metrics that do not have a clear alignment with your goals and therefore do not effectively tell your story.

So, at the most basic level, once you have some sort of strategic plan and SMART goals in place, the next step is to select the right assessment measures. It is impossible for your organization to measure everything you'd like to know, so use your plans to keep your focus on reaching your true purpose and telling that story in accessible and compelling ways to those outside your organization. The adage "We manage what we measure" is true, so make sure you are choosing to measure the things you most want to focus your time and attention on. And that's why we bother with measurement at all: to determine how well we are accomplishing our goals.

TYPES OF EVALUATION

Evaluation can either cover a single event, slate of events, or program(s) or assess your program's impact over longer swaths of time; the second type is called an **impact evaluation**. Each evaluation approach measures distinct aspects of performance. Peter Rossi, Mark Lipsey, and Gary Henry outline four types of evaluation: process, program theory, program impact, and organizational impact.[2] Each type uses a different lens or scope to assess aspects of your organization, so they emphasize different outcomes and require different data. Although you may not choose to do each on a continuous basis, consider how each might provide insights you need to make better decisions. All promote organizational learning and improvement if you feed the results back into your decision-making and planning.

Process Evaluation

According to Rossi and colleagues, process evaluation "examines what a program actually is, the activities undertaken, who receives services or other benefits, and the consistency with which it is implemented in terms of its design and across sites."[3] By examining your processes, you can identify inefficiencies that are costing your organization excess money and time. Is your team spending too little time getting the word out about your events, resulting in small crowds? Or too much time filling out unnecessary paperwork when a shared document file might streamline your process? Scrutinizing your processes can also help determine areas of inequity in your services. Are your marketing processes systematically leaving out certain areas of your community? Are your pricing structures exacerbating unequal access to the arts in your community? These, along with a variety of other questions, can be answered by thinking through your processes.

Much of what we are covering within this book has to do with fiscal processes, and assessing how well your organization is carrying those processes out is an important question for your organization, but all your process decisions impact your financial bottom line. Process evaluation could take place less frequently than other types of evaluation, but if you haven't conducted one in a while, a process evaluation would be a way to identify areas for improvement.

Program Theory Evaluation

Theory helps us answer questions about why and provides frameworks for understanding why things work together the way you expect them to. Your organization's theory of change is your program theory. Program theory links your plans for operation and services (therefore some aspects of your process) by

describing how they connect within the whole system. It gives you a big-picture view of all the parts of your operation and how they work together to produce results. David Hanna wrote, "Every organization is perfectly designed to get the results that it gets."[4] By taking a holistic view of all the parts of your organization and how they all fit, you can better understand what parts of that system you need to change to get the results you want. Program theories are likely the least-used type of assessment, and arguably, if your organization practices strategic thinking on an ongoing basis, you are already considering how all the components of your organization fit on a consistent basis. But if you have not engaged in a program theory evaluation, the time spent could be highly profitable, particularly if you are struggling to obtain your objectives.

Program Impact

Rossi and colleagues define program impact as the "difference between the outcomes that occur with implementation of the program and those that would have occurred otherwise," or, in other words, the effect of your program.[5] Within the program evaluation portfolio there are multiple layers, including everything from assessing the success of a single event to a larger program like your children's initiatives. Program impact should be an ongoing part of your organization's culture and promote consistent organizational learning. Your staff may be equipped to handle program impact assessment internally; if not, consultants could help your program design and execute them. Both internal and external evaluation have pros and cons. For example, internal evaluators may save you money but interpret the results in a biased way, saying what they think you and your board want to hear and hesitating to point out problems, especially if pointing out any problems would cast a negative light on the evaluators themselves. External evaluators will likely cost more, but they may offer a higher level of expertise and a more balanced perspective.

Organizational Impact

Organizational impact evaluation is program evaluation in spades. While program impact looks at certain segments of your organization's work, impact evaluation examines the long-term difference your organization is making toward mission-central goals over time. Rossi and colleagues call impact evaluation "one of the most highly valued by stakeholders and evaluators alike, in no small measure because of its potential to influence policy and high-level program decisions."[6] Typically, an impact evaluation examines your organization's influence over a significant chunk of time, like twenty years, relative to your key, big-picture goals and objectives. While a few organizations can handle such

a big evaluation project in house, having an outside and impartial consultant involved lends the process greater legitimacy and expertise.

We encourage you to dig deeper into these four types of evaluation and to work with your internal evaluation team or an outside consultant to identify an overall evaluation plan for your organization if you don't already have one. Doing so will help ensure that you are incorporating your evaluation into your organizational learning culture, reducing redundancies, eliminating needless operations and unnecessary data gathering, and minimizing challenges in measuring performance.

CHALLENGES TO MEASURING PERFORMANCE

One of the primary challenges for arts organizations is establishing the appropriate context of performance measurement. First, your organizational leadership and stakeholders must understand the placement of your work within the community and the value, in general, of arts and cultural organizations within society as a whole. Such an understanding can help position your organization to advocate for measures that may not match up with those typical for other nonprofits. Doing so will also help them interpret your measures appropriately. Second, as noted in the vignette at the beginning of this chapter, your team is pressed on many sides, and evaluation presents several challenges for leadership. Finding the time to gather data and evaluate performance can be difficult and can require a financial commitment. Planning such activities is essential and should be a deliberate part of your organization's culture, not just a reaction to an external push. Use the strategies below to help overcome some of the challenges your organization may encounter as you navigate the performance measurement cycle.

MEASURING THE RIGHT THINGS: OUTPUTS VS. OUTCOMES

Quantity measures are often used for evaluation because they are straightforward and simple to understand. Take our arts executive from the beginning of the chapter. The arts council gathered data regarding the number of people who attended and how many concessions they purchased but not how impactful the performance was, either artistically or in terms of educating or changing thinking. Measures of attendance and concessions sold are output measures. **Output measures** or services provided or received by your stakeholders are easily quantified but cannot explain quality or impact.[7] For example, let's say you record the number of young people who attend your cultural interpretive talk;

that measure tells you the quantity of those who received the program but not how those individuals were changed or what they learned as a result of hearing that speaker.

Better for telling your story are **outcome** measures that demonstrate something about quality and impact of your work, but such measures are harder to assess. According to Rossi, Lipsey, and Henry, outcomes are "observable characteristics of the target population or social conditions, not of the program, and the definition of an outcome makes no direct reference to program actions."[8] So outcomes are not about your organization; rather, they are about the way your organization is causing others around it to change. In our prior example regarding the interpretive speaker, an outcome measure would be a measure of how much the audience learned about the historical figure or event because of hearing the speaker. The arts council in our example realized that their measures of participation alone were not meaningfully conveying their impact on the community. As a result, they worked with others to develop a measure demonstrating that money spent on the arts accelerated money spent elsewhere in the community. This more meaningful measure was used in grant applications and elsewhere to widen the scope of how the arts council mattered not only to its direct participants but also to the businesses and workforce.

You can't measure everything, so be strategic and stick close to your organization's identified goals and mandated measures. Define the metrics that are the most meaningful for your organization—your key performance indicators, those that are most in keeping with your organization's goals.

UNDERSTANDING WHAT TO MEASURE: THE FACE METHOD

Key performance indicators can vary across arts and cultural subsectors, but some are consistent regardless of what type of organization you run. Just like a good goal, a good metric is first measurable. And most things can be measured if we are creative and thoughtful enough about the process. Next, a good metric has meaning for your organization; it is not collecting data for data's sake but is producing information key to your organization's purpose and success. One way to ensure that measures are meaningful and contribute to organizational learning and to helping you better share your story is to clearly align them with your organization's mission, plans, and stated goals.

Although the universe of metrics is vast, we group them into four categories of metrics—Finance, Artistic value, Community, and Engagement, or FACE (figure 9-2)—because these things serve the same purpose as your face: they are forward looking but also can look back when needed, serve to guide you and

FACE Performance Metrics

FINANCIAL	ARTISTIC	COMMUNITY	ENGAGEMENT
Ratios	Individual perceptions	Social	Participation
Return on event		Economic	Satisfaction
Workforce	External validations	Long-term impact	Buzz

FIGURE 9-2

collect information as you walk through the world around you, help keep you on the right path, and warn you of dangers or necessary course alterations.

Finance

Financial metrics include a variety of ratios that indicate how well your financial outlook is, either in the short or long term. Some of the more commonly used financial metrics include liquidity (short-term financing), margin (short-term sustainability), solvency (ability to pay your debts and financial obligations), and profitability (long-term sustainability).[9] Along with these essential financial metrics, let's also look at options for assessing the financial success of individual events (short-term wins or losses) and your workforce satisfaction (which can have long-term financial impact).

Let's say you want to know the financial return on an individual event (gala, exhibition, training, show, etc.). You can get a quick financial assessment of the event or activity's profit margin—what is made above its cost—just by subtracting the event's expenses from the revenue it generated. However, if you want to better understand the full costs of this same event to your organization, estimate the cost of employee time dedicated to planning, preparing for, and working the event plus any other internal costs and divide that number by the revenues made. The second margin will give you a more accurate assessment of what it truly cost your organization. And you may be surprised at the difference between the two.

Although workforce metrics are largely satisfaction measures, we are including them under financial metrics because the satisfaction levels of your employees directly impact your bottom line. Some estimates indicate that replacing

an employee costs 33 percent or more of that person's salary.[10] How satisfied are your employees? How likely are they to leave the organization? Is your organizational workforce representative of the community you serve?

If your organization has problems with workforce satisfaction, identifying these problems will allow you to address and improve them. Clearly arts and cultural organizations have some work to do on this front. If you look at Zippia's 100 Best Nonprofit Organizations to Work for in Virginia for 2021, only three arts organizations are represented: the Christian Broadcasting Network at number 37, the Virginia Living Museum at 75, and the Science Museum of Virginia at 82.[11] In addition, evidence indicates that nonprofit arts organizations are missing the mark in terms of compensating their employees, particularly employees of color, in appropriate ways.[12] An example of positive efforts to combat poor artistic compensation is the Working Arts and the Greater Economy (WAGE) certification project, which recognizes nonprofit organizations that voluntarily, and consistently, pay artist fees that meet minimum standards.[13] Whether through WAGE or just your own organization's pay standards, demonstrating such a commitment and sharing that commitment with your stakeholders would not only benefit the artists working with your organization but could also be a strong indicator of your organizational integrity. And if folks love to work for your organization, that's a good metric to share to recruit excellent new artists and employees.

Artistic Value

You understand the value of your work and its artistic merit and likely have many powerful anecdotes at your disposal that capture and convey it. Although measuring artistic value is less straightforward than measuring financial metrics, there are effective and efficient ways to measure the innovation, image, and reputation of your services.

Most individual perception measures of artistic value involve gathering data via Likert-type questions about your artistic output. A Likert scale allows respondents to answer questions not with a simple yes or no but instead to rate how *strongly* they feel about their answer: for example, "Please rate the innovativeness of this work on a scale from 1 to 5 with 1 being very innovative and 5 being not at all innovative" or "Please rate how much you agree with the following: this work made me think or feel differently." Such fine-tuning of answers might help you understand whether you need to merely tweak a program or to eliminate it altogether.

Another measure of artistic value, external validation, is the value ascribed to your work by others. External organizations can provide a credible indication

of your organization's innovation and reputation relative to other similar organizations. Have you or any of your team won awards? Does your creative team have special certifications that demonstrate quality? Does your team get outside requests to do consulting or advising on a regular basis, or do you have other evidence of achievements or standing within your creative industry? Keep track of and tout these kinds of external validation of your organization's artistic influence. Other easily tracked measures of your organization's reputation include media imprints, or "buzz," including website trends like the number of hits your website has per week (or month or year) or other social media metrics.

Community

Trickier but more powerful than a single point in time or short-term snapshot of your organization are the measures that demonstrate your long-term impact on your community. And really, community impact is the most important story you can tell about your organization and is the most critically aligned with your long-term mission. After all, your organizational influence is more than the sum of your individual programs and technical expertise; it is "above all a substantive and political one relating to the nature of the arts and the function of publicly funded arts organizations in individual communities and in society in general."[14] And don't undervalue your organization's fiscal contribution to the community's economic well-being. The arts council in our opening vignette was seeking a way to demonstrate its economic impact on the community. Early in my career, the arts organization I worked with spent months developing a formula to identify how many times a single dollar spent on the arts turned over, creating more spending in the community. It was arduous. Nowadays, though, technology has simplified such tasks: for example, Americans for the Arts offers a free Arts & Economic Prosperity Calculator on its website.[15] All you have to do is put in the size of your community, total revenues, and number of attendees, and the calculator spits out totals for full-time equivalency jobs, household income, along with local and state government revenues associated with your work. The Creative Vitality Index provides a regional comparison of arts economic contributions to the economy that considers cultural nonprofit revenues as well as performing arts participation, creative occupations, and arts sales that can help your organization demonstrate the potential of the arts in your area to contribute to larger community and economic prosperity.[16] Such tools can be very useful both for organization morale and, in particular, for current and potential funders: these metrics can show them the impact of their "investment."

But of course, not every measurement you will use for your community impact will be economic, at least not in any immediate return. Consider Artrain:

> Artrain's core mission, enriching lives and building communities through the arts, is directed towards social sustainability. Programs are developed to provide individuals with a cultural experience, an experience that can be life changing. People are encouraged to discover the arts and from there they go on to explore their creativity, become involved in local cultural organizations and/or become arts consumers. The broad-based community effort required to host an Artrain exhibition typically fosters new relationships among community members and local arts organizations. These new relationships can have such long-lasting results as the creation of new arts exhibition facilities, programs, and funding relationships. More than a traveling gallery of visual arts exhibitions, Artrain is a catalyst for community growth through the arts.[17]

Such a mission takes time to achieve and cannot be measured by a single-point-in-time exit survey. Low-cost ways to assess long-term impact in this case could be focus groups or interviews with community partners or digital surveys to community partners to anonymously share their perceptions and experiences of Artrain.

But thankfully, there are shorter-term ways to demonstrate your organization's community impact. Access to programming for a wide variety of community members, particularly those of diverse background or socioeconomic status, is a critical component of community impact. Scholars sometimes use free and reduced tickets as a measure of social impact or community value, tracking the numbers of free or discounted tickets, special events that encourage diverse participation, school programs, elderly services programming, or training and programming that emphasizes BIPOC artists.[18]

If you haven't already, take some time to consider who your organization is accountable to and for what. The answers to such questions will help determine your overall social goals, which in turn help determine who will measure such goals and how.

Engagement

Levels of engagement are typically among the easiest metrics to capture and are also easy for your stakeholders to understand. The Urban Institute recommends awareness, attendance, and access measures for arts and cultural nonprofits, and each of these falls under the engagement category. Some scholarly research in

arts contexts examines increased attendance (number of attendees), increased awareness of arts programs and activities (number of website visits), and increased access to diverse audiences (measured by number of free tickets) as social program outcomes that measure engagement.[19]

Participation is often simply measured by attendance numbers, which can be acquired through a quick headcount or ticket sales. However, participation metrics can be calculated in a variety of ways, including numbers of general attendees (visitors, audience, website attendance etc.), number of attendees across types of participation (series, trainings, etc., if you have multiple activities), and numbers by specific market segmentation (age, geographic, income stratification, etc.). Such metrics can be identified for individual events, entire series of programming, or, even better, attendance across events or years.

You can also get information beyond just whether or not people showed up. To find out more about how your attendees engaged with an event, training, exhibition, or performance or how they became aware of your activities, you can conduct a quick on-site or digital survey or short interview with participants. Satisfaction measurement is a low-level, low-cost way to evaluate. But satisfaction measurement can be unreliable: in many cases you mainly get responses from those who are on the extremes, either really enthusiastic about what you're doing or really upset by it. Folks who are somewhere in the middle are less likely to respond to low-interaction satisfaction surveys ("rate your satisfaction" cards on a table, for example), but you can encourage broader response by stationing volunteers who politely and respectfully ask for attendee feedback.

More advanced engagement measures include the ways that segmented groups engage. Although one-time engagement measures can be helpful in evaluating an event's popularity, engagement trends are more convincing to external funders, so capturing engagement data across multiple events or multiple years is advisable. If your organization has the capacity, think about incorporating metrics relative to specific types of audience. For example, Audiences London identified twenty different types of audiences across all art forms in the Greater London region, including "bright young things," "convivial homeowners," "garden suburbia," "multicultural towers," and "serious money," to name just a few.[20] Articulating your various audiences, as well as other key stakeholders and which metrics are most pertaining to them, can create a more detailed response with the potential for targeted strategies. Like external validation, social media and website hits can also be used as proxy measures of engagement, according to the Hewlett Foundation's Performing Arts Program Strategic Framework.[21] As well as providing evidence of certain types of access and awareness, back-end analytics on your social media platforms can in some cases reveal information

about those who are engaging most and allow for targeted marketing and engagement strategies.

Some metrics are very specific to a particular arts subsector. A music distributor would potentially measure things like cost per new listener, spins, or potential reach, for example. Years without serious injury may be a suitable metric for circus acts but might not apply more generally. An arts advocacy group may benefit from measuring impacts of specific advocacy interventions like increasing knowledge of the issue. You may have specific metrics besides the more general ones mentioned here that will make a strong case for your organization.

DATA-GATHERING STRATEGIES THAT WON'T DRIVE YOU CRAZY

If the artistic director in our vignette at the beginning had a better system in place to efficiently and effectively gather and track data consistently throughout the year, their frustration with evaluation wouldn't have been so great. (We're not going to lie to you: frustration is never going to go away completely, but it can also be fun when the data starts rolling in.)

But to make evaluation as painless—and as useful—as possible, have plans in place that will accurately capture the relevant data using the best methods, so that gathering the information so doesn't overburden your staff or waste time, money, and energy on useless efforts. In setting up your evaluation goals, just keep in mind your organization's mission goals, strategic goals, and hoped-for impact. Figuring out how to assess these things is not nearly as hard as one might imagine, as long as you first sit down and think things through to make sure you truly are measuring what you need to. Just remember that you don't go into a shoe store and expect to be measured for a hat.

PRESENTING YOUR STORY

To make sure the work you have put into evaluation is fulfilling its purpose in the performance measurement cycle, you must make others aware of your findings. You likely already have a variety of outlets in place where you can provide more information to your various public members. Your annual report is a natural fit. The annual report should be placed prominently on your web page and feature any evaluative findings for the year alongside your financial reports. Depending on the breadth and depth of your evaluative activity within a given time span, you could produce stand-alone publications on your findings. Also, you may have collected data for a specific purpose, such as a grant or contract evaluation, but there may also be other places to share that data.

After you've completed your evaluation assessments, you'll want to craft appealing and easily accessible layouts to share it. This is not just about vanity and pride; it is the bottom line, critical to your organization's fiscal responsibility measures. Grantors, board members, stakeholders, and potential donors all need to be convinced that you are worthy of investment. But the detailed, nitty-gritty, in-depth reports from your evaluations will likely be helpful for you (and maybe for grant-reporting purposes), but most of your audience (board members, stakeholders, and the general public) *will not* want to be inundated with columns of data and text-heavy reports and findings. Your presentations need to be appropriate for each specific audience. So, what can you do?

Make it savvy. Choose data and findings that are relevant and truly support your conclusions.

Make it simple. Don't overload. The presentation should be simple to digest immediately.

Make it satisfying. By making it savvy (relevant data) and simple (easy to immediately understand), you'll ensure that your presentation can be satisfying to those receiving it. And if there are those who want more details, you can present them with the deeper evaluations that formed your presentation.

What are some ways to present your savvy, simple and satisfying presentations? Analytics can be displayed in engaging ways through infographics, organizational scorecards, and self-updating dashboards. A visually engaging dashboard displaying vital organization statistics at a glance can be a powerful tool for any nonprofit. Being able to visualize financial, staff, and other key factors in an easy-to-read display can be a great way to introduce core statistics to everyone from board members to clients without having to get deep in the paperwork weeds. If you don't have the staff capacity for more complicated visuals, simple charts and graphs developed from a spreadsheet can still get your message across.

As you are considering what to present, ask yourself some key questions. What are the key metrics you are most proud of or that best demonstrate your impact? What metrics best demonstrate needs where stakeholders can come alongside and help your organization? As you prepare visual representations of your findings, keep asking yourself, What is the story I most want to share from this data? Tailoring your findings to specific audiences, to the extent that your organization has capacity to do so, can maximize the impact of your data across those target groups you desire to engage.

Performance measurements are critical components that help ensure that your organization is as successful as it could be, or to understand why it isn't. The time to avoid the train wreck is *before* you go off the rails, not after.

SMART planning and using FACE concepts will help you focus not only on *what* things to measure but also on *how* to measure them. And once you've done that measurement work, share your smart, simple, and satisfactory findings with your key stakeholders in targeted and engaging ways. After all, it's not enough for your arts nonprofit organization to believe in itself; you must make others believe in it as well.

KEY TERMS

FACE performance measures
impact evaluation
metrics
outcomes
output measures
performance measurement
SMART goals

QUESTIONS TO CONSIDER

How well does this goal align with our mission?

What resources do we need to accomplish this goal (human, technical, social, financial, etc.)? What are the individual roles necessary to accomplish this goal, and who will be responsible for each?

What is the time frame for accomplishing this goal? Is it a short-, medium-, or long-term action item?

How will we evaluate whether we have been successful in accomplishing our mission?

What data are necessary to evaluate this goal? What data do we already have, and what do we still need to gather?

ADDITIONAL READINGS

Chiaravalloti, Franscesco. *Performance Evaluation in the Arts: From the Margins of Accounting to the Core of Accountability*. Groningen: SOM Research School, University of Groningen, 2016.

Kaiser, Michael M. *Strategic Planning in the Arts: A Practical Guide*. Waltham, MA: Brandeis University Press, 2018.

CHAPTER TEN

Accountability and Governance for Arts Stability

*It takes less time to do a thing right
than to explain why you did it wrong.*
—HENRY WADSWORTH LONGFELLOW

LEADER TAKEAWAYS

After reading this chapter, you should be able to

- Understand models for effective fiscal compliance and the role of staff, board, and volunteers in the process
- Identify mechanisms for maintaining accountability in arts and cultural organizations
- Consider the leadership role of boards and characteristics of financially competent boards
- Identify roadblocks to high-performing boards and find ways to bypass them
- Embrace your role as leader in maintaining accountability

A few years ago, Johanne Turbide and Claude Laurin determined from their study of arts nonprofit boards that "among NPOs in this sector, governance is still viewed as a narrow concept where board members are mainly passive, basically rubber-stamping decisions for the benefit of external funders."[1] If this is still true, then it helps explain headlines like these:

Rhizome Board Member Resigned because of
Claims of Toxic Leadership

Metropolitan Museum of Art Scrubs Sackler Name
during Opioid Scandal

MoMA Board Chair Leon Black Has Been under Fire for His Business Ties

Americans for the Arts Have Been Critiqued for Inadequately Supporting BIPOC Arts Community Members[2]

Although these headlines are indicators that organizations are hopefully on their way to addressing and rectifying accountability and leadership problems, the best plan of attack is practicing strong accountability and oversight before problems arise. **Accountability** is an obligation or willingness to be responsible for one's actions. Arts organizations are responsible for compliance to industry standards as well as broader responsibilities to clients and patrons and society at large. **Compliance** in this sense means conformity in fulfilling official requirements. In other words, this isn't the time to be creative. While this book is centered squarely on financial accountability, general accountability is critical for good business and has positive ramifications for cultural organizations' bottom lines. Strong accountability can translate to better public relations, satisfied partners, and donors, and increased organizational legitimacy, all of which have beneficial impacts on your organization's financial picture.

While public organizations have several formal oversight mechanisms, arts nonprofit oversight by the government has historically been sparse, sporadic, and reactive rather than proactive. Research indicates that arts organizations "actively pursue accountability along . . . financial, organization, and mission" and that their "concerns about customers, audiences, and creative mission take precedence over efficiency concerns but also that certain subsectors in the arts have varying levels of oversight."[3] Museums, for example, have fewer policies and practices related to oversight than other nonprofit organizations do.[4] Yet, aside from your board, who holds your organization accountable?

Outside of IRS reporting requirements, federal oversight in the United States has been reserved primarily for contract and granting relationships. Public sector officials are used to being under the media spotlight as well as responsive to public scrutiny, while nonprofit arts managers have come lately to this role, particularly considering some high-profile scandal or mismanagement crisis like Rhizome's, the Sackler case, or MoMA's recent board distresses. Over the past thirty years, calls for greater accountability in the public and private sectors have filtered through to arts nonprofits. The limited current governmental oversight offers the sector flexibility, yet within the past decade the expectations have been rising: a new movement is urging nonprofits to behave more like the public and private sectors, encouraging nonprofits to embrace "philanthropic marketplace" management practices, including performance measurement, cost-benefit analysis, and the like.

Federal and state government laws and regulations regarding nonprofits have been put in place to support the donors and assets of these organizations. In this way, the government has been concerned with accountability for years; however, nonprofit organizations have been under increasing scrutiny over the past thirty years as the federal government has turned attention to nonprofit fiscal policy, charitable solicitation practices, oversight issues, and advocacy rights in addition to more federal outlays through grants and contracts.

In the mind of the public, nonprofits are supposed to do good and to be good. Accountability systems and fiscal compliance structures are established to ensure organizational adherence to financial and ethical standards for arts and all other nonprofits, a necessary step to promote public trust in the sector, which is unfortunately low across institutions, according to a 2021 Independent Sector report.[5] While state regulations monitor fiscal policy and practices in conjunction with the laws of the state, the states have varying levels of regulations regarding nonprofit organizations, ranging from mildly regulated states like Kentucky to highly regulated states like Illinois and California.[6] Many watchdog organizations and nonprofits themselves feel this initiative and other state regulations fall short of the need for accountability.[7]

Beyond state regulations or accreditation requirements such as the National Office for Arts Accreditation for schools of arts and design, the IRS provides the most oversight of nonprofit activity through the initial process of obtaining tax-exempt status and also annually through the submission of Form 990, which US nonprofits with gross receipts of $200,000 or more or total assets of $500,000 or more are required to file annually.[8] The IRS encourages very small nonprofits who are not required to file the 990 to submit a shorter form in order to increase data collection and therefore promote a fuller understanding of the sector overall. With some exceptions, nonprofits whose annual gross receipts are normally $50,000 or less may file Form 990-N (e-Postcard).[9]

SARBANES-OXLEY AND BEYOND

Accountability of nonprofits became a more significant question in the early 2000s in light of public financial scandals and passage of the Sarbanes-Oxley Act of 2002 for the private sector. Although the Sarbanes-Oxley Act established greater accountability parameters for private organizations covering accounting, management, administration, and transparency practices, the spirit of Sarbanes-Oxley reform permeates the nonprofit arts sector as well.[10]

Two provisions of Sarbanes-Oxley altered the federal criminal code and therefore directly apply to nonprofit arts organizations. In terms of law, nonprofits are affected by the provisions regarding (1) whistleblower protection

and (2) document destruction. Nonprofits cannot retaliate by punishing whistleblowers, nor can they destroy litigation-related documents and must adhere to specific processes for appropriate document destruction. Other Sarbanes-Oxley provisions do not specifically alter nonprofit activity but influence the way they operate. These provisions reference several **fiduciary** (holding money in trust for another) responsibilities, including an independent audit committee, responsibilities of auditors, financial statements, insider transactions, conflict of interest, and disclosure.[11]

Nonprofit managers have responded to calls for greater accountability and oversight in a variety of ways, including adopting some Sarbanes-Oxley practices voluntarily and lobbying at the state and federal level. In addition, nonprofit managers can support and implement self-regulatory measures (such as internal controls and policies, as detailed in chapter 12) within the arts sector.

Arts organizations that contract with either state or federal governments are bound to more stringent reporting standards, regardless of their organizational mandates. Granting agencies are becoming increasingly strict in their reporting requirements for grantees in efforts to bolster the accountability of funded organizations. Problems with nonprofit grant recipient management have been noted at the federal level.[12] After Charitable Choice was enacted in 2002, the General Accounting Office recommended greater federal clarity in communicating the terms of the statute to help organizations comply.[13] Legislative interest in the accountability of nonprofit organizations has increased, and so has public outcry from watchdog agencies and donors who want more information on organizational practices and fiscal principles. Calls for greater accountability in the nonprofit sector are evidenced by legislative hearings.

Early accountability standards concentrated on financial and fundraising best practices, but these early models have expanded in recent years to encompass all areas of organizational governance. Along with suggesting or promoting guidelines for accountability, some organizations, such as the Better Business Bureau's Wise Giving Alliance, Ministry Watch, the Maryland Association of Nonprofit Organizations, and other watchdog nonprofits, have instituted accountability ratings systems that are available to the public, along with extensive reports on individual charities. These organizations cover arts organizations along with all other types of nonprofits. The ratings provide easier outside scrutiny of an organization over a range of disclosures and best practices but do not convey a complete picture of an organization's accountability or degree of mission attainment.

To encourage the incorporation of accountability practices throughout the nonprofit sector, the Panel of the Nonprofit Sector conducted a study of existing

codes, ratings, and best practices. The study concluded by recommending the voluntary adoption of thirty-three measures covering four main categories, including (1) legal compliance and public disclosure, (2) effective governance, (3) strong financial oversight, and (4) responsible fundraising.[14] Although over 100 organizations and agencies provide accountability frameworks, including best practices in general management and the disclosure of information to the public, and most organizations embrace accountability practices, there are few sanctions for noncompliance outside of donor influence or governmental intervention. Arguably, nonprofit organizations in general have weaker "lines of accountability" than the public sector.[15] The headlines at the beginning of the chapter could be the result of these weaker lines of accountability.

Considering these potential barriers to holistic accountability practices in nonprofits, what practices can help your organization become more accountable?

ENSURING YOUR ORGANIZATION'S ACCOUNTABILITY IN PRACTICE AND PERFORMANCE: YOUR BOARD

While state and federal oversight is useful, your organization's first line of defense with accountability and fiscal compliance is your board. The board not only performs essential financial oversight but also ensures that your organization is operating within the law, earning money honestly and spending it responsibly, adopting policies and procedures to carry out the mission, and supporting the executive director. To use a political analogy, your board is like Congress. Their job is to create big-picture policies and possess general knowledge. You and your staff are the bureaucrats who implement policy and have the technical and specific information to do so.

In *Nonprofit Governance and Management*, Fisher Howe writes, "The board as a whole—and its members individually—are answerable for everything the organization does and how those things are accomplished."[16] Unfortunately, however, many accept a board position without realizing what the job entails. BoardSource conducts a survey of executive directors and board chairs every other year to find out about, among other things, the size and composition of boards, and how well boards and executive directors think their organization is doing in carrying out board responsibilities. In 2021, the responses of 820 executives and board chairs across the United States gave their boards a grade of B-minus on "understanding the Board's Roles and Responsibilities."[17] Groups like ArtsFund (Washington state), the Arts + Business Council of Greater Philadelphia, the Minnesota Council of Nonprofits, Propel Nonprofits, the National Center on Nonprofit Enterprise, and other arts consulting groups

offer training for board members. Financial accountability is just one of the multiple responsibilities discussed in such training but is our primary focus in this chapter.

You can help your board do a better job by helping them realize the scope of their charge, and they will, in turn, do a better job for you. Clear communications regarding your expectations for your board members can help them be more productive and less frustrated. While board members are specially invited to serve in part because of expertise they hold, do not expect your board member to do for free what they would normally get paid for unless you have set those expectations in advance and know the potential board member is all right with that arrangement. Doing otherwise can make an asset into a potential adversary. The larger point is that clearly communicating expectations about their job, even with those who have other board experience, is critical for a well-functioning and high-performing board.

The board's responsibilities can be broken up into three major categories: leadership, structural mechanics, and oversight.

> **Leadership:** The board is the primary guardian of your organizational mission, vision, and values, and your job as staff is to enact them. The mission involves who your organization is, and your values reflect how you intend to carry the mission forward. Your vision is a demonstration of how the world will be different if you accomplish your work, and your board's vision imperative emphasizes its planning role. Where is the organization headed, including strategic plans like establishing goals and objectives as well as tactical plans like succession planning?[18] Finally, the board serves an important job as guardians of your organization's public standing by advocating for and reminding the public of the importance of your organization's work. One of your board's duties in providing this public face is fundraising. When a board fails in its leadership responsibilities, headlines like the ones at the beginning of the chapter can result.
>
> **Operations / internal management:** Along with leadership, your board has some functions that are inherent to its relationship with the executive director and its own operations for efficient and effective governance. Relative to the executive, the board both selects and supports the executive director. In addition, the board must establish and maintain its own structures like committees and subcommittees, build the board and select the right people to join, and approve and enforce your organization's accountability policies.

Oversight: Most of the responsibilities we'll elaborate here deal with the board's legal, ethical, and financial oversight functions. Along with practicing the concept of due diligence, these functions also include monitoring programs and services and evaluating the executive director.

As you consider ways to help your board step up its game, it might be helpful to ask how much time your board spends in each category. If you are focusing most of the board's time on structural issues, and not spending as much on leadership functions, you may want to consider how to create more space for your board to exercise its leadership role. Since our purpose is financial health, we'll focus most closely on the board's oversight responsibilities here. But obviously, there are overlaps among these three categories, and the effective execution of each of the board's functions has some type of economic ripple effect on your organization.

For example, to "monitor, strengthen programs and services," a board must assess the financial viability and sustainability of those programs and services. In ensuring legal and ethical integrity, a board must act in accordance with generally accepted accounting principles and make sure the organization has effective fiscal controls in place. Part of effective planning is determining that plans decided are backed by sufficient resources to accomplish them.

The legal concept of **due diligence** is the polestar of any board's responsibilities. Cornell Law School defines *due diligence* as "care or attention to a matter that is sufficient to avoid liability, though not necessarily exhaustive."[19] Three key legal mandates spring from the concept of due diligence for board members, including the duties of loyalty, care, and obedience. **Duty of loyalty** is a dictate that the board member places the organization's interests first, ahead of any personal interest. This duty requires that board members abide by policies and procedures and maintain confidentiality for all board dealings. **Duty of care** pertains to how an individual operates as a board member. They exercise care in the conduct of their job. For example, board members read materials, attend meetings, seek to monitor programs, and budgets, and set the context of big policy decisions. The **duty of obedience** pertains to a board member's obedience to local, state, and federal law, as well as your organization's articles and bylaws.

By faithfully adhering to these duties, board members will not be legally held liable for wrongdoing committed within the organization. Protect yourself and your organization through prudent behavior, and protect your board members by providing indemnification clauses in your board documents, or at

least recommending those clauses as well as liability insurance to cover them in case of financial or other scandals related to your organization. Similar to the "innocent until proven guilty" maxim we are supposed to assume in US courts, the "business judgment rule," a phrase borrowed from business terminology, assumes that "unless proved otherwise, management is acting in the interests of the corporation and its stakeholders."[20] If your board has reasonably made efforts to get correct and appropriate information through competent people and act within the boundaries of the duties of care, loyalty, and obedience, then they have operated in good faith.

Along with loyalty, care, and obedience, board members should exercise candor during their deliberations. They need to talk with each other in a candid and respectful way so that all people know what is going on and can make solid and informed decisions.

While all board members are responsible for abiding by the principle of due diligence, the board members with the highest degree of oversight of your organization's money comprise your finance committee.

YOUR BOARD'S FINANCE COMMITTEE

Although some board committees come and go, your board should consistently have a standing finance committee. (Sometimes it is called by different names, but its purpose should be the same). The finance committee should be chaired by your board's treasurer and is responsible for

- Overview, approval, and monitoring of the organization's budget
- Approval of the audit
- Oversight of all financial statements and investments throughout the year
- Fostering engagement with the entire board regarding financials
- Making recommendations regarding fiscal policy and procedures

Members of your finance committee should be well versed in financial policies and procedures with experience in these areas, if possible, so that they will be prepared to move into the treasurer role.

CHALLENGES: ROADBLOCKS TO HIGHLY ACCOUNTABLE BOARDS

We read stories like the near-bankruptcy of the New York City Opera, the "people's opera," and wonder, How did this happen?[21] Why didn't someone notice the problems with finances and do something about it? The board was

reviewing financial statements, right? And although NYCO's story has a happy ending, complete with a knight-in-shining-armor rescue by board member and hedge fund manager Roy Niederhoffer, it shouldn't fall to a board member to resuscitate an organization; rather, the whole board should consistently practice vigilance and make healthy decisions for the organization.[22]

In responding to a board's stated duties of care, loyalty, and obedience, some boards perform better than others. Also, boards are acting on the information they are given. In the case of the New York City Opera, which side of the coin was uppermost is uncertain, although financial difficulties had been present for some time.

Sadly, the finance functions of the board are often the ones that a majority of board members abdicate to the finance committee or solely to the treasurer. In our experience, this behavior is particularly true with smaller arts and cultural boards, founder-led organizations, or those that lack much financial expertise. Although financial oversight is rated as one of the most important parts of their job and on average board members give themselves a grade of B for their performance in this area according to the 2021 Leading with Intent survey, performance in this area varies widely and depends on a board's level of financial preparedness and comfort with regard to reviewing financial statements. You can help your board avoid financial foibles by establishing a finance/audit committee if you don't already have one; making sure your board's treasurer has the financial experience to understand and help translate finances to your board members lacking that experience; sending out finance reports well before the board meets, with notes from the finance committee on issues to consider; and encouraging the full board to attend workshops or special sessions on how to read a financial statement.

Typical roadblocks to a financially high-performing board are fear of finances, lack of participation, ineffective committees, misunderstanding board and staff roles, and micromanaging. Fortunately, these roadblocks all have solutions.

Fear of Finances

Some folks are just afraid of dealing with finances or feel inadequate to deal with financial reports. And whether from fear or other factors, many people are far too willing to simply trust that others on the board or the auditors will catch any problems on financial statements. Remind your board that everyone is responsible for and needs to understand the financial position of your organization, even if their primary responsibilities are creative. And help remove potential fears by providing clear resources that will help them better understand how to read and interpret financials.

TABLE 10-1. Roadblocks to High Performance

Roadblock	Solution
Lack of participation	Be engaged, implement policy on employee participation
Ineffective committees	Revisit committee purpose, revise committee structure
Misunderstanding board and staff roles	Improve communication between ED and board
Micromanaging	Reduce fear
Founder transition	Do succession planning

Lack of Participation

If your board members are not fully participating, or maybe not even showing up for board meetings, provide them with additional opportunities for engagement. Like your other volunteers, your board members need to feel like what they are doing is important for your organization. Talk with them individually to find out how connected they feel to the mission of your organization, what they love about your organization, and what they like or don't like about being part of the board. Such conversations may be particularly important for larger organizations, whose board members may be less engaged, partly because there are better-established policies and procedures in place.[23] These conversations may illuminate some of your difficulties with engagement and provide direction on how to best utilize the talents on your board. Consider other ways to engage or reengage your board between meetings through contacts from your office, opportunities to socialize, or events they can attend.

If all your engagement strategies fail, look at your bylaws and see what kind of term limits are in place for board membership. If you have board limits in place, make sure they are enforced, to allow your organization the infusion of new enthusiasm and new thinking. If you don't already have term limits in place, establish them now. This not only lets those who might be willing but hesitant to serve on the board see that they are not "hooked for life"; it also brings new ideas into the mix. And it can also help keep the organization from being dominated by one board member who has been around long enough to see themselves as the king or queen whose will must be obeyed without question.

Ineffective Committees

Ineffective committees spring from ineffective leadership. If you do not already have board committees that meet and have work to accomplish in between your

regularly scheduled full board meetings, then do so immediately. That can be one strategy for keeping people thinking about and advocating for your organization more consistently. If the load expected of your board members is so light that it is almost meaningless, then the board members may see their own contributions and expectations as meaningless as well. And don't just give them busywork! There is enough *real* work in any organization to keep board members contributing and engaged.

Misunderstanding Board and Staff Roles and Micromanaging

Does your board show up unannounced to your office, call a staff member directly regarding a project, or overstep their boundaries in other ways? If so, you may have an issue with role conflict and micromanaging. Several factors can lead an individual board member or even a full board to micromanage, and most of those factors are framed with good intentions. For example, if your board misunderstands their role relative to you and your staff, micromanaging behaviors can result. But you can take steps toward eliminating that problem by clearly explaining the board roles (as have been outlined in this chapter) and the job descriptions for your staff. Often, just understanding the differences in their respective roles will help. Micromanaging can also occur when a board has been a managing board, more involved by necessity in day-to-day operations, to a governing board that is appropriate for a more mature organization. That switch can be difficult for some who have been used to expressing their board responsibilities in a hands-on fashion. Once again, communication is key. Make sure the board understands its roles and responsibilities as a governing board versus a managing board. And if that doesn't work, see the previous comments on term limits!

Effective communication between you as the executive and your board chair is essential to addressing and resolving each of these and the myriad other issues that will arise. The extra effort you can put into maintaining strong communication streams and building a positive relationship based on mutual trust with your board chair will bring positive returns.

Putting these practices into place should help your organization achieve a financially competent board. And what should such a board look like?

CHARACTERISTICS OF FINANCIALLY COMPETENT BOARDS

Along with following general accountability principles, financially competent boards are comfortable with financial decisions and consistently practice transparency, inclusivity, and engagement.

Financial comfort: Financially competent boards share fiscal responsibility and are engaged in financial planning and resource development. You can help build the financial comfort of your board by being explicit about the expectations, providing clear resources, and carefully determining the composition of your finance committee and treasurer.

Transparency: Make sure that communication between yourself and the board and your organization's stakeholders is clear and honestly represents the financial position of your organization. Posting financial statements, 990s, and annual reports on your organization's website is a great way to demonstrate financial transparency.

Diversity and inclusion: Diverse boards bring different financial perspectives and could help your organization reach different audiences, consider alternative funding mechanisms, and demonstrate your organization's commitment to equity. Assess your board's composition and consider how various stakeholders are involved and valued by your organization.

Engagement: Higher levels of board engagement create a better experience for all your board members and can often lead to better financial decisions and oversight. Committee, subcommittee, and taskforce work can create opportunities for engagement between board meetings and increase the productivity of your board. Having each committee submit a brief report to share with the full board before the meeting or report about their committee's activity between full board meetings can also help keep folks engaged. Give them meaningful work to do, and get your board chair's support in holding them accountable to get it done.

YOUR ROLE AS LEADER IN MAINTAINING ACCOUNTABILITY

As part of your organization's overall mission fulfillment, a simple yet very helpful exercise is to ask, Who are we accountable to, and what are we accountable for?[24] The answers to these questions will undoubtedly be multilayered and complicated; however, identifying them can help you determine your organization's accountability map. And because most organizations lack the capacity to appropriately address every accountability relationship for their organization, mapping your accountability landscape can also improve everyone's understanding both about where accountabilities might overlap and about which to prioritize in accordance with your organization's mission and financial structures.

TABLE 10-2. Practices of a High-Performing Board

Practice	Means
Transparency	Open communication, public access to documents
Accountability	Consider to whom and for what is the organization accountable
Diversity and Inclusion	Access board composition, stakeholder involvement
Engagement	Participation makes a better board experience

You can and should help your board and staff accomplish their financial oversight objectives by managing up, across, and within:

Manage up to your board. Boards can only act on information given to them. You are responsible for getting them accurate and timely financial information. Help them by allotting appropriate time and resources to financial discussion during and in between board sessions.

Manage across your staff. Develop policies and procedures that limit opportunity for malfeasance, exemplify ethical behavior, convey that everyone has a role in the organization's financial sustainability, and create a culture where accountability and financial literacy are valued, fostered, and expected. Share financial information with pictures and words as well as numbers. Infographics and dashboards can effectively convey financial facts about your organization in a clearer way than handing someone a spreadsheet or financial statement; just make sure they accurately reflect the numbers.

Manage within. Hold yourself accountable as well. By reading this book, you've demonstrated a desire to learn more and become a better financial leader for your organization. If you continue to build your own comfort level with finances, you can be a better advocate to your board and other stakeholders about your organization's financial needs and opportunities.

KEY TERMS

accountability
compliance
due diligence
duty of care

duty of loyalty
duty of obedience
fiduciary

QUESTIONS TO CONSIDER

What is our organization accountable for?

Who are we accountable to?

Are there policies in place that hold each piece of the organization accountable? If so, are they traceable to the individual(s) actually directly responsible for that piece?

Does your organization's board understand whether they are a managing or a governing board?

Are you getting the most out of your board? Are you asking too much of its members? What can you do to correct for either apathy or micromanaging?

ADDITIONAL READINGS

BoardSource resources for support and research—www.boardsource.org.

Kearns, Kevin P. *Accountability in the Nonprofit Sector.* New York: M. E. Sharpe, 2010. See especially pp. 197–210.

Rentschler, Ruth. *Arts Governance: People, Passion, Performance.* Milton Park, UK: Routledge, 2014.

Turbide, Johanne, and Claude Laurin. "Governance in the Arts and Culture Nonprofit Sector: Vigilance or Indifference?" *Administrative Sciences* 4, no. 4 (2014): 413–32.

The website of your state attorney general's office, for information regarding nonprofit regulation and oversight.

CHAPTER ELEVEN

Worth a Pound of Cure

Preventing Fraud and Abuse in Arts Nonprofits

An ounce of prevention is worth a pound of cure.
—BENJAMIN FRANKLIN

LEADER TAKEAWAYS

After reading this chapter, you should be able to

- Identify potential types of fraud in arts nonprofits
- Identify and implement mechanisms for preventing fraud and abuse
- Create policies helpful in preventing fraud and abuse
- Embrace your role as a leader in fostering an organizational culture of compliance

A paid staff member who began as an enthusiastic volunteer had handled all the finances for a small founder-led youth choir for the past two years. The day she needed $125 to keep her bank account from being overdrawn, she knew no one would pay any attention to the overcharge she added to the sheet music bill, and besides, she fully intended to pay it back. But her credit card charges slowly increased over the next eighteen months. She had been right, though: no one noticed. Even though there were many parent volunteers, no one noticed—not the ones who helped catalog the music, altered the performance wardrobes, or set up the sound system, and not even the ones who volunteered on the board and saw the balance sheets—until the day one observant parent finally did start asking questions about the numbers. By then over $12,000 had been pulled from the choir's account.

Although this particular scenario is one we made up, very similar scenes are happening at nonprofits all the time. Although most evidence indicates that true fraud of any real size within the nonprofit sector is fairly negligible, it can

be equated to damage in a car wreck—it's not negligible if it's happening to you. And even a small incident in your organization could lead to big problems. That ounce of prevention can spare your organization losses—not just financial ones but also others that might be even harder to recover from. A scandal, breach of compliance, or some other type of fraud will impact your bottom line and could also cause you to lose credibility, legitimacy, and potential future engagement as well as future funding prospects. In such a case it might take an organization years to recover—and it may never recover, in fact, because your organization's trustworthiness is one of your most important assets for ongoing sustainability and financial success.[1]

So don't skip this chapter because you think it can't happen to you. After all, very few people buy a car with the expectation of having a wreck, yet despite the many laws, rules, and regulations for drivers, accidents still happen. Imagine how many accidents would happen if there were *no* rules in place! **Fraud**, by its simplest definition, is deceit or trickery. But more specifically, according to *Merriam-Webster*, it is "intentional perversion of truth in order to induce another to part with something of value or to surrender a legal right."[2] Over the next few pages, we'll discuss some common types of fraud and how to establish and monitor a system of internal controls to reduce the risk of fraud to your organization.

What constitutes fraud and abuse in arts and cultural organizations? Unfortunately, there are all kinds of fraud and abuse possible within these organizations because there are all kinds of opportunities for fraud and abuse in financial systems in general. All it takes is a bit of creativity and, most important, opportunity. While organizational leaders cannot wholly control incentives for committing fraud, you can at least put policies and practices in place to help eliminate the opportunity.

Academic scholars discuss **principal-agent theory**, a theory born from the idea that people seek their own interests and are easily drawn into circumstances where they can be opportunistic or turn an opportunity to their advantage. In principal-agent theory, an agent acts on behalf of an organization, but because humans are naturally opportunistic, agents cannot be inherently trusted to safeguard the interests of the organization rather than their own. Therefore, agents need a principal watching over them to make sure they're not taking advantage of the organization and are being held accountable. It's a bit like the old Dr. Seuss story of the bee watchers of Hawtch-Hawtch, where one person is assigned to watch a bee but needs another to watch him, who needs another to watch him, and on and on.[3] And while that story is purposefully absurd, oversight *is* key and you do need to have the internal controls in place

to detect, or even better, to prevent fraud and abuse in your organization. A funny word with multiple meanings, **oversight** can mean either an inadvertent omission or error, or its exact opposite: watchful, responsible care. The latter definition is the one we want to encourage and foster. By implementing internal controls, you will hopefully arrive at the latter definition and avoid the former.

The choir scenario at the beginning of the chapter could have been prevented, or at least caught much earlier, with some very simple financial policies and procedures in place. Of course, other types of fraud and abuse can take place (contractual, sexual harassment, abuse of technical crew work hours, etc.), and you will need to be vigilant in seeking safeguards against those as well. Gather the resources and awareness needed to watch all the bees in your hive and, as we will discuss, establish a culture of transparency for your organization, one that makes it difficult for any nasty surprises to be hiding in the dark.

Our focus in this chapter is financial fraud. We'll spend just a few moments discussing some common types of fraud and then move on to the important work you can do to prevent a financial predator from taking advantage of your organization.

TYPES OF FRAUD IN NONPROFITS

Some of the most common types of financial fraud include credit card overcharges, expense understatement, fictitious assets, inventory manipulations, liability understatements, related party transactions, and revenue manipulations, according to Paul Clikeman's book *Called to Account*.[4] **Revenue manipulations** can be either recording revenue before it has been taken into the organization (i.e., within the GAAP allowable guidelines) or creating the illusion of greater revenue stores through understating returns on sales.[5]

Credit Card Overcharges

A credit card overcharge, like the one in our fictional example above, takes place when someone with credit card authority buys more than needed for the organization and sells or pockets the surplus.

Fictitious Assets

Organizations or their employees can post fake sales to fictitious patrons or clients known as "ghost customers," creating extra assets on the books. Recording sales on the books over and above what are made to real patrons or customers is another way to perpetrate this fraud tactic. Why do it? Either of these methods make the organization look more fiscally sound than it actually is and masks

mismanagement—at least for the short term. However, like most such Ponzi-type schemes, this house of cards will come tumbling down and often bury not only those caught but also possibly the unsuspecting managers who allowed such things to occur, or even the organization itself.

Overstating Assets

Like fictitious assets, this fraud tactic makes an organization look healthier on its books than it really is. If we use the calculation of assets minus liabilities to understand our organization's net assets (or equity), then a higher asset amount will result in higher net assets if liabilities remain equal. Understating liabilities has the same effect as overstating assets. Both make your organization look like it is performing better than it really is.

Expense Manipulations (Expense Understatement)

A common and simple way to understand your organization's profit margin is to deduct your expenses from your revenues. If the resulting number is positive, you are in a safe zone; if that number is negative, your balance is in the red. Think about your own bank account and what having no funds would mean—misery, just as Dickens's Mr. Micawber said. So the expenses your organization reports will make a difference to that bottom-line number, and if your expense reporting is inaccurate, that balance will be inaccurate too. Expense understatement makes the balance more positive than it actually is. If I have ten dollars in revenue and ten dollars in expenses, my balance is zero; but if I have ten dollars in revenue and ten dollars in expenses but only report *seven* dollars in expenses, then my profit is overstated by three dollars, giving a false impression of financial safety.

Timing also comes into play with this type of fraud. If your organization recognizes an expense or expenses in the following fiscal year that should have been realized, or recorded, in this fiscal year, then your current fiscal year balance will show up on your balance statement as greater than it actually is. Understating expenses and overstating revenues produce the same result on net income. In both cases, the organization is misleading stakeholders, including the board, regarding your true financial picture. And this is also likely to affect many more things regarding how your organization operates and what opportunities it will have going forward.

Liability Understatements

Like overstating assets, understating liabilities creates the illusion that an organization is better off financially than it is. This tactic underrepresents the

liabilities and allows for an expense of a similar size to not be recorded. According to generally accepted accounting principles, a "reasonable estimate" of liabilities must be reported.

Either not recording a liability or recording it at less than its actual value is fraudulent. On the balance sheet, both would mean that an associated expense is not accurately recorded, because that financial document must demonstrate a balance between assets and liabilities.

Inventory Manipulations

Inventory may or may not be a significant asset for your organization. In either case, any inventory needs to be cataloged and accounted for within financial statements. Inaccurate or negligent accounting of material inventory can be manipulated. For example, someone with access to inventory could pull out some of the existing stock and resell it, or if they are involved with the incoming inventory, they could simply underreport the amount coming in and sell the rest.

Related Party Transactions

If you have a conflict-of-interest policy in place, you already have your antenna up to identify potential related party transactions. Anyone who can exert undue influence on someone else, whether a relative, business partner, or board member, is potentially a related party. Transactions could be either services, obligations, or resources. Colluding in a related party transaction can create a sweetheart deal where the interests of the related parties take precedence over the interests of the organization, therefore violating the duty of loyalty. If your organization buys its tech from a company owned by your board chair's brother, that will fall under the definition of a related party transaction, because your board chair has a strategic responsibility within your organization, and the transaction benefits someone related to your chair. On the other hand, if your organization buys its tech from a company where one of your employee's brothers works as the shipping clerk, that would not conform to the definition of related party transaction, because the related parties would not be wielding significant influence or reaping any direct personal benefits within that transaction even though they are closely related biologically.

Tax Evasion

No one loves paying taxes, and typically we don't discuss taxes in books about nonprofits, since they are exempt from many kinds of tax. Given that taxes are ubiquitous, however, it is not surprising that evading taxes can be an enticement you need to guard against. Tax avoidance is considered smart business, but tax

evasion is criminal. Typically, tax evasion takes place on the donor side in the arts world where donors can take advantage of exorbitant price estimates on artwork and donation incentives in the tax code to achieve higher levels of tax deduction. And while you cannot monitor your donor's behavior, your organization has some pitfalls to watch out for, too, namely unrelated business income and nonexempt taxes.

On the organization side, if an organization collects unrelated business income but does not report this income as taxable, then the organization is defrauding the government from the tax money on those transactions. Unrelated business income tax (UBIT) is required on revenue obtained by a charitable organization but not directly tied to its mission. For example, if a historical society had a pickle business on the side, the revenue from pickle sales could be classified as unrelated to the historical society's mission. However, if the pickle sales are tied to funding the organization's preservation and cultural purposes, no tax would be required. Although the UBIT issue is not one likely to plague your organization internally, you'll want to be mindful of any potential taxes your organization might be required to pay for unrelated revenues as well as any local taxes for certain activities you may perform.

Nonexempt taxes can catch an arts organization off guard. If there are local taxes, for example, a new or ill-informed director may fail to pay them because they don't understand the system. Talk with local officials about what taxes may be required of your organization and research whether they apply. If they do, establish procedures for paying them in a timely manner.

AN OUNCE OF PREVENTION: INTERNAL CONTROLS AND OTHER MECHANISMS FOR REDUCING FRAUD AND ABUSE

Financial controls are necessary to prevent the types of fraud and abuse opportunities mentioned above. And the good news is they are easy to implement with little to no added cost. In fact, as Deb Polich with Artrain and Creative Washtenaw shared, "We're all about best practices. Whether an organization is large or small, financial policy should apply to everyone. . . . If we have rules and things to follow, then we don't have to make them up every day. I don't know if that's laziness or efficiency. I don't want to make something up every three days."[6]

Having policies and procedures can save you time and headache because they reduce the amount of time you must spend making decisions. We'll go over several for you to revisit or consider implementing within your organization

and encourage you to take the self-assessment provided by the Nonprofit Association of Oregon (see appendix table A2) to see how well prepared your organization is to prevent problems and create strong accountability systems.

Mechanisms for Reducing or Eliminating Fraud and Abuse

Nearly all the organizations we talked to in preparing this book noted key policies that help them reduce the opportunity for fraud. Chief among these are conflict of interest, separation of duties, and financial access. The examples we provide here are not exhaustive, but they offer a bare-minimum place to start. If your organization does not currently have these policies and practices in place, start making steps today to establish and enforce them. If you do have such policies and practices, take the time to review them to make sure they reflect the current status of your organization's practice, a process known as an **accountability audit**.

Policies and Procedures

Organizational policies dictate organizational procedures—or at least they should. **Policies** are the written guidelines that your organization strives to uphold, and your **procedures** are how you carry out your policies in operations. Codifying what you intend to do or how you intend to behave sets boundaries for identifying transgressions from those goals and helps to hold you, your staff, and board accountable. The following list is not exhaustive, but each of the following policies, when faithfully enacted and followed, can mitigate the potential for financial fraud in your organization.

Conflict-of-Interest Policies

Merriam-Webster again gives us a concise, straight-to-the-heart definition: a **conflict of interest** is "a conflict between the private interests and the official responsibilities of a person in a position of trust."[7] Conflict-of-interest policies are important and can protect your organization in several ways.[8] So if you don't have any, create some immediately. Primarily, such policies, if assiduously implemented and followed, ensure that no double-dealing is taking place by members of your board or staff. And secondarily, having conflict-of-interest policies in place signals credibility to your donors and other stakeholders.

Separation of Duties

A simple yet effective accountability mechanism for your financial practices is separation of duties.[9] Basically, you provide checks and balances in your

financial processes to make sure that multiple people are aware of and sign off on financial transactions. For example, the person who lists the checks in the account book is not the same one who deposits the checks in the bank. Or the person who writes the checks is not the same person who authorizes the checks (usually over a specific amount).

Smaller organizations, due to limited personnel, may be forced to ignore some of these practices; however, in such cases, a board member, perhaps the board treasurer, can and should step up to provide the oversight needed to have more than one set of eyes on your day-to-day financial transactions. Perhaps the board chair or treasurer would provide a second signature on checks above a certain amount or be required to approve expenditures. While this might sound unwieldy or simply an extra bother, such steps are likely both to avoid much greater time and trouble later and to make board members truly feel a part of the operation.

Financial Access and Authorization

Set up secure access for organizational accounts with banks, vendors, credit, and investment accounts and make sure the passwords for those accounts are kept in a secure place with limited access. The same is true for access to computers housing financial software or accounts, credit card numbers, or other financial access. People whose jobs have nothing to do with financial transactions should not have access to those accounts. However, make sure that someone trustworthy does have access and that all passwords are stored in a secure place in case of emergency. One arts education executive shared that her organization's previous policy had given password access to only one person. When that staff person abruptly left in a huff, the passwords went with her, creating all kinds of headaches for those remaining until others could reboot the systems and create new passwords. Even though the whole organization and all organizational stakeholders should be able to access public financial documents, access to financial accounts should be guarded and restricted to those who need that information to do their jobs and keep the organization financially stable.

Here are some practical day-to-day steps you might want to take if you haven't already:

Credit Cards, Bank Account Numbers, Passwords
- Just as you do with your personal cards and information, this sort of information should be kept as private as possible, with only those needing such information having access to it. Many organizations, especially arts organizations, rely on volunteer help, and whereas most

such helpers are trustworthy and honest, it only takes one person that sees temptation as an opportunity.
- Keep computers with such information, along with files, and so on, under password protection and not out in the open where access is easy.
- All credit cards, account numbers, and so on should be locked up and available only to a limited few who can access such things when needed. However, as our arts administrator above reminded us, this does not mean that these items should be treated as one's personal information. Such information should be available to more than one person and kept in a secure place so that an organization does not suddenly find itself unable to function and operate simply because a disgruntled employee quits or goes on vacation.

Cash and Checks

- Handling cash is one of the easiest ways for fraud to occur. It can easily "disappear" before it can be recorded, or it can be recorded and then find its way to other pastures. Although you cannot eliminate every opportunity for fraud, remember to put safeguards in place wherever possible.
- If cash is collected at fundraisers or sales, try to have more than one person collecting or working so that temptation might be cut down.
- Have cross-references available, if possible, for summary accounting.
- Lock up petty cash and, again, limit access to it.
- Make sure receipts are collected for all cash payments.
- Require that more than one person is needed for writing and signing checks, at least above a certain amount.
- Establish a process for securing and recording all checks and other such payments, such as deposit-only restrictions at your bank, rather than allowing third-party checks to be cashed directly.
- Establish a process for approving purchases in advance, and develop clear guidelines for what types of things can be purchased with a credit card or petty cash; a dollar-amount limit on purchases; and at least a double approval requirement for purchases beyond that dollar amount.
- Reimburse only for things that have been approved in writing and in advance, and detail what kind of expenses can and cannot be reimbursed. For example, many organizations do not reimburse for alcohol or first-class tickets or hotel costs beyond a previously stated amount per night.

- Perform reconciliation, which includes not only accounting procedures to make sure that all items are costed and accounted for but also inventory and vendor tallies and periodic check-ins. One common scheme that can be difficult to catch if you don't watch for it and do regular oversight is that of checks going out to fictitious vendors for "ghost" goods and services.

Gift Acceptance Policies

Another area of potential abuse, uncertainty, and just flat-out awkwardness is not so obvious: gift acceptance. Although the onus of responsibility for accurately reporting individual gifts coming into your organization is the responsibility of the donor, your organization's gift acceptance policies will help you figure out when to say no to a gift that may have negative consequences (negative publicity, potential tax burden, difficult to use or dispose of, etc.). And not all gifts are presents to your organization (see chapter 3 for more). Like the horse the Greeks "gave" to the Trojans that was full of trouble, not all gifts should be welcomed. Gift rejections need to be handled with finesse so as not to offend any well-meaning potential contributor, of course, but you might save yourself a world of hurt by taking a lesson from the Trojans.

There are many online sources for guidance about gift policies, including the National Council of Nonprofits and Creative Washtenaw, a member arts advocacy organization in Michigan that has a nine-page gift acceptance policy, including guidance on accepting everything from cash, securities, real estate, and personal property including furniture, marine vehicles, and even airplanes! Just remember to be mindful of potential gift issues before they arise; by preparing in advance, you can save yourself from worry and headache.

Other Policies

Along with standard financial policies and procedures, arts organizations sometimes have other organizational imperatives that create the need for additional policies. Americans for the Arts, the International Association of Blacks in Dance, and the Council of Nonprofits, among others, offer recommendations on policies and procedures such as codes of conduct, harassment policies, privacy policies, photography/audio/video consent and recording policies, and even event safety and responsibility policies. Along with your financial policies and procedures, use these organizations and others for examples of things you should consider as part of your accountability and fraud prevention soup.

Establishing a Mindset and Culture of Ethical Behavior

Setting up policies and acting on them is one of the most important factors in combating fraud. The other essential criteria are establishing and maintaining a culture counter to one that encourages fraud and abuse to occur. As an organizational leader, you are essential in creating and upholding a culture of ethical behavior within your organization. You can establish ethical expectations and model that behavior to all your internal and external stakeholders, and you can foster an atmosphere where staff feel valued and supported in expressing dissent or questioning decisions in appropriate ways. But you are not superhuman, and every possible contingency cannot be accounted for through policies and procedures, so what are some steps you can take to create this important culture?

Here are a few things you can do:

Accept responsibility and criticism. Not every criticism is warranted, of course, and no one is suggesting that you become a doormat for every complaint directed your way. But far too often we do not want to hear about our faults or areas where we could improve. Such an attitude is circular and will inevitably prevent improvement. Be confident enough to listen to criticism, and wise enough to know when to act upon it. And accept responsibility when it is yours. Hold people accountable for their responsibilities, but hold yourself accountable as well—sometimes a much harder task if there is no immediate supervisor to report to.

Foster and model ethical behavior. You cannot expect others to act in ways or meet expectations that you yourself are not modeling. Just as the actions of parents speak much louder to their children than any amount of scolding, nagging, or pleading, employees also respond much more strongly to what they see in the work culture than what they simply hear, especially if it runs counter to what they see. The saying "Physician, heal thyself!" is a good reminder of the limitations of recommending one thing while doing another.

Foster communication. If those around you are afraid to offer feedback, it will be impossible to hear any. And often those who feel their opinions and thoughts are not valued are not as open to receiving thoughts and opinions from others. Open communication does not mean the ability to share anything with anyone at any time. Too much of such "freedom" can lead to abuse, harassment, discontent, and so on. Again, you as the leader need to set the accepted parameters and model the behavior

needed to encourage a thriving and vibrant atmosphere where everyone can feel safe and valued.

Unfortunately, fraud is a very real part of our world. The best way to get out of quicksand is to avoid getting into it in the first place. Likewise, the best way to avoid fraud is to have policies, practices, and performance measures in place to stop it *before* it occurs.

KEY TERMS

accountability audit
conflict of interest
fraud
oversight

policies
principal-agent theory
procedures
revenue manipulations

QUESTIONS TO CONSIDER

Do you have policies and procedures in place to limit opportunities for fraud and abuse in your organization?

If so, do you actually follow them?

Do you need more?

Do you have conflict-of-interest policies in place?

ADDITIONAL READINGS

Blue Avocado. "Accounting Policies and Procedures Sample Manual." https://blueavocado.org/finance/accounting-procedures-manual-template/.
CompassPoint. "Nonprofit Fiscal Policies and Procedures: A Template and Guide." www.compasspoint.org/sites/default/files/documents/Guide%20to%20Fiscal%20Policies%20and%20%20Procedures.pdf.

CHAPTER TWELVE

Short- and Long-Term Trade-Offs
Investing Funds and Managing Debt

An investment in knowledge always pays the best interest.
—BENJAMIN FRANKLIN

LEADER TAKEAWAYS

After reading this chapter, you should be able to

- Understand the short- and long-term financial trade-offs involved in investment and debt revenue
- Create an investment policy, asset allocation targets, and the process for investment selection and monitoring
- Effectively determine whether investment or debt revenue are appropriate for your organization
- Work with your board and finance committee to strategize how investment and debt revenue fit into your overall financial portfolio

"In 2013, Rasmuson Foundation worked with Cook Inlet Tribal Council (CITC) to structure an investment with CITC as the nonprofit sponsor of a special video-gaming initiative focused on developing a portfolio of game-infused learning programs that include Never Alone (Kisima Ingitchuna). The initiative generates new, unrestricted revenue that can be flowed back to CITC core social service programs while also reinforcing the organization's commitment to cultural engagement and social justice. Initially, CITC approached the foundation with a request to make an equity investment directly in its indigenous-owned gaming company. Rasmuson wanted to share risk with CITC by participating on equal footing, which led the foundation to structure a recoverable grant with equity-like provisions for use of proceeds, profit sharing, return of capital, and preferred

distribution of returns. The $1 million investment involves a fifty-fifty split on profits until the foundation's initial investment is repaid, with an additional 5 percent return paid out over time. The PRI's [program-related investment's] structure reflected Rasmuson's relationship-based grantmaking approach and social investing philosophy and also allowed the funder to shape CITC's business plan by expanding their target home consumer to educational consumers. The foundation requested the creation of a curriculum guide that could enable educators to use the game in classroom settings and align with standards and measurable educational outcomes. Rasmuson's investment in CITC created leveraging opportunities that also attracted additional investors while sharing in the risk."[1]

Financial decisions are always about short- and long-term trade-offs as well as mitigating risk. Built on the shared gaming initiative, the CITC and Rasmuson Foundation creative partnership binds cultural heritage and modern culture for an educational purpose and embodies how the arts can provide a vessel for doing both well. Their partnership highlights values investment, risk sharing, and cultural imperatives. In the short term, the decisions we make about equipment purchases, building maintenance, programming, and investment impact our purchasing power in the future. Financial leadership in complex environments means constant awareness of these trade-offs and thinking ahead to balance your organization's current needs and future priorities. Considering your organization's relationship with **investment** and **debt** is a significant part of those short- and long-term trade-offs. We share here about the types of, uses of, and tactics for both investment and debt since together they exemplify the tension between the current opportunities and those on the horizon.

In organizations as in your personal finances, investments require setting aside money in the present in hopes of gaining a financial return in the future. Debt financing is the opposite: with debt, future payback funds current needs or strategic opportunity. Like all financial decisions, investment and debt are related; research indicates that debt credibility can influence investment opportunities. For example, arts organizations with endowments may borrow money at lower interest rates, and some of our earlier research finds that arts organizations with larger endowments are less likely to have high relative debt.[2] Both have the potential to influence the way your donors support your organization, and both can provide revenue stability for organizations of varying size and artistic mission if approached strategically and thoughtfully.

WHY SHOULD ARTS ORGANIZATIONS CONSIDER INVESTMENT AND DEBT AS PART OF THEIR FINANCIAL STRATEGIES?

Access to and inclusion of both investment and debt in your organization's financial strategies are important for arts nonprofits, indeed all nonprofits, because unlike for-profit movie studios, music firms, video production services, publishing, or other artistic industries, nonprofit arts organizations have much more limited access to capital, or cash. While companies can issue shares for others to purchase and become shareholders and raise cash to fund operations and expansions, nonprofits cannot do this. The "nondistribution constraint" means that nonprofit organizations cannot distribute any profits to shareholders or others connected with the organization. Because of this nondistribution constraint, nonprofits also have historically been unable to attract investors since philanthropic investors receive social, and not financial, returns. In the main, we call philanthropic investors "donors" and reward their investments in civil society with personal and business tax incentives. This differential access to capital has pushed the creation of new organizational forms, such as limited liability corporations (LLCs) and benefit corporations (or B-corps), that use for-profit organizational forms for a public benefit purpose.

Therefore, nonprofit arts enterprises do not have the same access to capital that for-profit arts enterprises do, and this difference drives some key distinctions in their funding structures. Along with the nonprofit/for-profit capitalization structures, the size of the arts organization influences their abilities to raise cash and engage in the arts marketplace. Research indicates that smaller cultural and arts organizations occupy more boutique, or niche, markets and that specialized foci and higher-end entertainment and more conservative programming belong to the larger arts organizations.[3] Yet, larger organizations are potentially better equipped to absorb risk, and therefore may be able to cater to niche target markets or provide wider community benefit.

In addition to limited access to capital, arts organizations typically are funded by a more elite donor base, which means that private giving patterns to arts and culture are more likely to change than those for social service organizations relative to changes in tax structures, economic downturns, or external shocks such as the COVID-19 pandemic.[4] So, museums, arts education and therapy organizations, theaters, and others need to be constantly evaluating the potential of other revenue streams for their organizations. According to Francie Ostrower, the fact that arts nonprofits rely more heavily on private donations and earned revenue and less on government grants than other types

of nonprofits can increase their susceptibility to financial volatility.[5] Other research finds that nonprofit arts organizations are also more likely to lease or own their venue than for-profit arts organizations are, decreasing the budget available for other expenditures.[6] Both investment and debt financing have the potential to provide alternative revenue streams when approached and utilized wisely.

INVESTMENT INCOME

Investment income, or organizational revenue derived from investment account earnings, is common among arts organizations. Once a corpus, or certain amount of accumulated funds, has been achieved, an organization can use the interest from the investment account as a steady stream of income. With spending rules in place and a determination to avoid dipping into the corpus when times are tough, interest income can be a relatively stable source of income. According to the Cultural Data Profile (CDP), on average, arts education is the subsector with the least amount of revenue derived from investment income, followed by arts support organizations, performing arts, and community arts, while museums and broadcasting have the highest investment returns.[7]

Along with providing a fixed and relatively stable income that can help guard against uncertainty as well as long-term operational sustainability and flexibility, investment income can help nonprofits fund specific spending projects and, sometimes, reach a financial goal.[8] In addition to these benefits, investments are typically viewed favorably by donors as a fiscally responsible financial decision.[9] Added to investment income's positive associations for donors, just having a brokerage account can help your organization receive noncash gifts like stocks or bonds. Such gifts are favorable to donors since they help them to avoid capital gains taxes.[10]

Investment income also has downsides that must be weighed alongside these benefits. If your organization has immediate pressing needs, a highly likely scenario, it's a difficult call to postpone funding those needs to put money into building your investment account. Staff who are not being appropriately compensated may not understand a leadership decision to prioritize or put money into investments rather than competitive salary or benefits packages. Your people are always a priority, and you also need to invest in them, making sure they have a safe work environment, health coverage, other benefits, and living wages: as you are no doubt well aware, arts careers can take a toll on technical directors, performers, and others who put in long and arduous hours on the job.

In addition, investment accounts also incur management fees, so this revenue

TABLE 12-1. Average Annual Investment Income for Arts Organizations

Arts Category	Average Investment Income
Education	$109,083
Support arts	$121,179
Performing arts	$147,077
Community	$219,982
Museums	$525,700
Broadcasting	$1,464,840

Source: Calculations made using data from SMU DataArts, https://culturaldata.org/what-we-do/for-researchers-advocates/access-the-dataset/.

stream will come with a matching expense line in your budget. On average, an investment management fee will be about 1 percent of the assets managed for an account of $1 million. For smaller invested assets, the management fee may be a flat rate. Your finance committee and board will have to monitor those investments to avoid any problems with their legality or poor results as well as spend time developing investment and spending policies if you do not already have them in place.

Because it is tied to a variety of big-picture issues within our financial environment, investment income, or organizational revenue derived from investment account earnings, comes with a certain level of **financial risk**, or the possibility of financial loss. The National Council of Nonprofits notes, "Any investment carries a certain amount of risk. Being prudent means taking into consideration that investments usually take time to grow but investing 100 percent of a nonprofit's cash in a long-term investment won't allow the nonprofit access to cash, if needed in the short term."[11]

TYPES OF INVESTMENTS

Organizations, like individuals, have a variety of options for investing. Yet, you must approach each type of investment as a long-term proposition because you don't want to position your organization as constantly playing the market and needing to closely monitor your investments. That type of behavior is very risky, has low potential to maximize your return, and causes undue organizational stress, and most organizations do not have the capacity to engage in it.

Most commonly when we think of investments, we think about stocks and bonds. Less prominent in our minds are other types of financial investment, such as endowments, notes, or ownership of real property. Here we'll hit the

highlights, but we encourage you to find a sound financial adviser who will be happy to help you determine the best route for your organization's investment journey.

Organizations can hold common stock or invest in **bonds**, just like individual investors. Individual **stocks**, or shares of a publicly traded company, carry a higher risk than bonds, which essentially serve as a loan to a corporation or government, yet could have a higher return over time. **Mutual funds** are an amalgamation of multiple stocks and bonds that collectively lower the risk of investment and even out the return over time, so they may be a better option than individual stock or bond investments. Your investment portfolio can also include property or other financial investments.

SHOULD MY ORGANIZATION HAVE AN ENDOWMENT?

Investment funds can be set aside for the express purpose of providing a consistent source of revenue for the organization in perpetuity, typically known as an **endowment**. Endowment funds are usually a combination of a variety of investment types (stocks, bonds, mutual funds, real estate, etc.) based on predetermined asset allocations. As we noted in chapter 6, endowments serve a different purpose than operating reserves (a.k.a. rainy day funds) or other cash reserves because they are often restricted to a specific purpose and are intended not to fill a short-term cash gap or serve as emergency funding but to provide a stable income stream that a nonprofit can apply to program expenses or to grow its asset base.[12] Endowments should be utilized as a long-term financial strategy.

Although arts organizations may view having an endowment as a mark of prestige that fulfills the desires of an elite donor as well as financial security, they are not a silver bullet for all organizations.[13] Not every arts nonprofit has an endowment; on average less than half do, according to research, and if you are one of those organizations, that's okay.[14] But if you are interested in considering how an endowment could support your organization's programs and services, talk with your trusted financial advisers regarding whether those trade-offs are appropriate for your current life stage and overall financial picture.

THE INVESTMENT INCOME PROCESS

What if your organization doesn't currently have any investments? An investment account can be difficult to build if you don't already have it. Organizations can use similar strategies to those found in the operating reserves chapter to

grow an investment account, but many investment accounts are derived from windfall gifts (e.g., a bequest or large unanticipated gift) or a large influx of cash (e.g., from the sale of property). Let's discuss a few things to keep in mind as you consider investment income strategies.[15]

Take care of basic financial needs first. As you weigh the pros and cons of setting aside some of your organization's scarce resources in investments, make sure you have your basic financial needs met before you jump into any new financial commitments. Are all your creditors paid? Are your employees receiving an appropriate wage and benefits? Are there sufficient funds to fully operate and achieve your goals and objectives, with some funding left over? If you are answering no to any of these questions, then you probably are not yet ready to commit to allocating funds to investments. After you take care of these basic financial needs, then reassess your position and determine whether you are ready for the next step.

Determine why you are investing. Keep your specific goals in mind. What is your organization's reason for investing? Do you want to achieve a stable source of income? Do you have a particular project you'd like to fund? Your organization's leadership and board should clarify and be in concert regarding your rationale for investing as well as the ethical guidelines you intend to follow in the process.

Investigate options. Once your financial house is in good order and you and your board agree on your plan to invest, perform your due diligence regarding what investment options are best for your organization. Along with considerations of the best type of investment or your own priorities, it is often wise to have an outside broker or financial adviser to help you make sound and prudent investment decisions. Before engaging someone for that service, review their achievements (and not just the ones they share on their website), ask around your community and other trusted professionals to gauge the reputation of potential financial advisers, and check with any watchdog groups or conduct a media search to investigate if there are any skeletons in the closet before handing over your funds.

Determine your level of comfort with risk. As we've noted, different kinds of investment carry different levels of financial risk. Consider how much risk your organization can absorb, and have candid talks with your organization's leadership to establish those signposts.

Determine the time horizon you are comfortable with. The time horizon is the span over which you'll be receiving and repaying your investment. Clarify how long you plan to build an investment account and the target amount you plan to invest, and how much return you hope to achieve. Set realistic goals for how long it will take to achieve those goals.

Get board approval. As is appropriate with all key financial decisions, seek your board's consent and approval before investing.

Have policies and procedures in place. Finally, make sure you have the policies and procedures in place to responsibly invest, monitor those investments, spend the investment revenue, and so on.

STRONG INVESTMENT AND SPENDING POLICY

Clear policy is key to the successful implementation and management of any financial decision, including investments. An excellent investment policy provides guidelines regarding **asset allocation**, types of investments sought by your organization, and how to deal with investment returns and downturns. You can find some excellent investment policy examples online. Organizations may choose to have one omnibus investment policy or specific policies for endowment or other investments. Whatever route you choose, your policy should address these issues: asset allocation, values preferences, and spending rules.

Asset Allocation

Asset allocation plans demonstrate preferences for how your organization's investment funds will be split between different types of investment vehicles, whether stocks and bonds, mutual funds, real estate, or low- or high-growth funds. Diversification among multiple investment types in your portfolio spreads out the risk associated with market fluctuations, including inflation and interest rates. The asset allocation plan allows you to articulate threshold percentages for each type of investment you want to pursue and sets targets for your investment types.[16]

Your board, particularly the finance committee, should review your investment and spending policies on a regular basis and consider whether there is a need for **rebalancing** any investments, or changing the asset allocation, to adjust for performance or changing priorities within your organization.[17]

Values Preferences

Along with identifying asset allocation targets, your investment policies should lay out if you have any value preferences about what you are investing in, or not

TABLE 12-2. Sample Asset Allocation Plan

Asset	Target Percentage of Total	Range Approved by the Board
Stocks and bonds	25%	15–30%
Mutual funds	30%	25–35%
Values investments	10%	3–15%
Real estate	25%	20–30%
Other investments	10%	0–15%

investing in. For example, some investment policies seek certain types of **impact investments**, funding women- or minority-owned businesses, or socially responsible investments, choosing funds that do not invest in certain products (e.g., tobacco or cannabis, fossil fuels) or types of business (casinos, etc.). Arts organizations are paying more attention to how their organizational values are aligning with their investment portfolios.[18] Like the Cook Inlet Tribal Council partnership with the Rasmuson Foundation mentioned at the beginning of the chapter, the Souls Grown Deep Foundation, a foundation that documents, preserves, and promotes contemporary African American arts from the southeastern United States, began partnering on values investments with Community Partnership in 2019. As a result, "Souls Grown Deep has invested with Community Investment Management to support loans to small businesses, many in the creative economy and led by women and people of color, and Impact Shares' NAACP Minority Empowerment ETF (ticker: NACP) to achieve broad equity market exposure to U.S. Large and Mid-Cap companies that fit the NAACP's vision of good corporate citizens. Most recently, Souls Grown Deep made a direct investment into Paskho, a Black-owned ethical and sustainable fashion brand."[19]

In another example, the Andy Warhol Foundation for the Visual Arts sought a values-aligned investment strategy, according to Upstart Co-Lab:

> The mission of the Andy Warhol Foundation for the Visual Arts is the advancement of the visual arts, with a focus on supporting the creation, presentation, and documentation of contemporary visual art, particularly work that is experimental, under-recognized, or challenging in nature. Since its establishment in 1987 in accordance with artist Andy Warhol's will, the Foundation's innovative grant program has been responsive to the changing needs of artists. The board's exploration of impact investing has been similarly proactive. The process, driven by the finance committee, began in 2018. While intrigued by mission-related investing, the board was concerned that mission-specific opportunities in the visual arts were

still too nascent. So, they focused on values-aligned investing to start.... In December 2019, the board allocated 25 percent of their endowment to a values-aligned ... strategy. The foundation expects that allocation to increase over time and is continuing to monitor mission-related investing opportunities. "It's not an all or nothing approach," said [CFO and Treasurer K. C.] Maurer. "Understand that this can be incremental. You don't have to jump in—dip your toe in and get used to the water!"[20]

It's easy to see the alignment between the organizational missions of Souls Grown Deep and the Andy Warhol Foundation and their investments from this example. As you explore your own options for values investments, look for similar opportunities, and remember Maurer's advice to dip your toe in the water.

Spending Rules

Finally, your policy should articulate how much of your investment returns you plan to spend. Typically, a wise plan is to spend only 3–5 percent of a multiyear rolling average to smooth out the volatility in your returns and stay ahead of inflation.

Taken as a whole, investment income can offer the promise of a long-term income stream for arts organizations, so we recommend considering strategies to begin or sustain investment income after your organization's other basic financial needs are met.

DEBT FINANCING

While investment income sets aside today's money for future stability, debt financing incurs future debt to meet current financial needs your organization may be facing. In short, **debt financing** is borrowing money to finance a current need. But debt has a bit of a bad reputation. Shakespeare's Polonius chided, "Neither a borrower nor a lender be for loan oft loses both itself and friend. And borrowing dulls the edge of husbandry." Steadier minds than Polonius's have also advised against debt, including Benjamin Franklin, who wrote: "But, ah, think what you do when you run in debt; you give to another power over your liberty."[21]

Even watchdog organizations contribute to the notion of debt as bad, or at least less responsible, policy for nonprofits. For instance, Charity Navigator bestows their highest rating only on nonprofits that keep a low debt ratio: between 0 and 15 percent.[22]

Advising financial prudence is wise, and frivolously incurring debt is bad

practice. But there are times when a strategic use of debt can have benefits for your organization as part of your overall sound fiscal policy. Used responsibly, debt financing can be a tool to help establish strong financial relationships, meet an immediate need, or take advantage of a strategic opportunity for your organization.

Practical Pros and Cons of Debt

There are several benefits to prudent use of debt for your organization.[23] Chief among them is current spending power. Debt can provide a source of quick cash for your organization without having to dip into any of your savings or investment accounts to take advantage of a strategic opportunity like a new building or piece of equipment. Debt can also help even out cash flow in your organization. For example, if you have a grant that has been allocated and requires that you start programming before the grant money hits your account, a small loan can help you pay for what's needed to get the program up and running before the grant money is released to your organization. Such a scenario is common: nonprofit organizations of all types report a need for such cash smoothing on occasion.

Debt can also be used to consolidate other debt. If your organization has a couple of small loans that need to be repaid, you may be able to get a lower interest rate on those loans by consolidating them into one. The added advantage of doing so is that rather than multiple debt payments, your finance officer only has one to track. Finally, there may be times when debt can help support your people or program in times of fiscal stress. The PPP loan program during COVID-19 is a positive example because those loans enabled some organizations to continue funding salaries or maintain programs when quarantine regulations kept folks away from arts venues.

As Polonius and Franklin remind us, however, there are excellent reasons to be cautious and careful in our determination to take on debt. Along with the eventual payback that obligates your organization to payments over time, along with interest on those payments, debt has some other downsides to consider. Donors may not like the idea of your organization carrying debt and may view debt as irresponsible.[24] Educating your board and using your board as public advocates for your financial plans to external stakeholders is the best way to combat this view of debt. But there are also practical considerations. For one, lender constraints exist, so you may not have the flexibility to engage in terms that would be optimal for your organization. Finally, there are costs associated with debt. Just like the interest payments on your credit card, any debt vehicle will have some types of fees associated with its use.

Prevalence of Debt in Arts Organizations

Research indicates that arts organizations are less likely to use debt than other nonprofit subsectors are.[25] Of our recent study of approximately 3,200 arts and cultural nonprofits, the majority (60 percent) of the organizations in the sample had no outstanding financial debt, and of those organizations carrying debt, the average financial debt was equal to 13.4 percent of their annual revenues.[26] The debt ratio—total liabilities divided by total assets—is a common metric used in the literature to describe a nonprofit's debt load.[27] Like investment income, the prevalence and size of debt, as measured below by the debt ratio, varies across arts subsectors. Performing arts, broadcasting, and education organizations carry higher levels of debt than community and support arts organizations do.[28]

And just as subsector matters, so does organizational size. Of those 3,200 arts organizations we studied, the organizations carrying financial debt are older and have larger boards.[29] This trend is also true of the wider community of nonprofit organizations, where debt is mainly utilized by larger organizations.[30] If you are a small cultural center, does that mean debt financing cannot ever benefit your organization? It may just mean you need to take it slow and build up your relationships and your capacity to carry debt. Smaller organizations may need to move in with smaller loans to establish a good reputation and creditworthiness, and we'll share some strategies in a few moments.

In general, nonprofit organizations with higher levels of private income, or donations, tend to have less debt, but organizations with higher levels of government support, like grants and government contracts, are more likely to issue debt and have higher leverage ratios.[31] Nonprofit organizations with proportionally more executive compensation are more likely to have a **mortgage**, and nonprofits with relatively higher total compensation costs are more likely to use financial debt.[32] Essentially, what this research tells us is pretty intuitive: larger organizations that have the capacity to pay their executives well or engage in funding relationships with the federal government also have the capacity to carry more debt within their organizations. And organizations that are heavily reliant on private donations may have concerns that donors will not look favorably on their organization carrying debt (with reason) and are thus more inclined to avoid it.[33]

These same tendencies were found within our arts study, where the organizations with financial debt had less direct support from private donors, more asset tangibility, and more earned revenue overall. Their compensation was also higher. In keeping with prior arts findings, the theaters, museums, and other organizations in our study were highly liquid, and the largest values were associated with no financial debt. What does all this mean for you? Debt financing

TABLE 12-3. Average Annual Debt Ratio across Arts Subsectors

Arts Category	Debt Ratio
Support arts	0.269
Community	0.280
Museums	0.365
Education	0.718
Broadcasting	0.721
Performing arts	0.840

Source: Calculations made using data from SMU DataArts, https://culturaldata.org/what-we-do/for-researchers-advocates/access-the-dataset/.

decisions will and should be part of your overall financial decision-making, and to some extent they depend on the other choices you make. Again, it's all about the trade-offs that your organization can and is willing to make.

When Is It Right for My Organization to Borrow Money?

Along with the pros and cons of debt financing, you will want to take the timing into account to evaluate and determine whether this path is right for your organization. Debt financing is like the difference between a joke that causes guffaws and one that falls flat—timing is critical. There is a right time and a wrong time to pursue debt financing for your organization. Propel Nonprofits provides a succinct way to consider whether your organization is at the stage to pursue debt responsibly. They counsel that the right time to acquire a strategic debt is when your organization (1) "know[s] how the funds will be used," (2) "[has] a plan for repayment that is based on reasonable assumptions for future income," and (3) "[has] the support of the board."[34] Alternatively, to keep you from becoming the joke's punchline, they propose you should not pursue debt if (1) your "organization has been operating with a persistent deficit," or (2) "a loan is not the appropriate tool to fill the gap and pay ongoing operating expenses," or (3) you do not have a feasible repayment plan.[35]

If your board supports debt financing, you have a specific purpose for the funds, and know how you will pay back the debt, the next step is to educate yourself on the debt options available to your organization.

Types of Debt

As you are no doubt aware from your own personal finances, there are various ways to borrow money. Credit cards and house mortgages are the ones that likely come to mind the most immediately. We all know that if we are irresponsible in either of these areas, we can get ourselves into big trouble; we also know

that, when used responsibly, our credit cards can help us sometimes get things immediately that otherwise we wouldn't be able to buy, and a mortgage allows us to have our dream home now by stretching out those payments over time.

With our organizations, it's no different. There are a variety of debt vehicles, like loans and credit, that come in an array of shapes, sizes, and repayment plans. We're categorizing them here by quick payoff versus long-term payoff.

Short-Term Debt

Some quick-payoff debts, including reputation loans, lines of credit, trade credit, and promissory notes, allow the borrowing nonprofits to cover temporary cash shortfalls so they can continue operations.[36] Often lumped together as **reputation loans**, or just small loans that your organization can pay off soon that can help you build a successful credit history and relationship with a local financial institution, such short-term debt instruments can provide a helpful cushion at times. For example, many arts nonprofits maintain a **line of credit** (LOC) with a local bank that allows them to continue operating when more money is going out than coming in. A **line of credit** is a bank or credit union account that allows your organization to borrow money with a relatively low limit that is set in advance. While a line of credit is a highly serviceable tool to get over the many bumps and challenges along the road to mission fulfillment, nonprofits can also free up cash flow with **trade credit**, or a commercial vendor credit account, although it is more expensive. Vendors usually allow a nonprofit thirty days to pay a bill in full, and many vendors also provide a prompt payment discount; but if a nonprofit fails to pay on time, vendors may charge late fees, some as punitive as 18 percent per year.[37] Finally, **promissory notes**, simple agreements between parties to pay a certain amount of money under specific terms, can be a beneficial short-term loan option.

Some nonprofits have loan programs specifically designed for arts nonprofits that can serve the purpose of reputation loans and help address cash flow shortages; the MacArthur Foundation and Northern California Grantmakers are just two examples. The Macarthur Foundation's Arts and Culture Loan Fund focuses on support for small and medium-sized arts organizations with a goal of capacity building, particularly regarding finances.[38] Likewise, Northern California Grantmakers' Arts Loan Fund serves the San Francisco Bay Area with the same services. Rosalie Cates and Shin Yu Pai describe Northern California Grantmakers' process:

> The Arts Loan Fund (ALF) has provided quick-turnaround, low-cost financial assistance to arts organizations located in the San Francisco Bay Area since 1981. ALF loans range in size from $10,000 to $50,000 and

encompass production support for galas and public performances to opportunity loans that help arts organizations develop new revenue streams or cost-saving opportunities. ALF also provides bridge loans intended to help small organizations with urgent cash-flow needs, and smaller loan products, like quick qualifier loans of up to $10,000, to those who have previously applied and have repaid their loans on time. The fund offers several application deadlines throughout the year, and steering committee members review applications on a six-week cycle, disbursing funds immediately after loan approval. Considered low risk at a 2.25 percent interest rate, loans must be repaid within one to twenty-four months, depending on the loan product and the confirmed source of income for repayment. To date, ALF has provided 1,345 loans totaling $18,679,581, a significant investment in the health of the Bay Area arts community.[39]

Long-Term Debt

Longer-term debt, primarily mortgages and bonds, typically involves larger amounts of money and much wider time horizons for repayment. Under some circumstances, loans may also be obtained from state and federal agencies, foundations, or venture philanthropists whose missions align with your own.

The Debt Income Process

Not all debt vehicles have the same results or consequences for our organization, so before applying for any type of loan or credit, be sure that your finance committee has (1) investigated the terms, (2) determined a plan of repayment, (3) put a well-researched proposal in front of your board, and (4) gotten their approval for the debt.

Loan application processes also vary, but you will typically need to provide two things: collateral and verifying documents. **Collateral** is an asset or assets belonging to your organization that you pledge to the lender in the event you cannot pay your debt with cash. If you default on your car loan, the lender will repossess your car, since that is the item of value they can claim instead. Along with some type of collateral, a lender will likely request your organization's articles of incorporation and bylaws. In addition to these items, you can expect a lender to ask about your organization's leadership and management structures and financial history to indicate your organization's fiscal responsibility and capacity to repay.

Part of the loan negotiation will involve setting up the loan terms and repayment plans. Loan terms can vary considerably according to the amount of time you have to pay back the money, the increments in which you pay (whether

monthly, quarterly, yearly, etc.), the interest rates and whether those rates are variable or fixed over a period of time, and potentially other features. Watch out for hidden fees or costs from the lender. Your board treasurer or other trusted financial adviser can be a big help in navigating loan terms. As you begin to pay down the loan, monitor closely to make sure your payments are going toward the debt in the way you want.

CONCLUDING THOUGHTS

As you consider whether to incorporate investment and debt strategies into your overall financial operations, remember to always consider these decisions in light of all your other revenue streams as well as your organization's plans and goals. Think about your overall revenue streams, weigh the advantages and disadvantages of each type of revenue, and get counsel from trusted financial advisers along the way. Hopefully this discussion of investment and debt revenue will help you use the IDEA framework—Identify, Determine, Evaluate, and Act—to figure out whether your organization's current investment and debt strategies are maximizing your current opportunities and future needs.

KEY TERMS

asset allocation
bonds
collateral
debt
financial risk
impact investments
investment

line of credit
mortgage
mutual funds
promissory notes
rebalancing
stocks
trade credit

QUESTIONS TO CONSIDER

Has my board had a healthy discussion about how much risk tolerance we have as an organization?

Does my organization have an investment and spending policy that is approved by the board? Do we have policies and procedures regarding the use of debt? If so, have we reviewed those policies lately?

ADDITIONAL READINGS

Charles, Cleopatra, Margaret F. Sloan, and John S. Butler. "Capital Structure Determinants for Arts Nonprofits." *Nonprofit Management and Leadership* 31, no. 4 (2021): 761–82.

Coffey, Greg. "Investment Policy Statement: Elements of a Clearly Defined IPS for Non-profits." *Russell Investments Research* (2019): 1–9.

Propel Nonprofits. "Loans: A Guide to Borrowing for Nonprofit Organizations." 2022. www.propelnonprofits.org/resources/using-loans-guide-borrowing-nonprofit-organizations/.

CHAPTER THIRTEEN

Keeping the Arts Alive
Adapting to Turbulent Times and Developing Resilience

> I run two arts organizations: Artrain and Creative Washtenaw. We relinquished the trains in 2009 because the railroads wouldn't run the trains any longer.... We took our skills and turned them into consulting and project management—so we identified with the train and questioned our viability without the train—we went through soul searching—but we were never a train organization, and we were always an arts organization. If you've ever turned railcars into museum cars, then you can do anything.... We created a business plan.
>
> —DEB POLICH, director of Artrain

LEADER TAKEAWAYS

After reading this chapter, you should be able to

- Implement resilience strategies for before, during, and after organizational turbulence
- Understand your organization's place within a system and the influences of internal and external shocks to that system
- Implement responsible and strategic budget cuts when needed
- Increase revenue during turbulent times
- Engage and talk to donors in a crisis
- Recognize and embrace both the threats and opportunities brought by fiscal crises
- Consider your potential as an adaptive and entrepreneurial leader through times of organizational stress

The main thing to remember about **organizational turbulence** is this: it will come. It may not come in the form of our Artrain example, where their trains literally stopped running, but in some form, at some time, it will come. After all, your organization exists in a messy, open system of interrelated political, economic, social, biological, and environmental influences. Most of these influences will have some impact on your finances and operations.

Systems thinking and complexity theories recognize that organizations are made up of several internal systems and are parts of larger systems. In addition, the arts are particularly ensconced in community. Arts have historically been created in concert with and in response to community needs, so they are constantly reaching within and beyond themselves and across organizational and sectoral boundaries, and for that reason they may be even more susceptible than most types of firms or industries to external shocks to the community they serve.

Turbulence is often external to your organizations, like natural disasters or recession, but internal turbulence, such as power dynamics or board turnover, can also occur and can be just as detrimental to your organization's mission. For example, one arts professional shared that his organization experienced two or three years where there was a lot of turnover on the board: "We couldn't get anything done because the priorities were constantly changing." Navigating times of turbulence, wherever they fall on the organizational continuum, is a primary leadership function. Strategic leadership stresses leadership within a changing environment, and the information here can help you get through the rough patches, consider how long your organization can endure them, and help you make ethical and strategic decisions amid them.

CRISES HAVE DIFFERENTIAL EFFECTS ON ARTS ORGANIZATIONS

External crises often affect arts and cultural organizations differently than they affect other nonprofits. In a crisis environment, the arts are often deemed nonessential services compared to human service, education, or health-care nonprofits, so when people and institutions start deciding where to allocate scarce resources, the arts can lose out. Donors' preferences for the arts are more elastic, meaning donors are more likely to change their decision regarding giving to the arts in the face of other competing demands for giving.[1]

Cutback budgeting processes, often employed during times of crisis, recommend that organizations ascertain which services are essential and nonessential and make nonessential cuts first.[2] When basic needs are threatened, arts organizations and programs can fall on a funder's nonessential list. School budgets that

cut music and art classes when the budget gets tight are following this line of thought. During COVID-19, Sloan and colleagues asked rural residents about the needs of their community in light of the pandemic's impacts. Although both local theaters were shuttered and arts courses were all canceled, not a single respondent mentioned arts as a particular area of need in the community.

Although we can argue to the contrary, the thinking of arts programming as nonessential impacts the influx of funds during times of fiscal stress elsewhere in the economy, no matter the cause. Consider these statistics regarding COVID-19:

Job loss: According to Independent Sector's Health of the US Nonprofit Sector report, job losses during COVID across recreation, arts, and entertainment sectors ranged from 12.5 percent, almost three and a half times more than other nonprofit subsectors.[3] Even after receiving loans from the federal government to maintain their workforce, arts nonprofits still laid off or furloughed 28 to 56 percent of their workforce (ArtsFund report).[4] According to CDP data, arts organizations reported furloughing between 0 and 282 employees during the pandemic.

Giving: During COVID-19, giving to arts, culture, and humanities groups is estimated to have declined 7.5 percent, to $19.47 billion. Adjusted for inflation, giving to the arts, culture, and humanities subsector declined 8.6 percent.[5]

Program cuts: The work of Mirae Kim and Dyana Mason demonstrates that during COVID-19, arts nonprofits were more likely than human service organizations to "cancel events, suspend programs, reduce hours of operation, cancel contracts, [and] experience lower demand" in response to the pandemic and subsequent social distancing restrictions.[6] ArtsFund's survey noted: "While the organization is finding ways to continue to serve dance artists and audiences, artists are struggling to make work during the pandemic, and feeling immense pressure to translate their live performances to virtual happenings. In some cases, this invites innovation; but it also asks for huge adaptations and learning from our artists."[7]

Taken as a whole, research indicates that arts and cultural nonprofit organizations experienced harsher repercussions from COVID-19 than other types of nonprofit organizations did.[8] Some, like the small community theater in our vignette in chapter 6 that put up a For Sale sign, have shuttered forever. Even with these considerations, however, we must note that some arts nonprofits,

like nonprofits across subsectors, ended up in a better overall financial position during COVID-19 due to the Paycheck Protection Program (PPP) loans and the subsequent forgiveness as well as other stimulus money provided by the federal government. Some state arts associations also offered extraordinary funding. But this deus ex machina is not likely again, and cannot be expected or guaranteed, in the future.

Even though the arts may have taken a larger hit from COVID-19 than other nonprofits, survey results from nonprofit grantees in general note that organizational leaders felt more hopeful about overcoming the negative effects of the pandemic.[9] The numbers of those saying COVID-19 had a moderate or significant negative impact on their organizations decreased by 84 percent six months after the height of the mask mandates.

While the COVID-19 pandemic may be unique, other periods of great stress occur too, and they are infrequent but not rare. And like the optimism present in the nonprofit grantees about their future after COVID-19, the news for arts organizations in other times of turbulence is not always as bleak as things may seem at the moment. Historical evidence from the United States' Great Recession in the 2000s demonstrates that arts and creative industries may have a quicker recovery overall. A National Assembly of State Agencies report found that "after the Great Recession of 2008–2009, the arts rebounded rapidly from economic shocks. In the year immediately following the Great Recession, the average gross state product per capita rose by 3 percent while the average state arts economy grew by 3.4 percent. Furthermore, the core arts subsector exhibited much higher growth rates than the general economy for the three years following states' economic low points. States with larger arts economies, especially, grew more rapidly after the Great Recession. The creative industries, in other words, have been a fast growth sector in hard times."[10]

Even with the hope of a quick recovery, however, organizations should take every precaution to smooth out detrimental effects when crises come. For example, even short-term job losses come at the risk of long-term loss of people with institutional memory and needed skills, ethical issues notwithstanding.

STRATEGIES FOR DEALING WITH TURBULENCE

If we know that organizational turbulence is inevitable, then it only stands to reason that one should have plans in place to deal with such circumstances. Even if we don't know what form the turbulence might take, there are still plans we can put in place.

Most training programs focus on how to manage your organization and its finances based on **incrementalism**, the expectation that what happened last year is likely to happen next year with slight increases or decreases. This incrementalist approach works well if things remain consistent but can be thrown for a loop when catastrophe strikes. Is there a path forward that allows for reasonable incrementalism with the expectation of big shifts sometimes? Nonprofit economist Dennis Young says nonprofits across the board should switch to **resilience** strategies rather than traditional, status quo modes of management.[11] Such strategies require that creative leaders consider both long- and short-term trade-offs, manage responsibly in the moment, and plan for the unexpected future. It sounds daunting, but you can employ some strategies to help foster resilience management for your organization so that when fire strikes, you can save as many of your belongings as possible.

Resilience strategies should not simply be thought of as tools to use during a fire, however. They will be most effective when employed and evaluated (1) before the fire ignites; (2) in the flames; and (3) after the smoke has cleared.

Before the Fire Ignites

Before a fire strikes is a terrific time to be planning the strategies that can position your organization to prevent catastrophic consequences when the unexpected happens. Along with sound practices discussed throughout this text, including keeping your internal house in order by developing a strong board, practicing sound fiscal policies and procedures, and providing a positive workplace culture to recruit and maintain employees, your organization should prioritize strategic thinking and reflection on an ongoing basis. Strategic thinking means being aware of and continually assessing your organization's environment, your place within the complex intersections of community/state/nation, and the alignment of your decisions with your core mission, vision, and values.[12]

As a player within this complex system, and before a crisis hits, take the time to advocate for the arts within your community; talk to and visit local leaders and fellow citizens to acquaint them with your organization, its goals and mission, and how it relates and interacts with the local community, or even the larger impact if that is the case. After all, in times of need you're much more likely to find an existing friend willing to help you than to find a stranger willing to become your friend. If all our creative organizations share the word about how arts benefit and transform our communities, those stories will resonate better in down times. As the Greater Kanawha Foundation recognizes: "By integrating the arts into all community development activities we can create a

virtuous cycle through which we strengthen our neighborhoods, attract new residents, and better support the artists who live here, who then support the next phase of growth in our community."[13]

Along with advocacy efforts, use the opportunity to become embedded within your community. Rural COVID-19 research demonstrated that organizations with leadership more firmly rooted in the community were more agile in navigating the crisis.[14] Typically, embeddedness is thought of as long-standing relationships, which often takes time, but even more important than time is whether a leader is laying down a track of solid partnerships and collaborations in his or her community, including other nonprofits, businesses, local government agencies, and others. By being a consistent positive partner, your organization can embed quickly.

Along with building partnerships, and hopefully strong friendships, for when trouble comes, to the best of your ability you should also try to anticipate possible turbulence and consider how your organization would respond to various contingencies. One easy way to plan for multiple scenarios is by creating various budget projections. For example, the Association for Research on Nonprofit Organizations and Voluntary Associations (ARNOVA) developed three different budget models during COVID-19 so the board could see the trade-offs between cuts and strategic priorities. Intellectual and theoretical decision-making becomes more real when one can see them on paper and see—or not see—the different budget lines change or even disappear depending on which option one decides to choose.

Use these contingency plans, along with the policies and priorities you already have in place, to guide decision-making when there are problems later. For example, endowment spending policies should outline under what circumstances the endowment revenue should not be spent and/or provide a percentage range so that in years when the market is underperforming, the organization does not act on the urge to take from the endowment corpus.

Other fiscal leadership strategies you can employ during the pre-turbulence stage are smoothing out risk, developing positive relationships with financial institutions and funders, considering your organization's optimal revenue mix, creating and maintaining operating reserves, and using activity-cost budgeting.

Risk mitigation can occur across programming, across audience and participant types, and across expenditures. By spreading risk across your organizational structures, you have some fallbacks in case any one area of risk fails. In examining orchestras, Pompe and Tamburri recommend that orchestras "address revenue issues, introduce dynamic programming, and engage in more community engagement to improve the institution's stability."[15] Organizations

can and should incorporate pricing structures that smooth risk over the span of their programming.

Employing differential pricing allows the arts to spread risk across your audience or participant types. In my early years working with an arts organization in a rural community, balancing our mission of providing arts experiences to those with less means and promoting rural artists often came face-to-face with the reality that popular programming is what paid the bills. By setting a season that had a couple of well-known shows and popular artists to draw in larger crowds and patrons in higher income brackets, we were also able to bus in elementary kids from other communities in poor counties for immersive arts encounters and support some more fringe programming that drew less of a crowd but created meaningful spaces for new artists and shared thought-provoking artistic visions. In a case of contemporary dance, a study in Sheffield, England, found that only 25 percent of contemporary dance audience members would consider paying more for their tickets, less than similar estimates for other arts.[16] Such studies demonstrate that willingness to pay differs among types of art form in addition to types of audience. Even in good times, live audiences across the arts are in decline.[17] In light of such long-term shifts in arts attendance, these strategies for balancing and maintaining ticket revenue with the artistic imperatives of your organization should cause arts leaders and boards to have serious conversations about whether their programming mix provides the right combination of access, artistic achievement, and affluence.

Organizations can also help stabilize revenues by choosing to pursue an appropriate number of stable revenue streams that will allow for some experimentation and innovation in areas that have a bit more risk attached. Having an operating reserve also stabilizes organizational volatility. Revenue volatility, though not a signal of financial distress in every case, is typically placed on the opposite end of the revenue stability continuum.[18] Irvin and Furneaux encourage nonprofit leaders to "maximize the net returns from the various revenue streams over time to fund their mission-related services" but to exercise caution "when revenue is so uneven that mission-related programming cannot be provided consistently."[19] In keeping with your organizational mission, vision, and values, when you're considering diversifying your revenue streams, balance prudence with risk, stability with opportunity. For both current and potential funding, ask yourself, How stable is this revenue stream?

Some factors that influence the decision to diversify include organizational size, capacity, stability, and subsector. Research indicates that there is no one-size-fits-all revenue model, so your organization really has to make this type of analysis personal: what works best varies across subsectors, and size does

matter.[20] Smaller organizations are served well by securing fewer but highly stable revenue sources, such as their loyal donor base, while larger arts organizations are better positioned to "leverage technological innovations, diversity product lines, and expand audiences through educational outreach," even though 90 percent of very large budget organizations across nonprofit sectors benefit from having a single, dominant source of funds.[21] As a success strategy, smaller arts nonprofits could seek to identify a potential dominant donor that could supply long-term stability.[22]

Another pre-turbulence financial strategy is activity or program-based costing and budgeting practices, which set your organization up to better understand the cost centers and revenue drivers for your various functions. Rather than have a single budget line for all programs, consider breaking out each program individually and allocating the personnel, fixed costs, and other expenditures related to every specific program. Then you can match your revenue projections and cost analyses and understand how much return on investment you are getting for each activity. Budgeting this way, rather than with bulk line items, will help you identify what areas of your programming needs attention or are draining resources from others so that you can make better decisions and better assess movement toward outcome achievement.[23]

Finally, mitigate risk by practicing fiscal stewardship consistently, keeping your expenditures and organizational consumption at reasonable rates, developing strong relationships with financial institutions and funders by prompt repayments on any lines of credit or small loans, and keeping clean accounts. Taken as a holistic set, these strategies can both help your organization budget for revenue growth on a consistent basis and be prepared when the fire strikes.

In the Midst of the Fire: Eight Strategies for Improving Your Financial Outcomes

Do you remember the simple yet effective directions we were given in elementary school of what to do if our clothing ever caught on fire?

"STOP! DROP! ROLL!"

What a simple yet beautifully effective plan! First, you STOP what you normally do because there is a crisis occurring. Second, you DROP. Running in panic will only make the flames larger and increase your risk, so you drop to put yourself in the best position to deal with the crisis. Third, you ROLL, because that is the best way to put the fire out.

Like "STOP! DROP! ROLL!," the following eight "fire" contingency strategies are also designed to minimize your risk while maximizing the potential of a good recovery:

1. Stay calm, remember your organization's worth, remind your community of your value, and respond to your community's needs.

To the extent possible, provide access to help others heal and persevere. Remember who you are as an organization within your community and what makes you unique. After 2009's Great Recession, the community of Bellevue, Washington, rather than panicking and retrenching, made a plan that capitalized on their community's unique artistic attributes. A report entitled *Creative Economies and Economic Recovery* related the scenario:

> Bellevue worked to strengthen its creative economy by focusing on key growth industries, like video gaming, while supporting the development of the region's arts and cultural organizations, particularly those that represent its growing immigrant communities. As a result, it adopted the Creative Edge Creative Economy Strategy in March 2018, which puts a focus on arts learning, digital technologies, and diversity as transformative forces for the region. As Josh Heim, former arts manager of the City of Bellevue, shares, "We focused on figuring out who we are rather than trying to be something we're not, that's what's different about Creative Edge."[24]

Rather than model themselves on existing programs or try to operate like other communities with a folklore or traditional arts base, the Bellevue community focused on their unique personality and strengths. Several organizations, like Arts Council of the Valley, shuttered their venue for a time during COVID-19's heights of mask mandates and social distancing but steadily worked to support and sustain their communities by providing alternative outdoor or virtual venues for artists and connecting arts organizations.

2. Maximize your creativity and innovation.

After you've taken that deep breath, bring all your creativity, ingenuity, and innovation to the surface. Arts organizations suffered during the COVID-19 pandemic because patrons could not attend events, discretionary income for most individuals decreased, and the restaurants that provided positive externalities and a complete night out for couples or families closed their doors. Not all venues could move their services outside. According to CDP data, on average 11 percent ceased programs, ranging from a 5 percent low for broadcasting to 22 percent for performing arts organizations. However, 65 percent reported modifying programs during the pandemic, ranging from 57 percent in the performing arts to 73 percent in arts education.[25]

Despite these trials, the examples of innovative program modifications because of COVID-19 are astonishing and encouraging. Choirs crafted multivocal

performances on Zoom; playhouses offered virtual performances; art and music teachers provided lessons to students on virtual platforms and used apps to connect. Such innovations often, but not always, involve virtual technologies.

One of our favorites is Barter Theatre, which has a long history of innovation and community collaboration. When indoor activities were not allowed by the state government, they purchased and repurposed an out of commission drive-in movie theater, rigged the sound system to pick up the stage, and held outdoor performances with the sound piped right into the cars of patrons, combining entertainment with safe social distancing. Moonlight theater was born. Better yet, Barter partnered with a local restaurant, also struggling without customers allowed inside, to provide optional boxed meals delivered to the cars. This sort of creative adaptation to one's original missions and goals is one we would certainly love to see replicated in other places.

3. Seek collaborators.

Just as Barter created partnerships with restaurants to develop meal boxes for the drive-in theater, adding value to their event and providing opportunity for another organization to also survive, identifying, and working with partners can spread out the burden and help the life of all the organizations in the collaboration. State associations can provide guidance and sometimes financial assistance as well.

Collaborations can range from joint programming and shared in-house administrative services to full-on organizational mergers. Could you share space or IT services with a community partner, or cosponsor an event? Collaborations do require a good deal of work and negotiation but can provide opportunities for outreach and growth, particularly during times of organizational stress or financial uncertainty. Some collaborations might seem more natural and comfortable (like the restaurant and the theater moved to the drive-in), while others (perhaps a childcare service that could offer babysitting at the theater) might take a little more imagination. Some collaborations will inevitably turn out to be bad decisions, but an even worse outcome is the great collaboration that never was because of a lack of imagination.

4. Engage your board, team members, and other stakeholders for solutions.

In our case study at the end of the chapter, Artrain, when faced with a difficult and unexpected path, turned to board members and other stakeholders to seek solutions. The people serving on your board should be familiar enough with, and committed enough to, your organization that they can always provide helpful guidance—especially in times of great need! If you value your team

and listen to them on a consistent basis, they will be engaged and prepared to offer input on potential solutions during organizational stress. Remember, sometimes they might be closer to the front lines than you are and might offer important and varied vantage points on the problems you are facing. And stakeholders are called such because they should be interested in the operations and success of your organization. Don't hesitate to be bold enough to ask for help from these people, especially in times of need. And these people might also be a source of unexpected opportunities or creative input that might have otherwise been overlooked.

5. Use reserves wisely.

During times of turbulence most normal operations are derailed, and that often means your normal funding operations are also either more restricted or possibly even eliminated. This is exactly the point of having a rainy day fund. So don't be afraid to use such a fund if needed; after all, that is exactly why you had the foresight to create one. But using such funds should bear even more scrutiny on your part about whether the stated need for using the fund is truly appropriate, which means it should match up with your organization's strategic priorities. Having well-thought-out strategic priorities, along with an ability to put a price on various operations individually, will help you make good decisions on such matters. And remember to practice prudence while making use of those funds. Don't use your reserve up completely, if possible, but do use it as appropriate to protect people and strategic priorities, with the understanding that the rainy day won't last forever. In fact, the average recession only lasts about ten months.[26] And while those may be ten loooong months, with good planning the rainy season will eventually come to an end and you will see the sun again.

6. Seek responsible cost reductions where possible.

We don't mean the straightforward, commonsense things like putting a hold on new purchases for things that are not truly critical; we mean things like seeking to negotiate and work with vendors in new ways. Much of the world still operates on barter and negotiation to conduct business—there is no better time to do so than when you are in financial difficulty. You would be surprised how many vendors will be willing to negotiate if you only ask. The National Center on Nonprofit Enterprise encouraged arts organizations during COVID-19 to seek cost reductions from vendors and others who might be able to provide flexibility or leniency in contracted terms. Offer tickets or other "goods and services" your organization has to vendors for their goods and services. Offer limited access or special programming to a company for their employees for a

special event. If you did not believe that what your organization was doing was important and worthwhile, you wouldn't be there—so you are offering valuable assets for trade! Have that confidence when talking to vendors.

7. Take care of your people.

Not only is it the right thing to do, but investing in the health, safety, and job satisfaction of your people will also help avoid burnout during stressful times. Ultimately, taking care of your people will lead to lower rates of turnover, which saves money in the long run. Just as listening to your people will encourage them to contribute to the organization in more meaningful ways, a feeling of trust and being valued will offer them more security, which in turn will make them more committed to helping ensure that your organization survives during hard times. If they are not feeling valued and supported, they are not likely to value or support the organization.

8. Use your organization's strategic priorities and plans to make any cutbacks or identify opportunities.

At some point during the crisis it may be necessary to cut expenses.[27] To the extent possible, avoid the negative consequences of cutback budgeting by using your strategic plans to help make the calls about which expenses are essential and which are not, and use performance measurement data to help make those calls.[28] Doing so will ensure that your cuts are the most reasonable ones for your organization to pursue; it will also allow you to avoid the typical cutback problems that accompany across-the-board cuts. Although across-the-board cuts may be politically expedient and perceived as fair, they can actually damage your organization by creating conflict, mistrust, and long-term financial instability of programmatic damage.

To further avoid the negative repercussions of budget cuts, communicate with your people and use your existing data to inform your budgeting decisions. Strategic use of data during times of fiscal stress is more difficult in a crisis because of perceived time constraints, lack of access to ready data, and sometimes limited analytical capacity, so it often doesn't happen. Keeping good data consistently and using activity-based costing on a regular basis can help identify the most strategic cuts in a time of fiscal setback. Be the anomaly among your peers and make your budget cuts strategically!

Alternatively, a crisis may turn out to be a time of opportunity. For example, interest rates hit historic lows during COVID-19.[29] So an organization that had been seeking a chance to purchase an expansion property might have taken advantage of those lows for long-term gain. Having those strategic priorities already identified and taking a long-view, systems perspective can help you as a

financial leader make recommendations to your board about seizing such opportunities even during periods of turbulence.

After the Fire: The Four R's of Resiliency

After the smoke has cleared and things are returning to a calmer place, use the time to recenter, reflect, reach out, and reignite your organization.

1. Reflect.

Yes, take your moment to reflect and celebrate that you survived the fire. But even more important, start reflecting on what you learned during the crisis that you can apply to your organizational health strategies as you move forward. Did a program innovation work? Did you connect with a new segment of your community? Do you have new partners or collaborators who can be important in the future as well? Don't be in such a hurry to go back to where you were before that you ignore or lose gains that might help you move forward.

Or are you still responding to the crisis in ways that are counterproductive to your mission? Taking some time after a crisis has passed to consider what you've learned and where you are as an organization will help you readjust your strategies if necessary, or to refocus if needed to keep the good and shuck the bad and move on.

2. Reach out.

Continue to make connections in your community. The old "make new friends but keep the old" mentality is also a proven strategic advantage during a crisis. Cultivating relationships within your community, even with sometimes unlikely partners (like the example of a daycare in the theater), can become fruitful and meaningful. National Center on Nonprofit Enterprise's resiliency training identifies networking as a key resilience skill, and research backs up the importance of those networks in times of trouble.[30] Remaining embedded in your community networks leads to agility and survival. And the best time to strengthen bonds is before they are stretched to the breaking point, such as during a crisis.

3. Recenter.

In our case study at the end of the chapter, Artrain experienced a unique type of external shock: the railway infrastructure system that carried their museum cars around the country stopped functioning. Deb Polich explained the moment of indecision and then the determination to move forward in the quote at the chapter's beginning.

Like Artrain, they determined that they, as an organization, weren't going

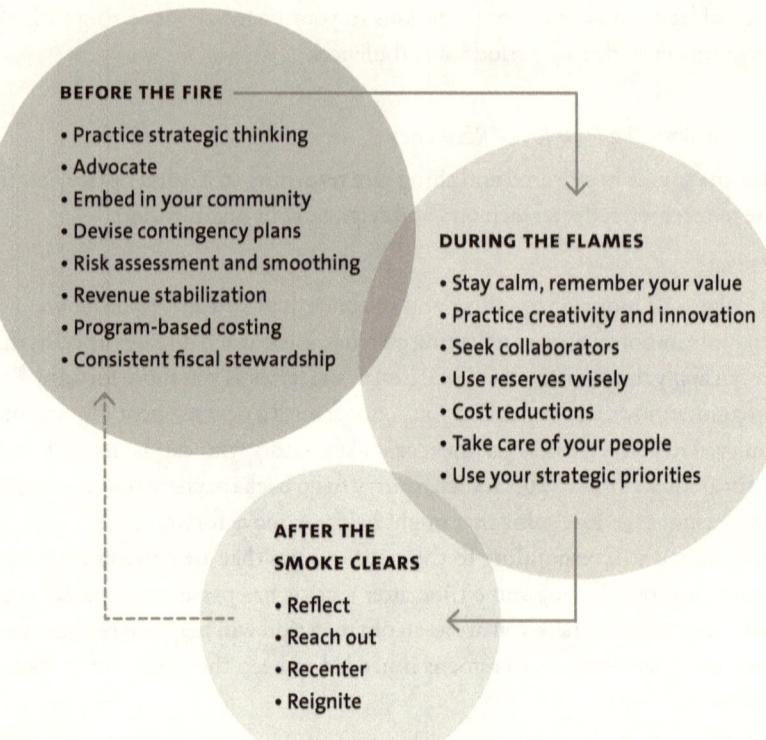

FIGURE 13-1. Fireproof Strategies for Improving Your Outcomes before, during, and after a Crisis

to come to a stop simply because their railroad cars were. So they went back to their roots: "We were always an arts organization." This recentering around their core identity allowed them to focus on their strengths and use those to help other creative organizations through consulting and project management. Go back to your core mission to understand your value proposition. What is the essence of who you are, and what are the values you hold as an organization? Just as walking into a garage doesn't make you a car, Artrain realized that showing art in railcars hadn't made them engineers. They were an arts-centered organization, first and last.

With the knowledge that you are part of a larger system, put the correct inputs in place to get the output you want. Remember David Hanna's observation that "every organization is perfectly designed to get the results that it gets."[31] If you aren't satisfied with those results, think about what inputs you should change to get the results you do want.

4. Reignite.

Remember that even a crisis "fire" might have some benefits when all is said and done (see figure 13-1). There are few things in nature more disastrous than a forest fire. It can rage uncontrollably, burning nearly everything in its path, seemingly leaving nothing but devastation in its charred path. Yet these fires also can clear away thick, tangly underbrush, remove diseased and dying trees, and offer opportunities for new life to grow. Sometimes a crisis "fire" can also help an organization to clear away underbrush that was unknowingly strangling other growth or limiting new growth opportunities. And if you plan ahead and are ready, when the fire comes hopefully you will be like a giant redwood, which survives forest fires that completely incinerate other trees and will be sprouting new growth almost before the fire is out.

Sometimes in extreme circumstances it feels like all you can do is hold on tight and hope for the best, but simply hoping is never for the best. Develop your resilience strategies so that, like a giant redwood, you can not only weather the turbulence but even be ready for new growth. Employing effective leadership, financial processes, and well-thought-out contingency plans can position your organization to not only prepare for a crisis, sustain your operations, and continue serving your community during the crisis but even to flourish as a result.

KEY TERMS

incrementalism
organizational turbulence
resilience
systems thinking

QUESTIONS TO CONSIDER

Does my organization employ resiliency strategies before, during, and after a crisis?

Does my organization have contingency plans to employ in a crisis?

Do I understand where my organization fits within larger systems?

Does my organization value its employees consistently? And, if so, do they know that?

Is my organization continuing to look for new collaborations and partnerships?

Is my organization embedded within our community?

Does my organization have an appropriate balance between mitigating risk and seeking opportunities?

ADDITIONAL READINGS

Bowman, Woods. "Financial Capacity and Sustainability of Ordinary Nonprofits." *Nonprofit Management and Leadership* 22, no. 1 (2011): 37–51.

Soh, Jung-In, Elizabeth A. M. Searing, and Dennis R. Young. "Resiliency and Stability of the Zoo Animals." In *The Social Enterprise Zoo*, 236–57. Cheltenham, UK: Edward Elgar, 2016.

CASE STUDY: ARTRAIN, BY DEB POLICH

More than three decades ago, a nonprofit organization called Artrain created a self-contained mobile art museum on vintage railcars and used this method to deliver art exhibitions and cultural programs to under-resourced places across the country. Artrain's mission is to enrich lives and build communities through the arts. It delivers world-class cultural exhibitions and education programs to communities while providing exceptional opportunities for learning, growth, and art appreciation and encouraging the development of local cultural programs and organizations. Artrain received the 2006 National Medal for Museum & Library Service, and its art exhibition *Native Views: Influences of Modern Culture* was named an American Masterpiece by the National Endowment of the Arts that same year. Founded in 1971, Artrain is headquartered in Ann Arbor, Michigan. More than 3.2 million people have visited Artrain during 845 community visits across the nation.

Artrain is unique. It is the only self-contained mobile museum that presents and tours museum-caliber exhibitions that contain original art and artifacts. Certainly, other museums have traveling exhibitions, but their tours do not include the communities Artrain serves, because these communities do not have venues that meet museum standards. Artrain offers small-town America what people in larger population areas take for granted: access to quality arts and arts education programs and the opportunity to discover the wonderful world of art in their hometown.

The "train museum" might be romantic, but it only reaches 30 percent of the country. So Artrain has found a new method of delivery: it is transitioning to state-of-the-art semitrailers and going "on the road" to accommodate more

communities and extend its reach to any city in the United States and possibly beyond. Already the only self-contained mobile museum project that meets museum standards, Artrain's transition to the road enables it to sell its services to any museum or cultural organization interested in program outreach. Artrain can set its standards high and position itself as the best provider of mobile museum projects in the country.

Artrain's decision to transition from rails to the road was initially motivated by self-preservation. After more than thirty years of being great partners, the US rail industry found it necessary to decrease, and in some cases eliminate, Artrain's access to the rails. The board and staff were forced to answer the question "If Artrain isn't on a train anymore, is it still a viable organization?" The resounding answer was yes. Artrain has delivered arts and cultural programs to communities with limited access to traditional providers of such programs. The method of delivery wasn't part of the mission. In order to continue, Artrain needed to find another way of delivering its award-winning cultural programs. A committee was formed to find another delivery vehicle that offered the ability to duplicate the required museum standards.

After significant research, Artrain's team selected state-of-the-art semitrailers for its new mobile museum galleries. Developed within the last ten years for the marketing industry for the experiential marketing movement, these mobile display units were designed originally for business-to-business and business-to-consumer marketing. Companies such as Sony, Anheuser Busch, the US Army, and others have used these semitrailers to promote their products and services at trade shows, county fairs, NASCAR races, or other events where consumers gather.

CHAPTER FOURTEEN

Creativity Takes Courage
Making Great Financial Decisions for Arts Leaders

Keeping your artistic self as creative as possible is a balancing act.
—KARRIN ALLYSON, singer

As the painter Henri Matisse once wrote, "Creativity takes courage." As an arts leader, you are intensely aware of the truth of this statement. To survive within a creative industry or in a nonprofit creative endeavor, creativity also requires balancing several financial and ideological imperatives.

In this book we've endeavored to provide a broad overview of numerous financial topics and tactics to help you forge the vital link between your work and its value in society and the financial health that allows you to continue to flourish. More than just Micawber's Maxim ("Annual income twenty pounds, annual expenditure nineteen, nineteen and six, result happiness. Annual income twenty pounds, annual expenditure twenty pound ought and six, result misery"), we know that arts organizations add to the bottom line of our communities and help them thrive. How we spend, save, allocate, manage, and prioritize our finances shows the world what we value and enables us to share the things we value.

During a 2021 National Public Radio series on resilience during the pandemic, arts entrepreneur and performer Carol Noonan shared her experience: "I'm the owner, along with my husband, of the Stone Mountain Arts Center in Brownfield, Maine, where I am a musician and a cook and everything else that *(laughs)* goes along with running this crazy place. I think artists are so used to having to be resilient. It's always an uphill battle financially, artistically in every way. And if you do make it, you're really lucky. But so many of us are still trying to make it or making it just enough. We're used to having to fight back, I guess."[1]

While we all love the spirit that encourages us to keep fighting when times are bad, we hope that it isn't "always an uphill battle financially" for your organization. Shedding the poverty mentality, the belief that scrimping for resources is what we should expect in the arts, and gaining financial knowledge and skills will move you further toward fulfillment of your mission.

Replace your poverty mentality with strengths-based thinking. A healthy respect for the financial challenges your organization could face is part of your contingency planning and financial prudence that keep you adhering to Micawber's Maxim, yet rather than viewing your organization in terms of its deficits, we encourage you to focus on your organization's strengths and develop your strategies within that mental framework. A strengths-based perspective is not wishful thinking. It's knowing your strengths and communicating your strengths. Strategic leadership understands the value of your organizational mission and its impact on society. Embrace a strengths-based perspective and that mindset will encourage opportunity seeking, present your organization as a viable partner and steward, and ultimately draw more resources to your cause. As a wise friend shared, "It's all right to make art *and* make money."[2]

Knowledge overcomes the poverty mentality and balances the trade-offs inherent in financial decision-making. Think about the circus performer who balances several spinning plates: like that performer, if you go too far one way or the other, you will get off balance and are likely to tip over. Arts organizations have several trade-offs to balance, including risk and stability, access and audience, artistry and affluence, passion and pragmatism, and community and capacity.

BALANCING ACTS: IT'S NOT JUST ABOUT YOUR CHECKBOOK

Stability and Risk

We all appreciate financial stability, and rightly so. But risk is a constant companion whose shadow can be wide or narrow depending on where the sun is shining. Therefore, rather than trying to eliminate risk (an impossible feat), your organization also needs to discuss and develop its risk tolerance. As we've noted throughout the text, any revenue stream has a promise and a risk. The turbulence strategies help us understand how to smooth risk, along with revenue considerations that consider the level of comfort and capacity that is appropriate for your organization and will allow it to pursue a variety of revenue streams and strategic opportunities. The risk and stability balance for your organization will be different than your neighbor's, so assess thoughtfully the right level of risk and revenue diversity for your organization.

To have impact both now and in the future, your organization must have both the short-term stability of immediate cash flows and long-term stability of sustained investment in the programming you haven't even dreamed up yet. These stable sources of revenue can also provide the opportunity for your organization to absorb some risk now and again when an opportunity arises. Risk is the opposite side of the stability coin, but both sides of that coin will spend. Like the difference between your financial statement, which is a point-in-time snapshot, and your savings account or operating reserve, keep attuned to both short-term, spot-in-time checks like the return on a specific event and long-term strategies like your impact assessment and contingency planning. As a leader, practice adapting to both short-term risk and long-term stability thinking and get others around you who can do the same. Seeing both the dance floor and the view from the balcony, as Ron Heifetz reminds us, is a skill to develop. Doing so will also help you invest in your people and relationships now, so that when the future brings trouble or opportunity, you'll be ready to maintain your balance.[3]

Access and Affluence

When you think about the mission of your organization, who is your ideal patron? What types of audience members, visitors, and clients do you have? Are you catering to only those on one or the other end of the financial spectrum? Would some lower-income members of your community benefit from access to your programming if they had the means to participate? Having a healthy balance between access and affluence means that you reach out to engage people who have little and those who have much.

Part of the art of balancing access and affluence is smart and equitable pricing structures for your services and programs. Considering your organization's pricing structures is an important revenue consideration that also has ramifications for social equity and community impact. For example, as part of their history of creating arts access in sometimes unlikely places, Artrain charges no admission to provide equal access for all visitors but encourages visitors to make a small contribution if they are able. A respondent to the 2021 ArtsFund survey demonstrated the difficulty of funding programs and providing programs to those with less means: "Our online audience is growing, but in order to survive we needed to monetize that as much as possible, so we decided that our content should not be free and should reflect the cost of what it takes to produce these events. Thus, our events are expensive—but have kept us in business. But we do make our content available to select communities via discount codes.... It is a tough balance."[4]

If your organization caters primarily to wealthy clients, what are some ways

you might encourage or foster access for other groups within your community? Can you provide differential pricing for certain programs or performances? Some strategies involve occasional Pay What You Will events, like Black Friar's Playhouse in Staunton, Virginia (which does so at the beginning of each production run), along with designated discount or free days, or even barter events, where you partner with another organization to sponsor a specific activity that has wide community impact. Many organizations have differential pricing for students and senior citizens, but what about those who live in particular areas of your community, who homeschool, who are in foster care . . . ? There are numerous options that could be particularly meaningful for your type of programming. Could you have a certain day of the month or once a year where admission is free?

On the other hand, do you have special opportunities to cultivate the community members in the higher socioeconomic strata, those who can attend higher-dollar events or have the ability to write sustaining checks? Elite donors and exclusive events can help pay for expensive traveling exhibitions, interventions, or artists-in-residence. To maximize your reach to your whole community, your organization will want to assess its outreach and access to individuals across all socioeconomic levels and regions of your community.

Artistry and Audience

Understanding and staying true to your organizational niche is important. In business, niche marketing can be a strength because it strengthens the uniqueness of your brand and people's identification of it. Cultural organizations are arguably essential to our civil society functioning, but sometimes people may not immediately see their personal connection with our unique brand of art. With cultural and artistic endeavors, we sometimes also need to invite people to experience our unique niche in ways that engage them in their own areas of interest first.

Like the balance between access and affluence, the balance between artistry and audience is a necessary one for your organization to recognize and develop strategies to maneuver through. Fiscal resources impact arts organizations at all levels and even influence programming decisions. Scholars find evidence that federal-level funding, particularly NEA funding, encourages arts organizations to take more programmatic risks, while funding from local governments is associated with more traditional content.[5] Small, medium, and large donors also discriminate in terms of content funded, with higher-end donors supporting innovative content and small to medium donors favoring more traditional output.[6] So there's a reason why *Greater Tuna* is part of many theaters' repertoires,

concert bills often have a Pops event, and *The Nutcracker* is ubiquitous during the holiday season.

Although this balance can be frustrating for some arts organizations who see popular programming as pandering or selling out to the public, consider popular programming as a way to support the more avant-garde or niche work your organization wants to promote. Barter Theatre once again offers a good case to consider. Their 2022 season touted popular shows like *9 to 5*, *Romeo and Juliet*, and *Murder on the Orient Express* along with the world premiere of the musical *Kentucky Spring*. Their season also helps support the development of new playwrights and artists and new work through the Appalachian Festival of New American Plays, the Black in Appalachia Initiative, and Young Playwrights' Festival. This balance of tried-and-true favorites with wide appeal enables the theater to have high levels of audience engagement and also spur innovation. If you are all artistry and no audience, are there additional ideas your organization could use to improve the balance?

Passion and Pragmatism

Live out your passion. Hopefully these chapters have given you some knowledge and resources to move forward with more financial confidence to accomplish the artistic vision you have set for your organization. If you still need help with finances (and who doesn't?), make sure you surround yourself with folks who possess practical financial knowledge on your staff, when possible, and on your board, particularly in the Treasurer and Finance Committee roles. Also, make sure you have a reliable accountant to advise and prepare financial documents and reports. Making sound financial choices consistently will free you up to pursue the artistic mission.

Passion and pragmatism also include setting the right policies and procedures in place, effectively evaluating your program and organizational impact, and seeking appropriate counsel when needed from people who also care deeply about your work. Passion means engaging everyone you can about your mission while also understanding the multiple accountabilities of your organization; and passion's counterweight, the practical capacity constraints you experience, means you cannot respond to all the calls for information and assessment that you'd like. This balance means engaging amazing new talent in your area of expertise, but also making sure they have equitable pay scales and supports, helping a new generation of artists to break the poverty mentality.[7] So use your strategic priorities, which embody passion and pragmatism, to help you make financial, evaluative, and workforce decisions.

Community and Capacity

Your artistic vision is achieved within a complex system of internal and external stakeholders, including community organizations along with your staff and board. These relationships undergird all your financial and artistic success strategies and also require a tremendous amount of energy and communication to manage effectively. Along with your financial resources, your volunteers and collaborative programs are resources that impact your financial bottom line. Plus, we know from research that community embeddedness (long-term and sustained interaction with the community) and networking are resilience strategies that help organizational leaders weather times of organizational turbulence. In many ways, financial efficiencies in cultural and arts organizations are related to wider social impact.[8]

Building and stewarding relationships with your financial institutions, governmental funders, foundations, individual donors, local businesses, and corporate partners should be a priority but, like the many accountabilities mentioned earlier, requires planning and prioritization. Such planning and prioritization will vary according to your organization's internal capacity. Large organizations are much better equipped to share the collective joy and burden of communicating performance evaluation, donor updates, and board reports (although the executive director will always share a big role in these functions regardless of size) than small programs with only a few staff people. Considering your organization's best balance between community and capacity pays dividends far into the future.

Tradition and Transition

In some ways, balancing the competing logics of expression and commercialism, or artistic merit and financial stability, can be viewed through the lens of tradition versus transition. Nonprofits have historically spoken of themselves in terms of businesslike behaviors but may need to shift their thinking from prior ways of doing business to new identities where boundaries are more permeable, where their organizational form or mode of delivery is different, or where an unexpected partnership bears fruit. As early as 1999, arts scholars encouraged creative entrepreneurs to consider options for "binding but not blurring the goals of for-profit and nonprofit arts organizations," noting that "significant new initiatives are possible in areas including philanthropy, joint ventures to create and disseminate new products, community redevelopment, technology, cultural preservation, and career development."[9] Within our current landscape, even richer hybridization opportunities exist. The trade-off here is holding on to

the core identity and mission of your organization while embracing, or at least considering, new models for how you do business.

ARTISTIC AND FINANCIAL LEADERSHIP

All the information covered in this text is intended to help you lead your organization into financing, funding, and sustaining your artistic mission. Your organization depends on both your artistic and financial leadership; if you can't keep operating financially, no matter how great your mission is, your organization will fail.

With both your artistic and financial leader hats, adopting an entrepreneurial mindset can help you balance a healthy risk tolerance with identifying strategic opportunities.[10] Scholarly work on entrepreneurial leadership classifies leaders who exhibit entrepreneurial thinking as both doers, who practice a balance of healthy risk and opportunity identification, and accelerators, who help others within their sphere of influence to do the same.[11] This type of mindset would help you consider sustainable new programs in light of all you learned through the crisis and encourage staff across the organization, both administrative and creative, to look for opportunities for programmatic and revenue growth.

Along with being entrepreneurial, artistic, and financial leadership also requires adaptation. Adaptive leaders understand their organization's place within complex systems and provide opportunities for their team to come together to discuss ideas, problems, and opportunities.[12] Something as simple as arranging convening spaces where creative directors and financial administrators can share information and think through issues together could be transformative. Adaptive leaders know their people and processes by being on the dance floor but also spend time considering the larger systems involved by stepping into the balcony. Cultivating both perspectives will position you to resolve problems with your processes or people earlier and to recognize an opportunity in the distance.

Finally, artistic, and financial leadership requires that you adopt a mindset that anticipates turbulence and prepares for it, remains calm and decisive during it, and recenters and reignites after crisis hits, so that you can continue to create amid chaos.

By striving to balance all your complementary and sometimes competing core trade-offs, you will at the very least make more thoughtful decisions about your organization's progress toward its mission, and at best, you will set the stage for sustained financial and artistic success.

Is all this a tall order? Of course. And sometimes you will fail, but more often

you will prevail. And, most important, if you haven't failed, you haven't tried. Use these principles and practices so that you can experience more financial calm and be free to express your artistic vision and improve your communities in the process. Keep creating and keep striving to improve your financial picture. Because after all, *ars longa, vita brevis*: life is short, art is forever.

APPENDIX

TABLE A1. Financial Ratios Cheat Sheet:
Ten Financial Ratios Every Arts Leader Should Know How to Measure

Ratios		What They Tell Us	Benchmark
Current ratio	Current assets ÷ Current liabilities	The nonprofit's ability to pay its outstanding obligations in a timely manner (<12 months)	2 or more
Days of cash on hand	(Cash + Short-term investments) ÷ ((Expenses – Bad debts – Depreciation) ÷ 365)	How long the nonprofit can survive in a fiscal crisis	Ideally 3–6 months
Debt to assets ratio	Total liabilities ÷ Total assets	Compares what the nonprofit owes to what it owns or tells us how much the organization relies on debt for its daily operations	0.5 or less
Debt to equity ratio	Total liabilities ÷ Total net assets	Viability ratio that compares what the nonprofit owes to its equity or net worth	Less than 1.0
Times interest earned ratio	(Change in net assets + Interest expense) ÷ Interest expense	How many times over the nonprofit would be able to make its interest payments on outstanding debt	At least 1
Return on net assets ratio	Change in net assets ÷ Net assets	The nonprofit's surplus/loss relative to its net assets	No benchmark, but should be positive with an upward trend
Receivables turnover ratio	Unrestricted revenue and support ÷ Total receivables	Approximately how many times during the fiscal year your nonprofit's receivables were fully collected.	At least 1

TABLE A1. (continued)

Ratios		What They Tell Us	Benchmark
Average collection period	365 ÷ Receivables turnover ratio	On average, how many days it takes to collect your nonprofit's receivables	45 days or less
Program services expense ratio	(Program service expenses ÷ Total expenses) × 100	What proportion of your nonprofit's total expenses is spent on fulfilling the mission—as opposed to administrative overhead or fundraising	Varies widely. Ideally 60–70 percent
Fundraising efficiency ratio	Unrestricted contributions ÷ Fundraising expenses	How much revenue is being generated for every dollar spent on fundraising	At least 1

TABLE A2. Nonprofit Financial Management Self-Assessment Tool from the Nonprofit Association of Oregon

I. FINANCIAL PLANNING/BUDGET SYSTEMS

	Don't Know	Inadequately Achieved	Partially Achieved	Fully Achieved
1. Organization has a comprehensive annual budget which includes all sources and uses of funds for all aspects of operations.				
2. All grant or contract budget agreements with funders are incorporated into the comprehensive annual budget.				
3. All grant or contract budget proposals are reviewed by fiscal staff before submission to funders.				
4. Program managers play an active role in the development of budgets for programs under their direction.				

Appendix 235

TABLE A2. *(continued)*

	Don't Know	Inadequately Achieved	Partially Achieved	Fully Achieved
5. A board committee has a detailed understanding of the annual budget and plays a significant role in directing the use of unrestricted funds.				
6. The full board formally authorizes the annual budget and revisions to the budget.				
8. The organization has integrated meaningful consideration of financial issues into any strategic planning processes it undertakes.				
9. The organization has a capital budget and multiyear plans for major maintenance and replacement of facilities and equipment.				
10. The fiscal planning process includes continuous assessment of risks and identification of insurance coverage needs and appropriate risk management procedures.				
11. Risk assessment includes general liability, professional liability, product liability, fire, theft, casualty, workers compensation/occupational safety, board and officer liability, vehicle operation, fraud and dishonest acts.				

II. EXECUTION

	Don't Know	Inadequately Achieved	Partially Achieved	Fully Achieved
1. The organization has written policies and procedures for fiscal operations including procedures for processing payroll, purchases, accounts payable, accounts receivable, etc.				

TABLE A2. *(continued)*

	Don't Know	Inadequately Achieved	Partially Achieved	Fully Achieved
2. Written policies and procedures are reviewed and revised regularly.				
3. Actual processing activities are consistent with written policies and procedures.				
4. The concept of separation of duties is implemented to the greatest extent feasible within the limitations of the size of the organization staff.				
a. Authorization functions for purchasing, signing checks, adjusting accounts, and extending credit are not performed by individuals who also perform recording functions such as disbursements and/or receipts, maintaining accounts receivable records, or cash handling functions such as receiving and depositing funds or preparing checks.				
b. Review and verification functions such as reconciliation of the bank statement to the record of cash receipts and disbursements are not performed by individuals who also prepare checks, record checks, receive funds and prepare bank deposits, and/or record receipts.				
5. Payroll policies and procedures are clearly documented and consistently followed.				
a. Written authorization is required for all new hires and pay rate changes.				
b. Written timesheets are prepared by all employees, signed by the employee, and approved in writing by the employee's direct supervisor.				

TABLE A2. *(continued)*

	Don't Know	Inadequately Achieved	Partially Achieved	Fully Achieved
c. Forms W-4 and I-9 are obtained and retained for each employee.				
d. Policies regarding overtime, vacation time, sick leave, holiday pay, and other leaves with or without pay are written clearly, and reviewed regularly for compliance with state and federal law.				
e. All fringe benefit plans are documented and in compliance with IRS and Department of Labor requirements. The proper tax treatment for all benefits and compensation arrangements has been determined and documented.				
f. Responsibility for maintaining fringe benefit records in accord with governmental requirements has been clearly assigned and records are reviewed regularly.				
6. Written purchasing policies clearly identify the purchasing authority of each staff position, and establish appropriate dollar limits for purchasing authority at each level.				
7. There are clear procedures for review of and authorization to pay all vendor invoices.				
8. Written policies and procedures for charging and collecting fees are followed consistently and reviewed regularly.				
9. Cash handling policies and procedures are well documented and are tested periodically.				
a. All checks are restrictively endorsed upon receipt.				

TABLE A2. *(continued)*

	Don't Know	Inadequately Achieved	Partially Achieved	Fully Achieved
b. Receipts are given for all cash transactions and donors/clients are informed that they should receive a receipt for all cash payments. Prenumbered, multicopy, customized receipts are used.				
c. A receipts log is maintained by the person responsible for opening the mail.				
d. Cash reconciliation sheets are maintained by all individuals responsible for accepting cash. All cash counts are initialed by the individual preparing the initial count and the individual receiving the cash for further processing.				
e. Postdated checks are not generally accepted, and if accepted, are secured carefully.				
f. All disbursements are made by check except for small purchases made through a Petty Cash fund.				
g. All unused check stock is carefully secured.				
h. Bank reconciliation is performed by someone who neither makes bank deposits nor prepares checks.				

III. RECORDING

	Don't Know	Inadequately Achieved	Partially Achieved	Fully Achieved
1. A complete written chart of accounts provides appropriate account titles and numbers for Assets, Liabilities, Net Assets, Revenues, and Expenses.				

TABLE A2. (*continued*)

	Don't Know	Inadequately Achieved	Partially Achieved	Fully Achieved
2. The Chart of Accounts clearly establishes the programs or func-\|tions which will be distinguished and the funding sources and/or distinct funds which will be tracked.				
3. The Chart of Accounts utilizes the same line item categories and the same program or function distinctions which are utilized in the comprehensive annual budget and the budgets for individual contracts or grants.				
4. Accounting policies and recording procedures are clearly documented in the written fiscal policies and procedures.				
5. Appropriate computer software and hardware is utilized to perform recording functions.				
6. Appropriate electronic and physical security procedures are utilized to protect the integrity of computerized accounting records.				
7. All accounting records are backed up daily. Backup media are stored in a secure area away from computer equipment.				
8. Backups of accounting data are stored off-site at least monthly.				
9. Detailed records of client fees and/or grants and contracts receivable are maintained and reconciled to the general ledger receivables balances.				
10. All contributions are recorded in the accounting records. If more detailed records are maintained by staff responsible for fund development, the fund development and accounting records of contributions are reconciled monthly.				

TABLE A2. (continued)

	Don't Know	Inadequately Achieved	Partially Achieved	Fully Achieved
11. All general ledger balance sheet accounts are reconciled at least quarterly. All cash, payroll liabilities, and accounts receivable control accounts are reconciled monthly.				

IV. REPORTING

	Don't Know	Inadequately Achieved	Partially Achieved	Fully Achieved
1. Monthly financial statements are available no later than the end of the following month (i.e., April 30th statements are available no later than May 31st).				
2. Monthly financial statements include a Balance Sheet as well as a Statement of Activities and Changes in Net Assets.				
3. In organizations with multiple programs, statements of the expenses of each distinct program are prepared monthly.				
4. In organizations which receive restricted funds, separate statements of revenue and expenses are prepared for each funding source.				
5. All revenue and expense statements (for the whole organization, for specific programs, and for specific funding sources) include the current month's activity, the fiscal year to date activity, and a comparison to the year to date or annual budget by line item.				
6. The excess (deficit) of support and revenue over expenses (net income) is reconciled to the change in fund balance between the beginning and ending of the accounting period.				

TABLE A2. *(continued)*

V. MONITORING

	Don't Know	Inadequately Achieved	Partially Achieved	Fully Achieved
1. The executive director and the program managers review the monthly financial statements carefully.				
2. The fiscal manager highlights unusual items and identifies potential problems in notes to the financial statements shared with the executive director and board committee or full board.				
3. A board committee or the full board reviews the monthly financial statements carefully.				
4. The board or a board committee selects an independent CPA to conduct an annual audit or review. The board determines whether the organization should have an audit or a review, and whether or not the audit must conducted within the guidelines of OMB A-133, as required for organizations receiving over $300,000 in federal funds or recommended for organizations receiving more than $100,000 each from more than one federal source.				
5. The board or a board committee reviews auditor's report, including any management letters, and reports on internal controls and compliance with governmental law and regulation.				
7. The board and executive director continually review the organization's financial statements to determine whether:				
a. The use of the organization's resources is consistent with the organization's mission and priorities.				

TABLE A2. (*continued*)

	Don't Know	Inadequately Achieved	Partially Achieved	Fully Achieved
b. The organization is solvent, i.e., has assets in excess of its liabilities.				
c. The organization has adequate cash and other liquid assets to meet its current obligations and assure its continuing ability to pay its employees, taxing authorities, and vendors on time.				
d. The organization is observing and documenting its observance of all restrictions imposed by funders and donors.				
8. The board and executive director are aware of the IRS requirements for maintaining tax-exempt status and continually evaluate organization's activities, use of funds, record keeping, and IRS reporting to assure compliance with all requirements.				

NOTES

INTRODUCTION

1. Dr. Jonathan Stewart, personal communication with Margaret F. Sloan, July 30, 2021.

2. William J. Baumol and William G. Bowen, "On the Performing Arts: The Anatomy of Their Economic Problems," *American Economic Review* 55, nos. 1/2 (1965): 495–502; Arthur C. Brooks, "The 'Income Gap' and the Health of Arts Nonprofits," *Nonprofit Management and Leadership* 10, no. 3 (2000): 271–86.

3. Dennis J. Rich, "Baumol's Disease in America," *Megatrend Review* 9, no. 1 (2012): 97–106.

4. Woods Bowman, "The Uniqueness of Nonprofit Finance and the Decision to Borrow," *Nonprofit Management and Leadership* 12, no. 3 (2002): 294.

5. Henry B. Hansmann, "The Role of Nonprofit Enterprise," *Yale Law Journal*, no. 89 (1979): 838.

6. Robert J. Yetman, "Borrowing and Debt," in *Financing Nonprofits: Putting Theory into Practice*, ed. Dennis R. Young (Lanham, MD: AltaMira, 2007), 244.

7. Michael Rushton, "Hybrid Organizations in the Arts: A Cautionary View," *Journal of Arts Management, Law, and Society* 44, no. 3 (2014): 147.

8. Pam Korza, Maren Brown, and Craig Dreeszen, *Fundamentals of Arts Management*, 5th ed. (Amherst: Arts Extension Service, University of Massachusetts Amherst, 2007).

9. Korza, Brown, and Dreeszen, *Fundamentals of Arts Management*.

10. Deondre' Jones, "National Taxonomy of Exempt Entities (NTEE) Codes," National Center for Charitable Statistics, April 2, 2019, https://nccs.urban.org/project/national-taxonomy-exempt-entities-ntee-codes.

11. Mirae Kim, "The Relationship of Nonprofits' Financial Health to Program Outcomes: Empirical Evidence from Nonprofit Arts Organizations," *Nonprofit and Voluntary Sector Quarterly* 46, no. 3 (2017): 525–48.

12. National Endowment for the Arts, "The Arts and Economic Growth," accessed May 3, 2023, www.arts.gov/impact/research/arts-data-profile-series/adp-34.

13. National Endowment for the Arts, "Arts and Economic Growth."

14. National Endowment for the Arts, "Arts and Economic Growth."

15. National Assembly of State Arts Agencies, *Creative Economies and Economic Recovery: Key Findings*, February 2021, https://nasaa-arts.org/wp-content/uploads/2021/02/Creative-Economy-and-Recovery-Case-Studies-Key-Findings.pdf.

16. Sally Mometti and Koen Van Bommel, "Performing Arts Organizations as Hybrid Organizations: Tensions and Responses to Competing Logics," *Journal of Cultural Management and Cultural Policy* 7, no. 2 (2021): 135–68; Mary Ann Glynn, Elizabeth A.

Hood, and Benjamin D. Innis, "Taking Hybridity for Granted: Institutionalization and Hybrid Identification," in *Organizational Hybridity: Perspectives, Processes, Promises* (Bingley, UK: Emerald, 2020), 53–72; Elena Dalpiaz, Violina Rindova, and Davide Ravasi, "Combining Logics to Transform Organizational Agency: Blending Industry and Art at Alessi," *Administrative Science Quarterly* 61, no. 3 (2016): 347–92; Rushton, "Hybrid Organizations in the Arts."

CHAPTER ONE

1. Dr. Jonathan Stewart, personal communication with Margaret F. Sloan, July 30, 2021.

2. Brian Smallwood, personal communication with Margaret F. Sloan, August 19, 2021.

3. "22 Great Nonprofit Mission Examples," *Donorbox Blog*, accessed February 22, 2022, https://donorbox.org/nonprofit-blog/mission-statement-examples/.

4. "Return of Organization Exempt from Income Tax," *Lincoln Center for the Performing Arts*, accessed December 18, 2021, https://res.cloudinary.com/lcpa-fountain/image/upload/o4ev5r1onzj7dmhiv63f.

5. Allen J. Proctor, *Linking Mission to Money: Finance for Nonprofit Board Members* (Worthington, OH: LMM Press, 2010), 15–24.

6. Marc Schultz, Betsy Reid, and Tom Zimmerman, "Financial Planning That Drives Your Strategy Forward," *Georgia Nonprofit NOW*, Summer 2014.

7. Proctor, *Linking Mission to Money*, 15–24.

8. Sarah Cascone, "Rocked by Embezzlement and Lye Attack, Healing Arts Initiative Shuts Down," *ArtNet News*, May 16, 2016, https://news.artnet.com/art-world/healing-arts-initiative-shutters-lye-attack-498320.

9. John Macintosh, "$750,000 Embezzled, Whistleblower Attacked and Bankruptcy: How the Healing Arts Initiative Recovered from the Unimaginable," *City and State New York*, June 13, 2017, www.cityandstateny.com/policy/2017/06/750000-embezzled-whistleblower-attacked-and-bankruptcy-how-the-healing-arts-initiative-recovered-from-the-unimaginable/180947/.

10. Macintosh, "$750,000 Embezzled."

11. "CharityWatch Hall of Shame: The Personalities behind Charity Scandals," *CharityWatch*, August 24, 2018, www.charitywatch.org/charity-donating-articles/charitywatch-hall-of-shame.

12. "CharityWatch Hall of Shame."

13. "CharityWatch Hall of Shame."

14. "CharityWatch Hall of Shame."

15. "Charity Board Fires ED Who Was Attacked after Questioning Finances," *Philanthropy News Digest*, May 12, 2016, https://philanthropynewsdigest.org/news/charity-board-fires-ed-who-was-attacked-after-questioning-finances.

16. Philanthropy News, "Charity Board Fires ED."

17. Kate Barr and Jeanne Bell, "An Executive Director Guide to Financial Leadership," *Nonprofit Quarterly*, January 10, 2019, https://nonprofitquarterly.org/executive-directors-guide-financial-leadership-2/.

18. David O. Renz and Rhonda Gerke, "An Executive Director's Primer on Financial Management," *Nonprofit Quarterly*, March 21, 2001, https://nonprofitquarterly.org/an-executive-directors-primer-on-financial-management/.

19. Renz and Gerke, "Executive Director's Primer."

20. Renz and Gerke, "Executive Director's Primer."

21. Gracia Chua, "4 Great Reasons to Outsource Your Nonprofit's Bookkeeping," *Enkel*, 2022, www.enkel.ca/blog/bookkeeping/outsource-non-profit-bookkeeping/.

22. Mary Diegert, "Role of the Nonprofit CFO in Executive Management: The Watchdog Responsibility," *Blue Avocado*, March 28, 2022, https://blueavocado.org/current-issue/role-of-the-nonprofit-cfo-in-executive-management-the-watchdog-responsibility/.

23. "Does Your Nonprofit Need a CFO?," *Mauldin and Jenkins*, May 22, 2019, www.mjcpa.com/does-your-nonprofit-need-a-cfo/.

24. Aaron S. Wilkins and Peter D. Jacobson, "Fiduciary Responsibilities in Nonprofit Health Care Conversions," *Health Care Management Review* 23, no. 1 (1998): 77–90.

25. "Board Role and Responsibilities," *Council of Nonprofits*, 2022, www.councilofnonprofits.org/tools-resources/board-roles-and-responsibilities.

26. Kim Donahue, "The Role of the Board in Nonprofit Budget Making," *Boardable*, October 7, 2019, https://boardable.com/blog/nonprofit-budget-board-of-directors/.

27. Hope Goldstein, "Nonprofit Budgeting: Key Board Roles and Responsibilities and Questions to Ask Prior to Approval," *Marks Paneth Accountants and Advisors*, May 29, 2018, www.markspaneth.com/insights/industry/industry/nonprofit-budgeting-key-board-roles-and-responsibilities-and-questions-to-a.

28. Goldstein, "Nonprofit Budgeting."

29. Brian Smallwood, personal communication to Margaret F. Sloan, August 19, 2021.

30. Robert D. Lee, Ronald W. Johnson, and Philip G. Joyce, *Public Budgeting Systems* (Burlington, MA: Jones & Bartlett Learning, 2020), 113.

31. Lee, Johnson, and Joyce, *Public Budgeting Systems*, 113.

32. Christine Burdett, "Financial Management in the Arts," in *Fundamentals of Arts Management*, ed. Pam Korza and Maren Brown (Amherst: Arts Extension Service, University of Massachusetts Amherst, 2007), 239–62.

33. Burdett, "Financial Management in the Arts," 239–62.

34. Dr. Jonathan Stewart, personal communication to Margaret F. Sloan, July 30, 2021.

35. Anonymous, personal communication to Margaret F. Sloan, July 30, 2021.

36. Mike Scutari, "The Arts Sector Is Being Decimated by Covid-19. What Are Funders Doing in Response?," *Inside Philanthropy*, March 23, 2020, www.insidephilanthropy.com/home/2020/3/22/how-can-funders-most-effectively-support-an-arts-sector-decimated-by-covid-19.

37. Mirae Kim and Dyana P. Mason, "Are You Ready: Financial Management, Operating Reserves, and the Immediate Impact of Covid-19 on Nonprofits," *Nonprofit and Voluntary Sector Quarterly* 49, no. 6 (December 2020): 1191–1209.

38. National Endowment for the Arts, "The Arts in the Time of Covid," *American Artscape*, no. 3 (2020), www.arts.gov/stories/magazine/2020/3/arts-time-covid.

39. Mirae Kim and Dyana P. Mason, "Federal Support Has Shored Up Nonprofits during the Covid Pandemic, but Many Groups Are Still Struggling," *The Conversation*, 2022,

https://theconversation.com/federal-support-has-shored-up-nonprofits-during-the-coronavirus-pandemic-but-many-groups-are-still-struggling-156359.

40. Kim and Mason, "Federal Support."

41. Kim and Mason, "Federal Support."

42. Alice Antonelli, "Making Your Budget the Backbone of Your Nonprofit," *Nonprofit Finance Fund*, 2021, https://nff.org/blog/art-forecasting-contributed-revenue.

43. Antonelli, "Making Your Budget."

44. Lena Eisenstein, "10 Nonprofit Budget Best Practices for Sound Financial Management," *Board Effect*, June 28, 2021, www.boardeffect.com/blog/10-nonprofit-budget-best-practices-for-sound-financial-management/.

45. Erica Gwyn, "Why Budgeting Is Important for Your Nonprofit and How to Do It Well," *Bloomerang*, accessed June 22, 2022, https://bloomerang.co/blog/why-budgeting-is-important-for-your-nonprofit-and-how-to-do-it-properly/.

46. D. K. Row, "Interview: George Thorn on the Ecology of the Arts Community," *The Oregonian*, May 2, 2009, www.oregonlive.com/art/2009/05/interview_george_thorn_on_the.html.

47. D. K. Row, "Interview with Michael Kaiser of the Kennedy Center," *The Oregonian*, May 14, 2010, www.oregonlive.com/art/2010/05/interview_with_michael_kaiser.html.

CHAPTER TWO

1. Bohor Enamhe, "Budgeting as a Strategic Tool for Development in the Arts," *Global Journal of Humanities* 8, nos. 1 and 2 (2009): 47.

2. Enamhe, "Budgeting as a Strategic Tool," 47.

3. Enamhe, "Budgeting as a Strategic Tool," 47.

4. Ellen Rosewall, *Arts Management: Uniting Arts and Audiences in the 21st Century* (Oxford: Oxford University Press, 2022), 124.

5. Rosewall, *Arts Management*, 124.

6. Rosewall, *Arts Management*, 124.

7. Cleopatra Charles, Margaret Sloan, and Peter Schubert, "If Someone Else Pays for Overhead, Do Donors Still Care?," *American Review of Public Administration* 50, nos. 4 and 5 (2020): 418.

8. Charles, Sloan, and Schubert, "If Someone Else Pays," 415.

9. Alice Antonelli, "Making Your Budget the Backbone of Your Nonprofit—Part 5," *Nonprofit Finance Fund*, 2017, accessed June 22, 2022, https://nff.org/blog/art-forecasting-contributed-revenue.

10. Ryan Jones, "A Guide to Nonprofit Revenue Forecasting and Diversification," *Keela*, December 2, 2020, www.keela.co/blog/nonprofit-resources/nonprofit-revenue-forecasting-and-diversification.

11. Jones, "Guide to Nonprofit Revenue Forecasting."

12. Rosewall, *Arts Management*, 146.

13. Jones, "Guide to Nonprofit Revenue Forecasting."

14. Lynne Weikart and Greg Chen, *Budgeting and Financial Management for Nonprofit Organizations* (Long Grove, IL: Waveland, 2022), 29–30.

15. Weikart and Chen, *Budgeting and Financial Management*, 87.
16. Rosewall, *Arts Management*, 124.
17. Community Brands, "Budget Checkup: Critical Components to the Nonprofit Budget Process," *Nonprofit Times*, 2019, https://files.ifea.com/iearchive/2019Spring-ARTICLE-BudgetCheckup.pdf.
18. Greg G. Chen, Lynne A. Weikart, and Daniel W. Williams, *Budget Tools: Financial Methods in the Public Sector* (Thousand Oaks, CA: CQ Press, 2014), 226.
19. Internal Revenue Service, "IRS Topic No. 704 Depreciation," accessed June 22, 2022, www.irs.gov/taxtopics/tc704.
20. Internal Revenue Service, "IRS Publication 946: How to Depreciate Property," accessed June 22, 2022, www.irs.gov/publications/p946.
21. PWC Viewpoint, "10.3 Works of Art, Historical Treasures, and Similar Assets," accessed June 22, 2022, https://viewpoint.pwc.com/dt/us/en/pwc/accounting_guides/not-for-profit-entities/Not-for-profit-entities/Nfp10_1/103_Works_of_art_10.html.
22. Rosewall, *Arts Management*, 146.
23. Rosewall, *Arts Management*, 146.
24. Community Brands, "Budget Checkup."
25. Community Brands, "Budget Checkup."

CHAPTER THREE

1. "Barter Theater History: A Glimpse at Our Beginning," Barter Theater, accessed May 21, 2022, https://bartertheatre.com/history/.
2. Lester Salamon, *The State of Nonprofit America* (Washington, DC: Brookings Institution Press, 2012).
3. Francie Ostrower and Thad Calabrese, "Audience Building and Financial Health in the Nonprofit Performing Arts: Current Literature and Unanswered Questions (Executive Summary)," in *Classical Music: Contemporary Perspectives and Challenges*, ed. Michael Beckerman and Paul Boghossian (Cambridge, UK: Open Book Publishers, 2021), 63–74.
4. "Applying Art History to Workplace Safety: Saving Lives and Growing Revenue at the Toledo Museum of Art," *American Alliance of Museums*, accessed June 22, 2022, www.aam-us.org/2021/11/22/applying-art-history-to-workplace-safety-saving-lives-and-growing-revenue-at-the-toledo-museum-of-art/.
5. Salamon, *The State of Nonprofit America*.
6. Americans for the Arts, accessed June 22, 2022, www.americansforthearts.org/.
7. "Growing Your Membership: 91 Ways to Recruit and Retain More Members," Stevenson Inc., accessed June 22, 2022, www.stevensoninc.com.
8. Francie Ostrower, "Elite Trustees: A Profile," in *Trustees of Culture: Power, Wealth, and Status on Elite Arts Boards* (Chicago: University of Chicago Press, 2020), 1–23.
9. Mirae Kim, "The Relationship of Nonprofits' Financial Health to Program Outcomes: Empirical Evidence from Nonprofit Arts Organizations," *Nonprofit and Voluntary Sector Quarterly* 46, no. 3 (2017): 525–48; Cleopatra Grizzle, "Efficiency, Stability and the Decision to Give to Nonprofit Arts and Cultural Organizations in the United States," *International Journal of Nonprofit and Voluntary Sector Marketing* 20, no. 3 (2015): 226–37.

10. "A Fundraising Platform to Support Your World-Changing Work," accessed June 22, 2022, Qgiv, www.qgiv.com.

11. Association of Fundraising Professionals, "Code of Ethical Standards," accessed October 1, 2023, www.afpglobal.org/ethicsmain/code-ethical-standards.

12. Giving USA, "Giving USA 2021: In a Year of Unprecedented Events and Challenges, Charitable Giving Reached a Record $471.44 Billion in 2020," press release, June 15, 2021, https://cdn.ymaws.com/www.givinginstitute.org/resource/resmgr/gusa/2021_resources/gusa_2021_press_release_fina.pdf.

13. Arthur C. Brooks, "The 'Income Gap' and the Health of Arts Nonprofits," *Nonprofit Management and Leadership* 10, no. 3 (2000): 271–86.

14. Henry Kurkowski, "Sponsoring the Arts Builds Business," *Forbes*, December 27, 2019, www.forbes.com/sites/forbesagencycouncil/2019/12/27/sponsoring-the-arts-builds-business/.

15. Americans for the Arts, "The pARTnership Movement," accessed May 18, 2023, www.partnershipmovement.org.

16. Erica Eisen, "Demonstrators Take Over British Museum in Biggest-Ever Protest against Oil Sponsorships," *Art Newspaper*, February 18, 2019, www.theartnewspaper.com/2019/02/18/demonstrators-take-over-british-museum-in-biggest-ever-protest-against-oil-sponsorships.

17. Martin Bailey, "Why Is the British Museum Still Accepting Tobacco Sponsorship?," *Art Newspaper*, April 2, 2019, www.theartnewspaper.com/2019/04/02/why-is-the-british-museum-still-accepting-tobacco-sponsorship.

18. Candid, "Foundation Directory," accessed June 22, 2022, foundationcenter.org.

19. Peter Kim and Jeffrey Bradach, "Why More Nonprofits Are Getting Bigger," *Stanford Social Innovation Review* 10, no. 2 (2012): 14–16.

20. Kim and Bradach, "Why More Nonprofits," 14–16.

21. National Endowment for the Arts, "Impact," accessed October 11, 2021, https://www.arts.gov/impact.

22. Judith Wolf, personal communication with Margaret F. Sloan, October 8, 2021.

23. National Assembly of State Arts Agencies, *State Art Agencies Dedicated Revenue Strategies*, accessed January 17, 2022, https://nasaa-arts.org/nasaa_research/policybrief-dedicatedrevenues/. Dedicated funding is funding that the grantor restricts for a particular purpose. It's different from grants made for general operating support, which is unrestricted and provides nonprofit leaders with the flexibility to direct spending toward the organization's strategic priorities.

24. National Assembly of State Arts Agencies, *The Federal-State Partnership in the Arts*, accessed January 17, 2022, https://nasaa-arts.org/nasaa_research/the-federal-state-partnership-in-the-arts-policy-brief/.

25. Mirae Kim and Gregg G. Van Ryzin, "Impact of Government Funding on Donations to Arts Organizations: A Survey Experiment," *Nonprofit and Voluntary Sector Quarterly* 43, no. 5 (2014): 910–25.

26. Anonymous, personal communication with Margaret F. Sloan, July 1, 2021.

27. Qgiv, "Fundraising Statistics: Incredible Insights to Raise More," accessed July 16, 2021, www.qgiv.com/blog/fundraising-statistics/.

28. Judith Wolf, personal communication with Margaret F. Sloan, October 8, 2021.

29. Woods Bowman, Elizabeth Keating, and Mark Hager, "Investment Income," in *Financing Nonprofits: Putting Theory into Practice*, ed. Dennis R. Young (Lanham, MD: AltaMira, 2007), 157–82.

30. Henry Donahue, *Advancing Collaboration with Save the Music Foundation*, Save the Music Foundation and Give.org, accessed January 14, 2021, https://give.org/docs/default-source/collab-downloads/advancingcollaborationcard_vh1savethemusic_2020.pdf.

31. Mary Ann Glynn, Elizabeth A. Hood, and Benjamin D. Innis, "Taking Hybridity for Granted: Institutionalization and Hybrid Identification," in *Organizational Hybridity: Perspectives, Processes, Promises* (Bingley, UK: Emerald, 2020), 53–72.

32. Michael Rushton, "Hybrid Organizations in the Arts: A Cautionary View," *Journal of Arts Management, Law, and Society* 44, no. 3 (2014): 145.

33. Minna Ruusuvirta, "Hybrid Third Sector Organizations in Finland—Arts and Cultural Institutions in Focus," *Nordisk Kulturpolitisk Tidsskrift* 16, no. 2 (2014): 217–38.

CHAPTER FOUR

1. Charles K. Coe, *Nonprofit Financial Management: A Practical Guide* (Hoboken, NJ: John Wiley & Sons, 2011), 127.

2. Greg G. Chen, Lynne A. Weikart, and Daniel W. Williams, *Budget Tools: Financial Methods in the Public Sector* (Thousand Oaks, CA: CQ Press, 2015), 239.

3. Hilda H. Polanco and John Summers, "Cash Flow in the Nonprofit Business Model: A Question of Whats and Whens," *Nonprofit Quarterly*, December 10, 2020, https://nonprofitquarterly.org/cash-flow-nonprofit-business-model-question-whats-whens/.

4. Polanco and Summers, "Cash Flow."

5. Polanco and Summers, "Cash Flow."

6. Ellen Rosewall, *Arts Management: Uniting Arts and Audiences in the 21st Century* (Oxford: Oxford University Press, 2022), 242–57.

7. Propel Nonprofits, "Cash Flow Management," accessed June 22, 2022, www.propelnonprofits.org/resources/managing-cash-flow/.

8. Propel Nonprofits, "Cash Flow Management."

9. Steven Lawrence, "The Art of Liquidity," SMU DataArts, June 1, 2018, https://dataarts.smu.edu/artsresearch2014/WC18-Liquidity.

10. Lawrence, "Art of Liquidity."

11. Lawrence, "Art of Liquidity."

12. Claire Knowlton, "Unpacking Your Organization's Unique Liquidity Needs," SMU DataArts, June 28, 2018, https://dataarts.smu.edu/artsresearch2014/WC18-NFF.

13. Zannie Voss, Manuel Lasaga, and Teresa Eyring, *Theatres at the Crossroads: Overcoming Downtrends and Protecting Your Organization through Future Downturns*, SMU DataArts, accessed June 22, 2022, https://culturaldata.org/pages/theatres-at-the-crossroads/.

14. Voss, Lasaga, and Eyring, *Theatres at the Crossroads*.

15. Michael M. Kaiser, *The Art of the Turnaround: Creating and Maintaining Healthy Arts Organizations* (Waltham, MA: Brandeis University Press, 2009), 36.

16. Kaiser, *Art of the Turnaround*.

17. Voss, Lasaga, and Eyring, *Theatres at the Crossroads*.

18. Voss, Lasaga, and Eyring, *Theatres at the Crossroads*.

19. Steven A. Finkler, Thad D. Calabrese, and Daniel L. Smith, *Financial Management for Public, Health, and Not-for-Profit Organizations* (Thousand Oaks, CA: CQ Press, 2023), 43.

20. Kaiser, *Art of the Turnaround*.

21. Kaiser, *Art of the Turnaround*.

22. Polanco and Summers, "Cash Flow."

23. Polanco and Summers, "Cash Flow."

24. Polanco and Summers, "Cash Flow."

25. Charity CFO, "5 Warning Signs of Nonprofit Cash Flow Issues," April 12, 2022, https://thecharitycfo.com/nonprofit-cash-flow-issues/.

26. Charity CFO, "5 Warning Signs."

CHAPTER FIVE

1. This chapter is informed by our prior work in the following articles: Cleopatra Grizzle, Margaret F. Sloan, and Mirae Kim, "Financial Factors That Influence the Size of Nonprofit Operating Reserves," *Journal of Public Budgeting, Accounting and Financial Management* 27, no. 1 (2015): 67–97; Margaret F. Sloan, Cleopatra Charles, and Mirae Kim, "Nonprofit Leader Perceptions of Operating Reserves and Their Substitutes," *Nonprofit Management and Leadership* 26, no. 4 (2016): 417–33; Margaret F. Sloan, Cleopatra Grizzle, and Mirae Kim, "What Happens on a Rainy Day? How Nonprofit Human Service Leaders Create, Maintain, and Utilize Operating Reserves," *Journal of Nonprofit Education and Leadership* 5, no. 3 (2015): 190–202.

2. Ilana Rose, "Taking Your Fiscal Pulse 2014: A Snapshot of the Current Fiscal Health of National Not-for-Profit Theater," Theater Communications Group, accessed May 9, 2022, www.tcg.org/pdfs/tools/TakingYourFiscalPulse2014.pdf.

3. Rose, "Taking Your Fiscal Pulse 2014."

4. Grizzle, Sloan, and Kim, "Financial Factors That Influence."

5. Mirae Kim and Dyana P. Mason, "Research Note: Bridging the Gaps between the Theory and Practice of Nonprofit Operating Reserves," *Nonprofit Management and Leadership* 32, no. 4 (2022): 669–82.

6. Renee A. Irvin and Craig W. Furneaux, "Surviving the Black Swan Event: How Much Reserves Should Nonprofit Organizations Hold?," *Nonprofit and Voluntary Sector Quarterly* 51, no. 5 (November 2021): 943–66.

7. Propel Nonprofits, "Operating Reserves with Nonprofit Policy Examples," accessed June 24, 2022, www.propelnonprofits.org/resources/nonprofit-operating-reserves-policy-examples/.

8. Nonprofit Operating Reserves Initiatives Workgroup, "Board-Designated Operating Reserve Policy Toolkit for Small and Midsize Nonprofit Organizations," updated edition, Nonprofit Accounting Basics website, April 2023, https://www.nonprofitaccountingbasics.org/nonprofit-reserves.

9. Mark A. Hager, "Should Your Nonprofit Build an Endowment?," *Nonprofit Quarterly*, June 21, 2006, https://nonprofitquarterly.org/should-your-nonprofit-build-an

-endowment/; Woods Bowman, "Financial Capacity and Sustainability of Ordinary Nonprofits," *Nonprofit Management and Leadership* 22, no. 1 (2011): 37–51.

10. All unattributed quotes in this chapter are from anonymous survey respondents.

11. Burton A. Weisbrod and Evelyn D. Asch, "The Truth about the 'Crisis' in Higher Education Finance," *Change: The Magazine of Higher Learning* 42, no. 1 (2010): 23–29.

12. Heng Qu, "Endowment for a Rainy Day? An Empirical Analysis of Endowment Spending by Operating Public Charities," *Nonprofit Management and Leadership* 31, no. 3 (2021): 571–94.

13. Robert Yetman, "Borrowing and Debt," in *Financing Nonprofits: Putting Theory into Practice*, ed. Dennis Young (Lanham, MD: AltaMira, 2007), 243–68; Woods Bowman, "The Price of Nonprofit Debt," *Nonprofit Quarterly*, 2015, https://nonprofitquarterly.org/the-price-of-nonprofit-debt/.

14. Woods Bowman, *Finance Fundamentals for Nonprofits: Building Capacity and Sustainability* (Hoboken, NJ: Wiley, 2011), 176.

15. John Zietlow, "Nonprofit Financial Objectives and Financial Responses to a Tough Economy," *Journal of Corporate Treasury Management* 3, no. 3 (2010): 244.

16. Nonprofit Operating Reserves Initiative Workgroup, "Maintaining Nonprofit Operating Reserves: An Organizational Imperative for Nonprofit Financial Stability," accessed June 24, 2022, www.nonprofitaccountingbasics.org/sites/default/files/03-BriefIntroToOperatingReservesInitiative2016-06.pdf.

17. Southern Methodist University, SMU Data Arts, https://culturaldata.org/; Mirae Kim and Cleopatra Charles, "Assessing the Strength and Weakness of the Cultural Data Profile Measures in Comparison with the NCCS 990 Data," *Journal of Public Budgeting, Accounting and Financial Management* 28, no. 3 (2016): 337–60.

18. Irvin and Furneaux propose a formula to establish the right operating reserve ratio for a specific organization. They write, "Compared with the difficulty of accumulating reserves, the task of identifying a target reserve size is comparatively straightforward. An organization can note their total gross revenue for the past several years and calculate the percentage change from each year to the next. After calculating the standard deviation of the revenue percentage change figures, the standard deviation can then be multiplied by the z values noted on page 14 to arrive at the percent-of-year figure. This figure corresponds to the percentage drop in revenue the organization would experience in a moderately bad year (10 percent chance of occurring) or a horrific year (1 percent chance of occurring). The expected drop in revenue—40 to 90 percent, for example—guides the organization in its determination of how much reserves to set aside to cover operating expense." Irvin and Furneaux, "Surviving the Black Swan Event."

19. Nonprofit Operating Reserves Initiative Workgroup, "Maintaining Nonprofit Operating Reserves"; Dennis R. Young, ed., *Financing Nonprofits: Putting Theory into Practice* (Lanham, MD: AltaMira, 2007).

20. Irvin and Furneaux, "Surviving the Black Swan Event."

21. Irvin and Furneaux, "Surviving the Black Swan Event."

22. Sarah Pettijohn, "Federal Government Contracts and Grants for Nonprofits," *Government-Nonprofit Contracting Relationships Brief 1*, May 2013, Urban Institute,

www.urban.org/sites/default/files/publication/23671/412832-Federal-Government-Contracts-and-Grants-for-Nonprofits.PDF.

23. Shari Jennell, finance director at the Barter Foundation, personal communication with Margaret Sloan, September 10, 2021.

CHAPTER SIX

1. Internal Revenue Service, "Section 6033(j) of the Internal Revenue Code," accessed June 24, 2022, www.irs.gov/charities-non-profits/automatic-revocation-of-exemption.

2. Karen A. Froelich, Terry W. Knoepfle, and Thomas H. Pollak, "Financial Measures in Nonprofit Organization Research: Comparing IRS 990 Return and Audited Financial Statement Data," *Nonprofit and Voluntary Sector Quarterly* 29, no. 2 (2000): 232–54; Karen A. Froelich and Terry W. Knoepfle, "Internal Revenue Service 990 Data: Fact or Fiction?," *Nonprofit and Voluntary Sector Quarterly* 25, no. 1 (1996): 40–52.

3. Froelich and Knoepfle "Internal Revenue Service 990 Data."

4. Karen A. Froelich, "The 990 Return: Beyond the Internal Revenue Service," *Nonprofit Management and Leadership* 8, no. 2 (1997): 141–55.

5. When reporting independent directors on the 990 Form, the IRS definition of "independent" includes members of the board who were neither involved nor had a family member who was involved in a transaction reportable on Schedule L during the fiscal year.

6. Internal Revenue Service, "2022 Instructions for Form 990-EZ," accessed September 19, 2023, www.irs.gov.

7. Mirae Kim, "The Relationship of Nonprofits' Financial Health to Program Outcomes: Empirical Evidence from Nonprofit Arts Organizations," *Nonprofit and Voluntary Sector Quarterly* 46, no. 3 (2017): 525–48.

8. Adam Hayes, "Accrual Accounting," *Investopedia*, November 27, 2021, www.investopedia.com/terms/a/accrualaccounting.asp.

9. Toni Cameron, "The Balance Sheet for Therapists," TLDR Accounting, September 10, 2020, www.tldraccounting.com/balance-sheet-for-therapists/.

10. Financial Accounting Standards Board, "Not-for-Profit Entities Topic 958, Presentation of Financial Statements for Not-for-Profit Entities," August 2016, https://asc.fasb.org/imageRoot/56/92564756.pdf.

11. Financial Accounting Standards Board, "Not-for-Profit Entities Topic 958."

12. See Hala Altamimi and Qiaozhen Liu, "The Nonprofit Starvation Cycle: Does Overhead Spending Really Impact Program Outcomes?," *Nonprofit and Voluntary Sector Quarterly* 51, no. 4 (2021): 1324–48. Using data on the US nonprofit arts and cultural subsector from 2008 to 2018, the authors found that 27 percent was the average overhead spending percentage for arts and cultural nonprofits.

CHAPTER SEVEN

1. See Mo. Rev. Stat. §355.821.1; Mont. Code Ann. §35-2-904; Neb. Rev. Stat. §21-1903.

2. See N.J. P.L. 2021 c. 381.

3. National Council of Nonprofits, "Nonprofit Audit Guide: Financial Audit Basics," accessed June 27, 2022, www.councilofnonprofits.org/sites/default/files/documents/YH%20-%20Audit%20Basics%20Final.pdf.

4. National Council of Nonprofits, "Nonprofit Audit Guide: Financial Audit Basics."
5. National Council of Nonprofits, "Nonprofit Audit Guide: Financial Audit Basics."
6. Jennifer Wilson, "Why Are We Still Auditing on Site?," *Journal of Accountancy*, December 4, 2017, www.journalofaccountancy.com/newsletters/2017/dec/why-auditing-on-site.html.
7. National Council of Nonprofits, "Nonprofit Audit Guide: What Is a Review?," accessed June 27, 2022, www.councilofnonprofits.org/nonprofit-audit-guide/what-is-a-review.
8. National Council of Nonprofits, "Nonprofit Audit Guide: What Is a Review?"
9. Hana Tagaki, "How Independent Audits and Audit Committees Protect Nonprofits," *Nonprofit Law Blog*, August 13, 2018, https://nonprofitlawblog.com/how-independent-audits-and-audit-committees-protect-nonprofits/.
10. Jacqueline L. Reck, *Accounting for Governmental and Nonprofit Entities*, 19th ed. (New York: McGraw-Hill, 2021).
11. National Council of Nonprofits, "Nonprofit Guide: What Does the Audit Committee Do?," accessed June 27, 2022, www.councilofnonprofits.org/nonprofit-audit-guide/what-does-audit-committee-do.
12. National Council of Nonprofits, "Nonprofit Guide: What Does the Audit Committee Do?"
13. National Council of Nonprofits, "After the Audit," accessed June 27, 2022, https://www.councilofnonprofits.org/print/741.
14. Karen Kitchling, "Audit Value and Charitable Organizations," *Journal of Accounting and Public Policy* 28, no. 6 (November–December 2009): 510–24.
15. Erica Harris, Christine M. Petrovits, and Michelle H. Yetman, "The Effect of Nonprofit Governance on Donations: Evidence from the Revised Form 990," *Accounting Review* 90, no. 2 (2015): 579–610.
16. Erica Harris, Christine Petrovits, and Michelle H. Yetman, "Why Bad Things Happen to Good Organizations: The Link between Governance and Asset Diversions in Public Charities," *Journal of Business Ethics* 146, no. 1 (2017): 149–66.
17. Harris, Petrovits, and Yetman, "Why Bad Things Happen."
18. Harris, Petrovits, and Yetman, "Why Bad Things Happen."
19. Emmanuel J. Francois, *Financial Sustainability for Nonprofit Organizations* (New York: Springer, 2014).

CHAPTER EIGHT

1. Ellen Rosewall, *Arts Management: Uniting Arts and Audiences in the 21st Century* (Oxford: Oxford University Press, 2014).
2. Andrew S. Lang, William D. Eisig, Lee Klumpp, and Tammy Ricciardella, *How to Read Nonprofit Financial Statements: A Practical Guide* (Hoboken: John Wiley & Sons, 2017).
3. Michelle Sanchez, "Nonprofit Ratios: How to Use Them and What They Measure for Your Organization," Warren Averett, May 12, 2021, https://warrenaverett.com/insights/nonprofit-ratios/.
4. Sanchez, "Nonprofit Ratios."

5. Sibi B. Thomas, "Using Effective Ratio Analysis at Nonprofits." Mark Spaneth, May 29, 2018, www.markspaneth.com/insights/category/articles/using-effective-ratio-analysis-at-nonprofits.

6. Jennifer A. Lammers, "Know Your Ratios? Everyone Else Does," *Nonprofit Quarterly*, March 21, 2003, https://nonprofitquarterly.org/know-your-ratios-everyone-else-does/.

7. Lynne Weikart and Greg G. Chen, *Budgeting and Financial Management for Nonprofit Organizations* (Long Grove, IL: Waveland, 2022), 150.

8. Lammers, "Know Your Ratios?"

9. Weikart and Chen, "Budgeting and Financial Management."

10. Giving Loop, "What Is a Good Fundraising Efficiency Ratio?," accessed June 27, 2022, www.givingloop.org/blog/what-is-a-good-fundraising-efficiency-ratio/.

11. Giving Loop, "Good Fundraising Efficiency Ratio."

12. Lang et al., "How to Read Nonprofit Financial Statements."

13. Mark Hager, Thomas Pollack, Kennard Wing, Patrick M. Rooney, and Ted Flack, "The Pros and Cons of Financial Efficiency Standards," *Nonprofit Overhead Cost Project: Facts and Perspectives Brief No. 5*, Center on Nonprofits and Philanthropy, Urban Institute, and Center on Philanthropy, Indiana University, August 2004, www.urban.org/sites/default/files/publication/57756/311055-The-Pros-and-Cons-of-Financial-Efficiency-Standards.PDF.

CHAPTER NINE

1. Bureau of Educational and Cultural Affairs, US Department of State, "Performance Measurement Definitions," accessed May 25, 2022, https://eca.state.gov/files/bureau/performance_measurement_definitions.pdf.

2. Peter H. Rossi, Mark W. Lipsey, and Gary T. Henry, *Evaluation: A Systematic Approach* (Thousand Oaks, CA: Sage, 2018), 92.

3. Rossi, Lipsey, and Henry, *Evaluation*, 92.

4. David Hanna, *Designing Organizations for High Performance* (New York: Pearson Education, 1988).

5. Hanna, *Designing Organizations*, 141.

6. Hanna, *Designing Organizations*, 142.

7. Rossi, Lipsey, and Henry, *Evaluation*, 116.

8. Rossi, Lipsey, and Henry, *Evaluation*, 116.

9. Christopher R. Prentice, "Understanding Nonprofit Financial Health: Exploring the Effects of Organizational and Environmental Variables," *Nonprofit and Voluntary Sector Quarterly* 45, no. 5 (2016): 888–909.

10. Terra Staffing Group, "The Real Cost of Replacing an Employee," accessed February 28, 2022, terrastaffinggroup.com.

11. Zippia, "Zippia's 100 Best Nonprofit Organizations to Work for in Virginia," accessed April 2, 2022, www.zippia.com/company/best-non-profits-companies-virginia/.

12. Cobi Krieger and Bronwyn Mauldin, *Make or Break: Race and Ethnicity in Entry-Level Compensation for Arts Administrators in Los Angeles County*, Center for Business and Management of the Arts, Claremont Graduate University, May 2021, https://www.lacountyarts.org/sites/default/files/makeorbreak_full_final.pdf.

13. WAGE, "Wage for Work Certification," accessed June 27, 2022, https://wageforwork.com/certification.

14. Francesco Chiaravalloti, "Performance Evaluation in the Arts and Cultural Sector: A Story of Accounting at Its Margins," *Journal of Arts Management, Law, and Society* 44, no. 2 (2014): 61–89.

15. Americans for the Arts, "Arts and Economic Prosperity Calculator," accessed June 27, 2022, www.americansforthearts.org/by-program/reports-and-data/research-studies-publications/arts-economic-prosperity-5/use/arts-economic-prosperity-5-calculator.

16. Creative Vitality, "Creative Vitality Index," accessed April 22, 2022, https://cvsuite.org/help-center/creative-vitality-index/.

17. Used with permission by Artrain 2022.

18. For example, see Ian Gilhespy, "Measuring the Performance of Cultural Organizations: A Model," *International Journal of Arts Management* (1999): 38–52; and Cleopatra Charles and Mirae Kim, "Do Donors Care about Results? An Analysis of Nonprofit Arts and Cultural Organizations," *Public Performance and Management Review* 39, no. 4 (2016): 864–84.

19. Charles and Kim, "Do Donors Care about Results?"

20. Audiences London, *Snapshot Audience Report*, 2012, https://www.culturehive.co.uk/wp-content/uploads/2013/04/Snapshot-Audience-Report-2009-10.pdf.

21. Hewlett Foundation, "Performing Arts Program Strategic Framework," accessed June 3, 2022, https://hewlett.org/wp-content/uploads/2019/11/Performing-Arts-Program-Strategic-Framework-2020.pdf.

CHAPTER TEN

1. Johanne Turbide and Claude Laurin, "Governance in the Arts and Culture Nonprofit Sector: Vigilance or Indifference?," *Administrative Sciences* 4, no. 4 (2014): 414.

2. "Rhizome Board Member Resigns in Protest of New Museum Leadership," *Art Review*, November 10, 2020, www.artreview.com/rhizome-board-member-resigns-in-protest-of-new-museum-leadership; Gabriella Angeleti, "Metropolitan Museum Drops Sackler Name from Its Galleries," *Art Newspaper*, December 9, 2021, www.theartnewspaper.com/2021/12/09/metropolitan-museum-drops-sackler-name-from-galleries; Eileen Kinsella and Julia Halperin, "Here Are the 12 Biggest Controversies That Rocked the Art World in 2020—and Why They Won't Disappear Next Year," Artnet, December 31, 2020, www.news.artnet.com/art-world/biggest-art-controversies-of-2020-1934132; Jeff M. Poulin, "It Is Past Time to Hold Americans for the Arts Accountable for Its Actions," Medium, November 25, 2020, www.jeff-14644.medium.com/it-is-past-time-to-hold-americans-for-the-arts-accountable-for-its-actions-6370aecfb87e.

3. Anna Bernadska, "Arts Organizations and Accountability," Faculty Research and Creative Activities Symposium, NEIU Digital Commons, Northeastern Illinois University, November 2018, https://neiudc.neiu.edu/cgi/viewcontent.cgi?article=1048&context=frcas.

4. Rosemary Tenuta and Vernetta Walker, *Museum Board Leadership 2017: A National Report*, American Alliance of Museums, January 19, 2018, www.aam-us.org/2018/01/19/museum-board-leadership-2017-a-national-report/.

5. Independent Sector, "Trust in Civil Society: Understanding the Factors Driving Trust in Nonprofits and Philanthropy," May 2022, https://independentsector.org/trust/.

6. Turbide and Laurin, "Governance in the Arts."

7. Internal Revenue Service, "Charities and Nonprofits," accessed June 27, 2022, www.irs.gov/charities/article/0,,id=129028,00.html. California's Nonprofit Integrity Act of 2004 required (1) thirty days instead of six months for charity's to file their Articles of Incorporation with the state attorney general's office, (2) independent audits of financial statements for charities with gross revenues of $2 million or more, and those organizations must also maintain an audit committee, (3) approval of executive compensation by a charity's executive board, and (4) commercial fundraisers to notify the attorney general's office before starting a solicitation campaign and to maintain written contracts with organizations for whom they work. See California Registry of Charitable Trusts, *Nonprofit Integrity Act of 2004: Summary of Key Provisions*, October 2004, https://oag.ca.gov/sites/all/files/agweb/pdfs/charities/publications/nonprofit_integrity_act_nov04.pdf.

8. Michael J. Worth, *Nonprofit Management: Principles and Practice* (Thousand Oaks, CA: CQ Press, 2020).

9. Internal Revenue Service, "Annual Form 990 Filing Requirements for Tax-Exempt Organizations," accessed May 31, 2023, www.irs.gov/pub/irs-pdf/p4839.pdf.

10. BoardSource and Independent Sector, *The Sarbanes-Oxley Act and Implications for Nonprofit Organizations*, January 2006, https://sps.columbia.edu/sites/default/files/2020-11/SarbanesOxley.BoardSource.pdf.

11. BoardSource and Independent Sector, *Sarbanes-Oxley Act*.

12. Donald G. Stephenson, *The Right to Vote: Rights and Liberties under the Law* (Santa Barbara, CA: ABC-CLIO, 2004).

13. US General Accounting Office, *Charitable Choice: Overview of Research Findings on Implementation*, Report to Congressional Requesters, GAO-02-337, January 18, 2002, www.gao.gov/assets/gao-02-337.pdf.

14. Panel on the Nonprofit Sector, *Principles of Good Governance and Ethical Practice: A Guide for Charities and Foundations* (Washington, DC: Panel on the Nonprofit Sector, 2007).

15. Peter Frumkin, *On Being Nonprofit: A Conceptual and Policy Primer* (Cambridge, MA: Harvard University Press, 2002).

16. Fischer Howe, "Nonprofit Accountability: The Board's Fiduciary Responsibility," in *Nonprofit Governance and Management*, ed. Victor Futter, Judith A. Cion, and George W. Overton (Chicago: American Bar Association and American Society of Corporate Secretaries, 2002), 29–38.

17. BoardSource, *Leading with Intent: BoardSource Index of Nonprofit Board Practices*, June 2021, https://leadingwithintent.org/wp-content/uploads/2021/06/2021-Leading-with-Intent-Report.pdf.

18. Basically, succession planning means that your organization has discussed, and has steps in place for, the time when your founder is no longer leading the organization. Consider who might step into the executive role either on an interim or short-term basis while a search for the next executive takes place. Identify what kinds of characteristics

the board would seek in the next executive and write them down. Discuss the long-term vision for your organization with the current founder and make sure the organization has a strategic plan in place that demonstrates and draws from that vision. Another issue that some organizations must deal with is that of founder transition. If not appropriately planned for, this can be a stumbling block for boards, particularly if those boards were overly reliant on the organization's founding executive for artistic direction or managerial oversight. Succession planning is the key to creating a seamless transition under these circumstances. Even if your founder-led organization (or even if *you* are the founder leading the organization) does not foresee the immediate exit of its founder, succession planning is still a good idea because you never know what's around the corner. Just as you make a will before it is needed, succession planning can help alleviate a lot of uncertainty and confusion later.

19. Cornell Law School, "Due Diligence," accessed April 30, 2022, www.law.cornell.edu/wex/due_diligence.

20. Adam Hayes, "Business Judgment Rule," *Investopedia*, April 27, 2022, www.investopedia.com/terms/b/businessjudgmentrule.asp.

21. J. Lunden, "Chronicle of a Death Foretold: New York City Opera Shuts Its Doors," *Morning Edition*, National Public Radio, October 1, 2013.

22. "Bankruptcy Court Says New York City Opera Can Sing Again; First Production Set," *Playbill*, January 13, 2016, https://playbill.com/article/bankruptcy-court-says-new-york-city-opera-can-sing-again-first-production-set-com-379208.

23. Bernadska, "Arts Organizations and Accountability."

24. Kevin P. Kearns, *Accountability in the Nonprofit Sector* (New York: M. E. Sharpe, 2010), 197–210.

CHAPTER ELEVEN

1. See George E. Mitchell and Thad D. Calabrese, "Proverbs of Nonprofit Financial Management," *American Review of Public Administration* 49, no. 6 (2019): 649–61.

2. *Merriam-Webster*, s.v. "fraud" (n., 1a), accessed September 17, 2023, www.merriam-webster.com/dictionary/fraud.

3. Dr. Seuss, *Did I Ever Tell You How Lucky You Are?* (New York: Random House, 1973).

4. Paul M. Clikeman, *Called to Account: Fourteen Financial Frauds That Shaped the American Accounting Profession* (Milton Park, UK: Routledge, 2010).

5. Clikeman, *Called to Account*.

6. Deb Polich, personal communication with Margaret Sloan, March 11, 2022.

7. *Merriam-Webster*, s.v. "conflict of interest," accessed September 17, 2023, www.merriam-webster.com/dictionary/conflict%20of%20interest.

8. Kenneth Cerini, "Related Party Transactions," 2020, https://nonprofitresourcehub.org/related-party-transactions/.

9. National Council of Nonprofits, "Internal Controls for Nonprofits," accessed June 27, 2022, www.councilofnonprofits.org/tools-resources/internal-controls-nonprofits; and Andy Robinson and Nancy Wasserman, "We're a Small Nonprofit. What Internal

Controls Do We Need to Have in Place?," blog post, National Council of Nonprofits, accessed June 27, 2022, www.councilofnonprofits.org/thought-leadership/we%E2%80%99re-small-nonprofit-what-internal-controls-do-we-need-have-place.

CHAPTER TWELVE

1. Rosalie S. Cates and Shin Yu Pai, "Impact Investing 101," *GIA Reader* 27, no. 2 (Summer 2016), www.giarts.org/article/impact-investing-101.

2. Cleopatra Charles, Margaret F. Sloan, and John S. Butler, "Capital Structure Determinants for Arts Nonprofits," *Nonprofit Management and Leadership* 31, no. 4 (2021): 761–82.

3. Kevin F. McCarthy, *The Performing Arts: Trends and Their Implications* (Santa Monica: RAND Corporation, 2001), www.rand.org/pubs/research_briefs/RB2504.html.

4. Francie Ostrower, *Why the Wealthy Give: The Culture of Elite Philanthropy* (Princeton, NJ: Princeton University Press, 1997); Francie Ostrower and Thad Calabrese, "Audience Building and Financial Health in the Nonprofit Performing Arts," in *Current Literature and Unanswered Questions Report* (Austin: University of Texas at Austin and the Wallace Foundation, 2019); Americans for the Arts, *Arts and Economic Prosperity 5*, 2015, www.americansforthearts.org/by-program/reports-and-data/research-studies-publications/arts-economic-prosperity-5; Mike Scutari, "The Arts Sector Is Being Decimated by COVID-19. What Are Funders Doing in Response?" *Inside Philanthropy*, March 23, 2020, www.insidephilanthropy.com/home/2020/3/22/how-can-funders-most-effectively-support-an-arts-sector-decimated-by-covid-19.

5. Francie Ostrower, "Nonprofit Arts Organizations: Sustainability and Rationales for Support," in *The Nonprofit Sector: A Research Handbook*, ed. Walter S. Powell and Patricia Bromley (Stanford, CA: Stanford University Press, 2020), 468–86.

6. Tim Donahue and Jim Patterson, *Stage Money: The Business of the Professional Theater* (Columbia: University of South Carolina Press, 2010).

7. Southern Methodist University, SMU Data Arts, accessed 2021, https://culturaldata.org/.

See also Mirae Kim and Cleopatra Charles, "Assessing the Strength and Weakness of the Cultural Data Project Measures in Comparison with the NCCS 990 Data," *Journal of Public Budgeting, Accounting and Financial Management* 28, no. 3 (2016): 337–60.

8. Theodore D. Schneider, "A Guide to Investing for Nonprofit Organizations," Cerity Partners, December 3, 2022, https://ceritypartners.com/insights/a-guide-to-investing-for-nonprofit-organizations/.

9. For more pros and cons of investment funding, see Woods Bowman, Elizabeth Keating, and Mark A. Hager, "Investment Income," chapter 7 in Dennis R. Young, ed., *Financing Nonprofits: Putting Theory into Practice* (Lanham, MD: AltaMira, 2007).

10. Kevin Chamber, "Best Practices: Investing for Nonprofits," Headwater Investment Consulting, accessed June 20, 2022, www.headwater-ic.com/blog.

11. National Council of Nonprofits, "Investment Policies for Nonprofits," accessed June 20, 2022, www.councilofnonprofits.org/tools-resources/investment-policies-nonprofits.

12. Burton Weisbrod and Evelyn Asch, "Endowment for a Rainy Day," *Stanford Social*

Innovation Review (Winter 2010): 41–47; Heng Qu, "Endowment for a Rainy Day? An Empirical Analysis of Endowment Spending by Operating Public Charities," *Nonprofit Management and Leadership* 31, no. 3 (2021): 571–94; Thad D. Calabrese, "Testing Competing Capital Structure Theories of Nonprofit Organizations," *Public Budgeting and Finance* 31, no. 3 (2011): 119–43.

13. Stan Hutton, "Endowments and Arts Organizations," Grantmakers in the Arts, accessed June 27, 2022, www.giarts.org/article/endowments-and-arts-organizations.

14. Ilana B. Rose, "Taking Your Fiscal Pulse," Theatre Communications Group, 2014, https://circle.tcg.org/resources/research/snapshot-surveys/taking-your-fiscal-pulse?ssopc=1; Charles, Sloan, and Butler, "Capital Structure Determinants."

15. This list is derived, in part, from the work of Woods Bowman's *Finance Fundamentals for Nonprofits: Building Capacity and Sustainability* (Hoboken, NJ: Wiley, 2011).

16. Greg Coffey, *Investment Policy Statement: Elements of a Clearly Defined IPS for Non-profits*, Russell Investments Research, 2019, https://russellinvestments.com/-/media/files/us/insights/institutions/non-profit/elements-of-a-clearly-defined-ips-for-non-profits-an-update.

17. Coffey, "Investment Policy."

18. Giving Compass, "Arts Organizations Are Ensuring Their Investments and Values Are Aligned," May 20, 2021, https://givingcompass.org/article/arts-organizations-are-ensuring-their-investments-are-value-aligned.

19. Laura Callanan, "How American Arts Organizations Can Invest Their Values," *ArtsBlog*, Americans for the Arts, May 20, 2021, https://blog.americansforthearts.org/2021/05/20/how-america%E2%80%99s-arts-organizations-can-invest-their-values.

20. Mission Investors Exchange, "The Guide: What Cultural Institutions Need to Know about Investing for Values and Mission," December 2020, https://missioninvestors.org/resources/what-cultural-institutions-need-know-about-investing-values-and-mission.

21. Quoted in Adeola Enigbokan, "We Are All Debtors and the Debt Shall Set Us Free," artanddebt.org, June 30, 2015, https://artanddebt.org/we-are-all-debtors-and-the-debt-shall-set-us-free/. The remainder of Franklin's words are: "If you cannot pay at the time, you will be ashamed to see your creditor; you will be in fear when you speak to him, you will make poor pitiful sneaking excuses, and by degrees come to lose your veracity, and sink into base downright lying; for, as Poor Richard says, the second vice is lying, the first is running in debt."

22. George E. Mitchell and Thad D. Calabrese, "Proverbs of Nonprofit Financial Management," *American Review of Public Administration* 49, no. 6 (2019): 649–61.

23. Robert Yetman describes four reasons for nonprofits to incur debt: (1) to smooth short-term working capital needs; (2) to purchase facilities and equipment; (3) to take advantage of a business opportunity or when experiencing unanticipated cash need; and, finally, (4) to refinance existing debt. See Robert J. Yetman, "Borrowing and Debt," in Young, *Financing Nonprofits*, 243–68.

24. Cleopatra Charles, "Nonprofit Arts Organizations: Debt Ratio Does Not Influence Donations—Interest Expense Ratio Does," *American Review of Public Administration* 48, no. 7 (2018): 659–67; Thad Calabrese and Cleopatra Grizzle, "Debt, Donors,

and the Decision to Give," *Journal of Public Budgeting, Accounting and Financial Management* 24, no. 2 (2012): 221–54.

25. Geoffrey Peter Smith, "Capital Structure Determinants for Tax-Exempt Organizations: Evidence from the UK," *Financial Accountability and Management* 28, no. 2 (2012): 143–63.

26. Charles, Sloan, and Butler, "Capital Structure Determinants."

27. Yetman, "Borrowing and Debt."

28. Southern Methodist University, SMU Data Arts; see also Kim and Charles, "Assessing the Strength and Weakness of the Cultural Data Project."

29. Charles, Sloan, and Butler, "Capital Structure Determinants for Arts Nonprofits."

30. Mitchell and Calabrese, "Proverbs of Nonprofit Financial Management."

31. Yetman, "Borrowing and Debt"; Robert J. Yetman, "Capital Formation," in *Handbook of Research on Nonprofit Economics and Management* (Cheltenham, UK: Edward Elgar, 2010), 59–68; Wenli Yan, Dwight V. Denison, and John S. Butler, "Revenue Structure and Nonprofit Borrowing," *Public Finance Review* 37, no. 1 (2009): 47–67.

32. Dwight V. Denison, "Which Nonprofit Organizations Borrow?," *Public Budgeting and Finance* 29, no. 3 (2009): 110–23; Marc Jegers and Ilse Verschueren, "On the Capital Structure of Non-profit Organizations: An Empirical Study for Californian Organizations," *Financial Accountability and Management* 22, no. 4 (2006): 309–29.

33. Prior research has found that both the debt service ratio and high levels of indebtedness are associated with reduced donations. See Charles, "Nonprofit Arts Organizations: Debt Ratio Does Not Influence Donations"; Calabrese and Grizzle, "Debt, Donors, and the Decision to Give."

34. Propel Nonprofits, "Loans: A Guide to Borrowing for Nonprofit Organizations," 2022, www.propelnonprofits.org/resources/using-loans-guide-borrowing-nonprofit-organizations/.

35. Propel Nonprofits, "Loans."

36. Woods Bowman, "The Price of Nonprofit Debt," *Nonprofit Quarterly*, August 2015, https://nonprofitquarterly.org/2015/08/06/the-price-of-nonprofit-debt/.

37. Bowman, "The Price of Nonprofit Debt"; Charles, "Nonprofit Arts Organizations."

38. MacArthur Foundation, "Arts and Culture Loan Fund Grant Guidelines," accessed June 27, 2022, www.macfound.org/info-grantseekers/grantmaking-guidelines/arts-and-culture-loan-fun.

39. Grantmakers in the Arts, "Impact Investing 101," accessed May 30, 2023, www.giarts.org/article/impact-investing-101.

CHAPTER THIRTEEN

1. Arts and higher education organizations are considered "elite" donor priorities, with more donors from wealthy income brackets whose donations are more responsive to tax changes and economic downturns. See Francie Ostrower, *Why the Wealthy Give* (Princeton, NJ: Princeton University Press, 1997).

2. Robert D. Behn, "Leadership for Cut-Back Management: The Use of Corporate Strategy," *Public Administration Review* 40, no. 6 (1980): 613–20.

3. Independent Sector, *Health of the U.S. Nonprofit Sector*, October 2021, https://independentsector.org/wp-content/uploads/2021/10/sector-health-report-2021-101421.pdf.

4. Hakim Bishara, "228 Arts Institutions Laid Off 28% of Workers after Receiving PPP Loans," *Hyperallergic*, October 12, 2021, https://hyperallergic.com/684020/228-arts-institutions-laid-off-28-of-workers-after-receiving-ppp-loans/.

5. Giving USA, "Giving USA 2021: In a Year of Unprecedented Events and Challenges, Charitable Giving Reached a Record $471.44 Billion in 2020," press release, June 15, 2021, https://cdn.ymaws.com/www.givinginstitute.org/resource/resmgr/gusa/2021_resources/gusa_2021_press_release_fina.pdf.6. Mirae Kim and Dyana P. Mason, "Are You Ready: Financial Management, Operating Reserves, and the Immediate Impact of COVID-19 on Nonprofits," *Nonprofit and Voluntary Sector Quarterly* 49, no. 6 (2020): 1191.

7. ArtsFund, "Winter 2021 Snapshot," accessed June 27, 2022, www.artsfund.org/wp-content/uploads/2021/03/ArtsFund-Winter-2021-Impact-Data_FINAL.pdf.

8. Kim and Mason, "Are You Ready."

9. Based on a survey conducted in February 2021 of CEP's Grantee Voice panel, the report, *Persevering through Crisis: The State of Nonprofits*, found that 66 percent of respondents said the COVID-19 pandemic has had a "moderate" (38 percent) or "significant" (28 percent) negative impact on their organizations, down from 84 percent (46 percent and 38 percent, respectively) in a survey conducted in May 2020. Respondents who reported "significant" (5 percent) or "moderate" (11 percent) positive impacts said that remaining open during the pandemic helped raise public awareness of the organization or that they were able to expand their online offerings and broaden their reach, while the majority of those who reported negative impacts described difficulty delivering programs and services.

10. Douglas Noonan, *The Arts and Culture Sector's Contributions to Economic Recovery and Resiliency in the United States: Key Findings*, January 2021, https://nasaa-arts.org/wp-content/uploads/2021/01/ArtsCultureContribEconRecovery-KeyFindings.pdf, via National Assembly of State Arts Agencies, https://nasaa-arts.org/nasaa_research/the-arts-and-economic-recovery-research/.

11. Dennis Young, "Managing for Resilience in a Crisis," National Center on Nonprofit Enterprise, January 2021, https://nationalcne.org/managing-for-resilience-in-a-crisis-12-part-video-series/.

12. Henry Mintzberg, "Strategic Planning," *California Management Review* 36, nos. 1–2 (1993): 32.

13. Quoted in National Assembly of State Arts Agencies, *Creative Economies and Economic Recovery: Key Findings*, February 2021, p.75, https://nasaa-arts.org/wp-content/uploads/2021/02/Creative-Economy-and-Recovery-Case-Studies-Key-Findings.pdf.

14. Margaret F. Sloan, Laura Trull, Maureen Malomba, Emily Akerson, Kelly Atwood, and Melody Eaton, "A Rural Perspective on COVID-19 Responses: Access, Interdependence and Community," *Journal of Nonprofit Education and Leadership* 12, no. 1 (2022): 53–68.

15. Jeffrey Pompe and Lawrence Tamburri, "Fiddling in a Vortex: Have American Orchestras Squandered Their Supremacy on the American Cultural Scene?," *Journal of Arts Management, Law, and Society* 46, no. 2 (2016): 63–72.

16. E. Owen and S. Shibli, "Pricing Issues Relating to Contemporary Dance Audiences in Sheffield," *Managing Leisure* 3, no. 4 (1998): 181–93, http://doi.org/10.1080/136067198375969.

17. Francie Ostrower and Thad Calabrese, "Audience Building and Financial Health in the Nonprofit Performing Arts: Current Literature and Unanswered Questions (Executive Summary)," in *Classical Music: Contemporary Perspectives and Challenges*, ed. Michael Beckerman and Paul Boghossian (Cambridge, UK: Open Book Publishers, 2021), 8.

18. Renée A. Irvin and Craig W. Furneaux, "Surviving the Black Swan Event: How Much Reserves Should Nonprofit Organizations Hold?," *Nonprofit and Voluntary Sector Quarterly* 51, no. 5 (2022): 943–66.

19. Irvin and Furneaux, "Surviving the Black Swan Event."

20. Dennis R. Young, ed., *Financing Nonprofits: Putting Theory into Practice* (Lanham, MD: AltaMira, 2007).

21. Peter Kim and Jeffrey Bradach, "Why More Nonprofits Are Getting Bigger," *Stanford Social Innovation Review* 10, no. 2 (2012): 14–16; Arthur C. Brooks, "The 'Income Gap' and the Health of Arts Nonprofits," *Nonprofit Management and Leadership* 10, no. 3 (2000): 271–86.

22. Kim and Bradach, "Why More Nonprofits."

23. Ringa Raudla and Riin Savi, "The Use of Performance Information in Cutback Budgeting," *Public Money and Management* 35, no. 6 (2015): 409–16.

24. National Assembly of State Arts Agencies, *Creative Economies and Economic Recovery: Key Findings*, February 2021, 64, https://nasaa-arts.org/wp-content/uploads/2021/02/Creative-Economy-and-Recovery-Case-Studies-Key-Findings.pdf.

25. CDP data analysis from SMU Data Arts, https://culturaldata.org/; see also Mirae Kim and Cleopatra Charles, "Assessing the Strength and Weakness of the Cultural Data Project Measures in Comparison with the NCCS 990 Data," *Journal of Public Budgeting, Accounting and Financial Management* 28, no. 3 (2016): 337–60.

26. Kim and Charles, "Assessing the Strength and Weakness."

27. Kurt Thurmeier, "Three Principles and a Sim: Guidance for Cutback Budgeting in the Covid-19 Recession," International City/County Management Association, June 1, 2020, https://icma.org/blog-posts/three-principles-and-sim-guidance-cutback-budgeting-covid-19-recession.

28. Robert D. Behn, "Cutback Budgeting," *Journal of Policy Analysis and Management* 4, no. 2 (1985): 155–77; Robert Berne and Leanna Stiefel, "Cutback Budgeting: The Long-Term Consequences," *Journal of Policy Analysis and Management* 12, no. 4 (1993): 664–84; Ringa Raudla, Riin Savi, and Tiina Randma-Liiv, "Cutback Management Literature in the 1970s and 1980s: Taking Stock," *International Review of Administrative Sciences* 81, no. 3 (2015): 433–56.

29. Thurmeier, "Three Principles and a Sim."

30. Young, "Managing for Resilience in a Crisis."

31. David Hanna, *Designing Organizations for High Performance* (New York: Pearson Education, 1988).

CHAPTER FOURTEEN

1. Carol Noonan, "How Artists and Performers Survived the Pandemic," interview by Leila Fadel, *Weekend Edition*, National Public Radio, June 26, 2021.

2. Dr. Jonathan Stewart, personal communication with Margaret F. Sloan, July 30, 2021.

3. Mirae Kim, "The Relationship of Nonprofits' Financial Health to Program Outcomes: Empirical Evidence from Nonprofit Arts Organizations," *Nonprofit and Voluntary Sector Quarterly* 46, no. 3 (2017): 525–48.

4. ArtsFund, "Covid-19 Arts Sector Impacts," accessed June 27, 2022, www.artsfund.org/covid-19-arts-sector-impacts/; ArtsFund, "Winter 2021 Snapshot," accessed June 27, 2022, www.artsfund.org/wp-content/uploads/2021/03/ArtsFund-Winter-2021-Impact-Data_FINAL.pdf.

5. J. Lamar Pierce, "Programmatic Risk-Taking by American Opera Companies," *Journal of Cultural Economics* 24, no. 1 (2000): 45–63.

6. Paul DiMaggio, "Can Culture Survive the Marketplace?," *Journal of Arts Management and Law* 13, no. 1 (1983): 61–87.

7. Cobi Krieger, "Troubling Earnings Disparities in the Arts," *Hyperallergic*, May 18, 2021, https://hyperallergic.com/646576/troubling-earnings-disparities-in-the-arts/.

8. María José del Barrio-Tellado, Luis César Herrero-Prieto, and Clare Murray, "Audience Success or Art for Art's Sake? Efficiency Evaluation of Dance Companies in the United States," *Nonprofit Management and Leadership* 31, no. 1 (2020): 129–52.

9. Alberta Arthurs, Frank Hodsoll, and Steven Lavine, "For-Profit and Not-for-Profit Arts Connections: Existing and Potential," *Journal of Arts Management, Law, and Society* 29, no. 2 (1999): 80–96.

10. M. Bergamini, W. Van de Velde, B. Van Looy, and K. Visscher, "Organizing Artistic Activities in a Recurrent Manner: (On the Nature of) Entrepreneurship in the Performing Arts," *Creativity and Innovation Management* 27, no. 3 (2018): 319–34.

11. M. Renko, "Entrepreneurial Leadership," in *Nature of Leadership*, ed. David V. Day and John Antonakis (London: Sage, 2017).

12. Ronald Abadian Heifetz, Alexander Grashow, and Martin Linsky, *The Practice of Adaptive Leadership: Tools and Tactics for Changing Your Organization and the World* (Boston: Harvard Business Press, 2009); Mirae Kim, "The Relationship of Nonprofits' Financial Health to Program Outcomes: Empirical Evidence from Nonprofit Arts Organizations," *Nonprofit and Voluntary Sector Quarterly* 46, no. 3 (2017): 525–48; J. Lamar Pierce, "Programmatic Risk-Taking by American Opera Companies," *Journal of Cultural Economics* 24, no. 1 (2000): 45–63; Paul DiMaggio, "Can Culture Survive the Marketplace?," *Journal of Arts Management and Law* 13, no. 1 (1983): 61–87; del Barrio-Tellado, Herrero-Prieto, and Murray, "Audience Success or Art for Art's Sake?"

INDEX

accountability, 9, 11, 163–76 passim; in audit process, 121, 126–27; in budgeting, 16, 19–20, 28; in policies, 186–88; in reserves, 89; role of leader in, 146; transparency, 117
accountability audits, 183
accounting equation, 8, 96, 106, 112
accrual accounting, 104, 112, 252
activity statements, 44, 95–96, 104, 107–8, 111, 135, 139. *See also* income statements; statements of activities; statements of support
Americans for the Arts, 26, 54, 56, 156, 164, 186
Andy Warhol Foundation for the Visual Arts, 197
Antonelli, Alice, 34
Artrain, 82, 157, 182, 207–8, 216, 219–20; case study of, 222–23, 227
Arts Council of the Valley, 215
ArtsFund, 167, 209, 227
Arts + Business Council of Greater Philadelphia, 167
asset allocation, 9, 189, 194, 196–97, 204
assets, 18, 20, 68, 71, 96–97, 100–109, 112, 218; accountability and governance of, 165; and audits, 121, 124–25; and budgeting, 35, 43–44; in financial ratios, 233–42 passim; in financial statements, 131–42; and fraud, 178–81; short- and long-term, 193, 200, 203. *See also* fixed assets; net assets
asset turnover ratios, 139–40
Association for Research on Nonprofit Organizations and Voluntary Associations (ARNOVA), 212

Association of Fundraising Counsel Trust for Philanthropy (AAFRC), 56
Association of Fundraising Professionals, 55–56
audits, 28, 115–28 passim; audit committee, 19, 171; external, 28, 116–17, 119; independent, 8, 24, 131, 166; internal, 121, 127

balance sheets, 8, 43, 81, 177, 181, 240, 252; analysis of, 131, 133, 137–38; financial statements, 95–96, 103–4, 106–8, 112
Barter Theater, 49, 87, 216, 229
Baumol, William, 4
Baumol's disease, 4, 12
benefit corporations (B-corps), 1, 64, 66, 191
Better Business Bureau Wise Giving Alliance, 83, 97, 127, 130, 140–41, 166
Black Friar's Playhouse, 228
boards of directors, 163–76 passim. *See also* governance
BoardSource, 167, 176
bonds, 62, 192–94, 196–97, 203–4
Bowen, William, 4
Bowman, Woods, 13, 83, 222
BP Oil, 56
Bradach, Jeffrey, 58
break-even analysis, 7, 29, 31–32, 35, 37, 46
break-even point, 35, 38, 46
British Museum, 56
budgets: assessment tools, 234–40; cash flow, 72–74; cutback budgeting, 208, 218; and operating reserves, 78, 86–89, 92; preparation, 30–47 passim; process, 15–29 passim; strategies, 212–14, 218

Burdett, Christine, 25
Bureau of Educational and Cultural Affairs, 146

capital budgets, 18, 29, 235
capital reserves, 81, 82, 92
cash budgets, 18, 29, 43, 73, 74
cash flow, 67–76 passim; budgets, 72–74; and reserves, 79–81, 85, 90; shortages, 18
cash flow statements, 96, 104, 111, 135–36, 141–42
CDP (Cultural Data Profile), 62, 192, 209, 215
Center of Visual Expertise (COVE), 53
certificates of deposit (CDs), 81, 106, 108, 111–12
certified public accountants (CPAs), 20, 116–17, 120
CFOs (chief financial officers): and role of 120–21, 122–23; and variance, 40
Charitable Choice, 166
Charity Navigator, 97, 118, 130, 198
CharityWatch, 83
charity watchdog organizations, 118, 127
Chen, Greg, 29, 35, 39, 47, 68, 141, 143
chief financial officers (CFOs): and role of 120–21, 122–23; and variance, 40
Chua, Gracia, 20
Clikeman, Paul, 179
Coe, Charles, 67
Coffey, Greg, 205
collateral, 203–4
Community Brands, 39, 147
Community Investment Management, 197
compilations, 117–18, 127
compliance, 96, 101, 105, 117–25 passim, 140, 143, 164–65, 167, 178
conflicts of interest, 122, 183, 188
conservatism, 33, 46, 95, 103
contingency plans: creation of, 45–46; and financial challenges, 226, 227

Cook Inlet Tribal Council (CITC), 189–90, 197
corporate social responsibility initiatives, 5, 12, 56–57
coverage ratios, 139
COVID-19: and damage to nonprofit arts organizations, 26, 42; and external shocks, 191; and giving, 56; impact of, 78, 209, 210, 212, 215–18; PPP loan program, 199; and reserves, 87
CPAs (certified public accountants), 20, 116–17, 120
Creative Vitality Index, 156
Creative Washtenaw, 82, 182, 186, 207
Cultural Data Profile (CDP), 62, 192, 209, 215
current ratios, 137, 233

days of cash on hand ratios, 137–38, 233
debt, 189–205 passim; in financial ratios, 233–34; financing, 61–62
debt-to-assets ratios, 137–38, 233
debt-to-equity ratios, 138. *See also* viability ratios
deficits: assessment of, 240; budgeting and, 34–36, 39, 41; prevalence of, 77–78; prevention of, 25, 49, 69; strategies to avoid, 85, 109, 201
depreciation, 43–44; in financial ratios, 233; in financial statements, 108, 110, 112, 134; straight-line method, 136
Diegert, Mary, 20
direct costs, 45–46, 97
donor restrictions, 21, 106–7, 112
due diligence, 101, 169–70, 175, 195
duty of care, 169, 175
duty of loyalty, 169, 175, 181
duty of obedience, 169

earned revenue, 52, 53, 66, 191, 200. *See also* fee-for-service revenue
Enamhe, Bohor, 32
Eisenstein, Lena, 27

endowments, 69, 80; and debt, 190; and investments, 193, 194; and spending policies, 212; as substitutes, 80–81
Eyring, Teresa, 71

FACE performance measures, 145, 153–54, 161. *See also* performance measurement
FASB (Financial Accounting Standards Board), 102, 106, 121, 128, 136
fee-for-service revenue, 52–53, 60, 65. *See also* earned revenue
fiduciary responsibilities, 19–20, 29, 95, 122, 166, 175
Field Museum, 54
Financial Accounting Standards Board (FASB), 102, 106, 121, 128, 136
financial risk, 138, 142, 193, 195, 204
financial statement analysis, 9, 125, 129–43 passim
fiscal year, 15–16
fixed assets, 43, 46. *See also* assets
fixed costs, 37–39, 46, 214
fixed revenue, 37–39, 46, 62
forecasts, 23, 26, 29, 46; in budgeting, 31–35; for cash flow, 68. *See also* revenue forecast
Foundation Center, 57
Foundation Directory, 57
Francois, Emmanuel, 127
fraud, 9, 19, 112, 132, 177–88 passim, 235; role of audits in prevention of, 116, 118, 124–27
full cost, 45–46, 154. *See also* total cost
fundraising efficiency ratios, 141
Furneaux, Craig, 213

GAAP (generally accepted accounting principles). *See* generally accepted accounting principles (GAAP)
generally accepted accounting principles (GAAP): and accrual accounting, 104; and auditing, 131; and board members, 169; defined, 102; and financial statements, 116, 118; and liabilities, 181; and revenues and expenses, 121; and unqualified opinions, 123, 124
Giving USA, 56
going concern, 68, 70, 76, 103, 112, 127
Goldstein, Hope, 21
governance, 163–76 passim. *See also* boards of directors
Greater Kanawha Foundation, 211
Great Recession, 7, 9, 26, 31, 58, 210, 215

Hanna, David, 151, 220
Hansmann, Henry, 4
Harris, Erica, 127
Healing Arts Initiative, 18–19
Henry, Gary, 150, 153
Hewlett Foundation, 158
Howe, Fisher, 167
hybridization, 8, 63, 230
hybrid organizations, 12, 52, 63, 64

IDEA, 50–51, 204
impact evaluation, 150–51, 161
impact investments, 197, 204
Impact Shares, 197
income statements, 107, 112. *See also* activity statements; statements of activities; statements of support
incrementalism, 211, 221
Independent Sector, 165, 209
indirect costs, 45–46
internal controls, 116–18, 122, 126, 178–79, 182, 241
Internal Revenue Service (IRS), 43, 131; 990 form, 96, 97, 101, 111, 130; 990-N (e postcard), 165; reporting requirements, 164–65
International Association of Blacks in Dance, 186
investments, 189–205 passim; accounts, 81–82, 184; analyzing, 20; capital, 80;

investments (*continued*)
 in financial ratios, 233; in human resources, 50; income from, 61–62; liquidity of, 73–74; long-term, 18; oversight of, 70; policy, 107; in programming, 227; return on, 51–56, 214; role of community, 5; short-term, 137
IRS (Internal Revenue Service). *See* Internal Revenue Service (IRS)
Irvin, Renee, 213

Jones, Ryan, 34–35

Kaiser, Michael, 28, 72, 75
Kelley Blue Book (KBB), 103
Key Performance Indicators, 153
Kim, Mirae, 209
Kim, Peter, 58
Knowlton, Claire, 70

Lammers, Jennifer, 140
Lang, Andrew, 135, 141
Laurin, Claude, 163
Lawrence, Steven, 69
leverage ratios, 138, 200
liabilities, 104; in financial analysis, 133–38, 142; in financial ratios, 233; in financial statements, 100, 106, 108, 113; misstatements, 180–81; in self-assessment, 238, 240, 242
Limited Liability Corporation (LLC), 5, 64, 66, 191
Lincoln Center for the Performing Arts, 17
lines of credit, 18, 28, 70, 81–82, 86, 136, 202, 204
Lipsey, Mark, 150, 153
liquidity: and affiliated foundation or nonprofit, 82; and assets, 106; and borrowing and repaying of funds, 111; and financial metrics 154; and financial statement analysis, 130; meaning of, 68, 80
liquidity ratios, 136–37, 142

Louvre Museum, 57
low-profit limited liability corporations (L3Cs), 64

MacArthur Foundation, 202
management letters, 116, 126–27, 241
Maryland Association of Nonprofit Organizations, 166
Mason, Dyana, 209
Mass MoCA, 7
Maurer, KC, 198
metrics, 148–49, 153–61, 200
Metropolitan Museum of Art, 12, 57, 163
Micawber's Maxim, 1, 7, 12, 225, 226
Ministry Watch, 166
Minnesota Council of Nonprofits, 167
mortgages, 200–204
mutual funds, 194, 196, 197, 204

National Assembly of State Agencies, 59, 210
National Center for Charitable Statistics, 79
National Center on Nonprofit Enterprise, 167, 217, 219
National Council of Nonprofits, 20, 118, 126, 186, 193
National Endowment for the Arts (NEA), 6, 58–59; on COVID-19, 26; and programmatic risks, 228
National Office for Arts Accreditation, 165
National Taxonomy of Exempt Entities, 6
NEA (National Endowment for the Arts). *See* National Endowment for the Arts (NEA)
net assets, 80; in operating reserves formula, 83; on 990 form, 100–101; defined, 104; in accounting equation, 106, 108; and donor restrictions, 107; in financial statements, 132–35, 138–39; and equity, 180. *See also* assets
New York City Opera, 170, 171
Niederhoffer, Roy, 171

Nonprofit Association of Oregon, 183, 234
Nonprofit Law Blog, 119
Noonan, Carol, 225
North Adams, MA, 6–7
Northern California Grantmakers, 202
North River Museum, 67

operating budgets, 17, 18; and cash flow management, 68; depreciation in, 44; and difference from cash budgets, 73; and operating reserve ratio, 83
operating reserves, 23, 77–93 passim; access and use, 89–90; alternatives to, 82; and capital reserves, 81; criteria for, 79–80; defined, 78; and endowments, 80–81, 194; size of, 83; and strategy, 79. *See also* rainy day funds
opportunity costs, 51, 60, 62, 66
organizational turbulence, 207–8, 210, 221, 230; avoiding, 206–24 passim
Ostrower, Francie, 191
outcomes: in evaluation, 150–51; financial, 214; in grants, 58; measurement of, 146, 152–53, 158; strategies for improving, 206–23 passim
outputs: artistic, 5, 155; measurement of, 145, 152
overhead expenses, 24, 33–34, 46, 110
oversight: in audit, 119, 121–22; fiscal, 90–91, 167, 186; mistake, 20, 27, 179; role of accountability in, 164–67; role of board in, 80, 89, 91, 121, 168–71, 174–75, 184
Owens Corning, 52

Pai, Shin Yu, 202
Paskho, 197
Paycheck Protection Program (PPP), 26, 199, 210
performance measurement, 102, 144–61 passim, 164, 218
Petrovits, Christine, 127
Polanco, Hilda, 68

Polich, Deb, 11, 182, 207, 219
Pompe, Jeffrey, 212
poverty mentality, 3–4, 12, 77, 226, 229
PPP (Paycheck Protection Program), 26, 199, 210
Proctor, Allen, 17
program expenses, 33–35, 40, 105, 110, 194
program revenue, 35, 46
program services expense ratios, 140–41, 143, 234
Propel Nonprofits, 69, 167, 201, 205

rainy day funds, 8, 21, 77–93 passim, 194, 217. *See also* operating reserves
Rasmuson Foundation, 189–90, 197
rebalancing, 196, 204
return on net assets ratios, 139, 233
revenue forecasts, 33–34, 46. *See also* forecasts
Rhizome, 163–64
risk assessments, 125, 132, 142, 220, 235
RONA. *See* return on net assets ratios
Rosewall, Ellen, 33, 37, 45, 68–69, 130, 143
Rossi, Peter, 150–51, 153
Rushton, Michael, 64
Ruusuvirta, Minna, 64

Sackler, 57, 163–64
salvage value, 44, 46
Sanchez, Michelle, 138
Sarbanes-Oxley Act, 165, 166
Save the Music Foundation, 63
Seattle Art Museum, 54
Sloan, Margaret, 209
SMART goals, 145, 148–49, 161
solvency, 9, 68, 76, 85, 129, 130, 139, 154
Souls Grown Deep Foundation, 197–98
statements of activities, 107–9, 111, 113, 134, 240. *See also* activity statements; income statements; statements of support
statements of financial position, 104, 106, 108, 113, 137

statements of functional expenses, 104, 109, 110, 113
statements of support, 107, 113. *See also* activity statements; income statements; statements of activities
Stone Mountain Arts Center, 225
Stroud, Emily, 129
Summers, John, 68
surplus, 16, 35; in financial statements, 109, 139, 141; in ratios, 139, 233; role in reserves, 75, 78, 80; surplus/deficit, 18, 36, 41. *See also* surplus ratios
surplus ratios, 139. *See also* surplus
systems thinking, 208, 221

Tate, 56
Thomas, Sibi, 140
Thorn, George, 28
Toledo Museum of Art, 52
total costs, 38, 46. *See also* full costs
trade credit, 202, 204
Turbide, Johanne, 163

unfavorable variance, 40, 46
United Way Worldwide, 79
unqualified opinions, 117, 123–25, 127, 131
unrelated business income tax (UBIT), 182

Upstart Co-Lab, 197
Urban Institute, 79, 142–43, 157

variable costs, 35, 37–39, 46
variable revenue, 37–39, 46
variance, 39, 42, 46; unfavorable, 40, 46; analysis, 32, 39, 40, 41, 46; reports, 21, 46
viability ratios, 138, 233. *See also* debt-to-equity ratios
Voss, Zannie, 71

Weikart, Lynne, 35, 68, 141
Williams, Daniel, 68
Wise Giving Alliance, 83, 127, 140–41, 166
Wolf, Judith, 11, 58, 60
Working Arts and the Greater Economy, 155

Yetman, Michelle, 127
Yetman, Robert, 4
Young, Dennis, 211
Young Adults Institute, Inc. (YAI), 18
Young Arts Arizona, 58, 60

Zippia, 155

www.ingramcontent.com/pod-product-compliance
Lightning Source LLC
Chambersburg PA
CBHW020856180526
45163CB00007B/2522